ANARCHY,
PROTEST
&
REBELLION

ANARCHY, PROTEST & REBELLION

AND THE COUNTERCULTURE THAT CHANGED AMERICA

Fred W. McDarrah

with Gloria S. McDarrah and Timothy S. McDarrah

THUNDER'S MOUTH PRESS • NEW YORK

ANARCHY, PROTEST & REBELLION
And the Counterculture that Changed America

© 2003 by Fred W. McDarrah, Gloria S. McDarrah, and Timothy S. McDarrah

Published by
Thunder's Mouth Press
An Imprint of Avalon Publishing Group Incorporated
245 W. 17th St., 11th Floor
New York, NY 10011

Library of Congress Cataloging-in-Publication Data is available.

ISBN: 1-56025-542-0

9 8 7 6 5 4 3 2 1

Designed by Paul Paddock
Printed in the United States of America
Distributed by Publishers Group West

This book is dedicated to all the reporters, editors, critics, and columnists who I worked with on the *Village Voice,* who made this book possible.

Arthur Bell, Jonathan Black, Howard Blum, David Bourdon, Marty Breasted, Millie Brower, Susan Brownmiller, Robert Christgau, A.D. Coleman, Paul Cowan, Ed Fancher, Jules Feiffer, Michael Feingold, Diane Fisher, Joe Flaherty, Ellen Frankfort, Gary Giddins, Jack Goddard, Susan Goodman, Vivian Gornick, Gornick, Pete Hamill, Molly Haskell, Michael Harrington, Stepanine Harrington, Margo Hentoff, Nat Hentoff, Deborah Jowitt, James Kempon, Sally Kempton, Letitia Kent, Leighton Kerner, Lucy Komisar, Jane Kramer, Seymour Krim, Annette Kuhn, Roz Lacks, John Lahr, Steve Lerner, Dan List, Barbara Long, Norman Mailer, Bill Manville, Anna Mayo, Michael C.D. McDonald, Don McNeill, David McRenyolds, Jonas Mekas, Carmen Moore, Frederic Morton, Marlene Nadle, Jack Newfield, Mary Perot Nichols, John Perreault, Joe Pilati, Robin Reisig, Ron Rosenbaum, Blair Sabol, Arthur Sainer, Andrew Sarris, Howard Smith, Michael Smith, Jerry Tallmer, Phil Tracy, Lucian K. Truscott IV, Alan Weitz, Clark Whelton, John Wilcock, Ellen Willis, Dan Wolf.

Fred W. McDarrah

Introduction

According to the old adage, "If you remember the 1960s, you weren't really there." Well, the book you are now holding in your hands drop-kicks that one right into the old dustbin of false clichés. Fred W. McDarrah was present at the creation, as Dean Acheson once said, and thankfully for the rest of us, and for history's sake, my dad took pictures.

Most children simply ignore what their parents do for a living. I wasn't much different. It wasn't until years after my childhood that I realized not only what I had witnessed but also what my dad had recorded for posterity with his little Nikon S2.

My parents took me to Woodstock. (Fred also took a bicycle—strapped it to the roof of the car—which turned out to be a stroke of genius in navigating the clogged roads.) When Martin Luther King delivered his "I have a dream" speech, I was at the bottom of the steps of the Lincoln Memorial (albeit in a stroller) I saw naked people douse themselves in blood and zoom down Prince Street in New York's SoHo. I played with Lego at Norman Mailer's place in Brooklyn Heights. I saw the Living Theatre perform in Avignon. I dug holes in Central Park with Claes Oldenburg. I picked up trash on 14th Street on the first Earth Day. (Little did I know that all this was not an early attempt to educate me, or anything like that; my folks just couldn't afford babysitters.) The point is, thanks to this book, everyone can remember the 1960s.

Three key things contributed to the historic photo document that is this book: Fred's tireless work ethic, his genuine interest in the world around him, and his being the only photographer for the *Village Voice*, generally regarded as the world's leading alternative weekly newspaper and the counterculture's house organ in the 1960s. Fred's uncanny ability to be in the right place at the right time—for about five decades now—is an example of a journalistic instinct and sense of duty that I have tried to emulate. As the eyes of the reading public, he felt a need to cover it all.

This book also shows Fred's interest in everything his beloved New York City had to offer in the 1960s (and beyond), everything from impromptu street protests to fringe theater groups to historic Penn Station to naked cello players. Because the 1960s were a kindler, gentler era in many ways, especially regarding access, Fred went to events and could get near people in a way that is not usually possible for photographers today. This is partly due to security concerns, but mainly due to the explosion of media outlets and the growth of the news and entertainment media beast that must be constantly fed.

For example, my dad was invited inside Dwight MacDonald's apartment for an SDS strategy session with Mailer, George Plimpton, and Mark Rudd regarding the Columbia University takeover. Andy Warhol would call Fred at home and tell him where he'd be that evening so Fred could come and shoot photos. Fred has some of the only pictures ever taken of Jimi Hendrix at the mixing board in the Electric Lady recording studio, around the corner from Washington Square Park.

As this book demonstrates, Fred's intimate photos of these cultural icons are numerous, revealing, and weighty in their impact on our understanding of the era.

C'mon, you say. Look at all those "lucky" photos: Who knew to shoot Al Pacino in his first play or Philip Glass at NYU's student center or a neighbor who happened to paint (Franz Kline)? Some of it must be just dumb luck. Perhaps, but I doubt it. Was Fred lucky to come across Woody Allen doing stand-up at the Gaslight in 1962 or to photograph Bob Dylan making what is believed to be his first appearance performing

at a MacDougal St. coffeehouse? Sure it was. But, remember, in the course of doing his job Fred also shot a million other young comics and folkies and artists and writers and politicians who never achieved fame or fortune.

Was Fred lucky that the Stonewall Inn, where the modern day gay rights movement was born, was located next door to the *Village Voice*'s office? Yes. But you are a lot luckier if you are always paying attention and get yourself there just after the police raid the place.

Was he lucky to get tear-gassed and then whacked in the head with a billy club by the Chicago cops in 1968? (Hmm. Maybe that explains some things . . .)

Finally, what does it all mean—the turmoil, controversy, social upheaval, protest marches, the fashions, and the rest of the decade known as the Sixties? What do I know? After many years at the *New York Post*, I now write a gossip column for a newspaper in Las Vegas. I'll leave the sociological explanations to the Todd Gitlins or Susan Sontags of the world. (Yes, Fred shot them in the '60s, too.)

Better yet, I'll leave it to you, the reader, to decide what the 1960s meant to our collective consciousness and history. After looking at the amazing photos in the book, and then looking at the world around you and seeing how it has changed in the decades since, at least one thing is clear: There's never been another decade like it.

Timothy McDarrah
East Hampton, New York
August 24, 2003

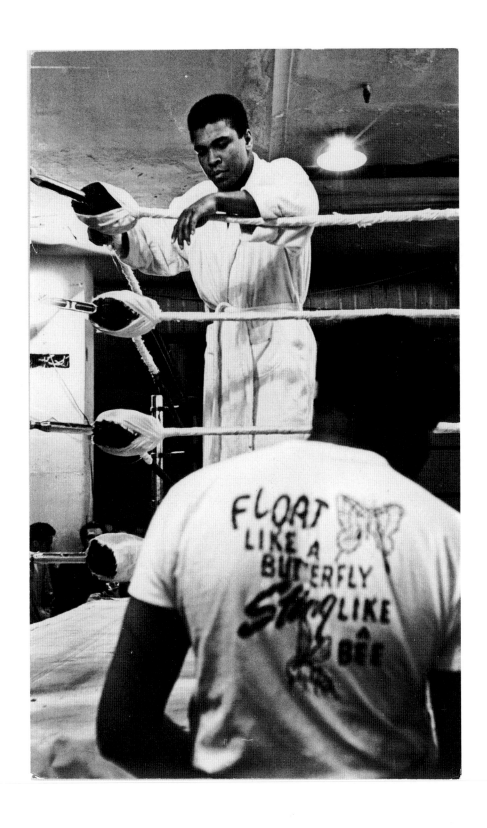

Heavyweight Champion Muhammad Ali, in basement of Madison Square Garden, March 16, 1967, the year he refused induction into the Armed Forces and became a symbol of resistance to the Vietnam War.

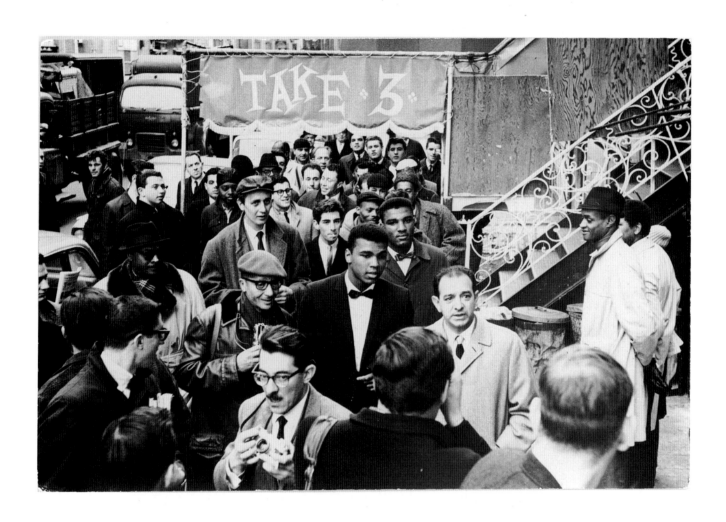

Cassius Marcellas Clay, Jr. arriving at the Bitter End Club, 147 Bleecker Street, March 12, 1963, to read poetry with fellow poets Jill Castro, Diane Wakoski, Betty Taub, Katherine Fraser, and Howard Ant.

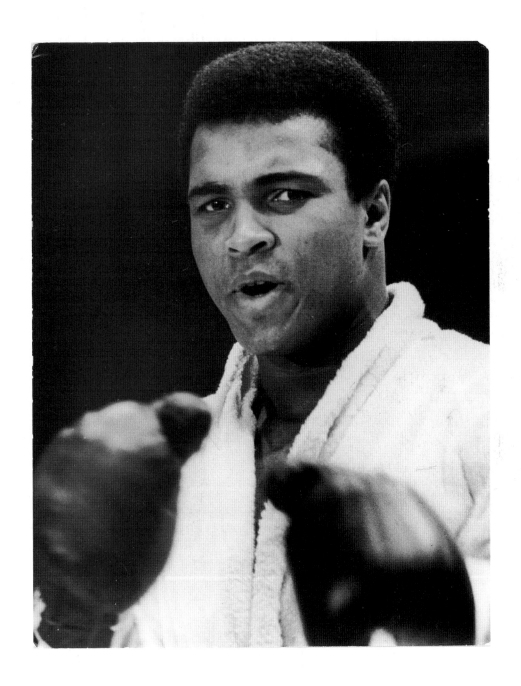

Muhammad Ali shadow boxing at the weigh-in at Madison Square Garden, March 3, 1971, before championship bout with Joe Frazier.

TOP: Hubert Selby and A. B. Spellman at the Living Theatre to celebrate reaching 1,000 performances, November 28, 1960. **BOTTOM:** Peter Orlovsky, Herbert Huncke, reading proofs of a new book at the publisher's loft, March 7, 1960.

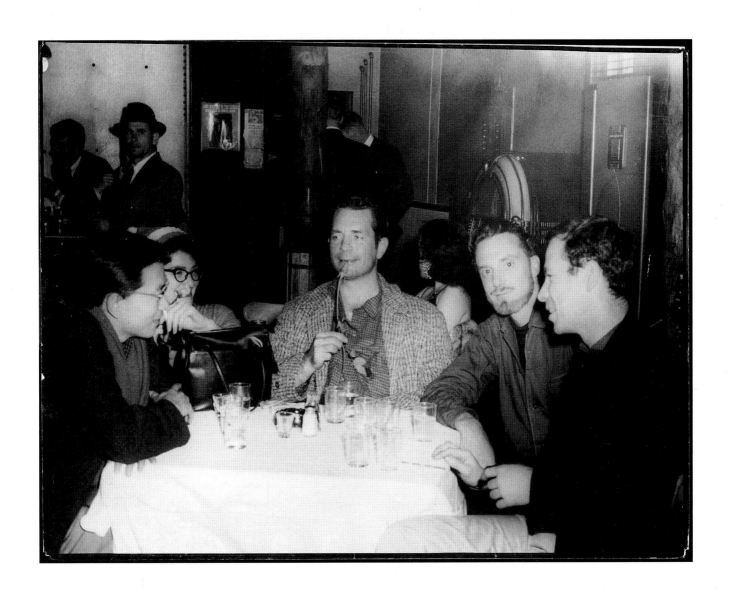

The Egyptian Gardens, 301 West 29th Street, December 10, 1959. Left: Albert Saijo, Gloria McDarrah, Jack Kerouac, Lew Welch, and Fred McDarrah celebrating a visit by the three poets.

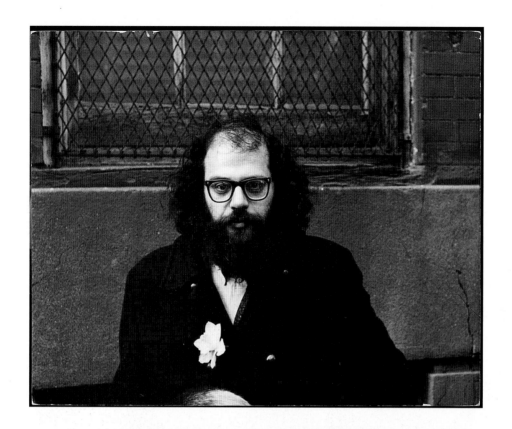

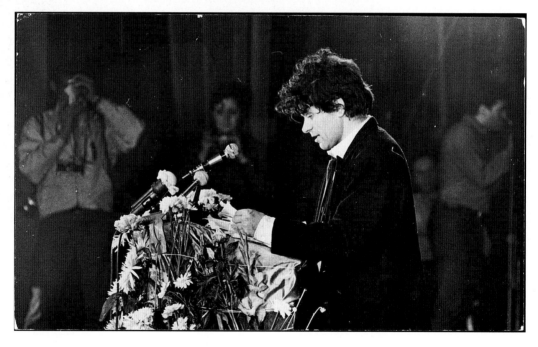

TOP: Allen Ginsberg in front of Judson Memorial Church, March 29, 1964, during a folk music protest in Washington Square Park. **BOTTOM:** Gregory Corso in a marathon reading for Andrei Voznesensky at the Village Theatre, May 18, 1967.

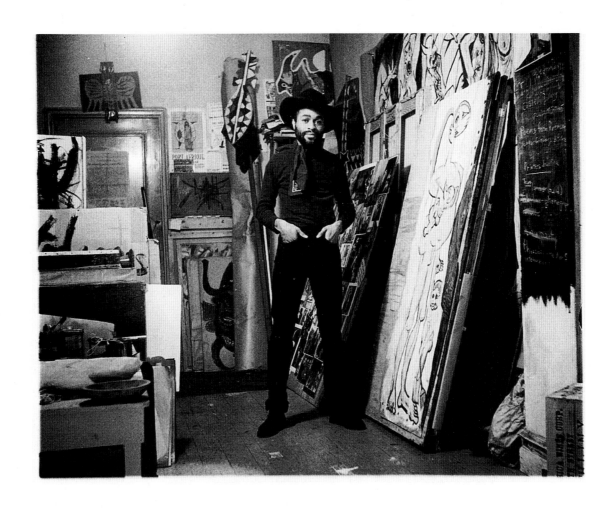

Ted Joans, artist, poet, party-giver, world traveler, in his loft, 22 Astor Place, November 4, 1959.

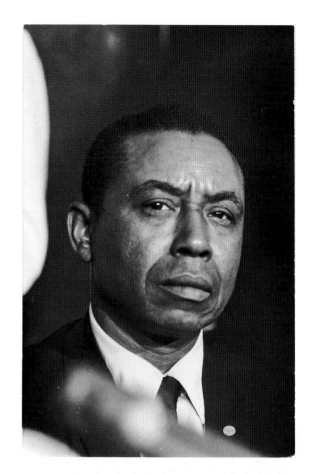

CLOCKWISE FROM TOP LEFT: H. Rap Brown, July 22, 1967, at a black power conference, became head of Student Nonviolent Coordinating Committee. In Cambridge, Maryland, Rap Brown was ambushed and shot in the head but recovered enough to be indicted for inciting a riot in Cambridge. He told a correspondent from the London Observer, "Violence is necessary. I love violence. You taught me violence." • Floyd McKissick, July 22, 1967, at black power conference, was national chairman of CORE. • James Farmer, July 22, 1967, was principal founder of CORE.

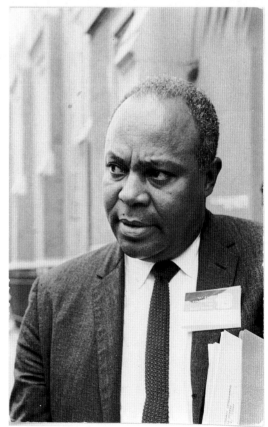

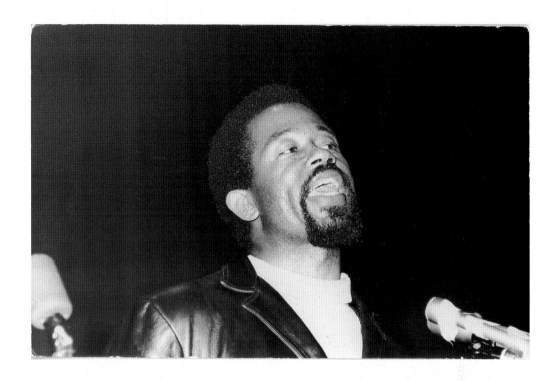

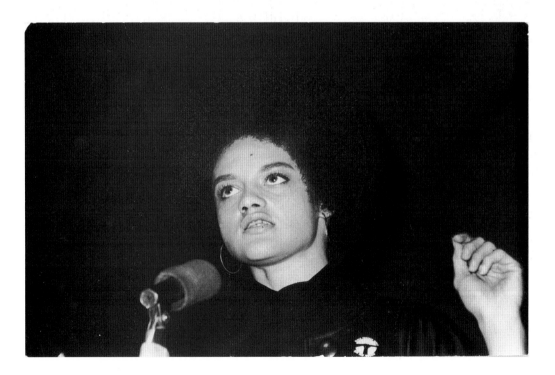

TOP: Eldridge Cleaver, October 11, 1968, Minister of Information for the Black Panthers, wrote *Soul on Ice* in 1968. **BOTTOM:** Kathleen Cleaver, former communications secretary for the Black Panthers at the Fillmore East for Malcolm X birthday celebration, May 20, 1968.

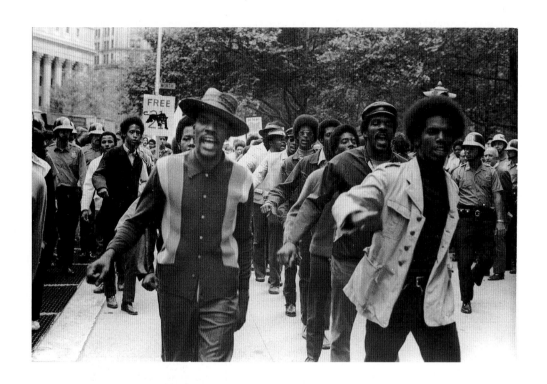

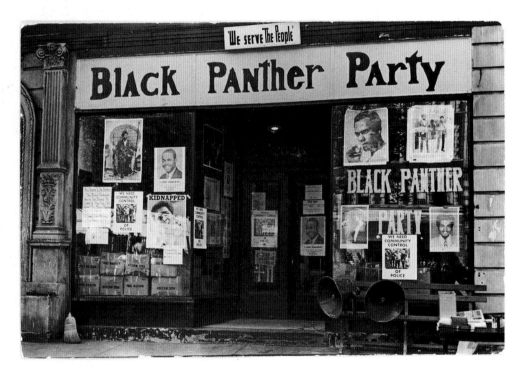

TOP: A Black Panther rally, September 7, 1970, in Foley Square to free the "Panther 21." They were charged with "conspiracy to blow up stores and trains." **BOTTOM:** Black Panther storefront headquarters at 2026 Seventh Ave. in Harlem, September 21, 1969. It had a neighborhood-based food and medical program to stop the "Syndicate Drug Traffic." J. Edgar Hoover called the Panthers "the greatest threat to the internal security of the United States."

Congresswoman Shirley Chisholm with Congressman Adam Clayton Powell, Jr., September 21, 1969, in Afro-American Day Celebration along Seventh Avenue in Harlem.

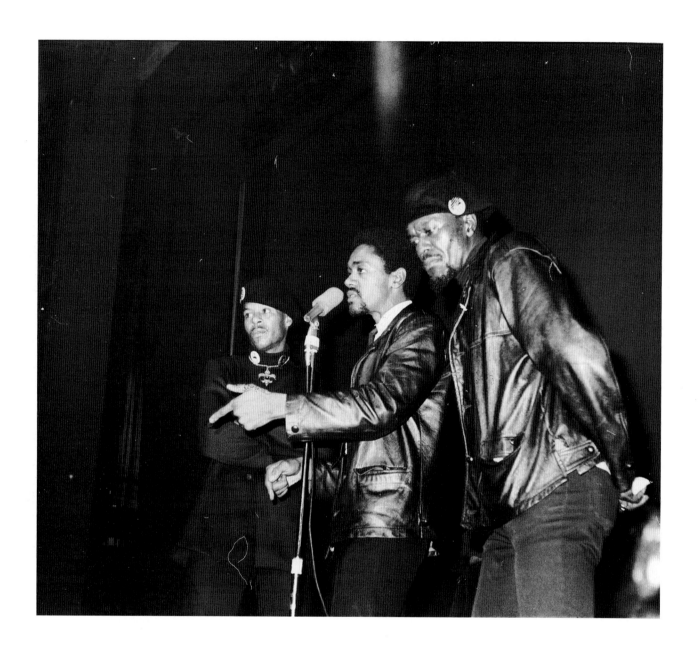

Bobby Seale at Fillmore East in a Black Panther celebration, May 20, 1968, marking the birthday of Malcolm X. Seale and Huey Newton formed the Black Panthers in 1966 for "self-defense."

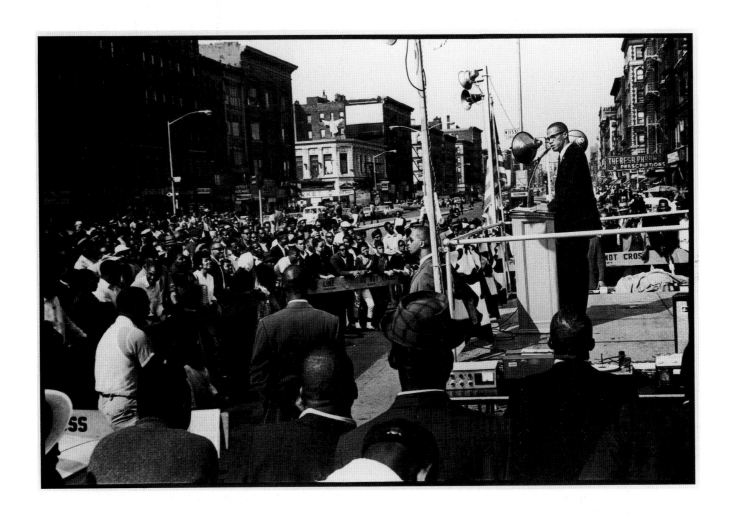

Malcolm X at a Harlem street corner rally, 115th Street and Lenox Avenue, September 7, 1963. He was shot to death February 21, 1965 at the Audubon Ballroom in Harlem.

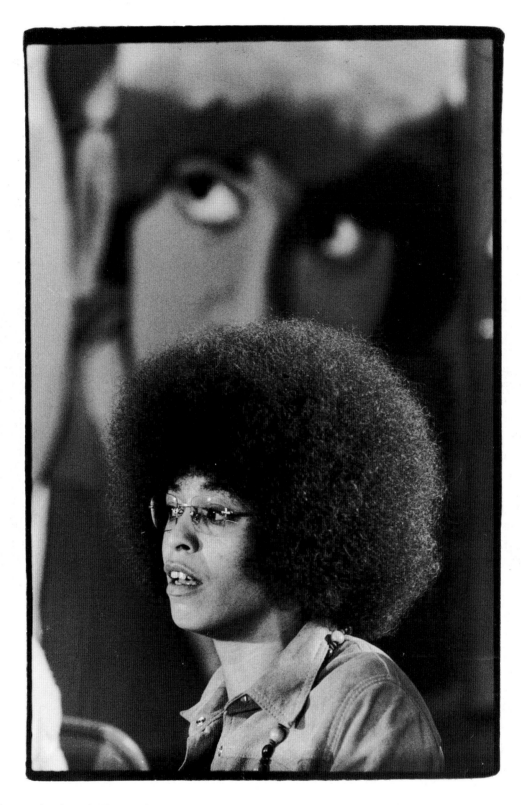

Press conference by Angela Davis, October 16, 1972, on her recent tour of socialist countries.

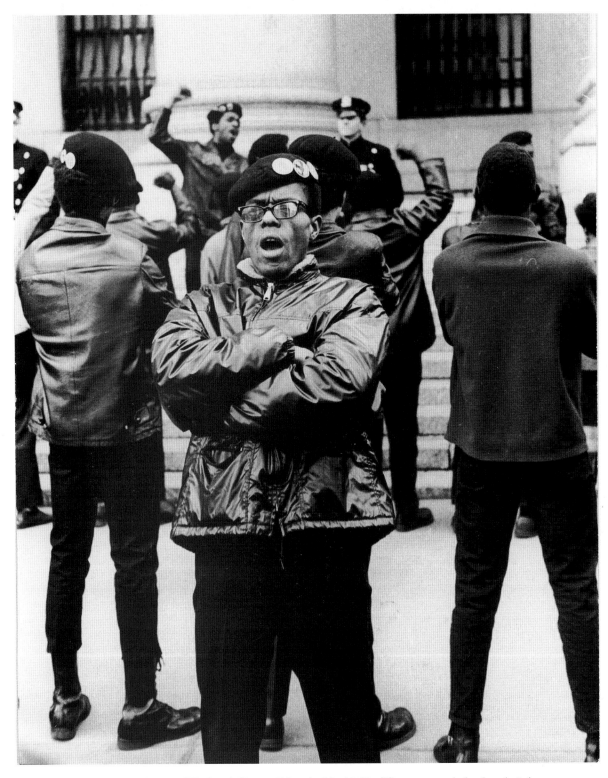

A Black Panther rally in front of Federal Court, March 22, 1969. They wanted the legal right to carry guns for protection against police abuse.

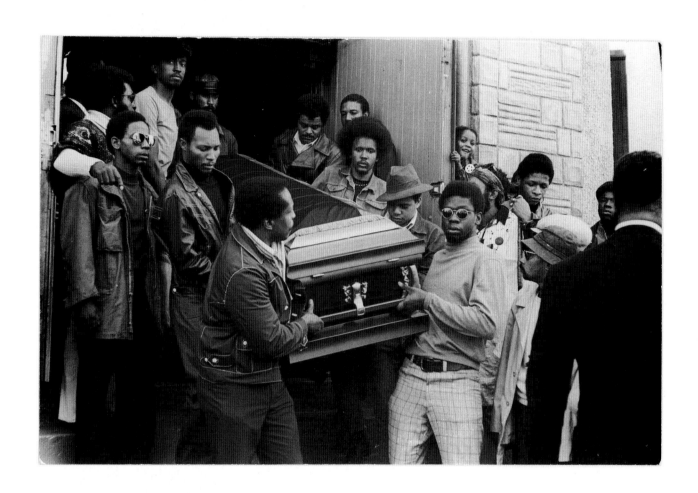

Funeral, September 25, 1971, for victim of Attica State Prison riots where thirty-nine inmates died in the uprising.

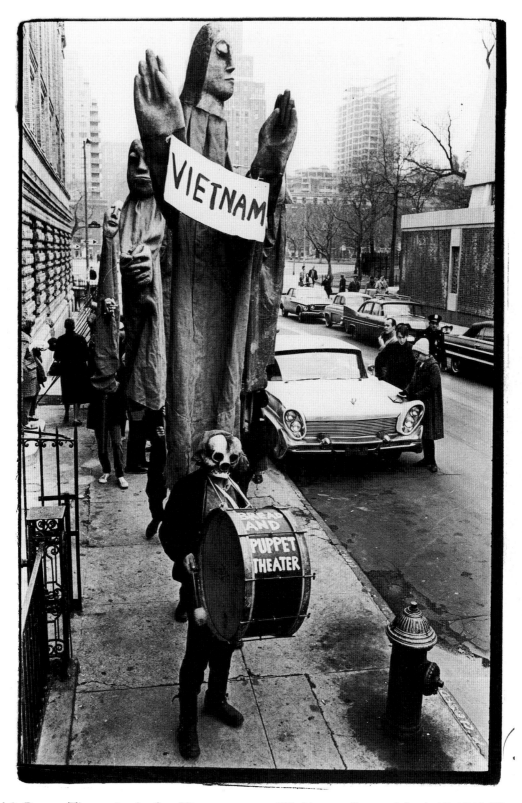

The Bread & Puppet Theatre in the first Vietnam protest, Washington Square, March 15, 1965. The company took its name from the dark homemade bread that they shared with audiences after each performance and the use of stick puppets.

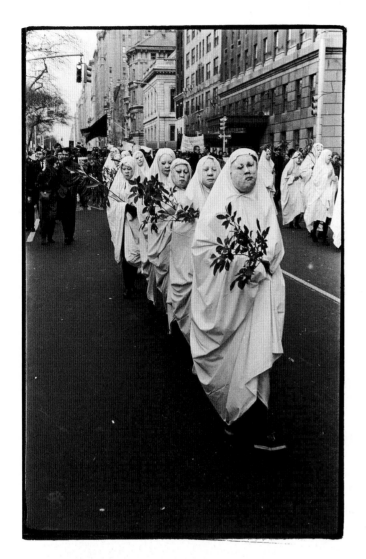

ABOVE: Bread & Puppet Theatre in anti-war demonstration, Fifth Avenue, March 26, 1966. The Bread & Puppet Theatre is a continuous workshop in painting, mime, dance, story-making, printing, puppeting, music and instrument-making. **RIGHT:** Bread & Puppet Theatre marching along Fifth Avenue, October 17, 1965, in Vietnam anti-war demonstration with puppet of LBJ seen with cigar, Uncle Sam hat, and lapel button "All the Way with LBJ."

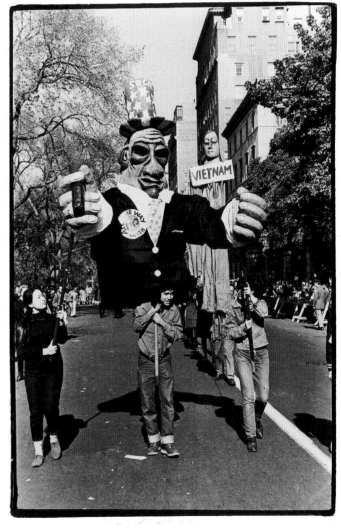

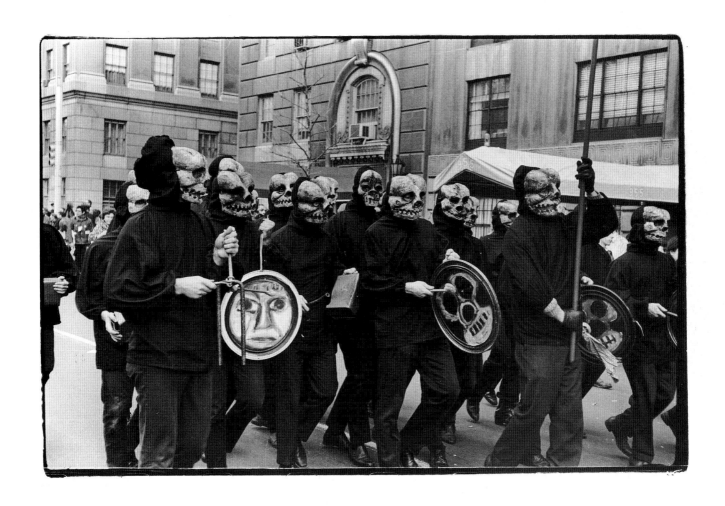

A death march by Bread & Puppet Theatre in front of 955 Fifth Avenue during anti-war demonstration, March 26, 1966.

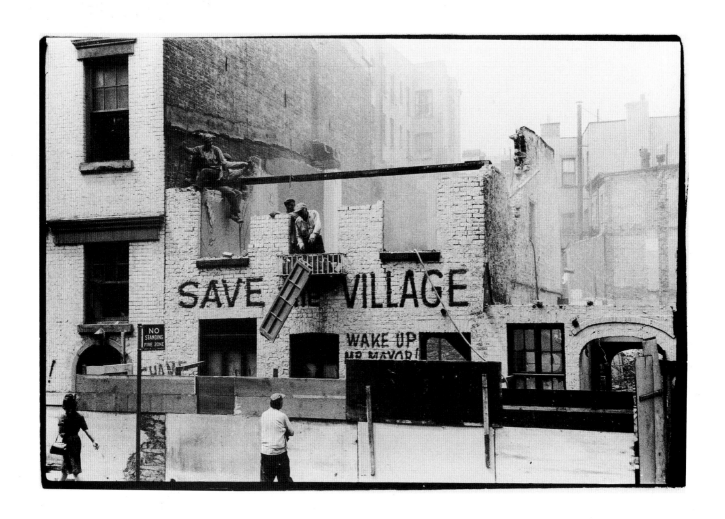

A landmark sculptor's studio at Tenth Street and Greenwich Avenue being demolished for new apartment building, May 16, 1960.

TOP: A view south of coffee houses, west side Front Street from Wall Street, Jones Lane to Gouverneur Lane, January 22, 1964. BOTTOM: No. 251 Water Street, Fulton and Peck Slip, Romanesque revival terra cotta, second brick warehouse 1988 by Carl F. Eisenbach, August 30, 1959.

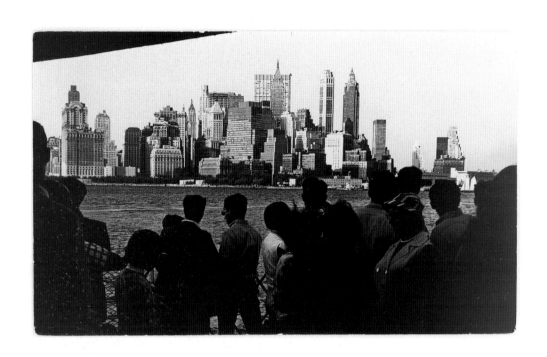

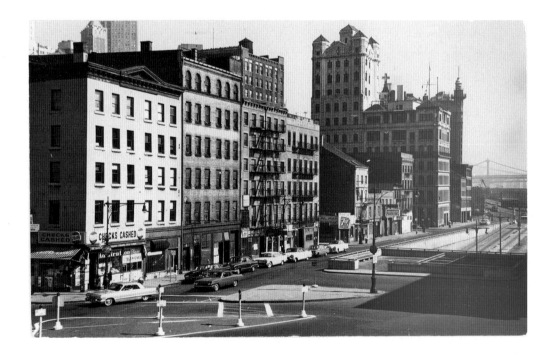

TOP: New York City skyline before the World Trade Center, September 10, 1966, viewed from Staten Island Ferry. **BOTTOM:** South Street looking north corner of Whitehall Street viewed from Staten Island Ferry terminal, October 6, 1963.

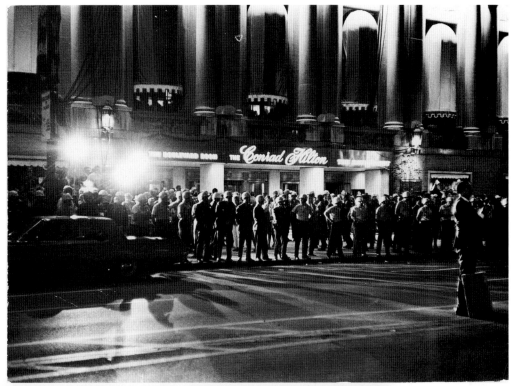

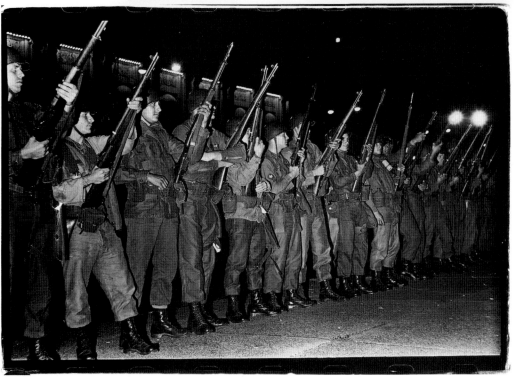

TOP: Police guarding Hilton Hotel on Michigan Avenue from Yippie demonstrators, Chicago Convention, August 25, 1968. **BOTTOM:** National Guard with loaded rifles wait for demonstrators.

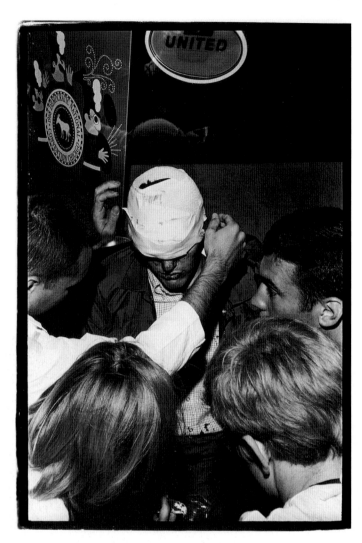

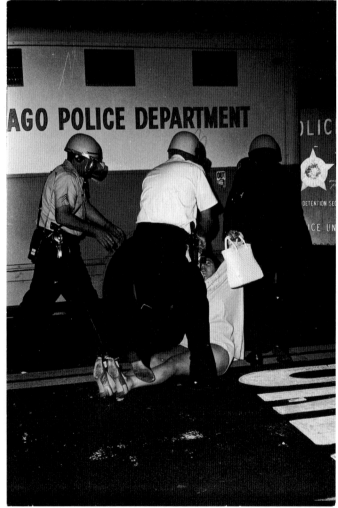

ABOVE: A casualty of the Michigan Avenue street riots at Chicago Convention, August 25, 1968. **RIGHT:** Cops show no favoritism by beating female demonstrator and dragging her into police van during Convention, August 26, 1968.

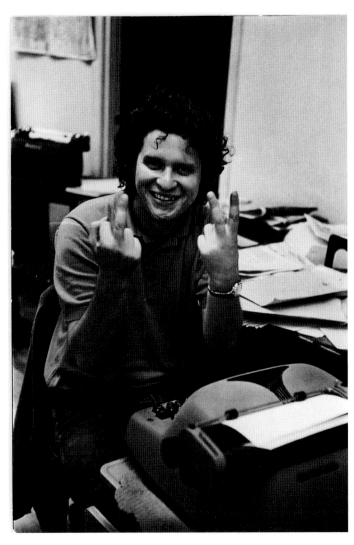

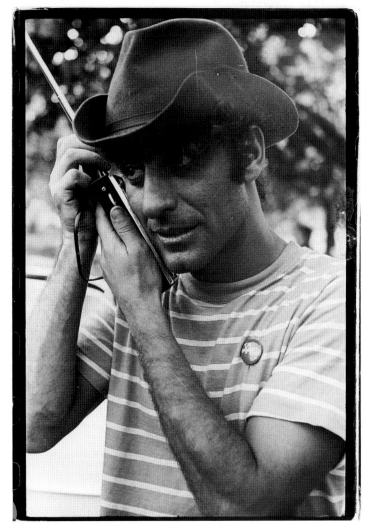

ABOVE: Paul Krassner in Daily Ramparts office makes victory sign at Yippie headquarters, Chicago, August 23, 1968. **RIGHT:** Abbie Hoffman directs all the action with a walkie-talkie at Chicago Convention. He was later indicted along with David Dellinger, which became the "Conspiracy 8." Bobby Seale was gagged during the trial.

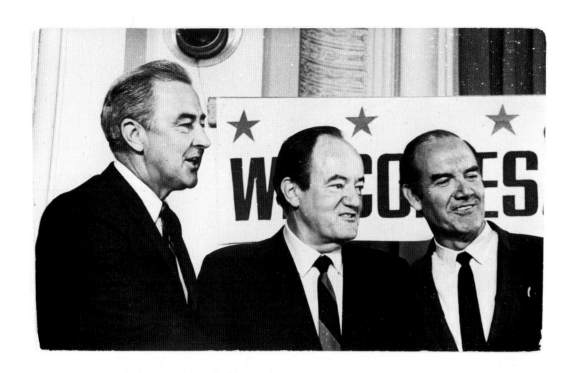

TOP: Three candidates who want to beat Nixon and become President—Left: Eugene McCarthy, Hubert Humphrey, George McGovern, at candidates' forum, Chicago Convention, 1968. Humphrey and McCarthy were in private suites at the Conrad Hilton; McGovern disappeared. **BOTTOM:** Dick Gregory (right), Mark Lane (left) candidates for president and vice president of Freedom and Peace Party pictured here at Democratic National Convention in Chicago, attend a rally for the Yippies, August 30, 1968.

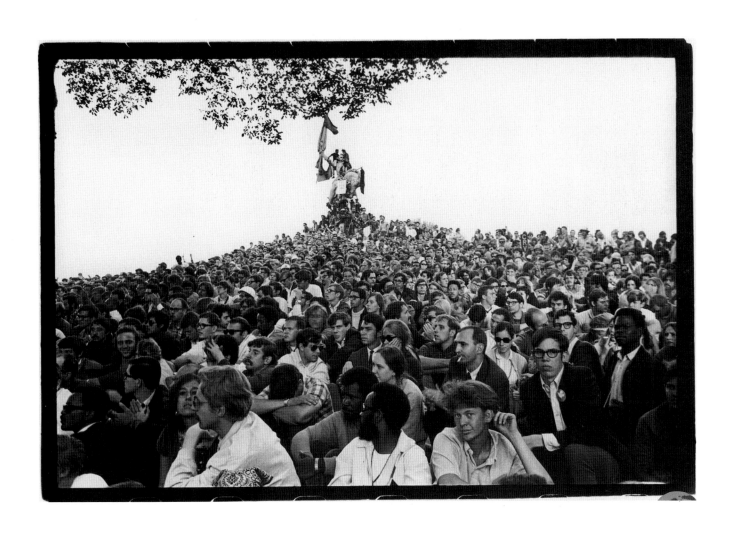

A cross-section of demonstrators at Grant Park, Chicago Democratic National Convention, August 27, 1968.

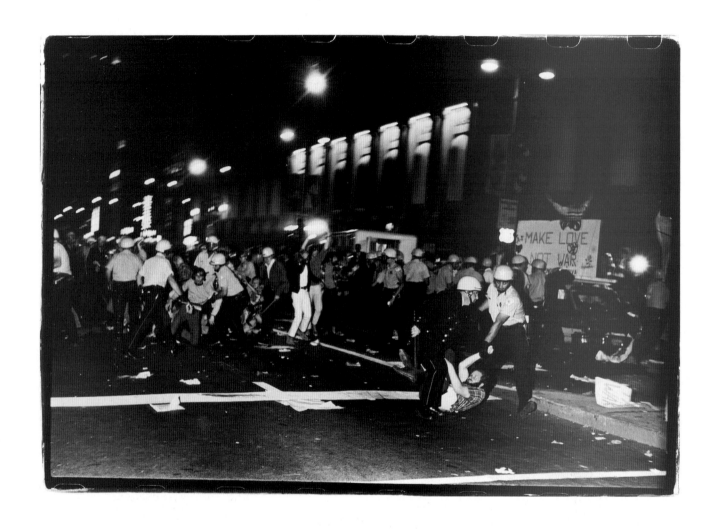

Demonstrators get beat up by Chicago police in front of Hilton Hotel on Michigan Avenue with sign in background says "Make Love not War."

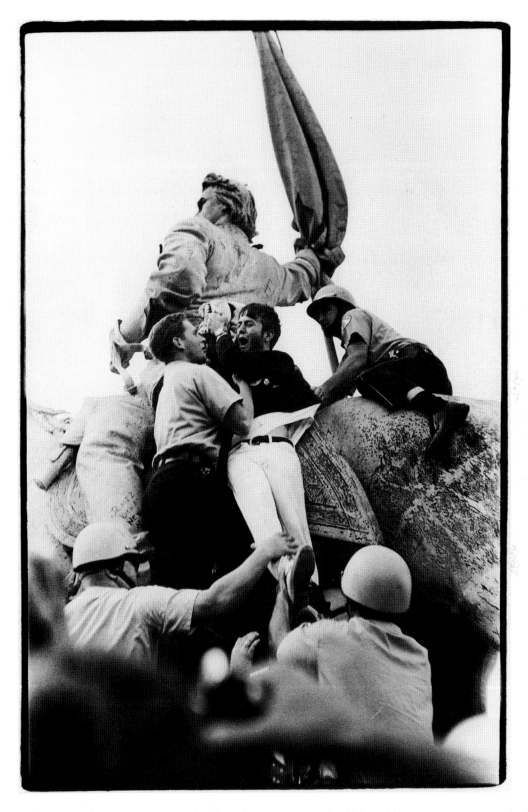

Grant Park, Chicago, August 23, 1968. Student demonstrator, David Lee Edmundson, gets yanked off top of statue of General John A. Logan (Union commander in the Civil War) for waving a Vietcong flag.

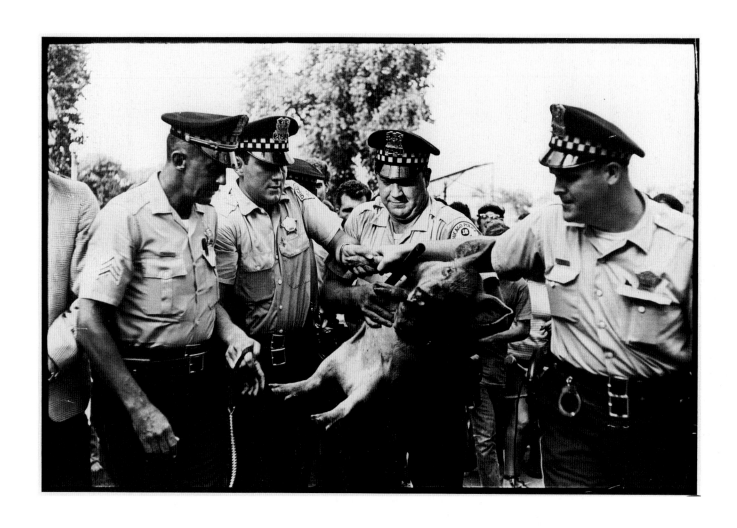

Pigasus and Pig, Yippie Presidential Candidate, at 1968 Democratic Convention, captured by police in Lincoln Park, Chicago, August 23, 1968.

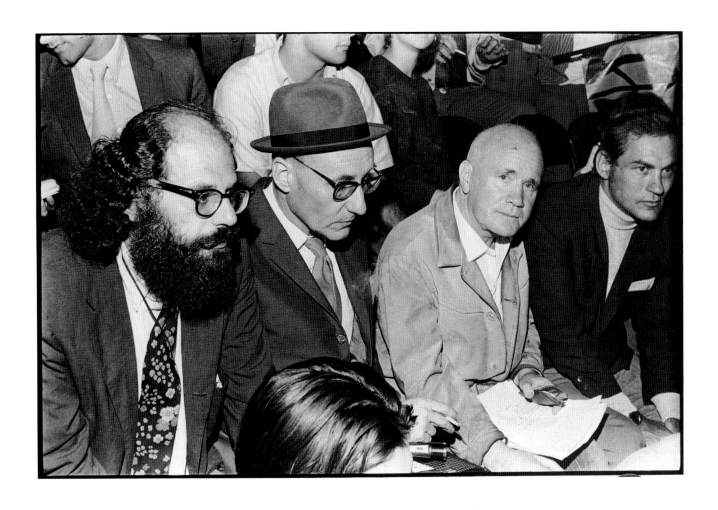

Allen Ginsberg, William Burroughs, Jean Genet, and Dick Seaver of Grove Press at the Chicago Democratic Convention, August 30, 1968.

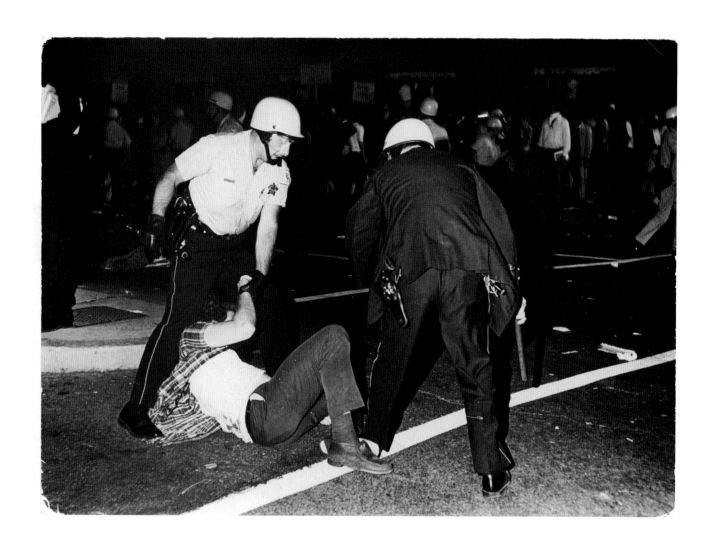

Chicago cops club Yippie on Michigan Avenue during Convention, August 26, 1968.

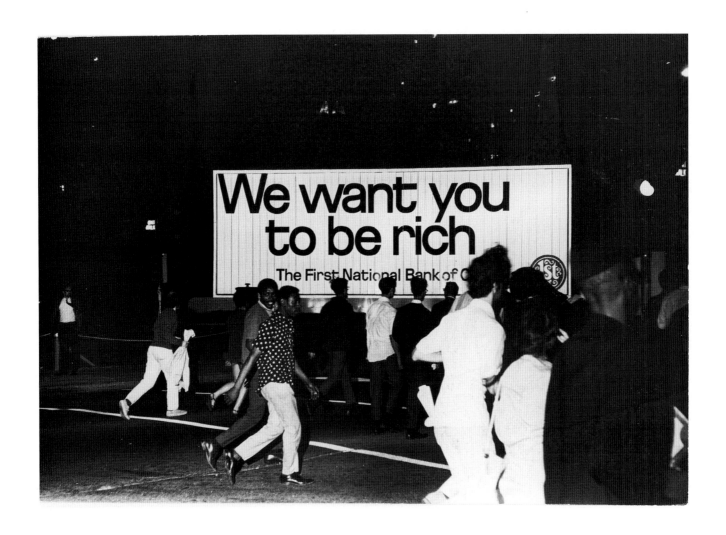

Demonstrators on Michigan Avenue during Chicago Convention run past bank billboard, August 26, 1968.

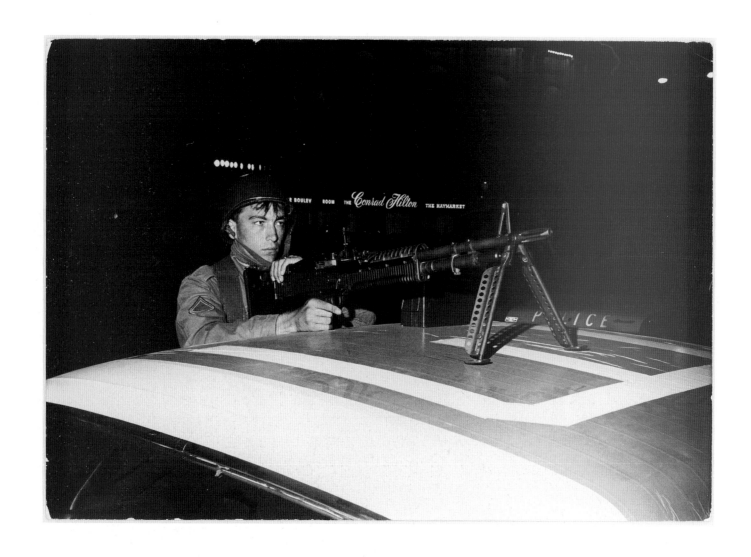

National Guard with machine gun ready for action in Chicago, August 25, 1968.

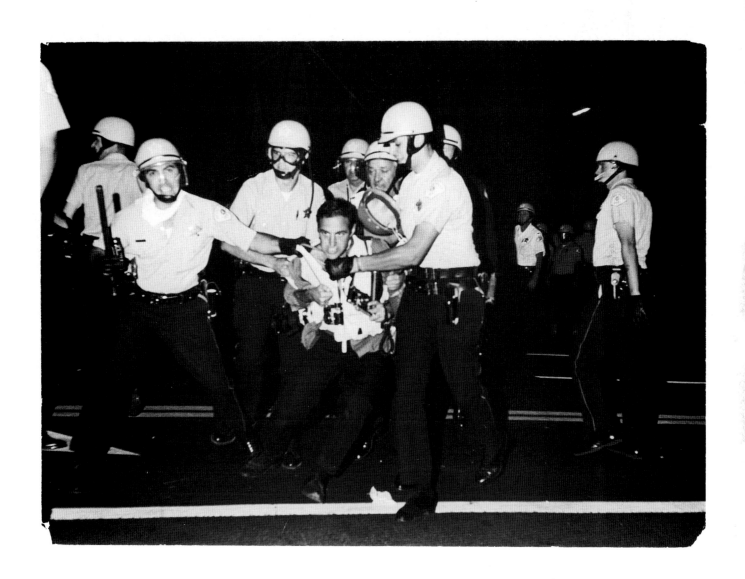

Barton Silverman, photographer for the *New York Times*, being arrested on Michigan Avenue during battle of Chicago, August 28, 1968, Democratic National Convention.

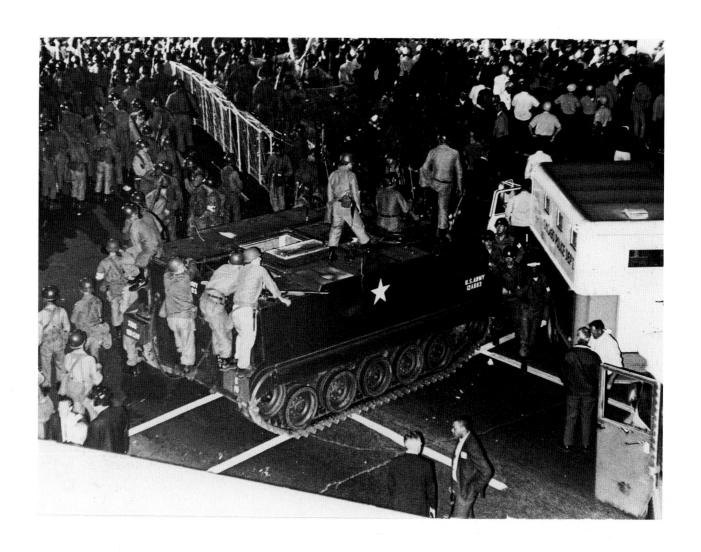

A Sherman tank rolls down Michigan Avenue in an attempt to stop demonstrators in Chicago, August 27, 1968.

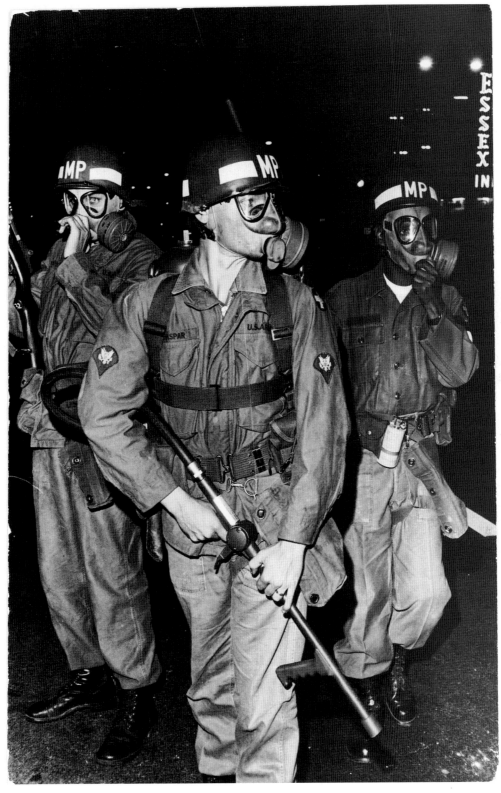

National Guard soldiers in Chicago wearing gas masks prepare to subdue Yippies with the teargas during Democratic Convention, August 27, 1968.

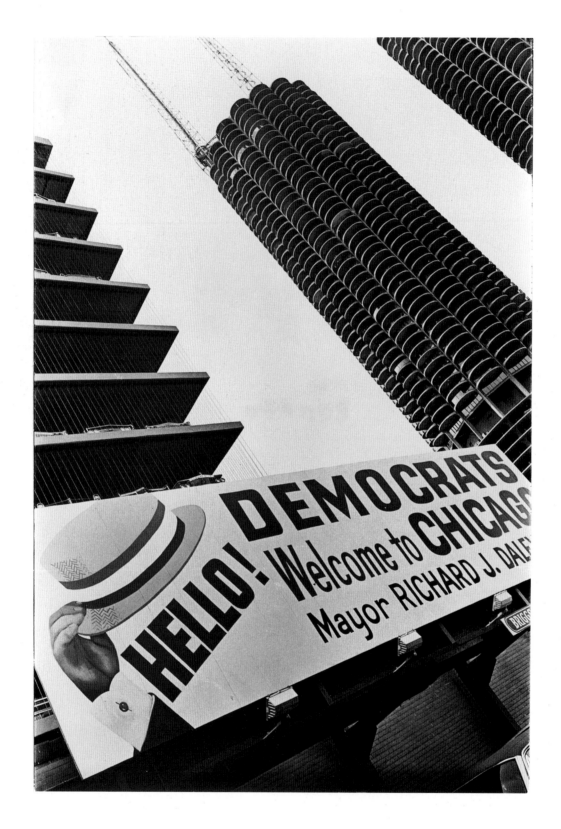

A billboard welcomes the Democrats, August 23, 1968. Mayor Richard Daley claimed terrorists planned to disrupt the Convention and paralyze the city.

TOP: Merce Cunningham in "Theater Piece," February 16, 1960, at Phoenix Theatre, with music by Morty Feldman, John Cage, and David Tudor. **BOTTOM:** Barbara Lloyd and Steve Paxton performing "Balloon" by Carolyn Brown at a dance studio, 81st Street and Broadway, in "New York Theatre Rally," May 14, 1965.

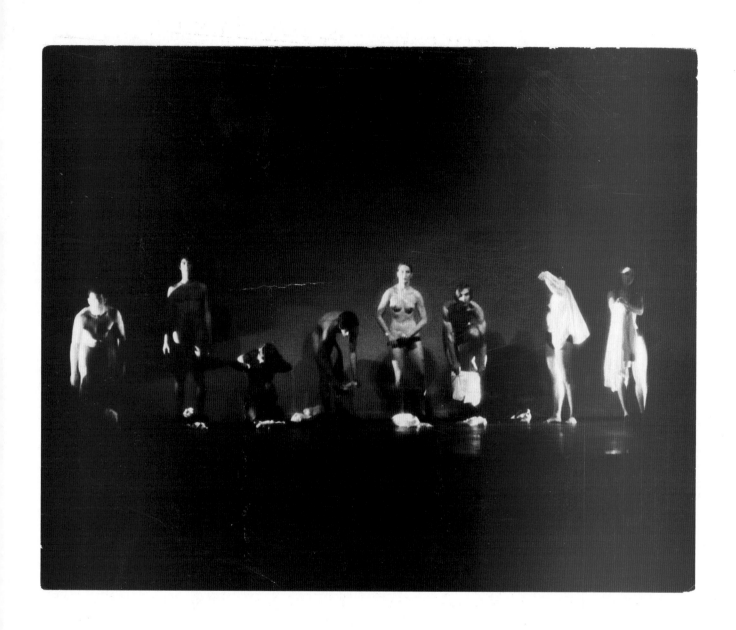

Ann Halprin Dancers' Workshop of San Francisco in a performance of "Parades and Changes" at Hunter College Playhouse, April 21, 1967.

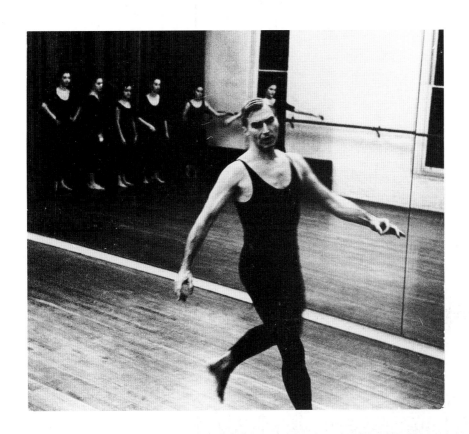

TOP: Erick Hawkins conducting a dance class in his studio, November 26, 1962. His signature performance is "Here and Now with Watchers." **BOTTOM:** Meredith Monk and William Dunas perform "Hippy Love Dance / Psychadelic Dance" at New York University, November 3, 1968.

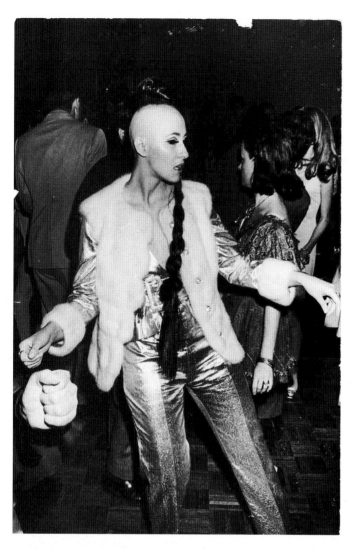

ABOVE: A very stylish bald-headed lady with a braided wig dances to the beat, April 24, 1969.
RIGHT: Everybody came to the Church Disco—rich Hippies, out-of-work royalty, and perpetual starlets, April 24, 1969.

ABOVE: The ultimate disco costume—whip, chains, and a bikini bottom, April 24, 1969.
RIGHT: Saints or Sinners Road, the invitation to the Church Disco, April 24, 1969.

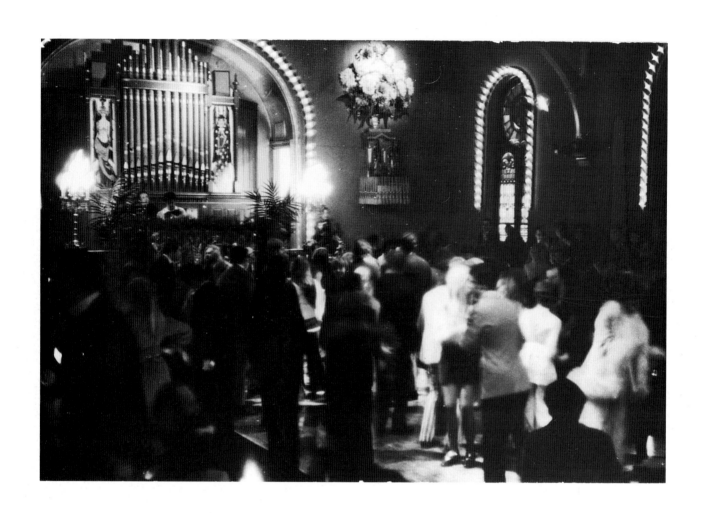

The German Lutheran Church, 407 West 37th Street, is recycled into a hip discotheque, April 24, 1969.

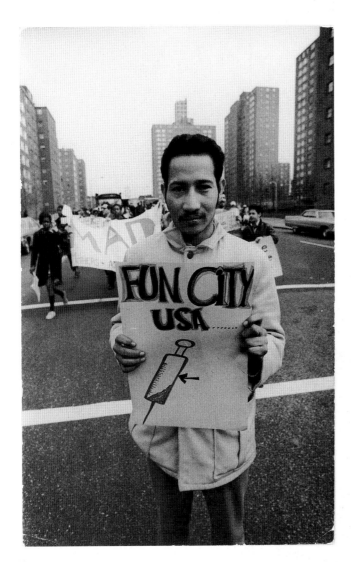

ABOVE: Fun City, U.S.A., begins a war on drugs, March 23, 1970. RIGHT: A landmark exhibit at the Museum of the City of New York, Fifth Avenue and 103rd Street, June 9, 1971, featured caskets.

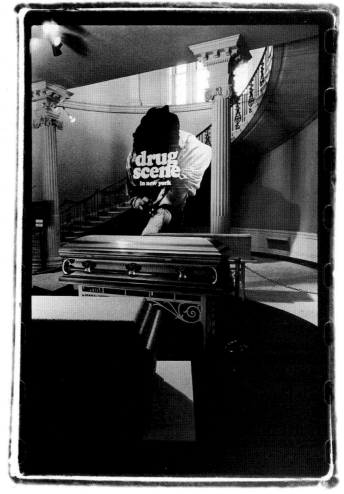

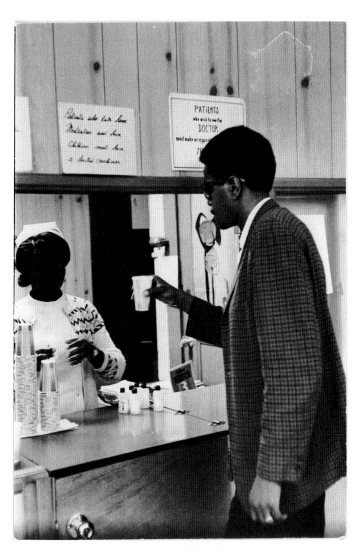

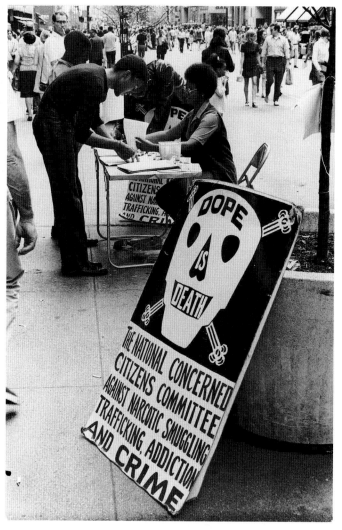

ABOVE: Methadone dispensing center, East 125th Street, March 8, 1969. **RIGHT:** Citizens sign up to stop drug trafficking, addiction, and smuggling, July 11, 1970.

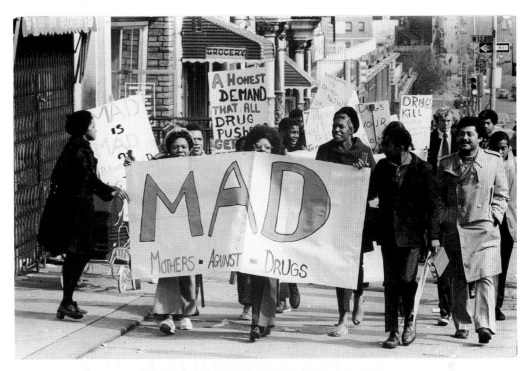

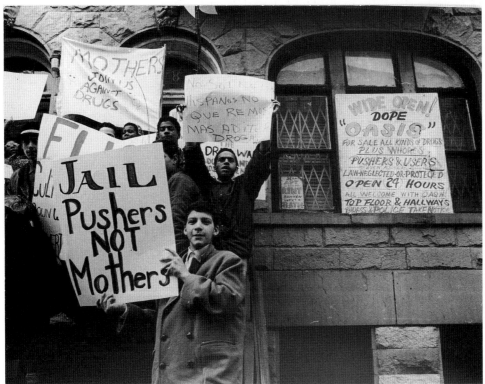

TOP: A grass-roots campaign against drugs, March 23, 1970. **BOTTOM:** Drug locations are picketed by Mothers Against Drugs, March 27, 1970. Pushers and users operate twenty-four hours a day.

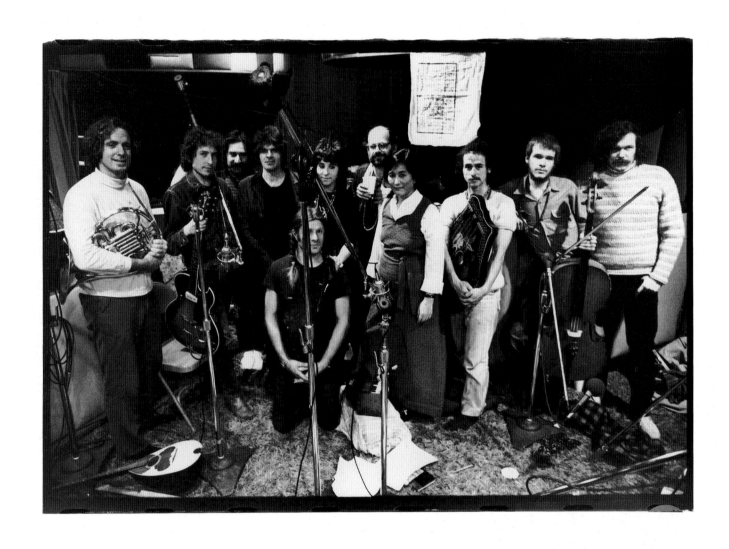

A recording session, November 9, 1971, with left to right: David Amram, Bob Dylan, Happy Traum, Gregory Corso, Peter Orlovsky, Denise Mercedes, Allen Ginsberg, Sadi Kazi, John Sholl, Arthur Russell, Ed Sanders.

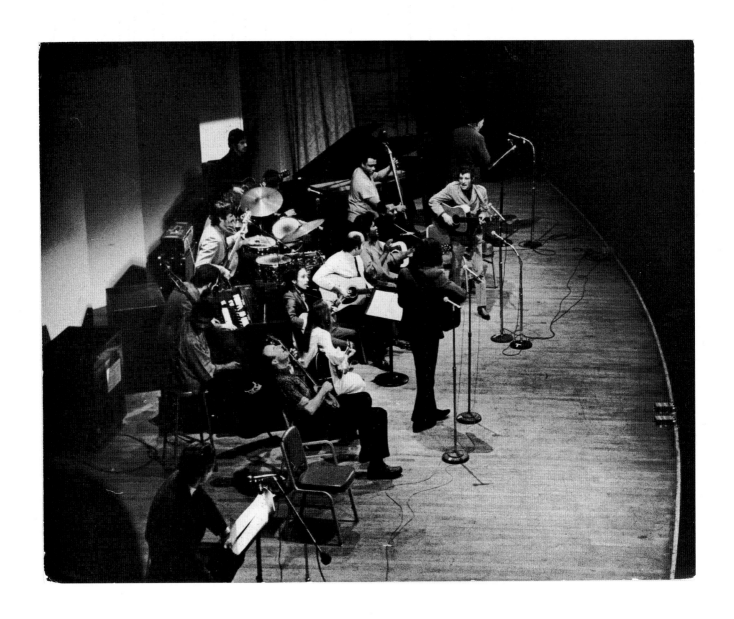

A tribute to Woody Guthrie at Carnegie Hall, January 20, 1968, with: Pete Seeger, Judy Collins, Bob Dylan, Arlo Guthrie, Tom Paxton, Odetta, Jack Elliott, Richie Havens. Concert proceeds went to the Committee to Combat Huntington's Disease.

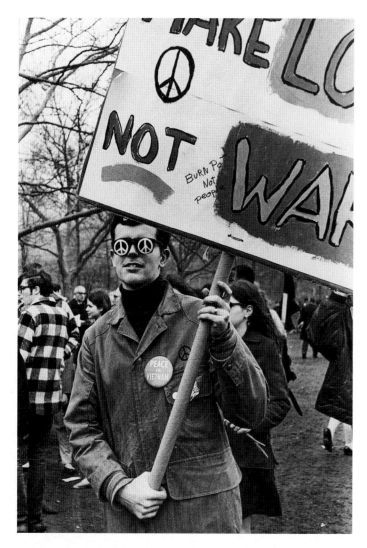

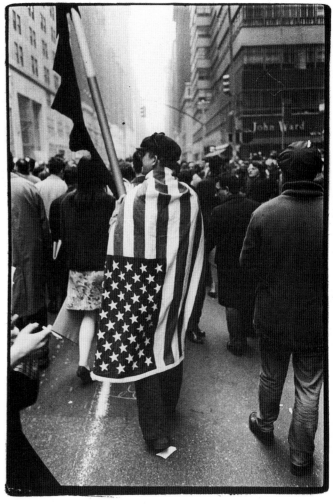

ABOVE: Peace in Vietnam is the message, Central Park, April 16, 1967. RIGHT: Rejection of the Vietnam War and the policy of Lyndon B. Johnson is expressed by this demonstrator, April 15, 1967.

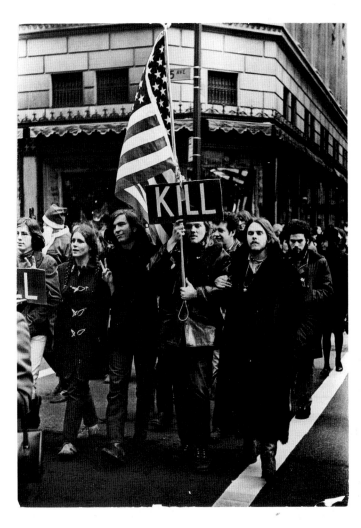

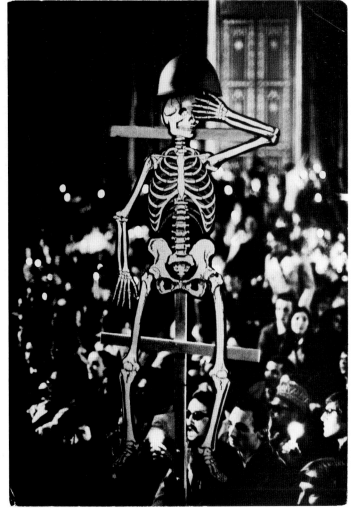

ABOVE: Anti-war protest, Fifth Avenue, December 23, 1967. **RIGHT:** On steps of St. Patrick's Cathedral, October 15, 1969.

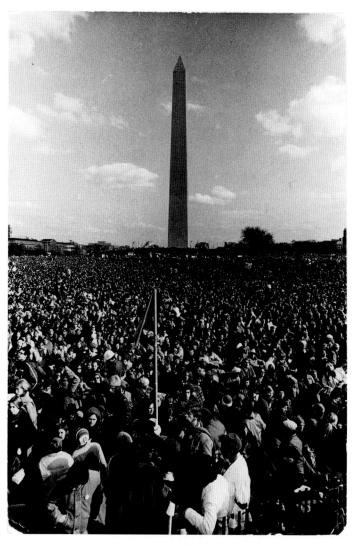

ABOVE: The peace movement in Washington, November 15, 1969. RIGHT: The McDarrah family protest the war—Tim, Patrick, Gloria, Washington, November 15, 1969.

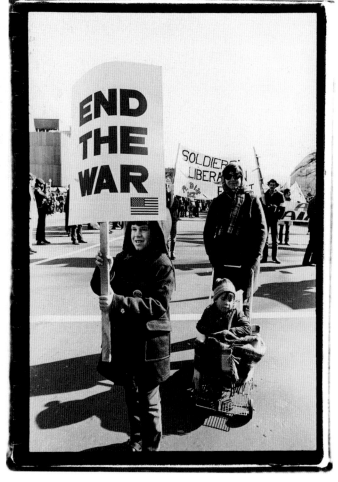

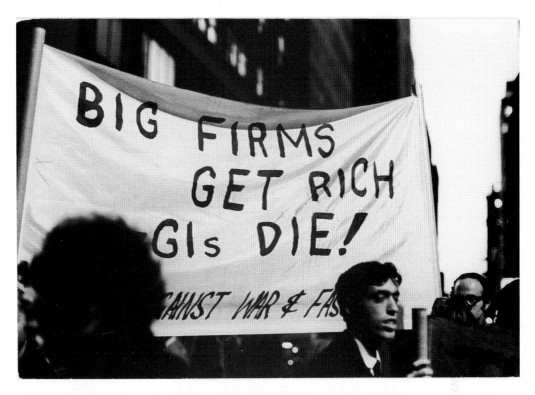

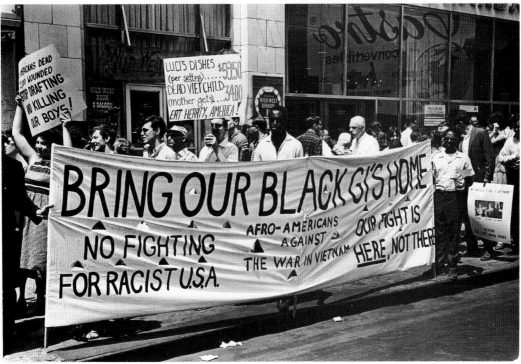

TOP: Bryant Park demonstration, October 15, 1969. BOTTOM: Blacks protest the war, Broadway, August 6, 1966.

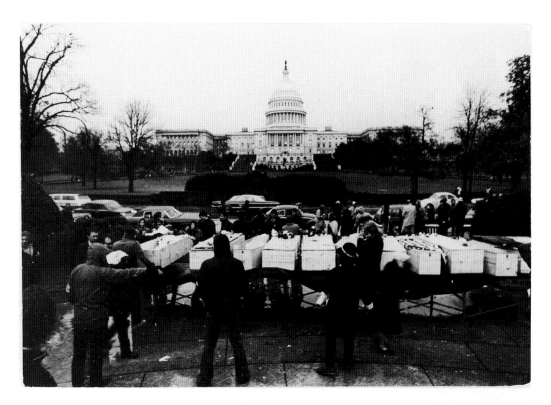

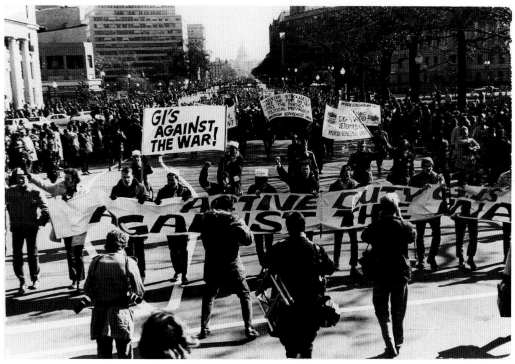

TOP: In a March Against Death: A Vietnam Memorial, a display of coffins is placed in front of the White House, November 15, 1969. BOTTOM: Massive anti-war turnout, Pennsylvania Avenue, Washington, November 15, 1969.

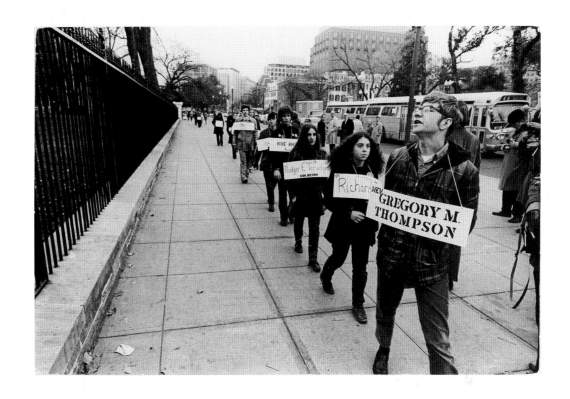

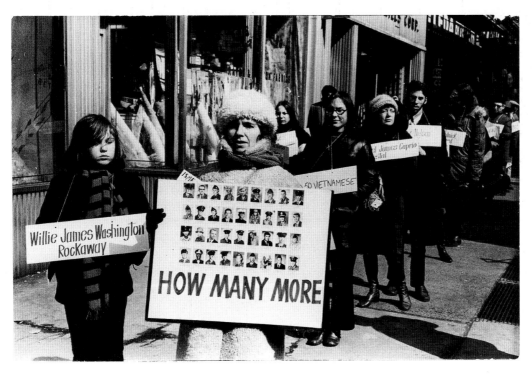

TOP: A message for the White House, November 15, 1969. BOTTOM: Grace Paley leads a march against the war, March 19, 1970.

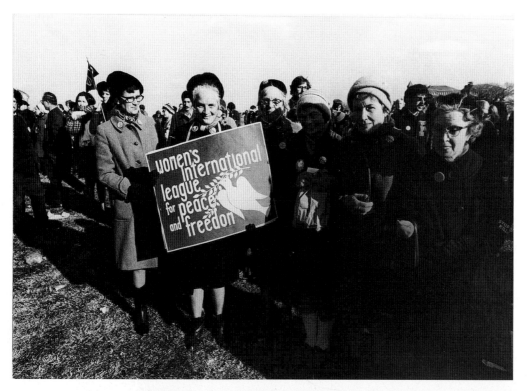

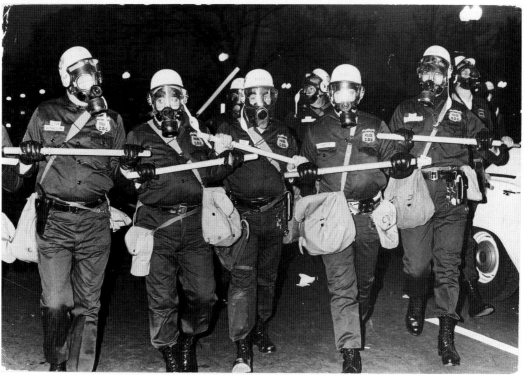

TOP: Women march for peace and freedom, Washington, November 15, 1969. BOTTOM: Washington, D.C. cops ready for action, November 15, 1969.

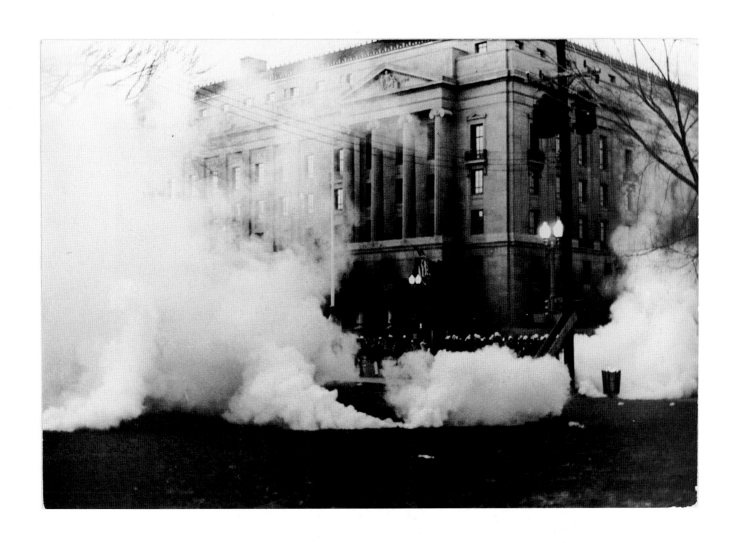

Justice Department seen through the teargas, November 15, 1969.

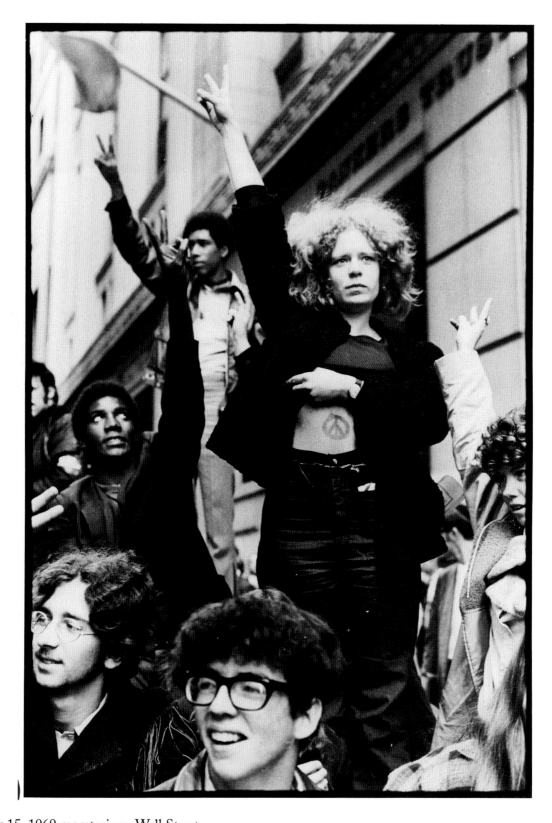

October 15, 1969 moratorium, Wall Street

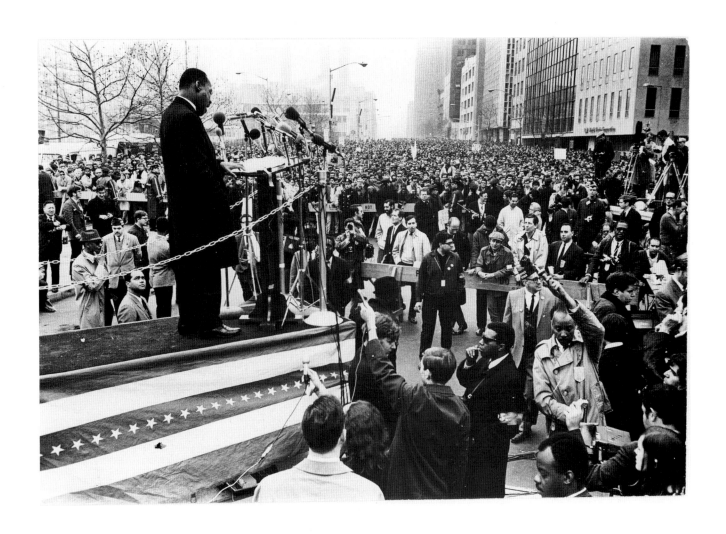

Martin Luther King at United Nations anti-war rally, April 15, 1967.

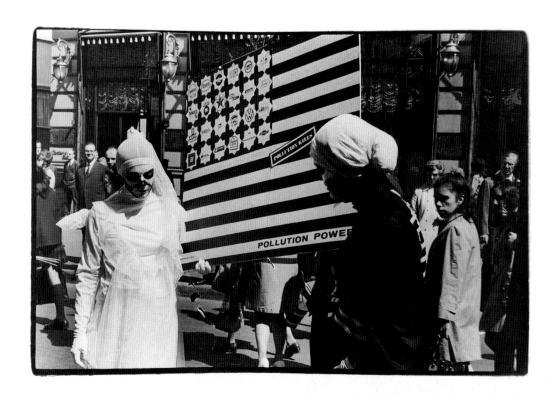

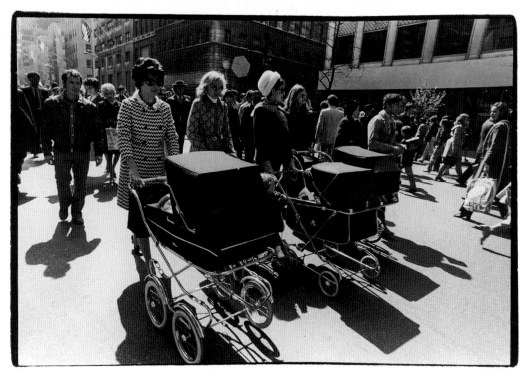

TOP: Flag displays logos of environmental polluters on Earth Day, April 22, 1970. **BOTTOM:** Baby carriages take the spotlight on Fifth Avenue, first Earth Day, April 22, 1970.

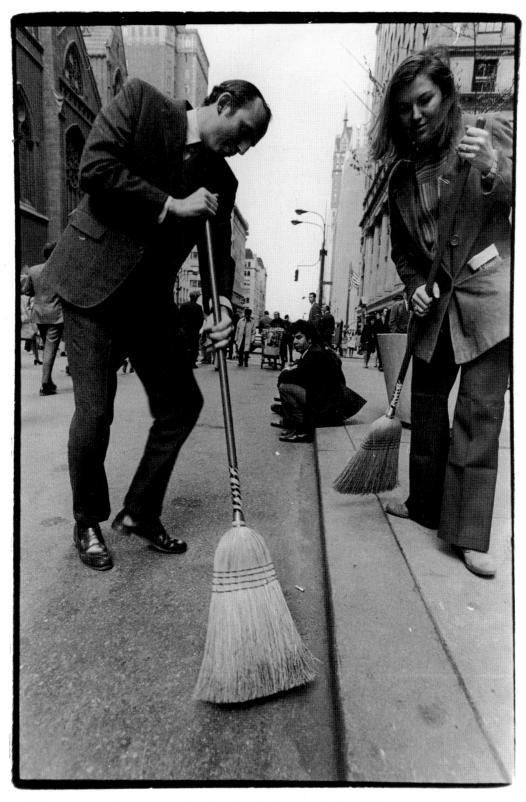

A couple on Fifth Avenue cleans up on the first Earth Day, April 22, 1970.

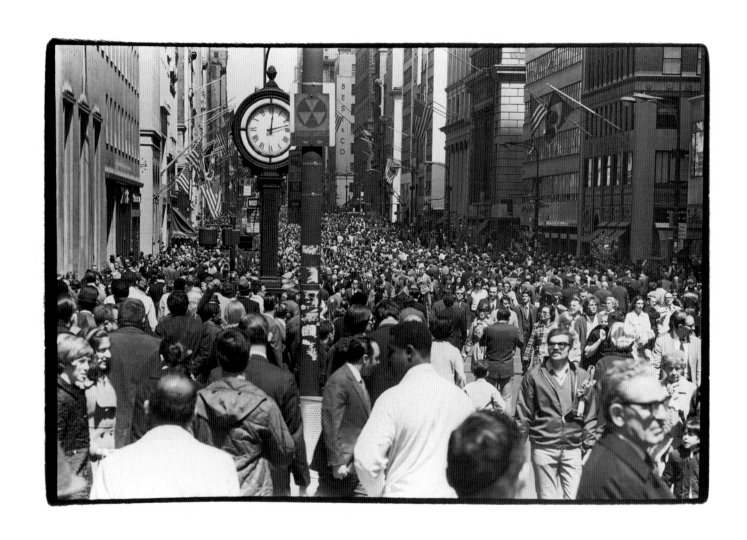

First Earth Day, Fifth Avenue, April 22, 1970.

ABOVE: Diggers give out stew in Tompkins Square Park, September 22, 1967. Name comes from 17th Century radical group in England that had protested the monopolization of land by the wealthy. **RIGHT:** Hot knishes all day long at Avenue C and Sixth Street, November 7, 1964.

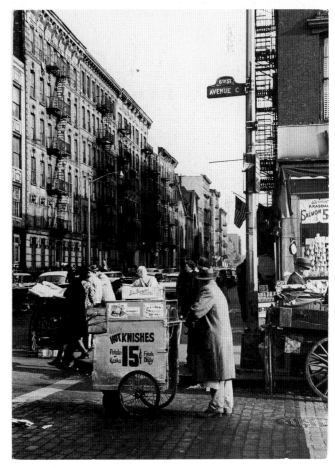

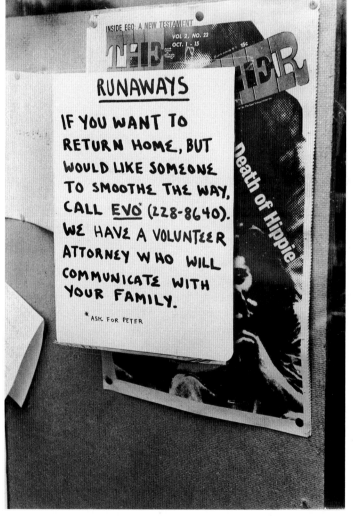

ABOVE: A runaway on Avenue B in East Village, November 12, 1967. **RIGHT:** Sign on window of East Village Other newspaper, Avenue B and Ninth Street, November 12, 1967.

TOP: Ed Sanders in Peace Eye Bookstore, 383 East Tenth Street, formerly a kosher chicken market, January 14, 1966. **BOTTOM:** Staff of East Village Other—Dan Rattiner, Walter Bowart, Allen Katzman, Don Katzman, January 14, 1966. They started the East Village Other in October 1965. John Wilcock worked briefly for the East Village Other.

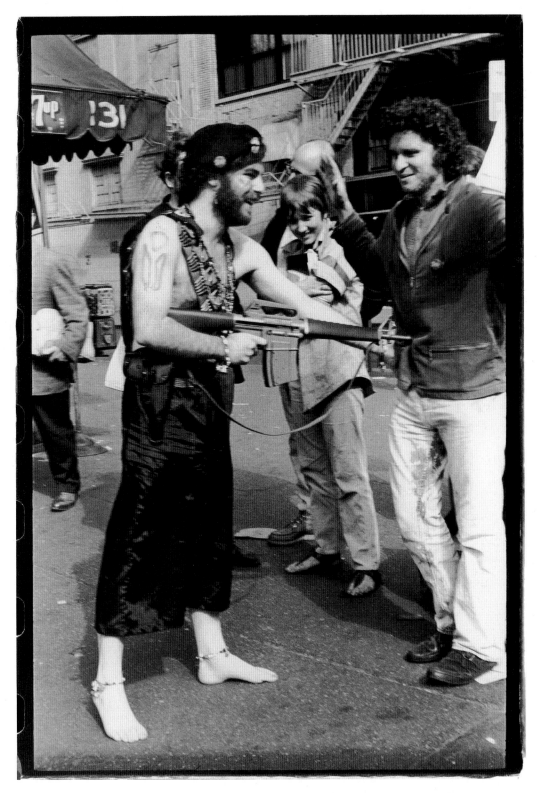

Jerry Rubin in guerilla costume confronts Paul Krassner, St. Marks Place, September 28, 1968. Rubin was indicted for "inciting a riot" at the Chicago Convention. He said it was "the greatest honor of my life . . . it is the fulfillment of childhood dreams." Also indicted were Abbie Hoffman, David Dellinger, Rennie Davis, Tom Hayden, Lee Weiner, John Froines, and Bobby Seale.

Tompkins Square Park, East Tenth Street and Avenue A, February 13, 1964.

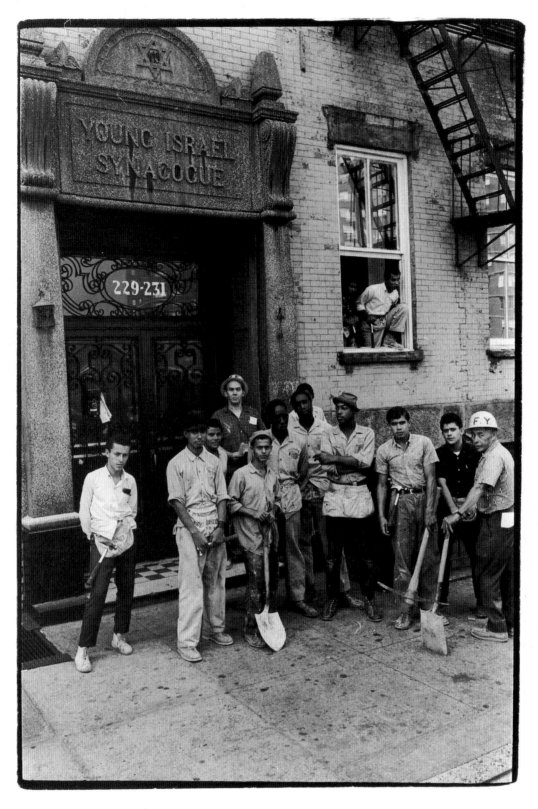

Mobilization for Youth rehabilitating synagogue on East Broadway, August 28, 1964. They earn while they learn on the job training to use carpenter's tools and fix automobiles-—girls learn typing and sewing.

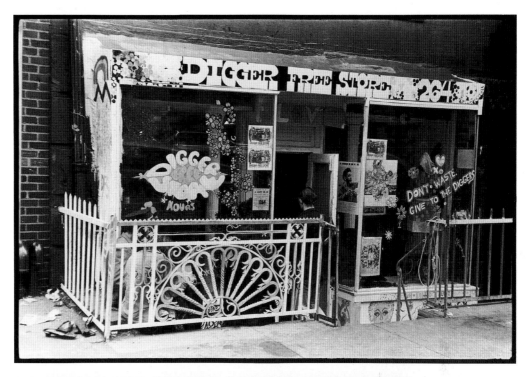

TOP: Diggers free store, 264 East Tenth Street, September 22, 1967. **BOTTOM:** Mickey Ruskin, later owner of Max's Kansas City, in his tavern, "The Annex," on Avenue B, October 31, 1964. The saloon featured barrels of peanuts.

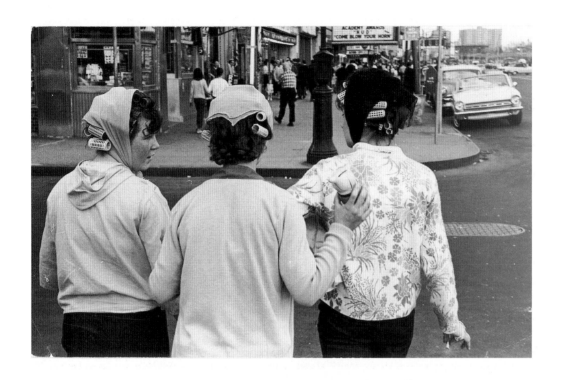

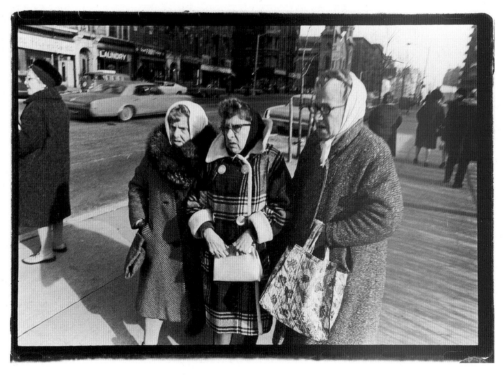

TOP: Three girls in curlers crossing Delancey Street, May 5, 1964. BOTTOM: Three friends wearing babushkas on Grand Street, February 13, 1969.

TOP: Locked out of P.S. 41, December 2, 1968, during teacher's strike. **BOTTOM:** Students at Junior High School 271, 1137 Herkimer Street, Ocean Hill Brownsville School District, Brooklyn, September 20, 1968. This is where the idea of decentralized schools first took hold.

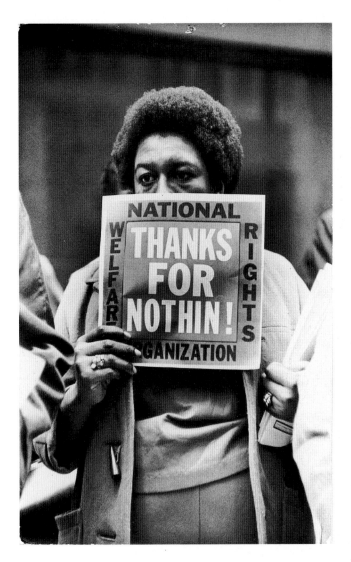

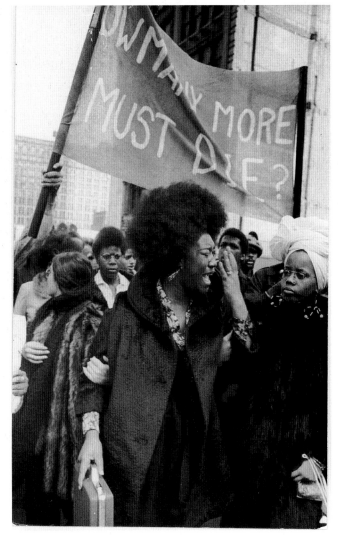

ABOVE: A national welfare rights picket at Thanksgiving Day Parade, November 25, 1968. **RIGHT:** Tears for a dead child, eight-year-old Tyrone Holland, at the Kimberly, a welfare hotel, February 26, 1971.

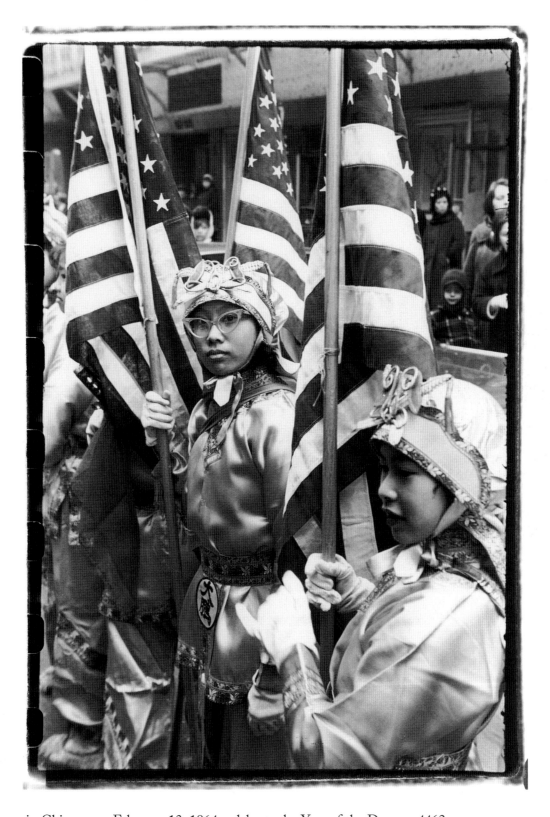

Americans in Chinatown, February 13, 1964, celebrate the Year of the Dragon, 4462.

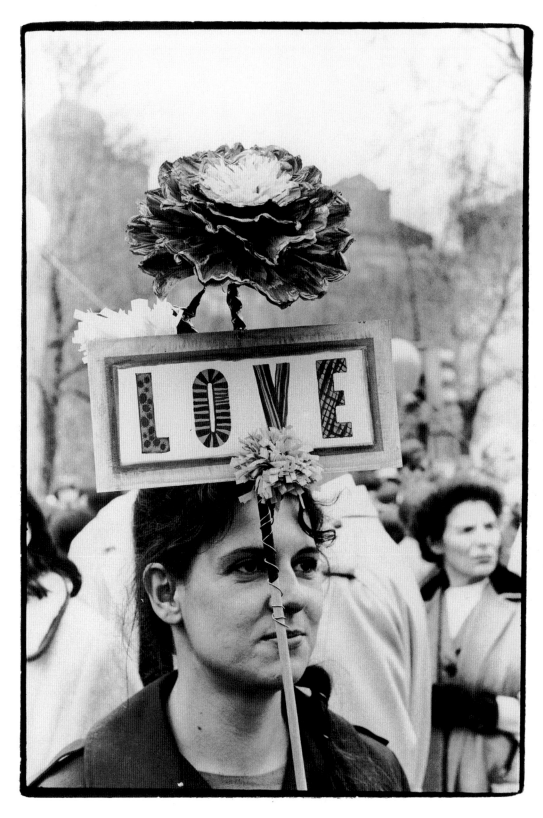

Love is the message to the United Nations at the peace march, May 15, 1967.

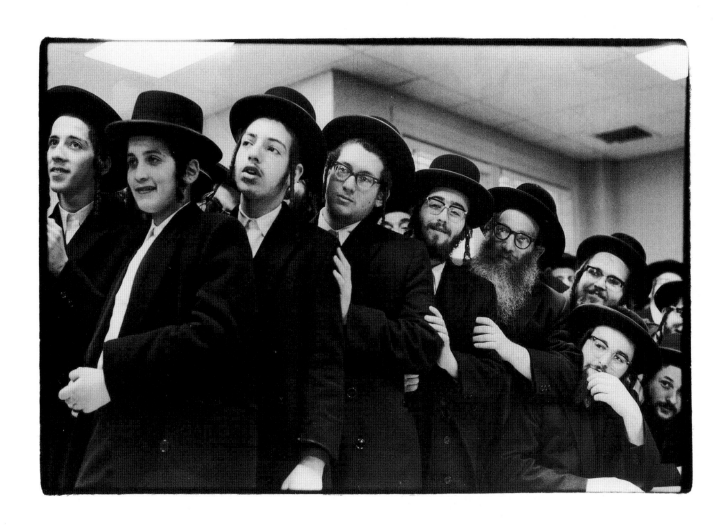

Hasidic men with traditional fur felt hats at Crown Heights gathering.

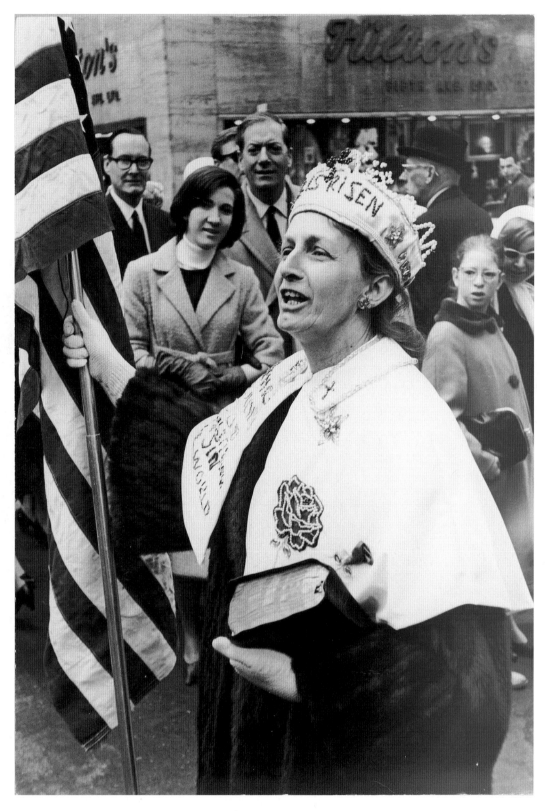

Evangelist at Easter Parade carrying a ten-pound Bible spreads her gospel—"He is Risen" at the Easter Parade, Fifth Avenue, March 29, 1964.

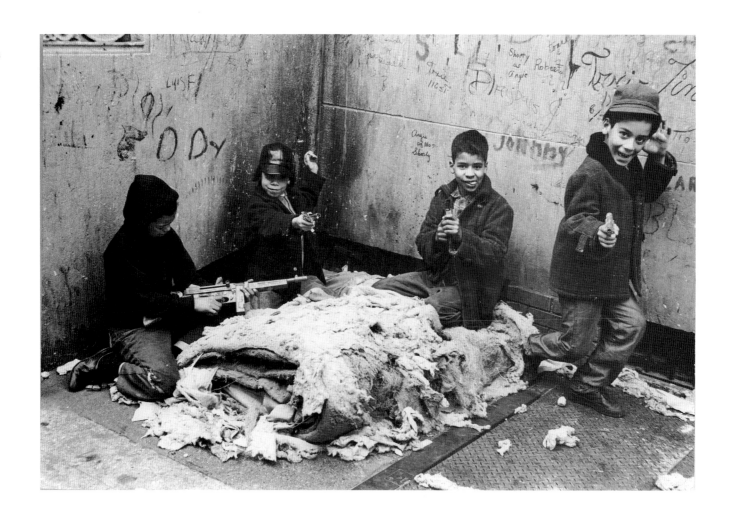

Playing with guns, front of Aguilar Branch New York Public Library, 174 East 110th Street, East Harlem, March 21, 1964.

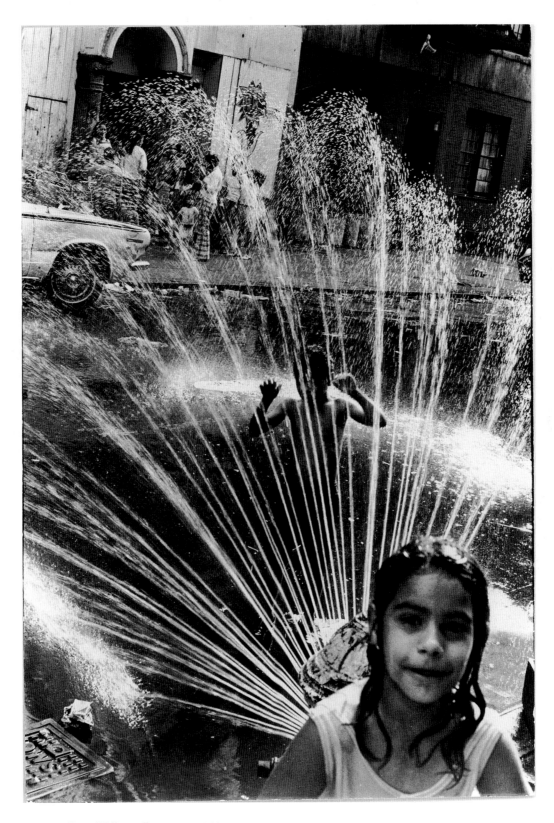

Outdoor shower, East Village, June 12, 1969.

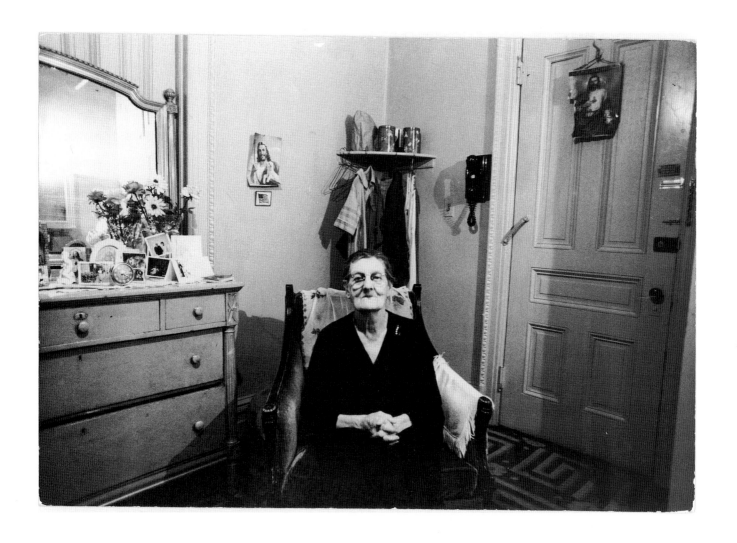

Eighty-four-year-old resident in SRO (Single Room Occupancy) hotel room, The Endicott, 101 West 81st Street at Columbus Avenue, October 4, 1969.

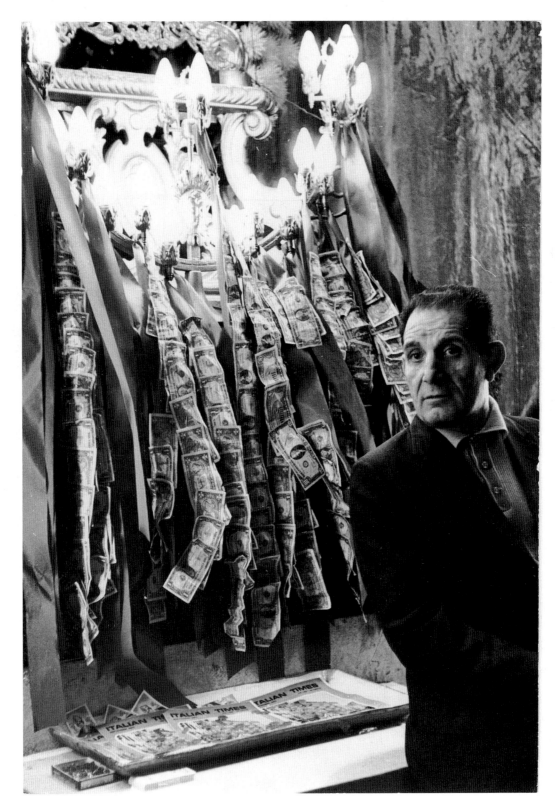

Collecting dollar bills at San Gennaro street fair, Mulberry Street, September 13, 1963.

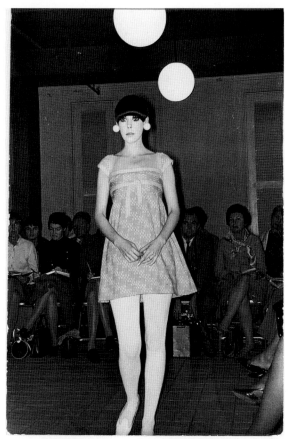
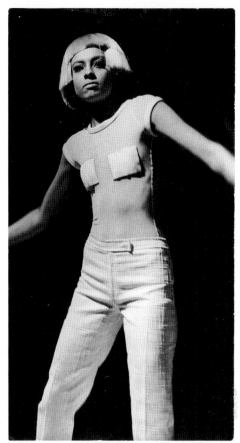
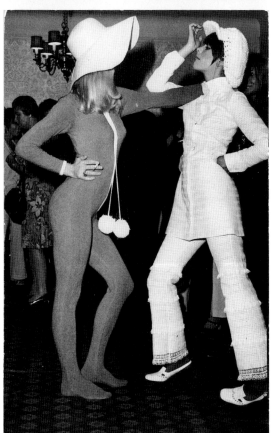
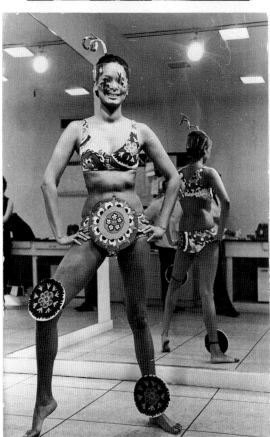

CLOCKWISE FROM TOP LEFT: Peggy Moffitt in Rudi Gernreich garment, October 31, 1968. • Andre Courreges' "Breast Band Aids," February 8, 1969. • Mary Quant casual wear, October 17, 1968. • Height of fashion, Jacques Tiffeau, February 5, 1968.

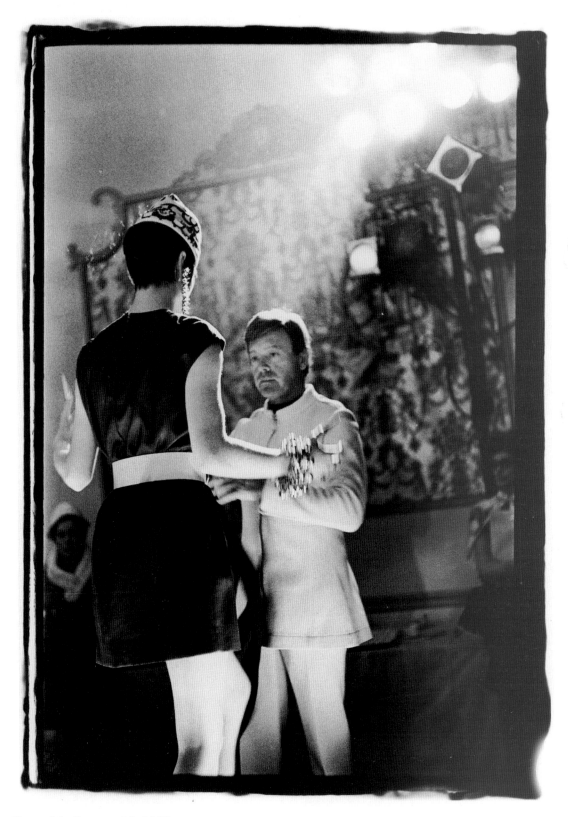

Rudy Gernreich, January 12, 1968.

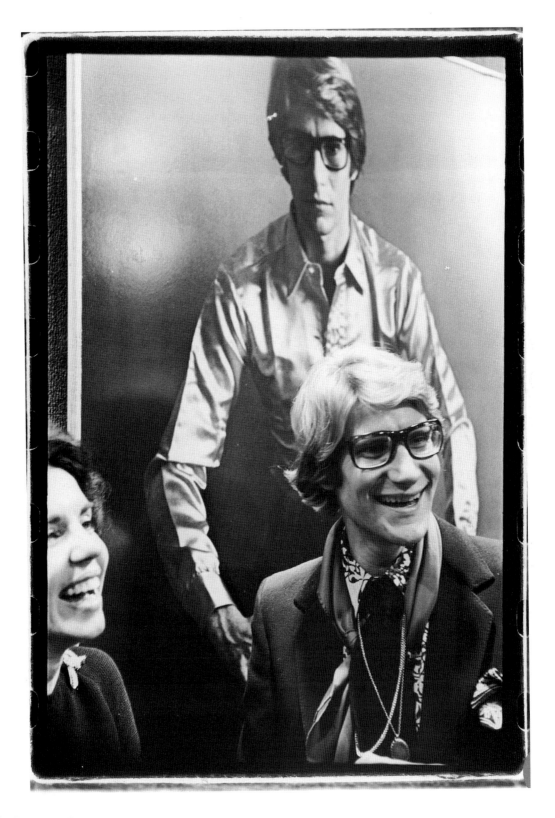

Yves St. Laurent, September 19, 1968.

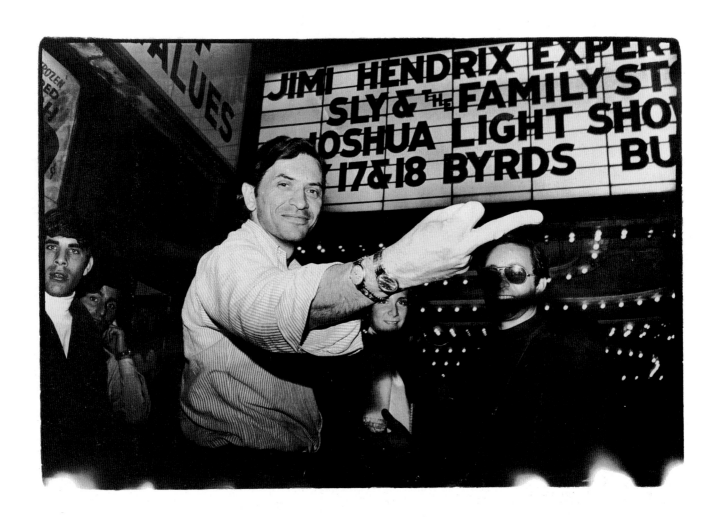

Bill Graham front of the Fillmore East, May 11, 1968. He always wore two watches, one for time at the Fillmore East, the other for time at the Fillmore West in San Francisco. Behind him is Voice fashion columnist Blair Sabol.

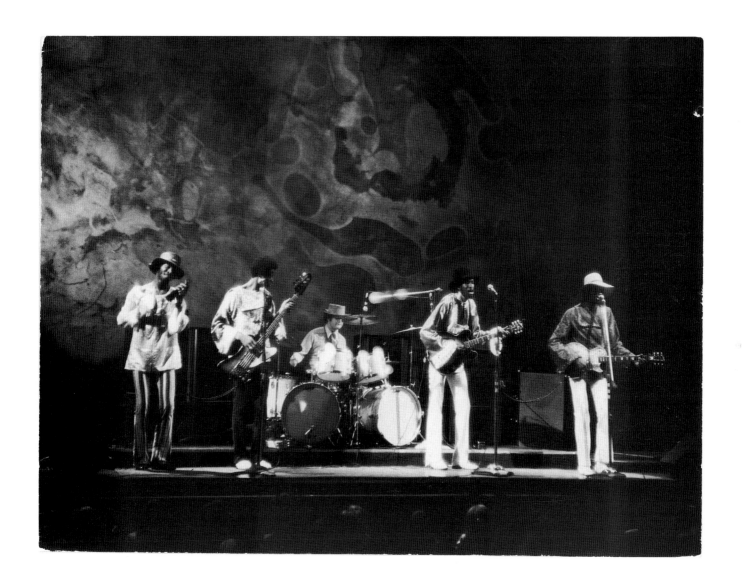

Chambers Brothers (George, Willie, Lester, Joe and Brian Keenan on Drums) with Joshua Light Show at Fillmore East, September 14, 1968. Lights were projected on to a large translucent screen hung behind the musicians. Colors were composed of oil, water, glycerine and other materials that did not mix.

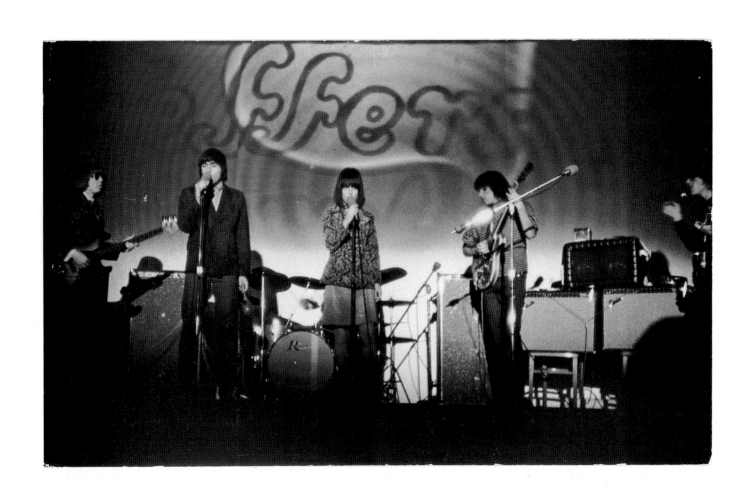

The Jefferson Airplane at the Fillmore East, January 8, 1967—Jack Casady, Marty Balin, Grace Slick, Jorma Kaukonen, Paul Kantner.

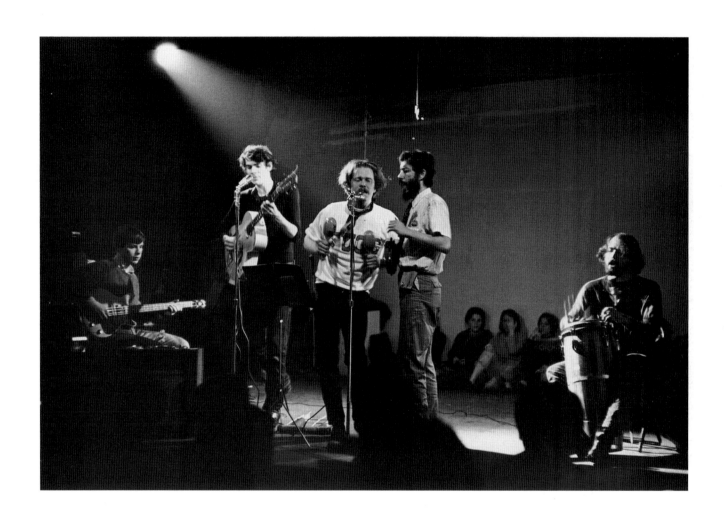

The Fugs, December 12, 1965, at the Village Theatre (later became the Fillmore East)—left to right: John Anderson, Steve Weber, Ed Sanders, Tuli Kupferberg, Ken Weaver.

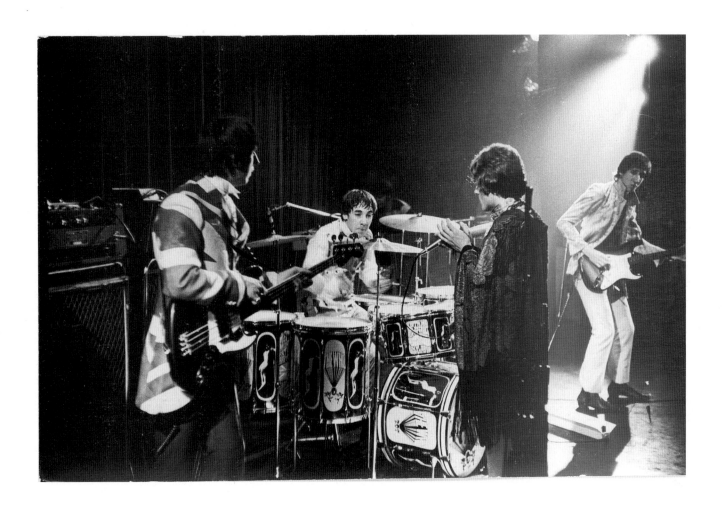

The Who at Fillmore East, July 8, 1967—left to right: John Entwistle, Keith Moon, Roger Daltry, Pete Townshend.

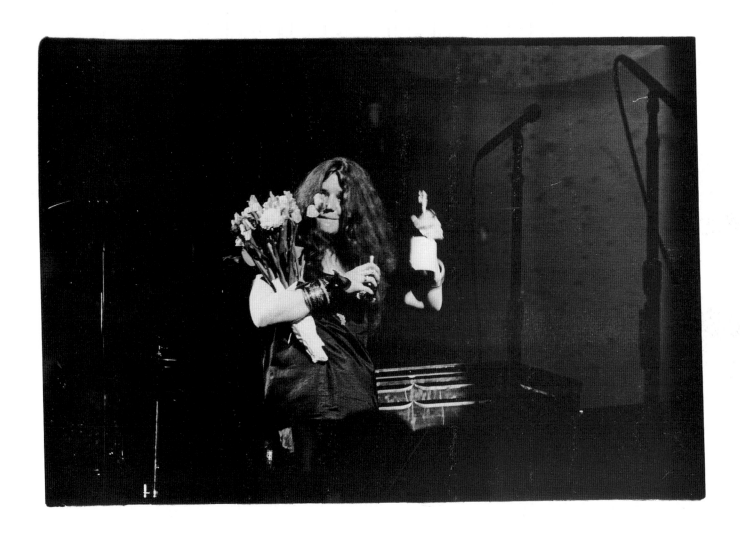

Janis Joplin on stage at the Fillmore East, 105 Second Avenue, with bouquet and bottle of Southern Comfort, February 11, 1969. The Fillmore opened on March 8, 1968.

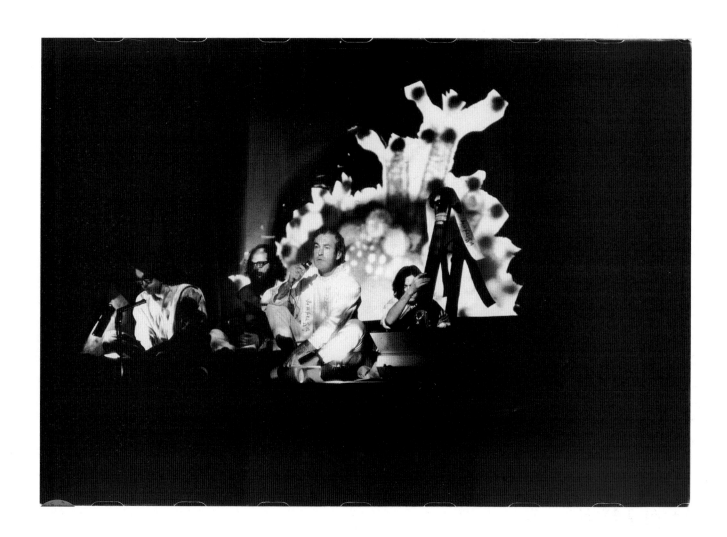

Timothy Leary, Allen Ginsberg, Richard Alpert, "Illumination of the Buddha," at the Village Theatre, name changed later to the Fillmore East, December 6, 1966. The event was a "psychedelic religious celebration."

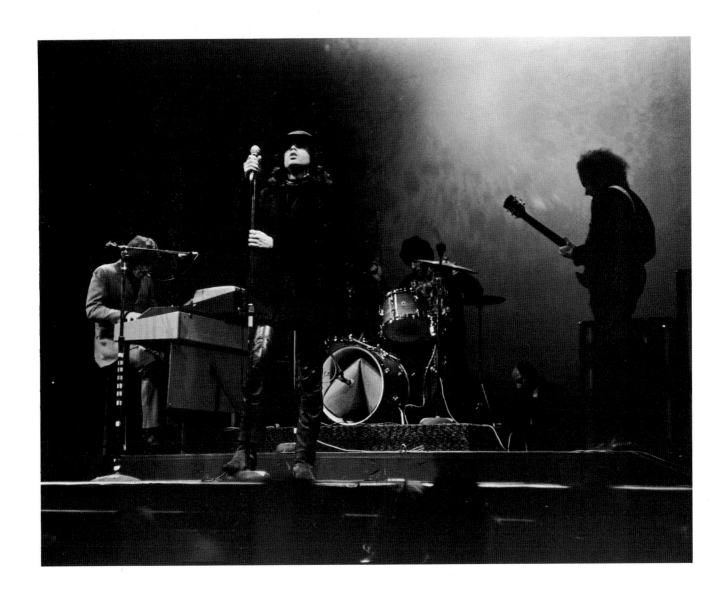

The Doors at the Fillmore East, March 22, 1968—Ray Manzarek (piano, organ and bass), Jim Morrison (vocals), John Densmore (drums), Robby Krieger (guitar). On this night they played "Light My Fire" and "Break on Through."

CLOCKWISE FROM TOP LEFT: Jack Smith of "Flaming Creatures" fame, August 8, 1964. • Robert Frank in Central Park, April 16, 1967, photographing an anti-war rally. • Richard Lester, October 16, 1967, is best known for his films *A Hard Day's Night* and *Help*. • Robert Downey at a screening of his film *Putney Swope*, August 20, 1970. His son, Robert Downey, Jr., is a television actor.

TOP: Martin Scorsese on Columbus Avenue at West 63rd Street, September 16, 1970. His 1968 film Who's that Knockin' at My Door? begins with "a series of street fights which look like tap dance routines in a musical." **BOTTOM:** Shirley Clarke and Jonas Mekas in Central Park, November 5, 1967, shooting an outdoor performance by the San Francisco Mime Company. Mekas created the Filmmakers Cinematheque, a place where underground and avant garde filmmakers have a permanent showplace.

ABOVE: The Creative Film Foundation Awards, January 25, 1961—left to right: Maya Deren, Robert Breer, Carmen D'Avino, Ed Emshwiller, Stan van der Beek, Richard Preston, Charles Boltenhouse, Shirley Clarke. RIGHT: Documentary filmmakers Albert (left) and David Maysles (right), June 10, 1965, worked on the 1969 U.S. tour of the Rolling Stones as well as "Gimme Shelter," and "Salesman." On both films and others they were assisted by Charlotte Zwerin.

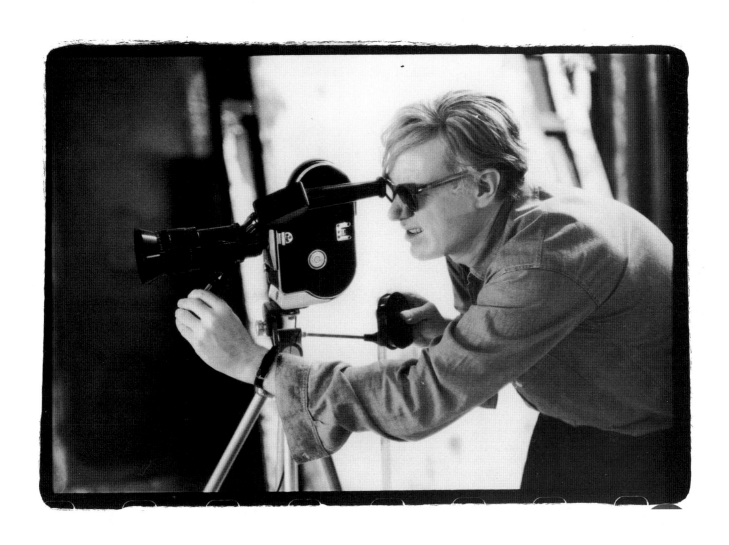

Andy Warhol with a 16 mm. Bolex shooting the film Taylor Mead's Ass, September 5, 1964.

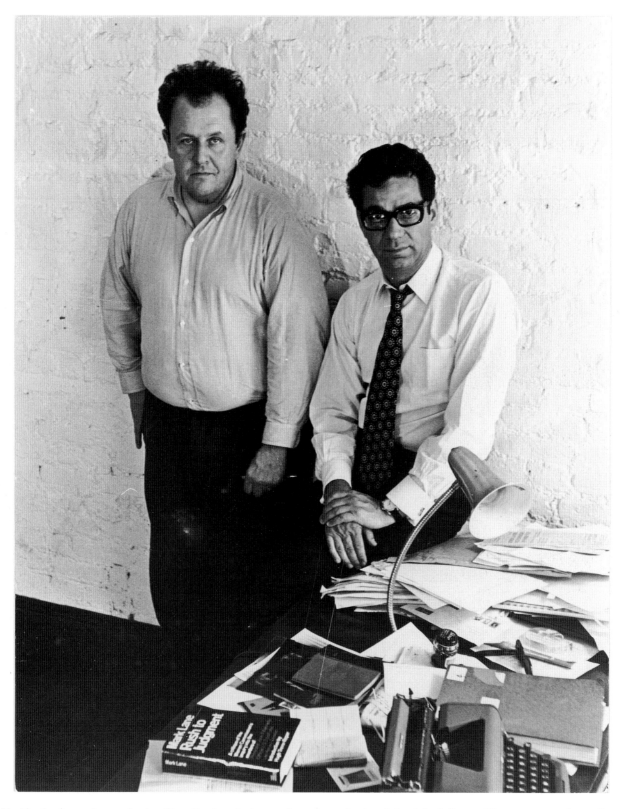

Emile de Antonio made the film *Rush to Judgment* based on the book by Mark Lane. They are seen here, June 22, 1966.

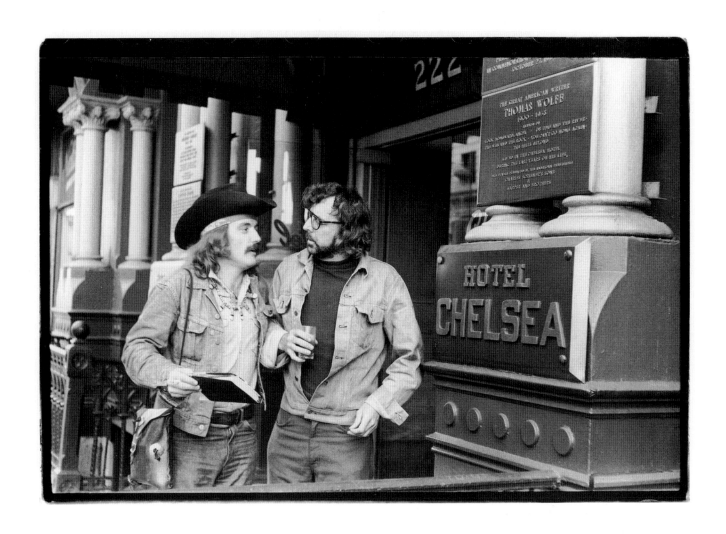

Dennis Hopper and Terry Southern at the Chelsea Hotel, 222 West 23rd Street, September 30, 1971. Both co-wrote *Easy Rider* with Peter Fonda.

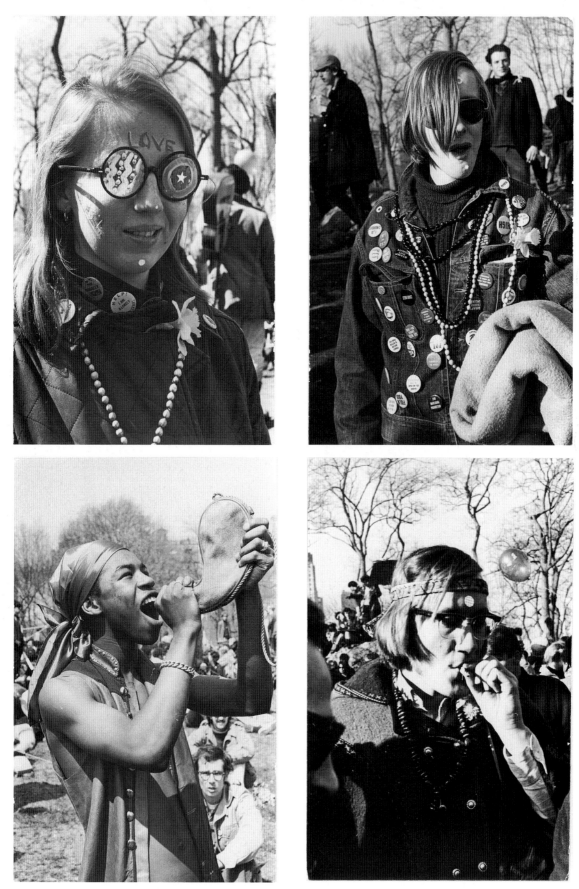

CLOCKWISE FROM TOP LEFT: Central Park "Be-in," March 26, 1967. Central Park Hippies, March 26, 1967. A drink from a pig-skin "Bota" canteen, Central Park, April 14, 1968.

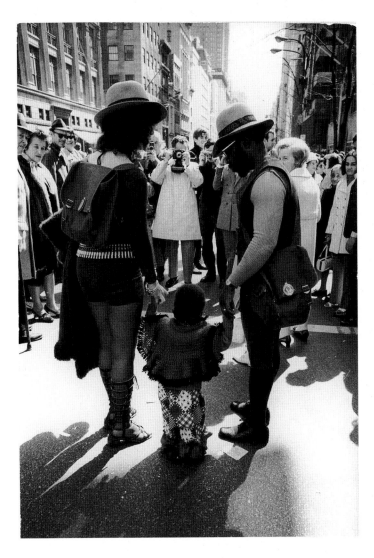

ABOVE: Easter Parade family, Fifth Avenue, April 11, 1971. **RIGHT:** An American family (with Volkswagen van), April 14, 1968.

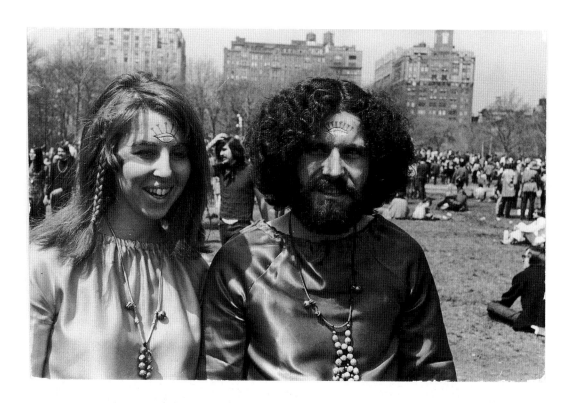

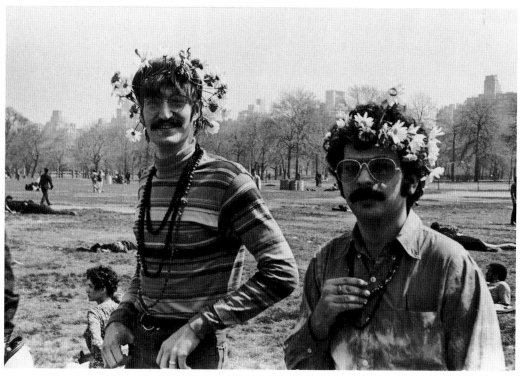

TOP: Silks and satins extra eyes, Central Park, April 14, 1968. **BOTTOM:** A crown of daisies, Central Park, April 14, 1968.

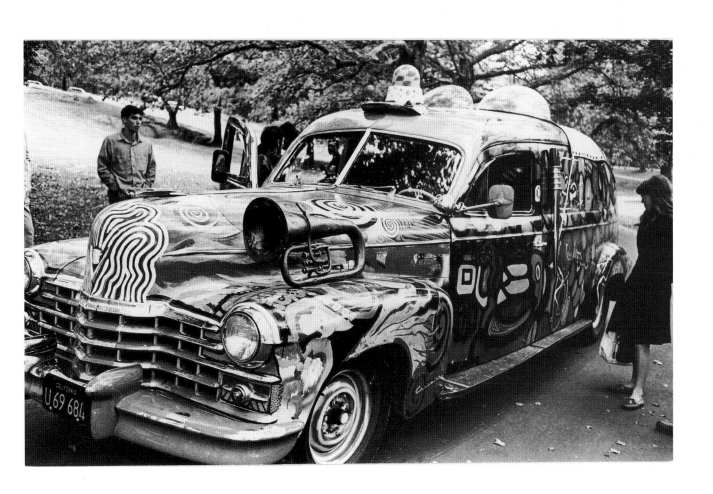

Psychedelic Cadillac by Rip Trigel and Miguel DeVita, Central Park, September 9, 1966.

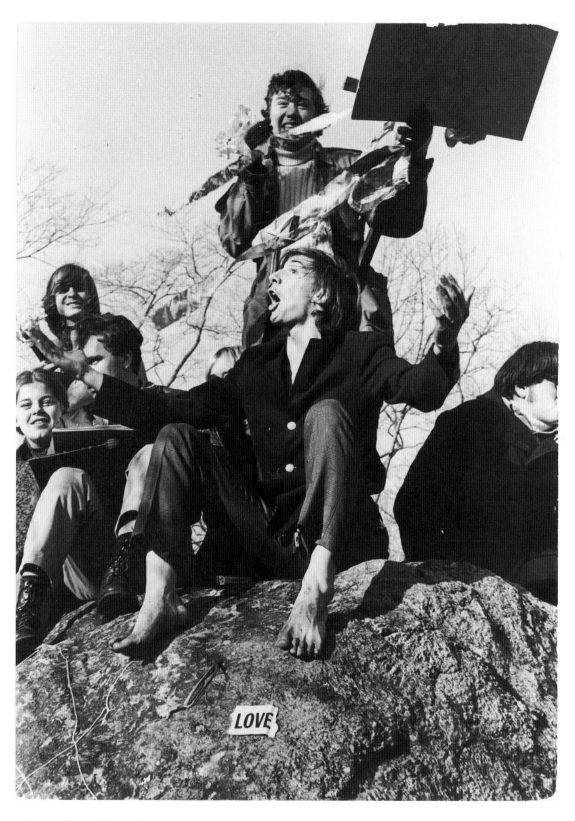

Love in bloom, Easter "Be-in," Central Park, March 26, 1967.

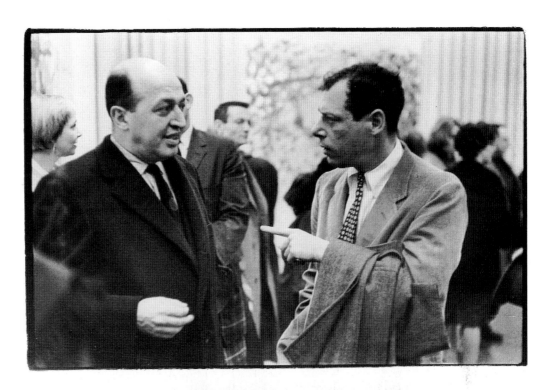

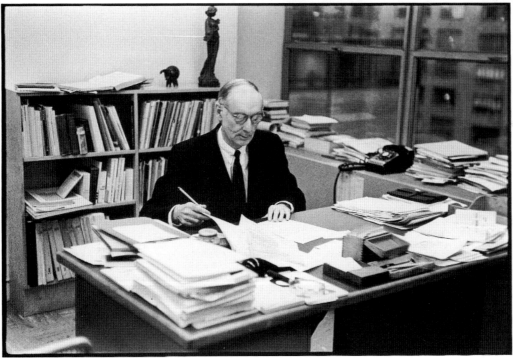

TOP: Art Critic Clement Greenberg and Art News editor Tom Hess at Poindexter Gallery, East 57th Street, for the opening of the Herman Cherry exhibit, February 20, 1961. **BOTTOM:** Alfred Barr Director of the Museum of Modern Art at his office, 11 West 53rd Street, February 21, 1961. His mission was to elevate photography and film to the realm of fine art, something new to the art world and the American art museums.

ABOVE: Christo and Jeanne Claude with critic David Bourdon at the Guggenheim Museum, September 18, 1969. The Christos are known for wrapping bridges, buildings, and landscapes in fabric and rope. **RIGHT:** *New Yorker* critic Harold Rosenberg at Louise Nevelson exhibit, Martha Jackson Gallery, 32 East 69th Street, October 28, 1959.

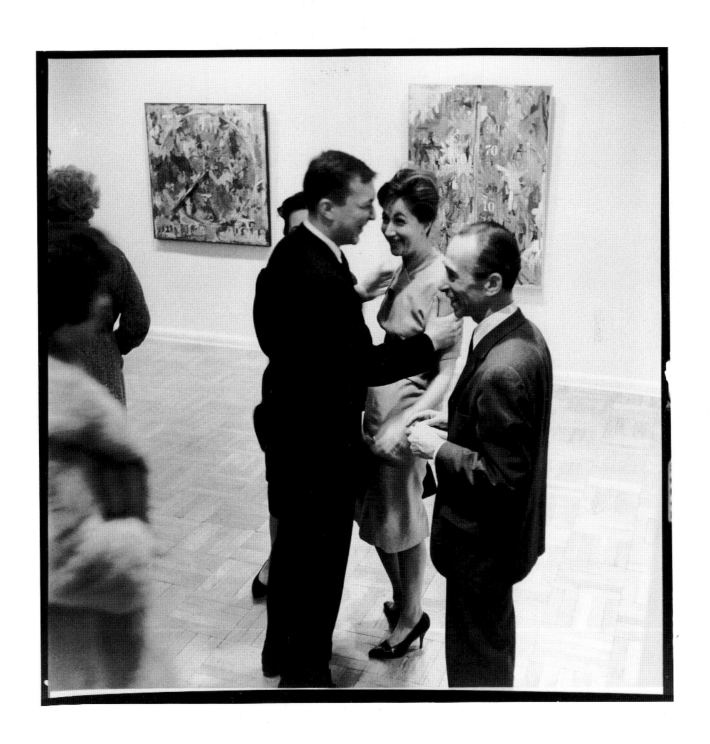

Jasper Johns at his exhibit with Ethel Scull and Leo Castelli at his gallery, 4 East 77th Street, February 15, 1960.

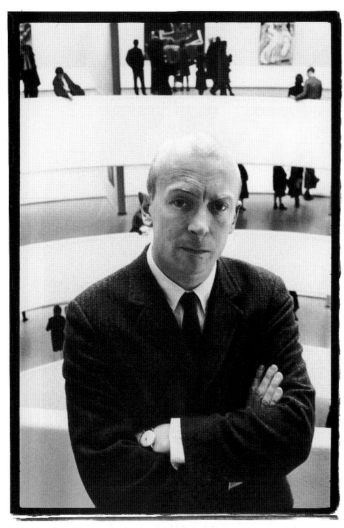

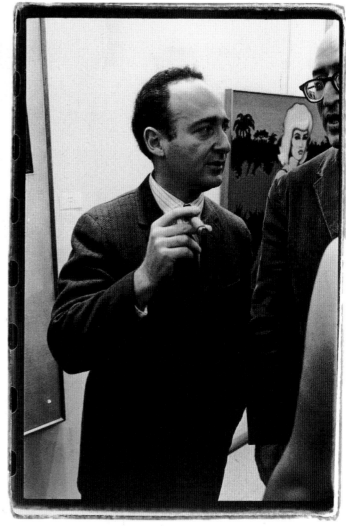

ABOVE: Lawrence Alloway, Director of the Guggenheim Museum, 1071 Fifth Avenue, January 28, 1964. He coined the expression "Pop Art." RIGHT: Ivan Karp worked at Richard Bellamy's Hansa Gallery, then at Martha Jackson, and finally at Leo Castelli. Ivan opened his own gallery, one of the first in Soho, O.K. Harris, in 1969 at 465 West Broadway.

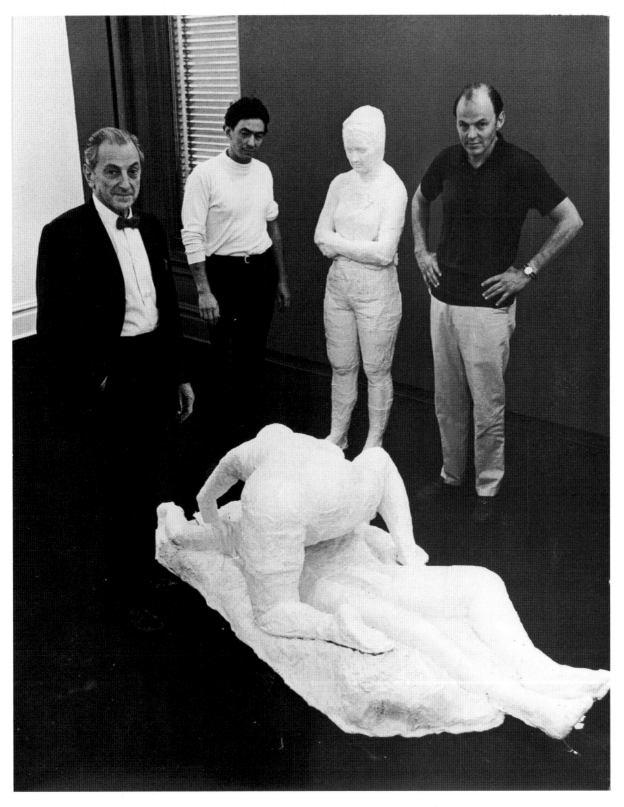

Sidney, Carroll, and Conrad Janis with George Segal sculpture at the Sidney Janis Gallery, 15 East 57th Street, September 23, 1966.

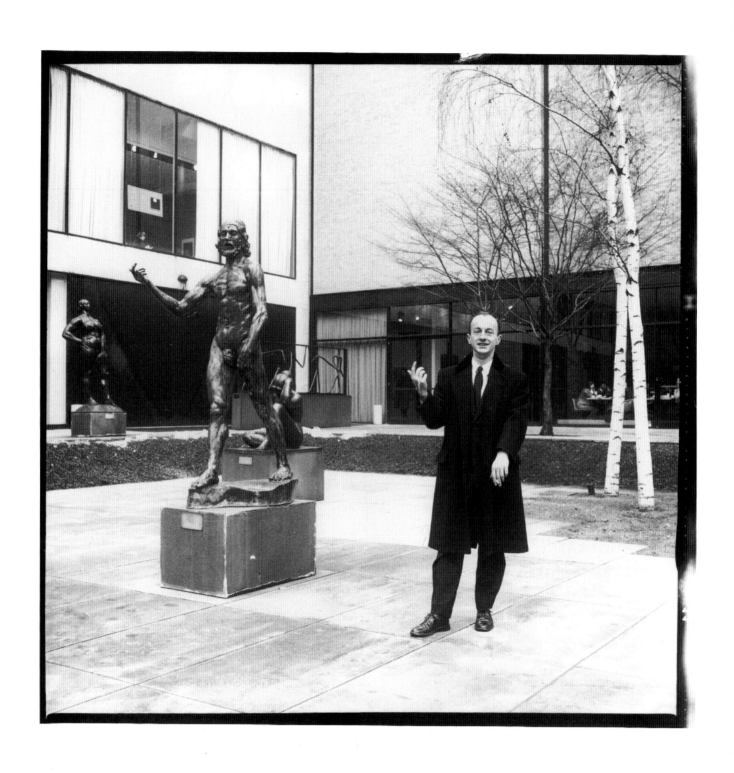

Curator Frank O'Hara in the Museum of Modern Art garden, January 20, 1960, with Auguste Rodin's "St. John the Baptist Preaching."

A garden party opening at the Museum of Modern Art, September 9, 1963.

Ray Johnson charming a snake in George Kleinsingers, Chelsea Hotel Studio, 222 West 23rd Street, February 10, 1965.

Holly Solomon in her loft gallery, 98 Greene Street, February 19, 1971.

Robert Smithson, Sol Lewitt, Dan Flavin, David Whitney, Dick Bellamy, Jill Kornblee during installation of
"Primary Sculptures" exhibit at Jewish Museum, 1109 Fifth Avenue, April 26, 1966.

Shel Silverstein in Washington Square Park, June 7, 1959. He was a contributor to *Playboy* and created the famous Uncle Shelby character.

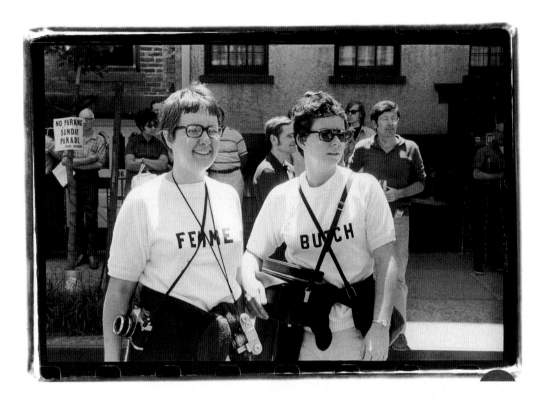

TOP: A butch and femme at Stonewall first anniversary event, June 28, 1970. **BOTTOM:** A drag queen beauty pageant at Town Hall, February 20, 1967.

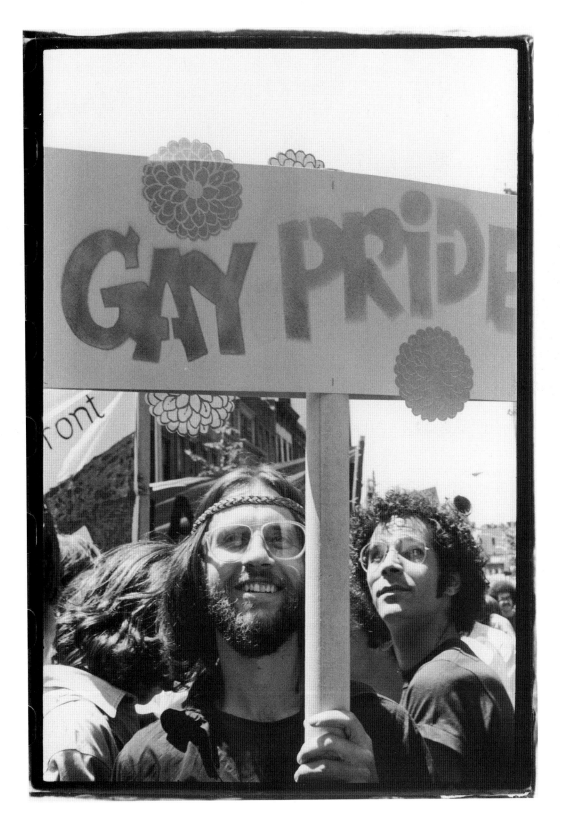

The first Stonewall anniversary march held on June 28, 1970.

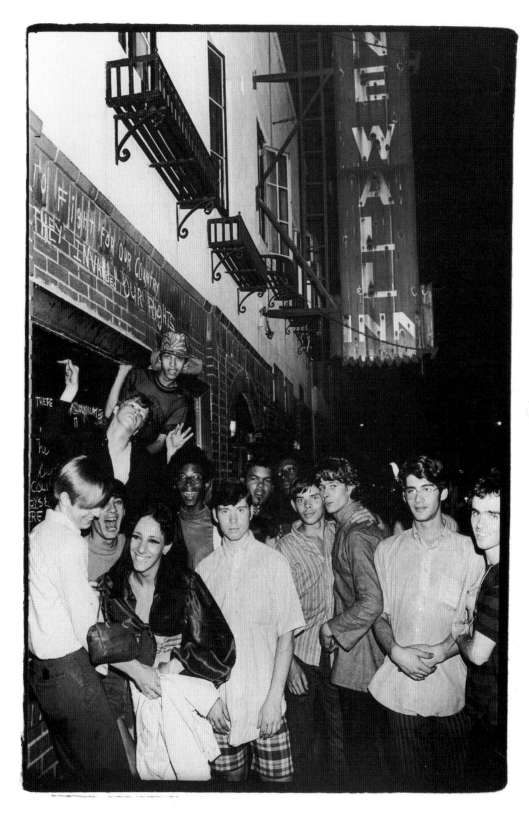

A weekend of Stonewall Inn riots, June 27, 1969.

Mattachine Society members at a Halloween party, October 27, 1967. Mattachine forced the State Liquor Authority to recognize the legality of gay bars and forced the police to abandon entrapment of homosexuals.

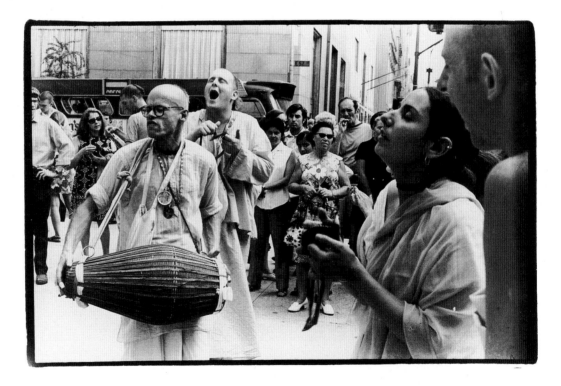

TOP: Finger cymbals on Fifth Avenue by Hare Krishna, August 2, 1969. **BOTTOM:** Hare Krishna performing on Fifth Avenue, July 11, 1970.

Alms for Hare Krishna, August 2, 1969.

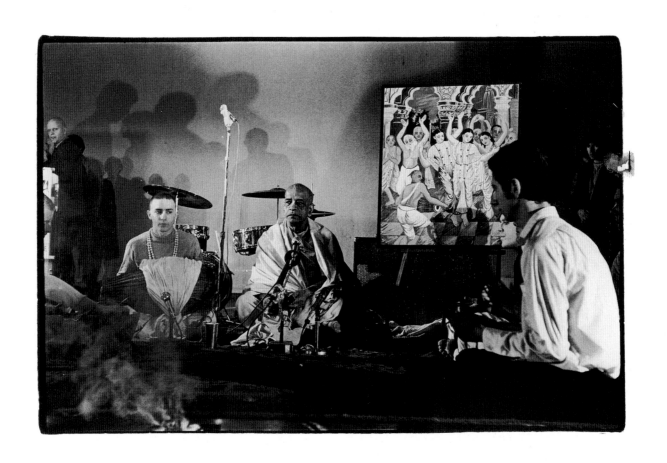

Swami Bhaktivedanta conducts service in the Village Theatre, April 23, 1967.

Abbie Hoffman at the American flag show, Judson Memorial Church, November 15, 1970.

Lin House performs wedding of Anita and Abbie Hoffman in Central Park, June 10, 1967.

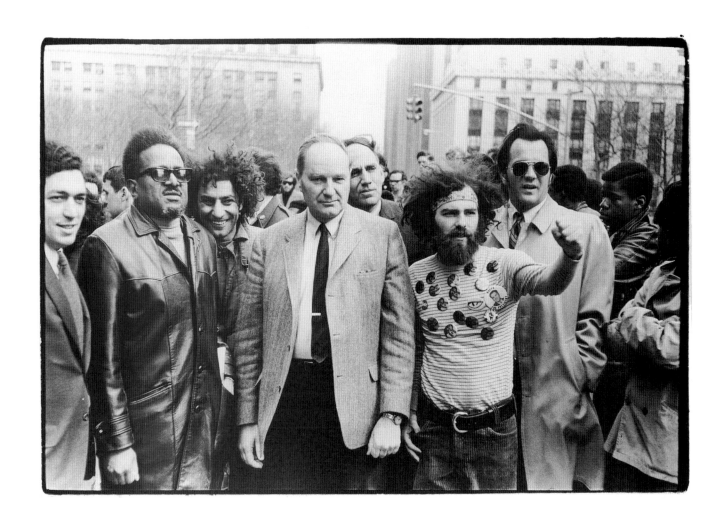

At Black Panther rally, Federal Court, Foley Square—left to right: Gerald Lefcourt, David Brothers, Abbie Hoffman, Dave Dellinger, William Kunstler, Jerry Rubin, Arthur Turco.

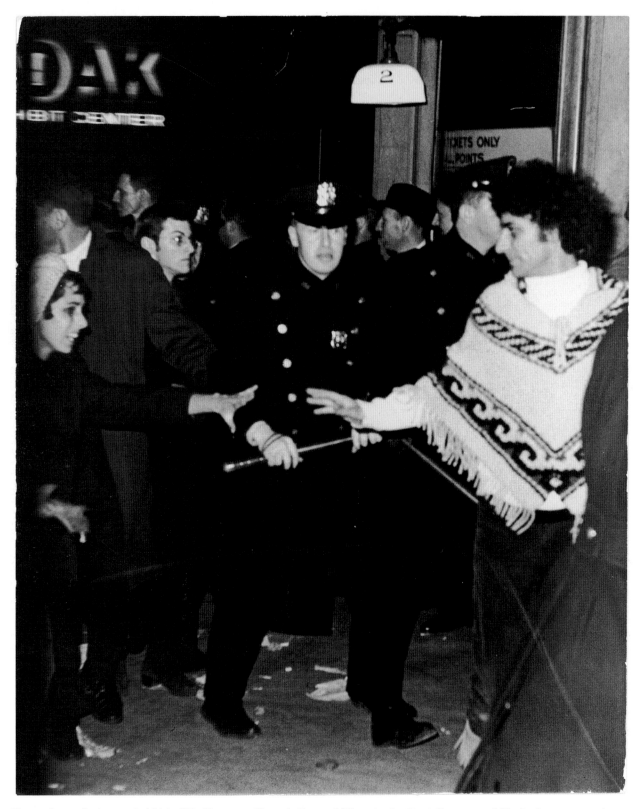

Cops chase Anita and Abbie Hoffman at Grand Central Terminal, 42nd Street and Park Avenue, anti-war protest, March 22, 1968. The announcement said to bring "bells, flowers, beads, music, radios, pillows, eats, love, and peace."

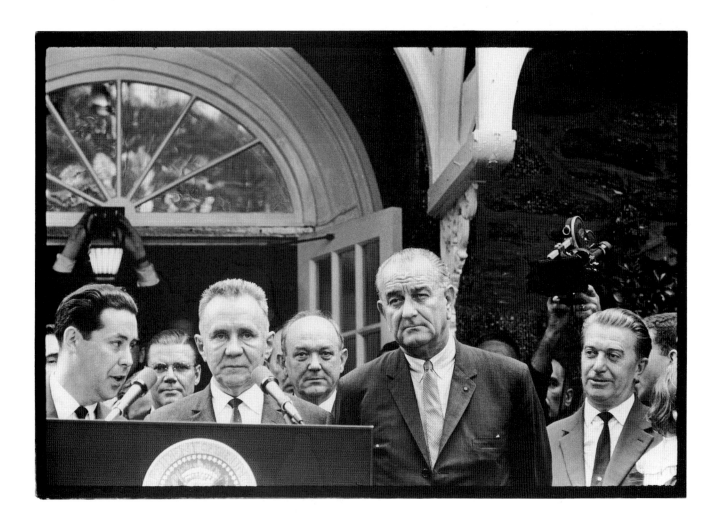

Holly Bush Summit, Glassboro, New Jersey, June 23, 1967—left to right: Secretary of Defense, Robert Strange McNamara, Soviet Premier Aleksei Kosygin, Secretary of State Dean Rusk, President Lyndon B. Johnson (with interpreters left and right). The Summit agenda included seeking a solution to the Arab-Israeli conflict, the Vietnam War, the Nuclear Nonproliferation Treaty of 1968, and the Strategic Arms Limitation Treaty (SALT).

ABOVE: Stacey Keach as LBJ in Barbara Garson's *Mac Bird* at Village Gate, February 1, 1967. **RIGHT:** LBJ as the hawk, Central Park demonstration, April 15, 1967.

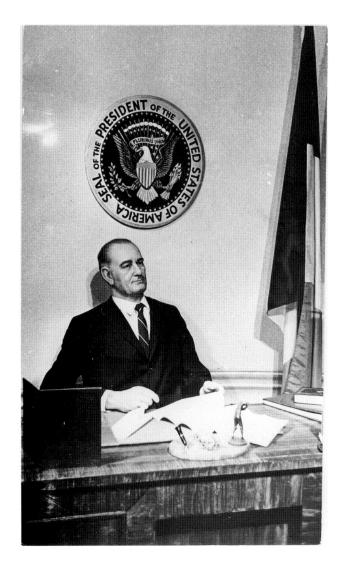

ABOVE: LBJ as wax figure in Ripley's Museum on Broadway, September 6, 1966. **RIGHT:** LBJ portrayed in Moliere's *The Love Cure* performed by Reathel Bean at Judson Memorial Church, November 12, 1966.

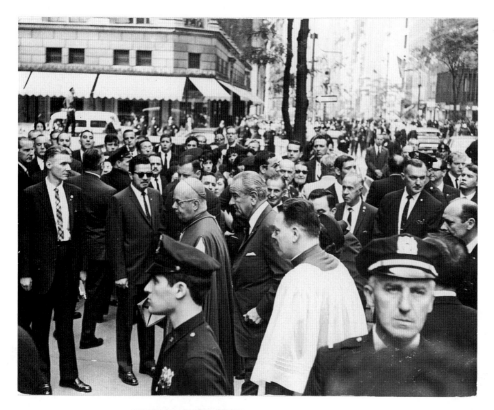

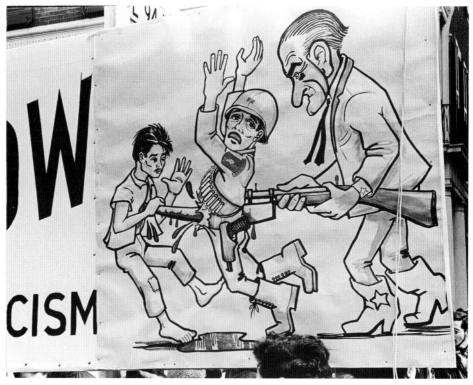

TOP: LBJ attends Robert Kennedy's funeral at St. Patrick's Cathedral, June 7, 1968. **BOTTOM:** LBJ and the Vietcong, March 26, 1966.

ABOVE: Pressing the flesh, Sixth Avenue, Greenwich Village, October 2, 1964. RIGHT: RFK on walking tour, Lower East Side, Orchard and Stanton Street, May 8, 1967.

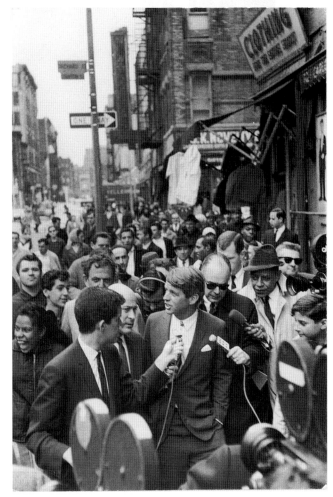

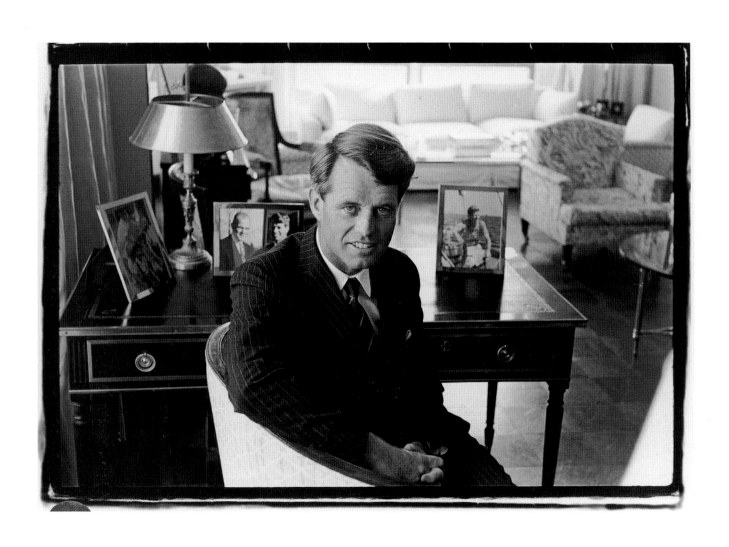

Robert F. Kennedy in his apartment at 860 United Nations Plaza, June 20, 1966.

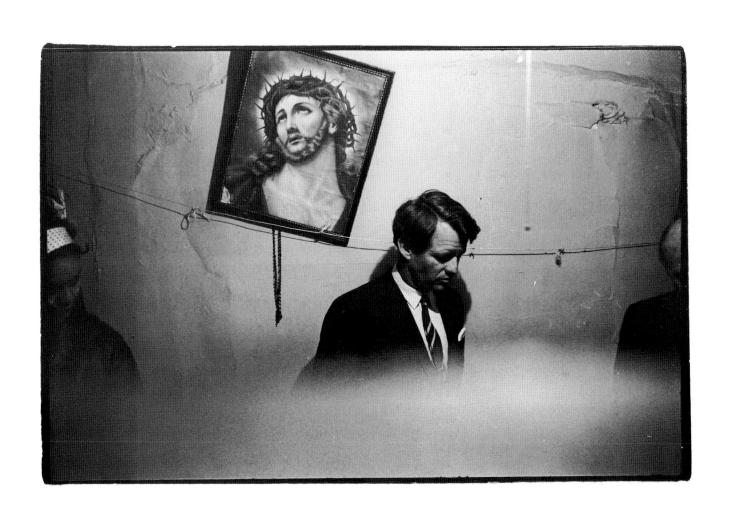

Robert F. Kennedy in Suffolk Street apartment once occupied by Senator Jacob Javits, May 8, 1967.

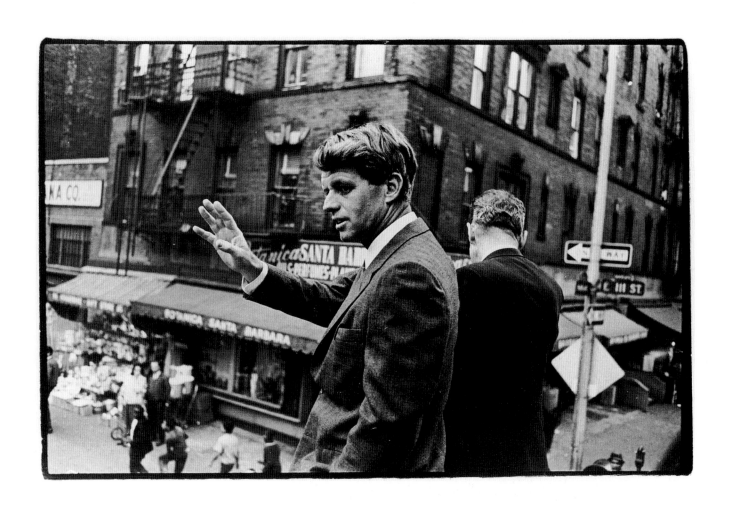

Robert Kennedy campaigning in East Harlem, October 29, 1966.

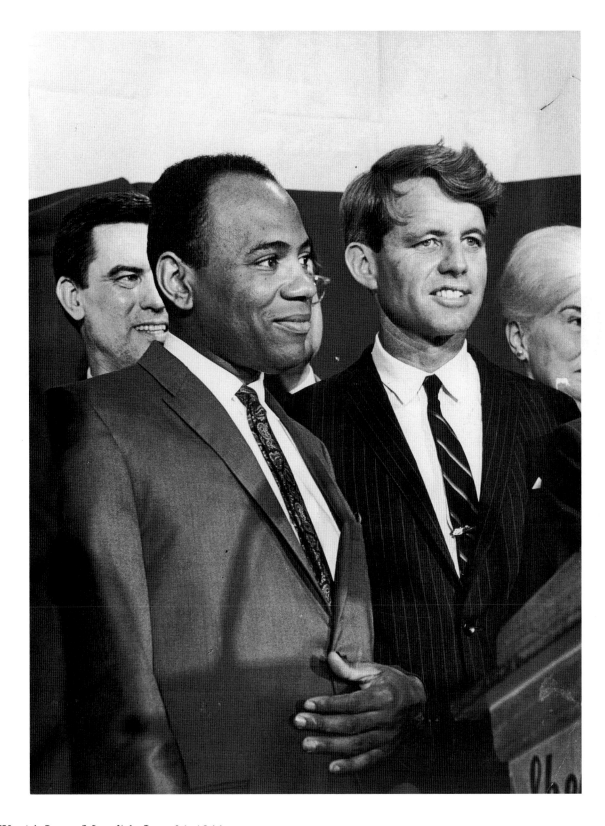

RFK with James Meredith, June 26, 1966.

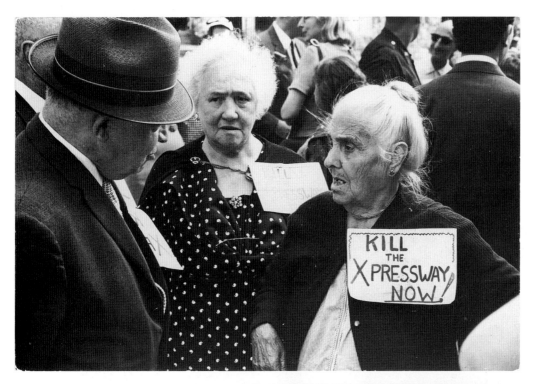

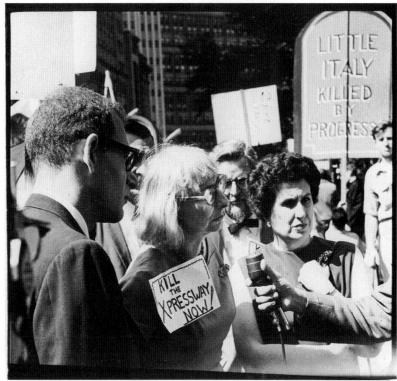

TOP: Community bans together to kill the Broome Street Expressway, August 23, 1962. **BOTTOM:** Martin Berger, Jane Jacobs, Rachel Wall community leaders against the Broome Street Expressway, August 23, 1962.

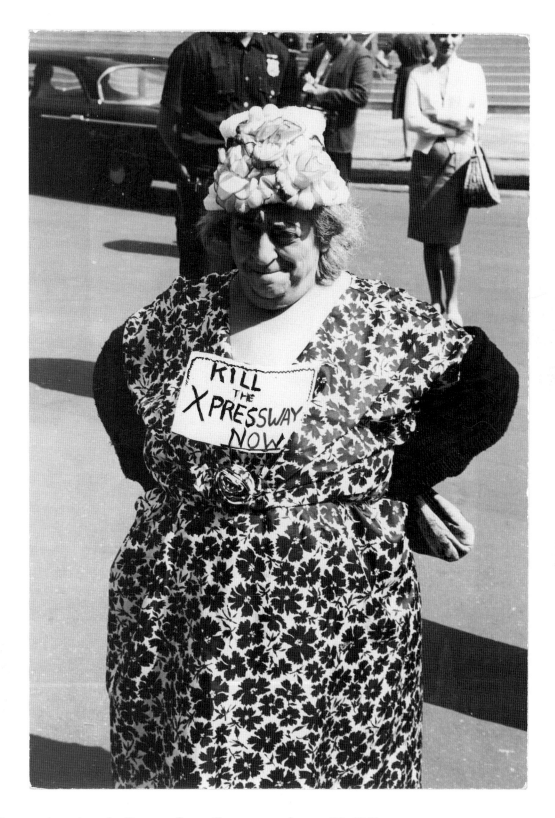

Standing tough against the Broome Street Expressway, August 23, 1962.

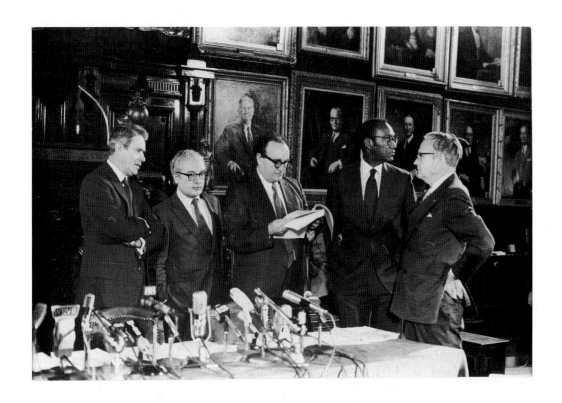

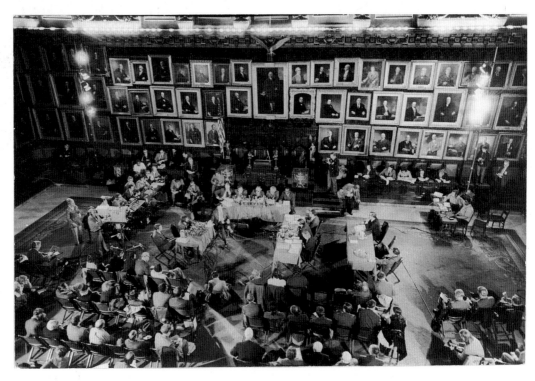

TOP: The Knapp Comission—Cyrus B. Vance, Joseph Monserrat, John E. Sprizzo, Franklin A. Thomas, Whitman Knapp, November 13, 1971. The purpose of the hearing was to "inform the public and to focus attention upon the corruption-related problems faced by the department and its individual officers." **BOTTOM:** The hearing room, 42 West 44th Street, for the commission to investigate alleged police corruption.

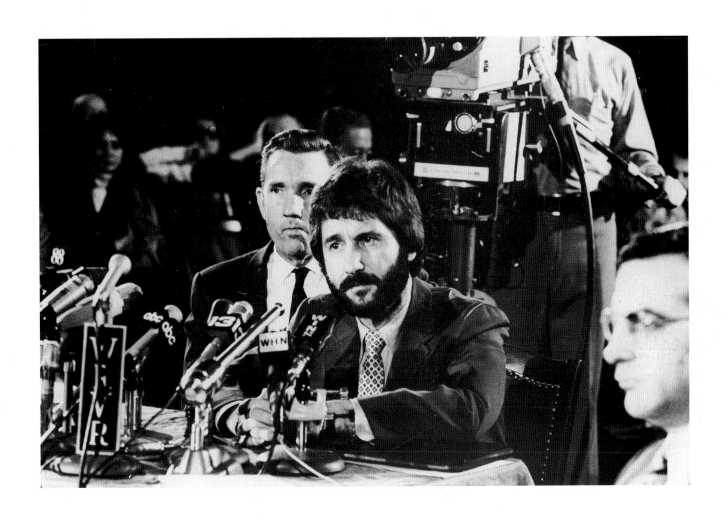

Frank Serpico with his lawyer, Ramsey Clark, testifying at the Knapp Commission on November 13, 1971.

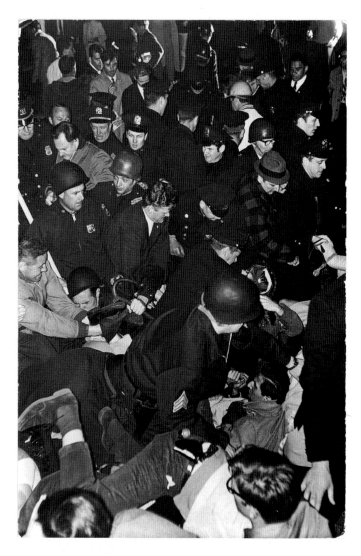

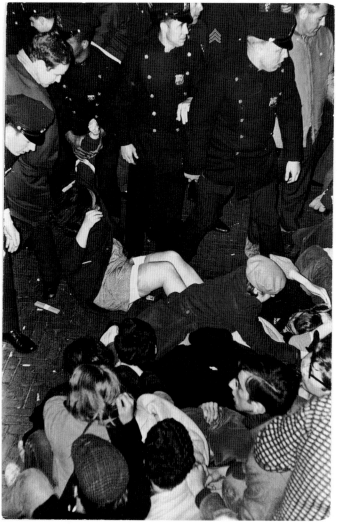

ABOVE: Police remove SDS sit-ins from Avery Hall, April 29, 1968. **RIGHT:** Police remove SDS sit-ins from Avery Hall, April 29, 1968. SDS demanded that Columbia stop construction in Morningside Park of a gym located in Harlem which would be off-limits to the residents of Harlem.

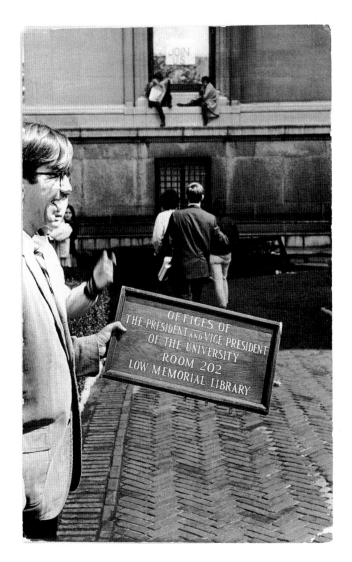

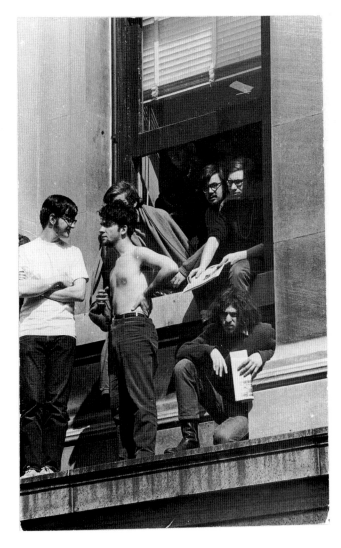

ABOVE: Student shows off sign removed from administration office of Grayson Kirk, April 29, 1968. Kirk, a target of SDS, was a director of Socony, Con Edison, IBM, and two foundations that received CIA funds. **RIGHT:** SDS students occupy Columbia University president's office during campus riots, April 29, 1968.

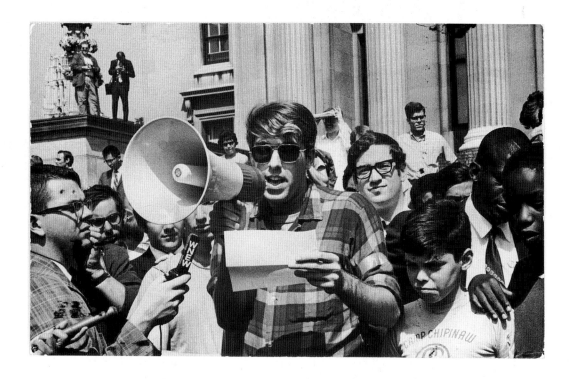

TOP: A clear message at Columbia University, April 19, 1972. **BOTTOM:** Mark Rudd on Columbia campus, September 20, 1968, reads "Student Demands to School Administration." Demonstrators closed down the campus in protest to university expansion into the black community.

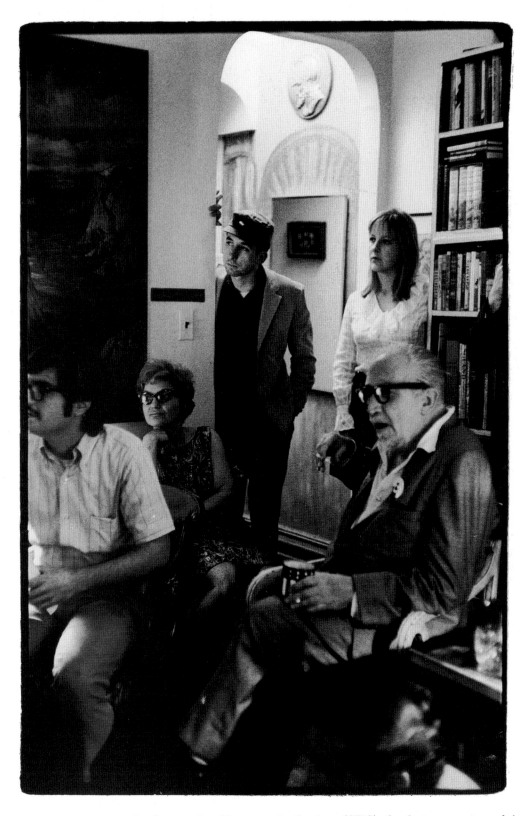

Tom Hayden in doorway at Students of a Democratic Society (SDS) fundraiser sponsored by Dwight MacDonald in his apartment, 56 East 87th Street, May 24, 1968. SDS pushes radical draft resistance as the dominant thrust of its political agenda.

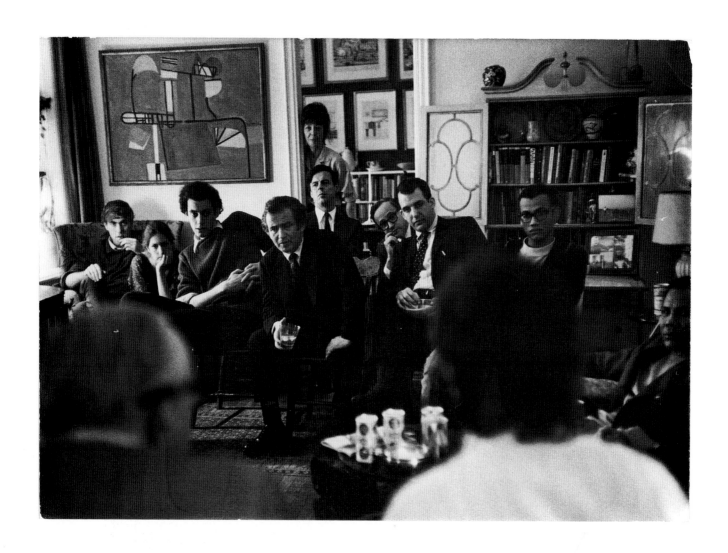

A discussion of SDS and the Columbia crisis at Dwight MacDonald's apartment—Mark Rudd (far left), Jose Torres (far right), Norman Mailer (center), George Plimpton (behind Mailer), May 24, 1968.

142

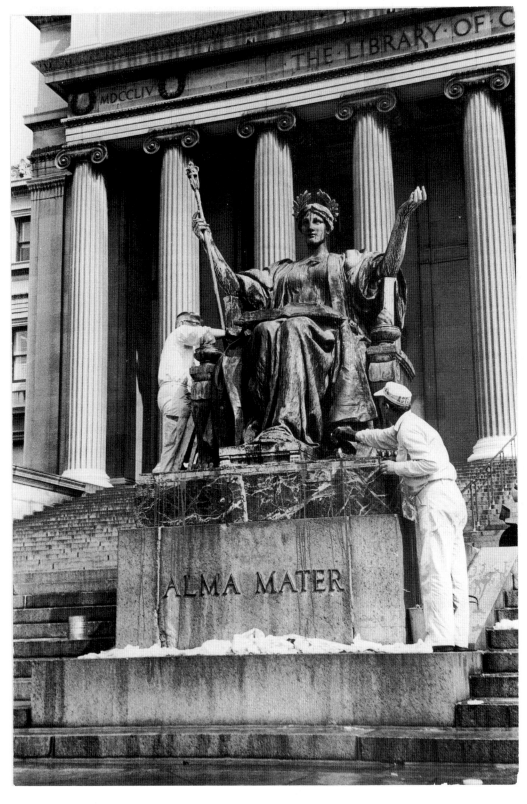

Washing off red paint, September 19, 1969, from statue of alma mater (Daniel Chester French 1903) in front of the library of Columbia University.

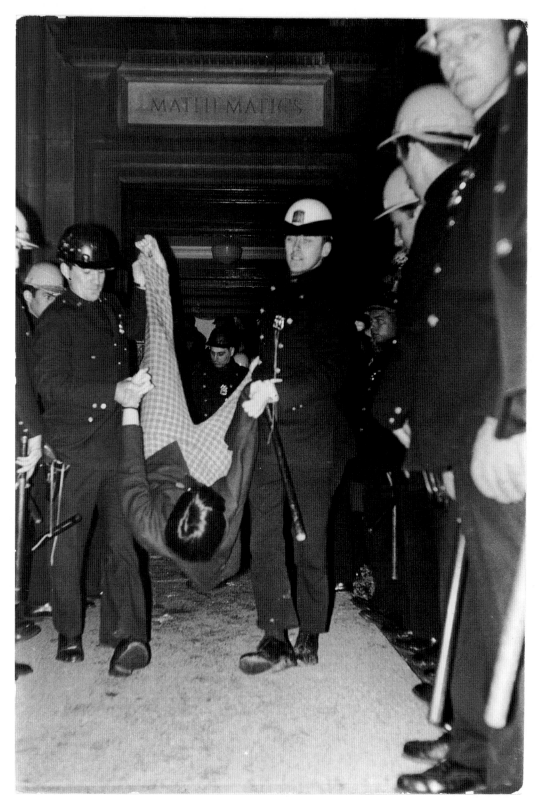

Female student being carried out of math building by police at Columbia University, April 29, 1968.

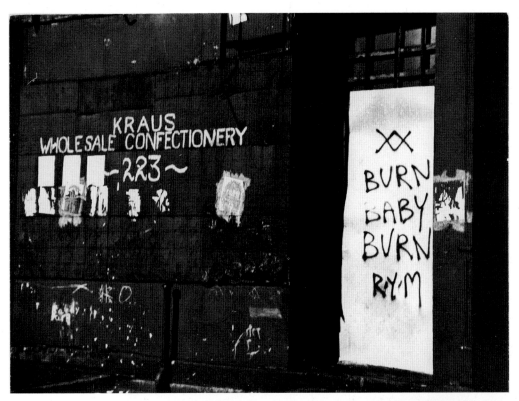

TOP: A message on closed and abandoned storefront, 223 East Third Street, January 7, 1967. **BOTTOM:** Every inch of space is used in this crowded two-room apartment, November 16, 1968. It lacks ventilation and daylight.

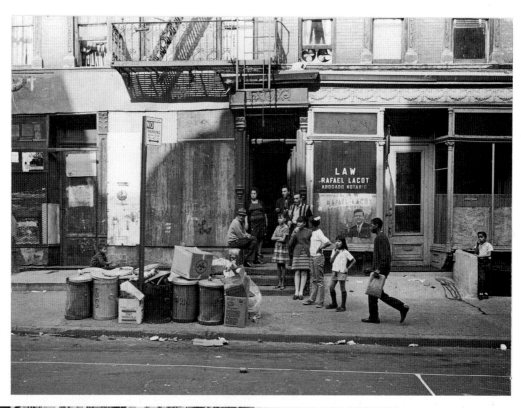

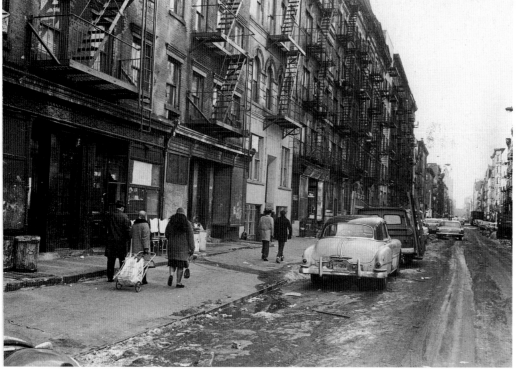

TOP: Typical ghetto scene, 625 East Fifth Street, October 15, 1967, with John Lindsay campaign poster in lawyer's window. **BOTTOM:** Streets in the ghetto like 638 East Sixth Street have a permanent depressed appearance, February 6, 1966.

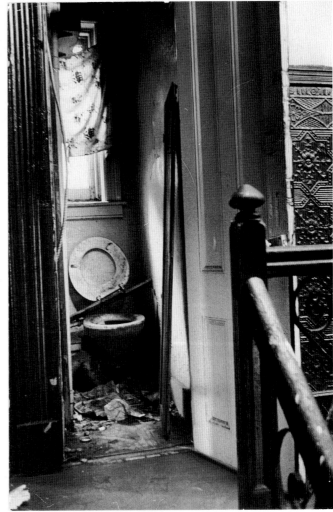

ABOVE: Many dilapidated tenements like this one at 704 East Fifth Street, February 6, 1966, are actually owned by the City of New York. **RIGHT:** One toilet in the hall, 706 East Fifth Street, serviced four families on one floor in this tenement, February 6, 1966.

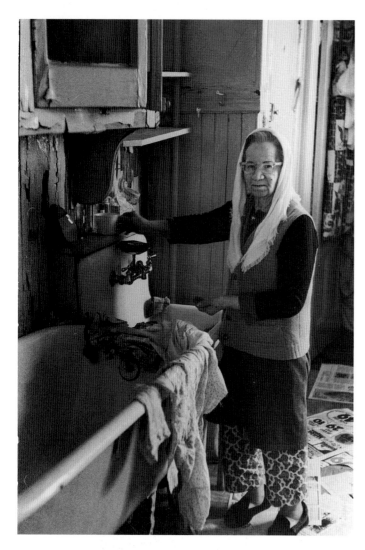

ABOVE: A typical tenement apartment, 286 East Third Street, February 18, 1971, with a tub in the kitchen for taking a bath—rent: $28 a month. **RIGHT:** No mail today at 286 East Third Street, February 18, 1971.

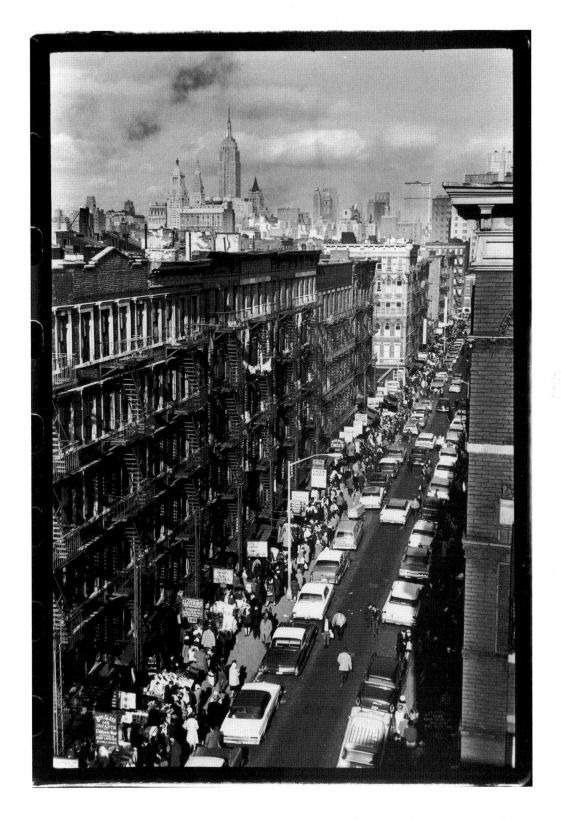

Tenements along Orchard Street, December 2, 1963, are recycled constantly to accommodate new ethnic groups that move to the Lower East Side.

This public bathhouse, March 12, 1967, at 133 Allen Street, one of many throughout the city, was closed down when the law required all apartments to have indoor plumbing.

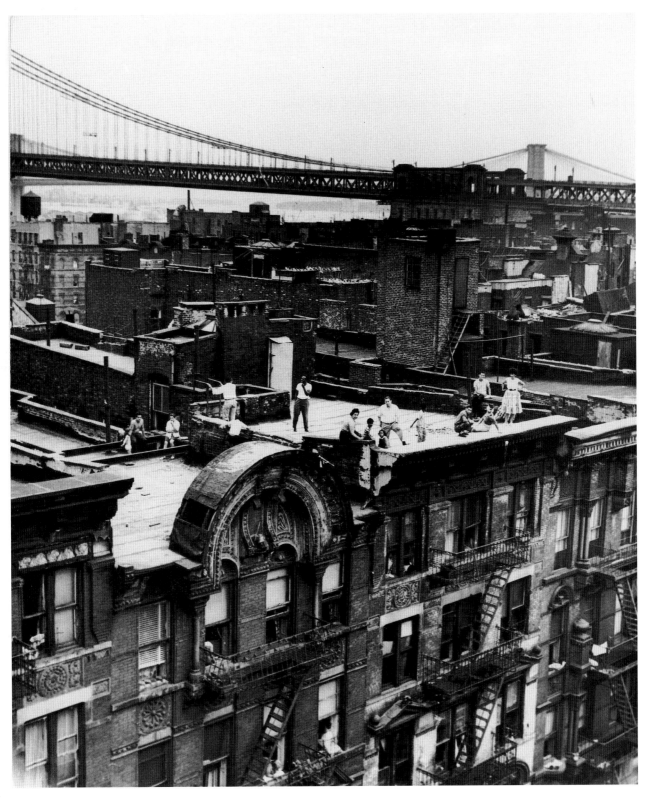

A tenement rooftop for cool summer breezes and views of the bridges from Henry Street, August 30, 1959.

ABOVE: Stanley Kunitz, January 21, 1962, Pulitzer Prize winner in poetry. RIGHT: John Berryman at book awards ceremony, March 7, 1969.

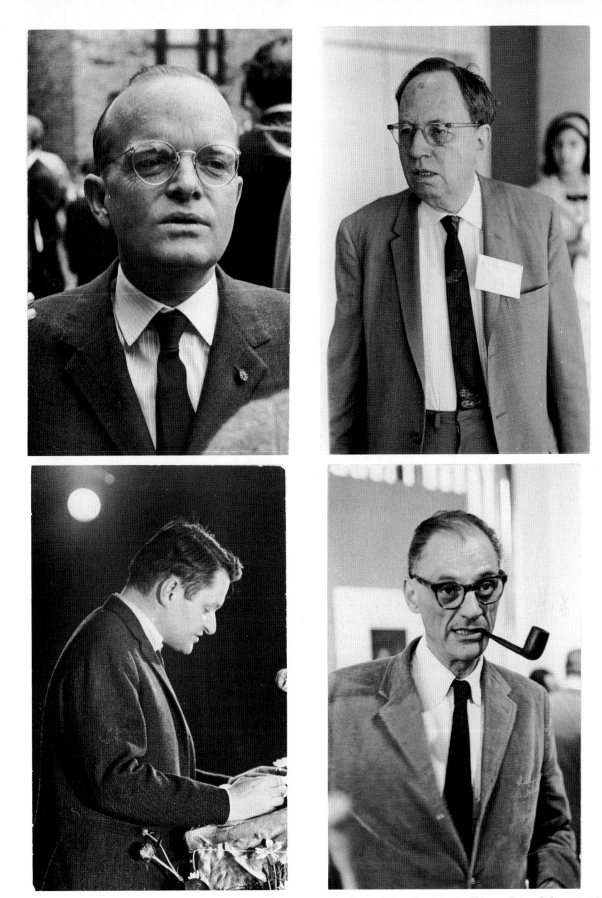

CLOCKWISE FROM TOP LEFT: Truman Capote at American Academy, May 26, 1967. • Elmer Rice, May 18, 1967, who wrote the "Adding Machine." • Arthur Miller on a round table, "The Writer as Public Figure," at P.E.N. conference, New York University, May 8, 1967. • John Ashbery, May 18, 1967, Pulitzer Prize winner in Poetry.

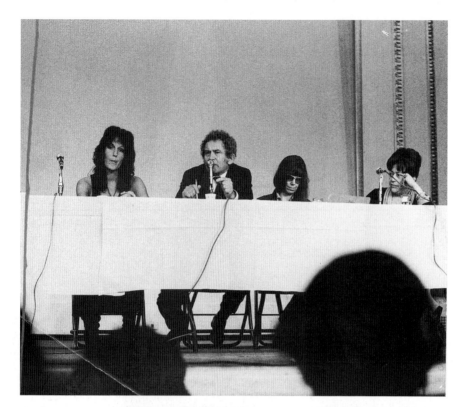

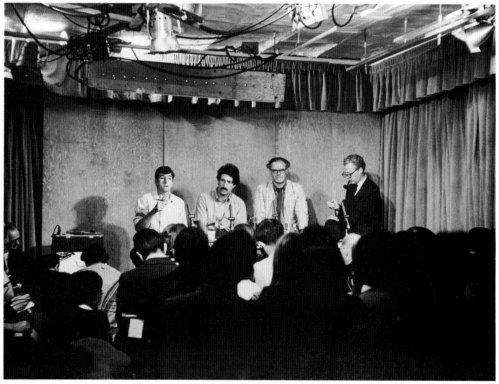

TOP: A confrontation in the Theatre for Ideas with (left to right): Jacqueline Ceballos, Germaine Greer, Norman Mailer, Jill Johnston, Diana Trilling at Town Hall, April 30, 1971. **BOTTOM:** "Theatre for Ideas," September 17, 1968—Tom Hayden, Jeremy Larner, Robert Lowell, Murray Kempton. In 1947 Lowell won a Guggenheim Grant and the Pulitzer Prize.

A symposium on sex at the Mills Hotel, December 2, 1962—Susan Sontag, William Gaddis, Alfred Chester, Bill Manville, Rhona Jaffe, Sam Kramer, David Amram, William Saroyan. The Mills Hotel was originally a flop house for men. Later it became a fancy condo.

ABOVE: Communications specialist, Marshall McLuhan, gives a lecture, May 9, 1967. RIGHT: Pablo Neruda in a round table, "The Writer in the Electronic Age," at P.E.N. Conference, New York University, June 14, 1966.

ABOVE: Philip Roth at the Gertrude Stein Gallery, 24 East 81st Street, October 8, 1963. On exhibit was the "Vulgar" show with works by Sam Goodman and Boris Lurie. RIGHT: Lillian Hellman doing a foxtrot with William Styron in hallway at the National Academy of Arts and Letters, May 21, 1969.

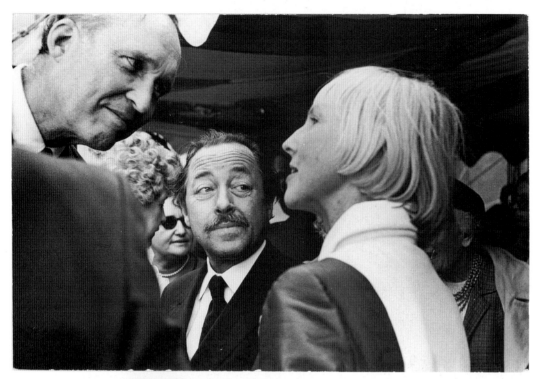

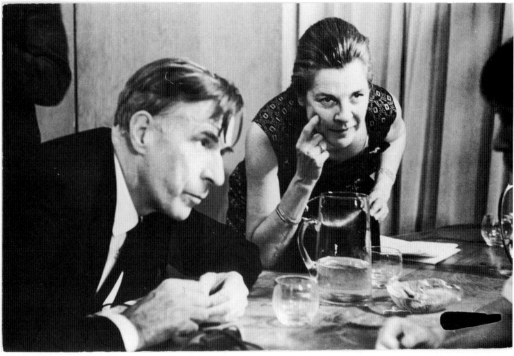

TOP: James Laughlin, New Directions publisher, Tennessee Williams, author Ruth Stephan at American Academy, May 21, 1969. **BOTTOM:** John Kenneth Galbraith and Mary McCarthy at Theatre for Ideas, September 17, 1968.

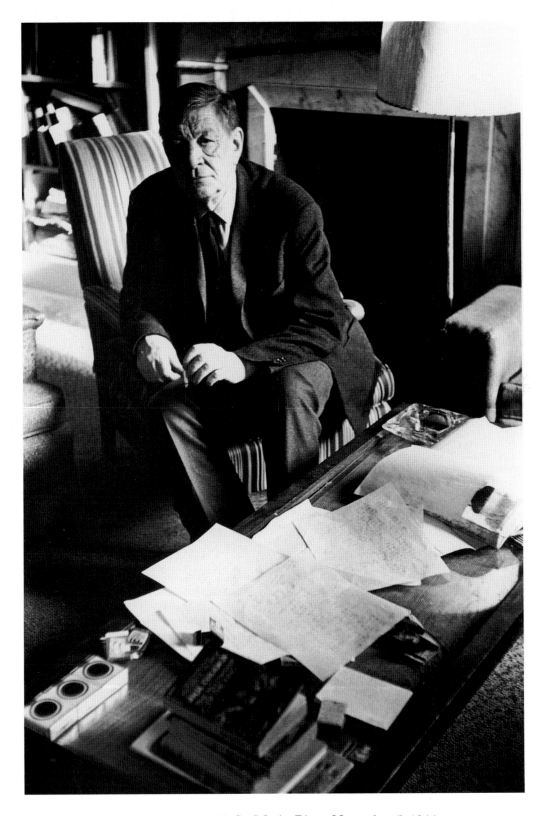

W. H. Auden in his brownstone apartment, 77 St. Marks Place, November 5, 1966.

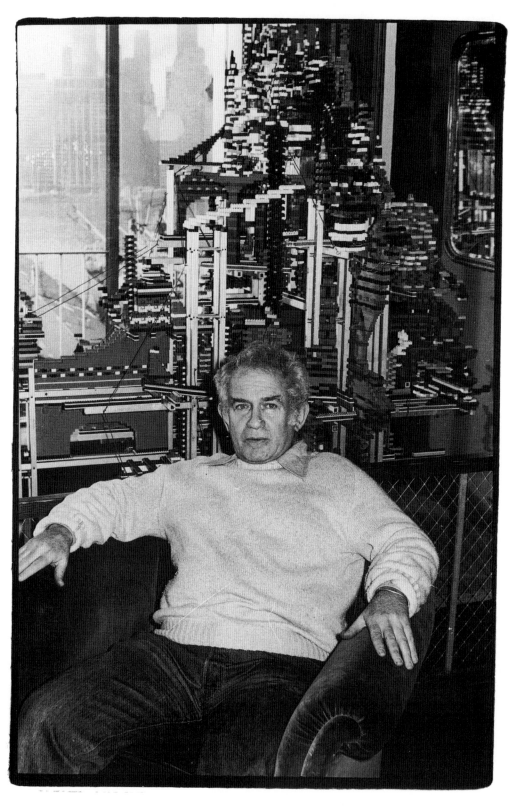

Norman Mailer with Lego city he constructed in his Brooklyn Heights apartment, February 14, 1965.

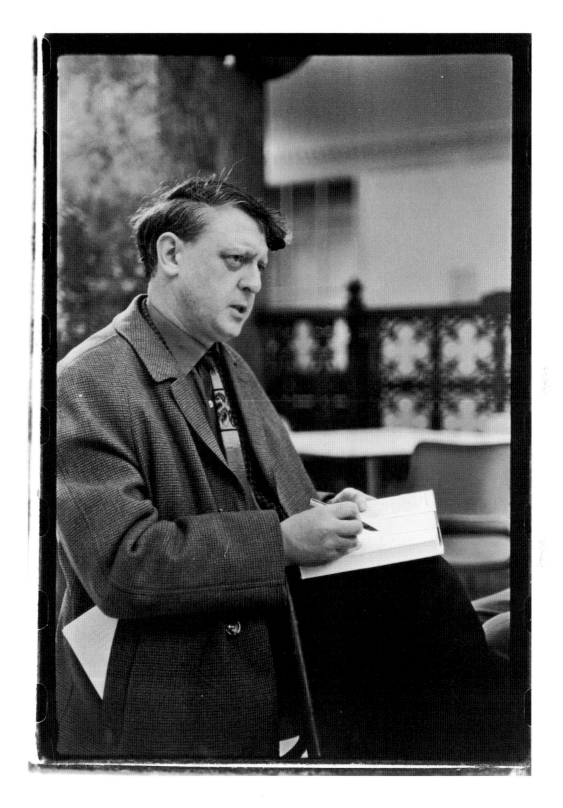

Anthony Burgess in a literary seminar at Long Island University, March 26, 1966.

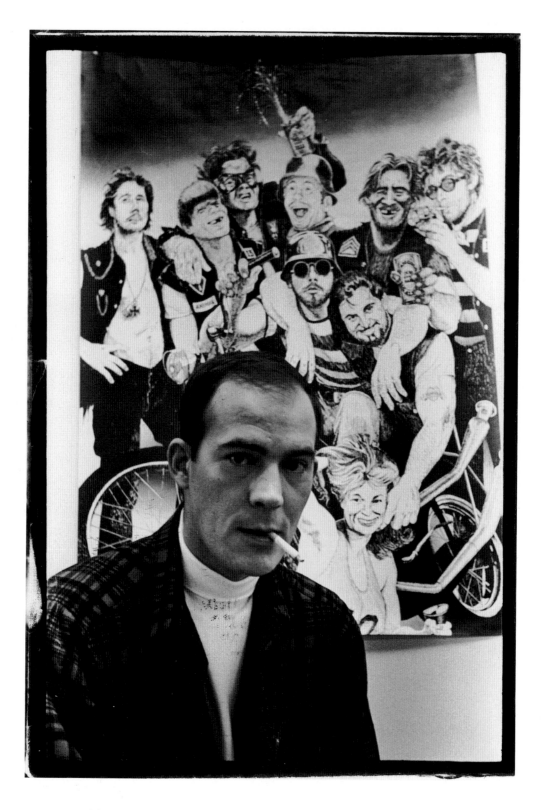

Macho author Hunter Thompson with Hell's Angels poster, February 16, 1967.

Albert Murray, Ralph Ellison (right) at the American Academy of Arts and Letters, May 26, 1967.

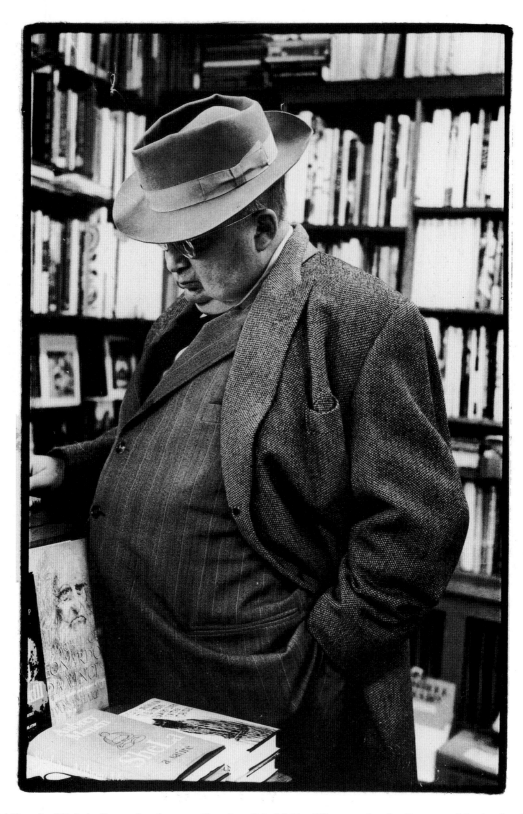

A. J. Liebling in Eighth Street bookstore, October 24, 1962. His new book, *Between Meals: An Appetite for Paris,* had just been published.

John Lahr (left), Joseph Heller attend a lecture, April 13, 1972. Lahr wrote a column, "On Stage" for the Village Voice; Heller is the Author of *Catch 22*.

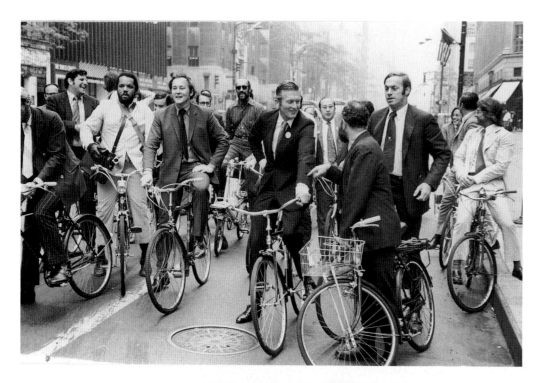

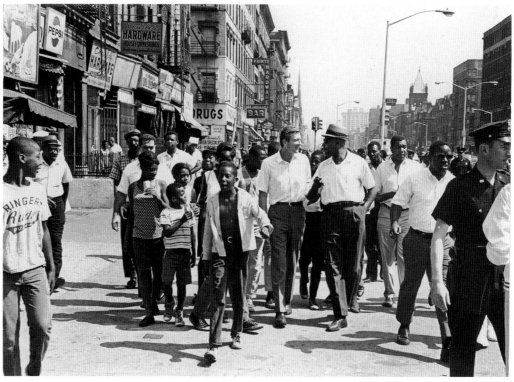

TOP: Mayor John Lindsay, September 16, 1970, bikes down Fifth Avenue with his staff. BOTTOM: Mayor John Lindsay on a walking tour of Harlem, August 6, 1966.

Tom Hoving and John V. Lindsay at a champagne supper in Central Park, January 18, 1967, in honor of Hoving's appointment as Parks Commissioner.

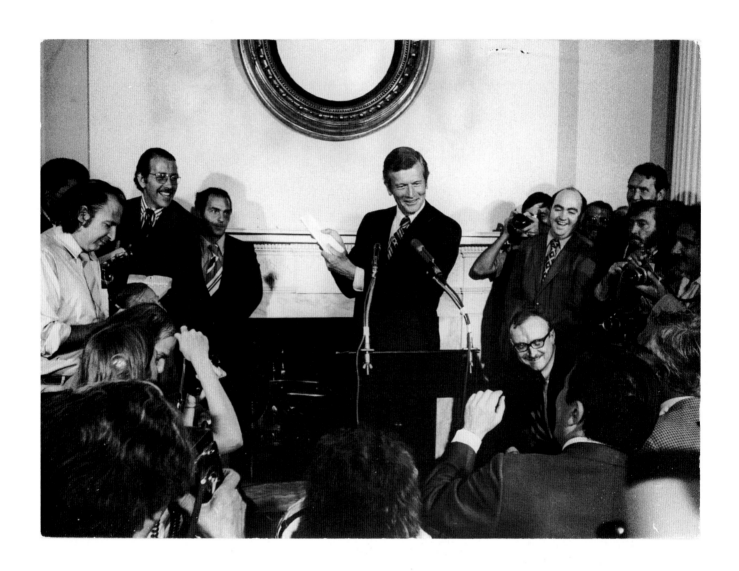

John Lindsay explains to the working press why he switched from the Republican to the Democratic party at Gracie Mansion, August 11, 1971.

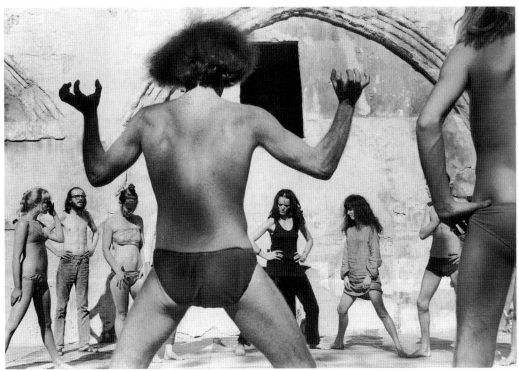

TOP: Julian Beck and Judith Malina, Living Theatre European tour, Avignon, France, July 15, 1968. **BOTTOM:** Living Theatre company rehearsing Paradise Now, July 15, 1968.

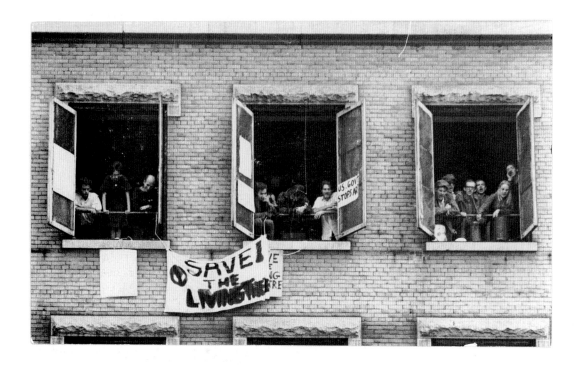

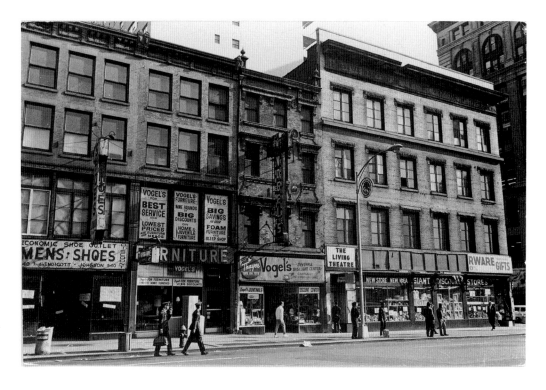

TOP: The Becks in window (left) during 24-hour vigil protesting Federal agents closing of the Living Theatre on October 18, 1963. **BOTTOM:** The Becks in 1947 presented plays in their living room, then moved to 2651 Broadway and finally the Living Theatre moved to Sixth Avenue at 14th Street.

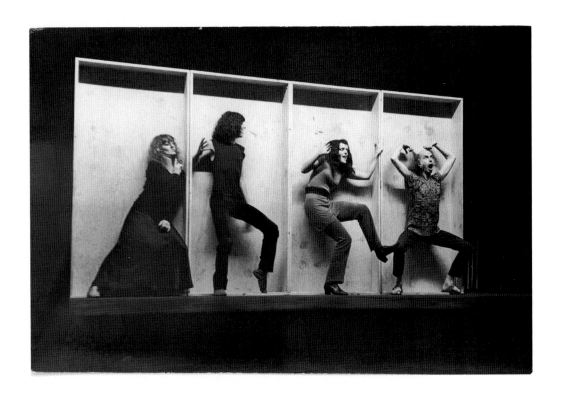

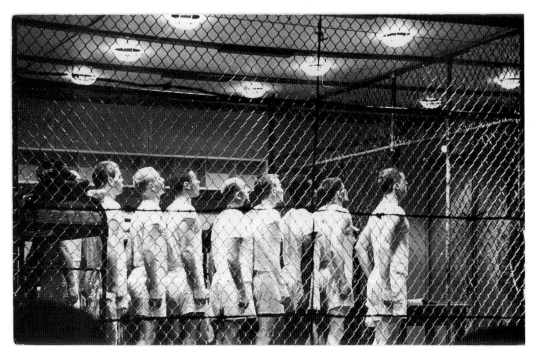

TOP: The Living Theatre in "Mysteries and Smaller Pieces" at Yale School of Drama, September 16, 1968. **BOTTOM:** Kenneth Brown's play, "The Brig," at the Living Theatre, May 15, 1963. It was the last production before the theatre was shut down by the I.R.S. for back taxes.

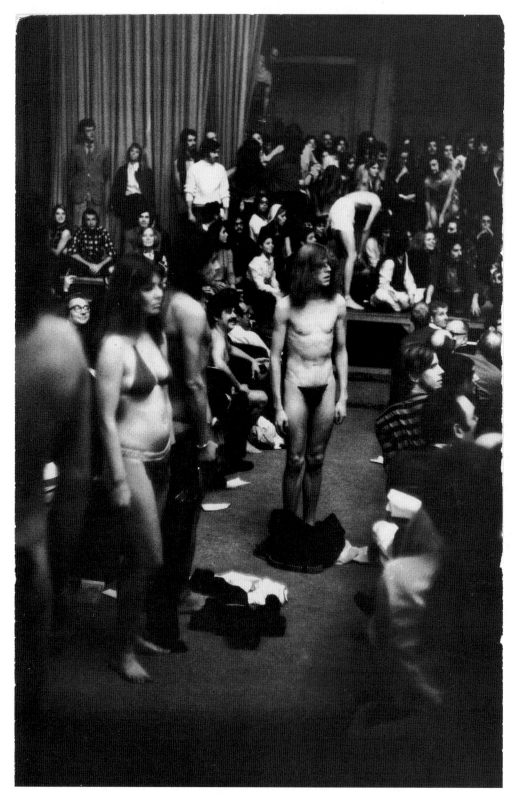

Paradise Now by the Living Theatre at the Brooklyn Academy of Music, October 14, 1968.

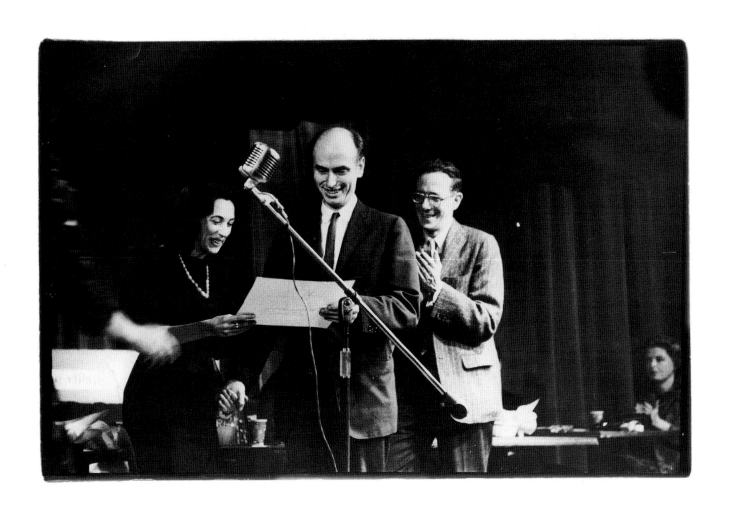

Judith Malina and Julian Beck get a Village Voice Obie from Jerry Tallmer, May 21, 1960.

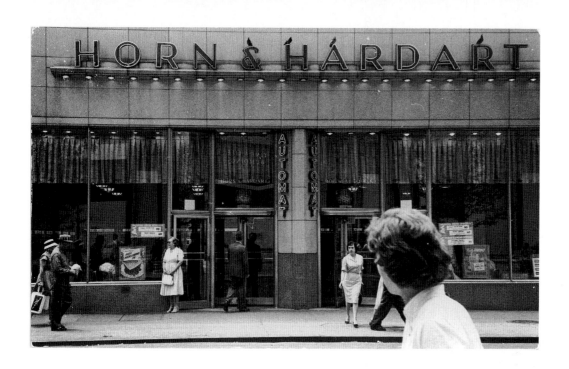

ABOVE: The last Horn & Hardart, West 57th Street, June 19, 1960. **RIGHT:** Pie section, 4 nickels, automat at West 57th Street, January 18, 1964.

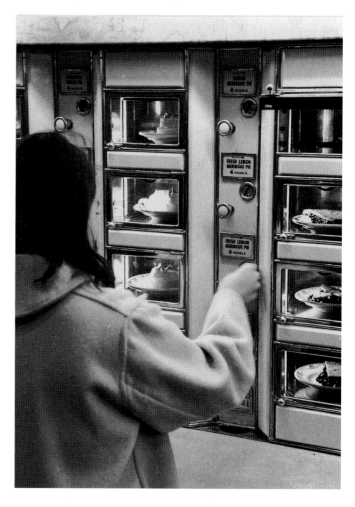

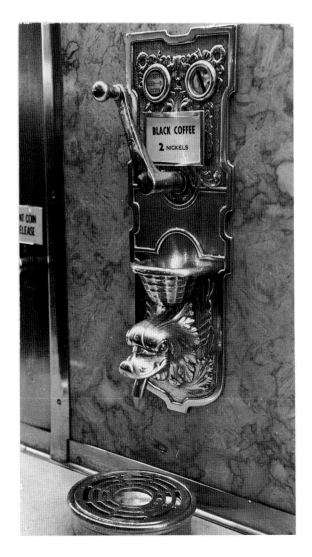

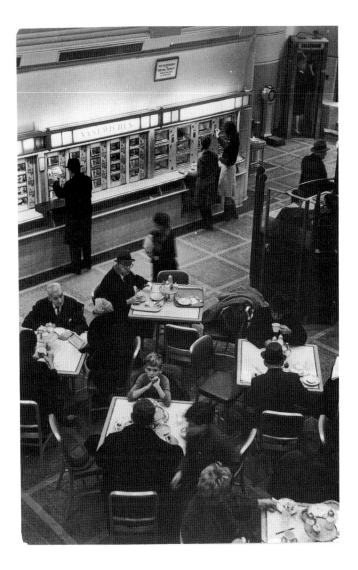

ABOVE: Silver coffee machine, the automat, January 18, 1964. RIGHT: Inside the automat, West 57th Street, scale and phone booth, January 18, 1964.

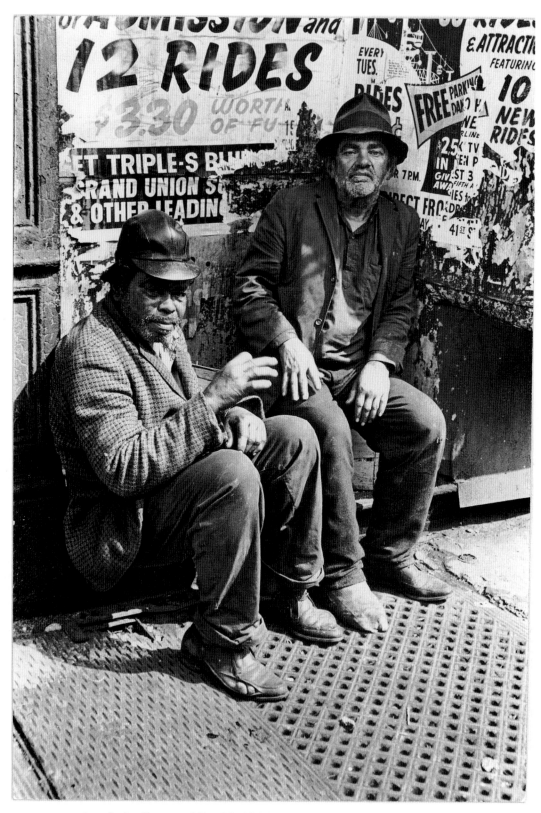

Two men, a common bond, the Bowery, May 20, 1966.

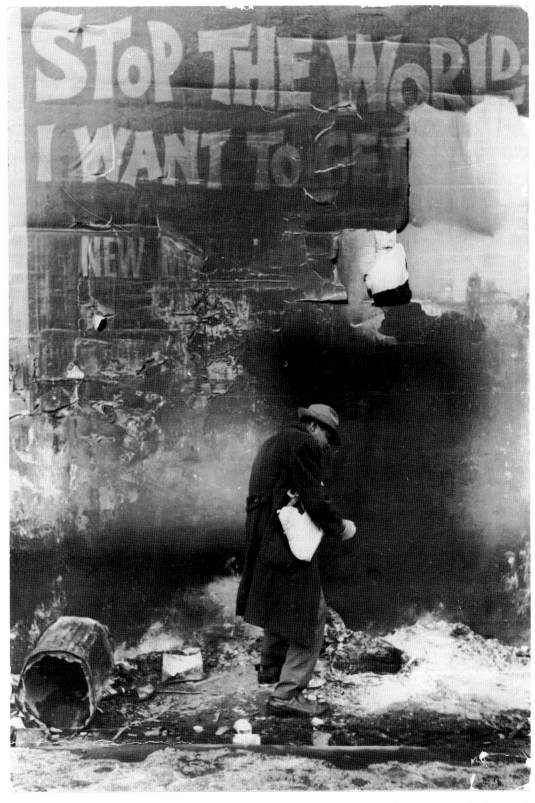

A message on the wall, East Houston and the Bowery, February 3, 1963. "Stop the World," a British music hall version of the seven stages of man played at the Shubert Theatre on West 44th Street.

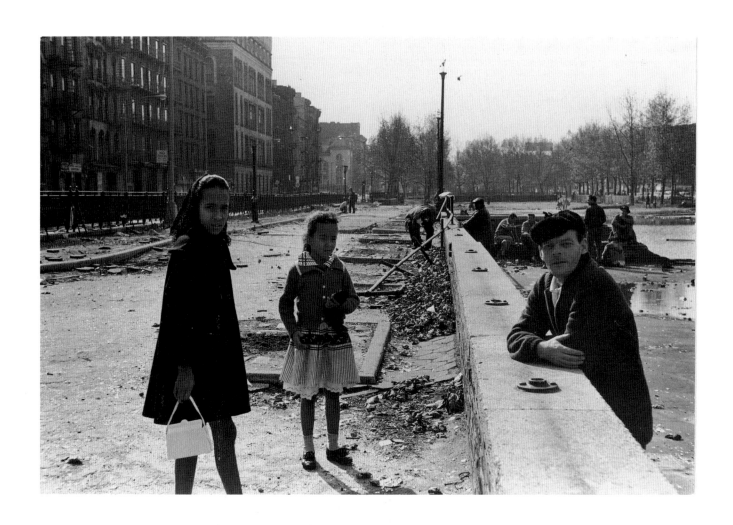

Making friends, Sara Delano Roosevelt Park, Christie Street at Houston, November 10, 1963.

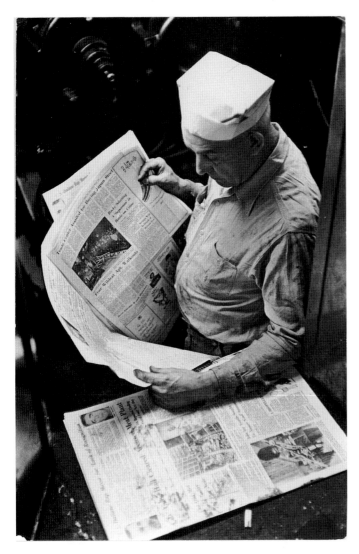

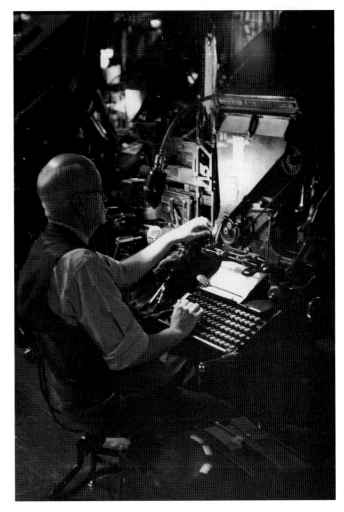

ABOVE: Inspecting first copies of the *Herald Tribune* off the press, May 5, 1967. **RIGHT:** Linotype operator at the *Herald Tribune*, January 29, 1964.

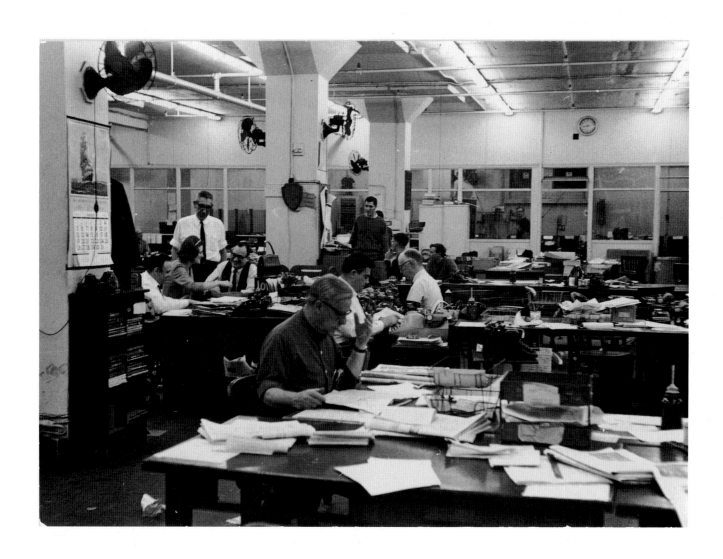

Night city room, *Herald Tribune*, January 29, 1964.

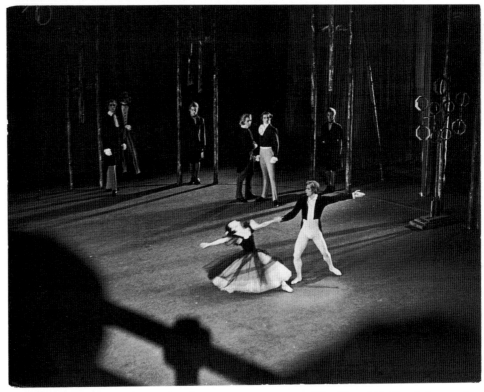

TOP: Metropolitan Opera House, 1425 Broadway, April 29, 1963. BOTTOM: The Royal Ballet, Marguerite & Armand, Margot Fonteyn and Rudolf Nureyev, sets by Cecil Beaton, at the Metropolitan Opera House, April 29, 1965.

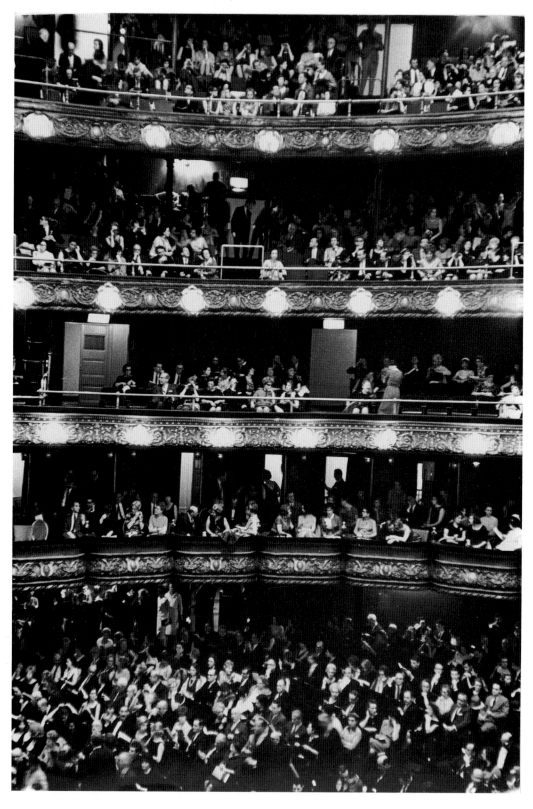

Audience at the Royal Ballet, Metropolitan Opera House, April 29, 1965.

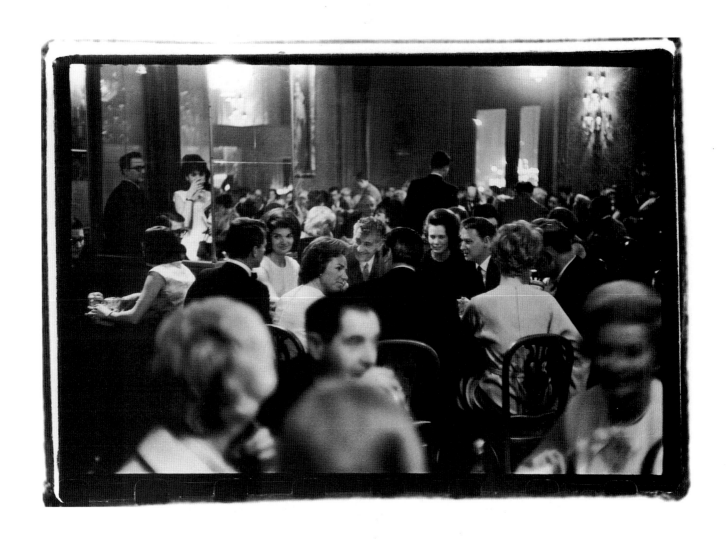

Dining room at the Metropolitan Opera House. Robert Kennedy, Jackie Onassis, Leonard Bernstein, Mr. and Mrs. Mike Nichols, Ethel Kennedy, and Peter Lawford.

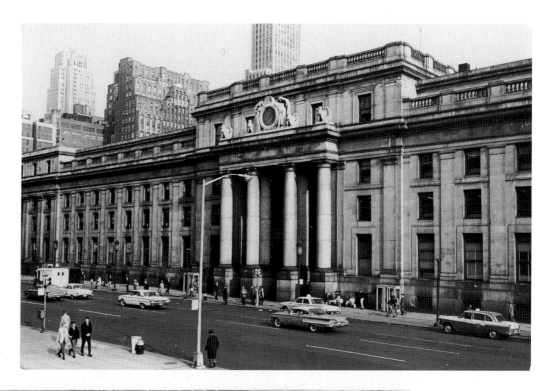

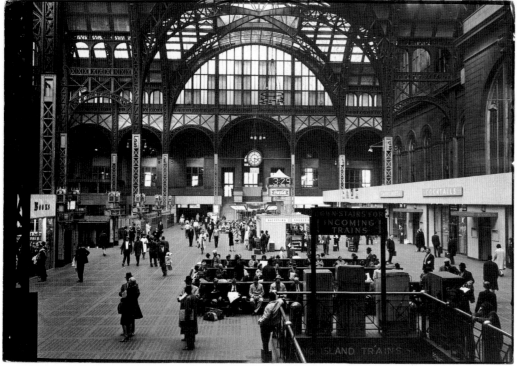

TOP: Penn Station, view from Eighth Avenue, October 18, 1963. The terminal covered two city blocks from 31st Street to 33rd Street. McKim, Mead and White designed the terminal after the Baths of Caracalla in Rome. Construction began in 1902. **BOTTOM:** Colossal interior, Pennsylvania Terminal, October 18, 1963.

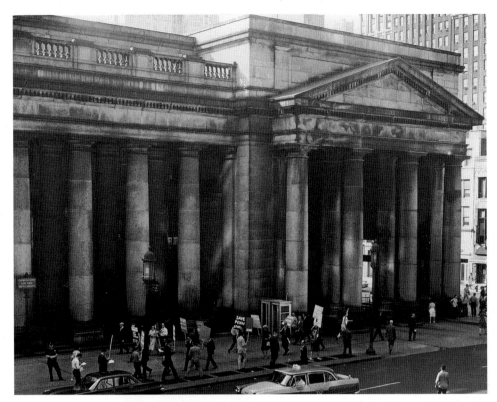

TOP: Architectural and Landmarks Community on Seventh Avenue, May 5, 1962, protested the demolition of Penn Station for four years but lost in May of 1966. **BOTTOM:** The remains of Pennsylvania Station, Seventh Avenue and 33rd Street, May 29, 1966.

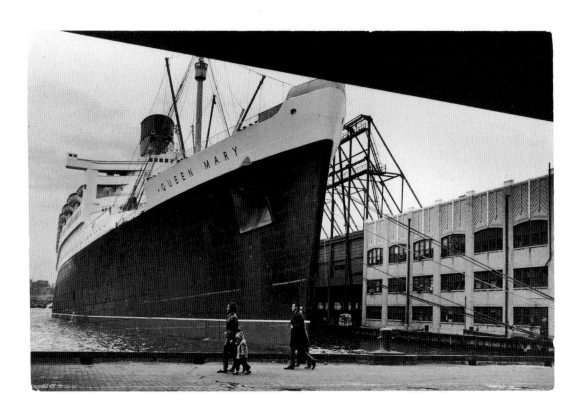

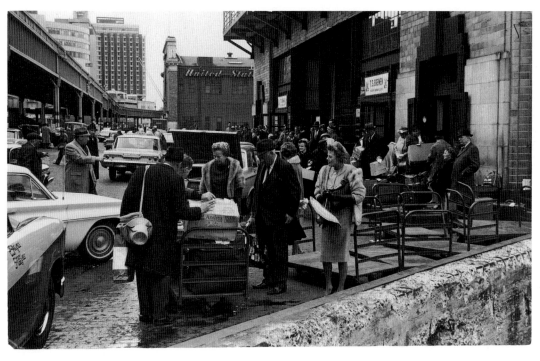

TOP: Queen Mary at Cunard Dock, Pier 92, West 52nd Street, March 17, 1964. Her maiden voyage from Southampton to New York began May 27, 1936. In 1967 the ship was sold to the City of Long Beach, California, for use as a museum and a hotel. **BOTTOM:** Passengers line on West Street with luggage to board steamship at Pier 88, West 48th Street, March 16, 1964.

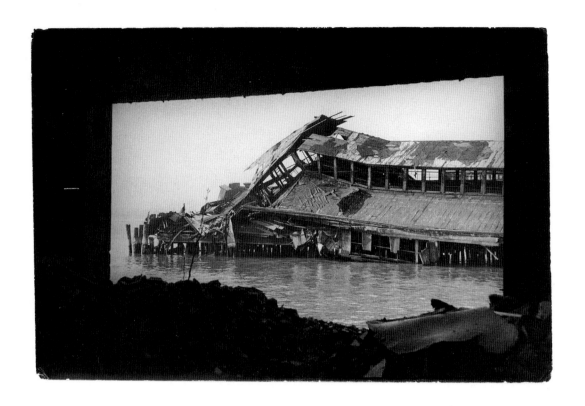

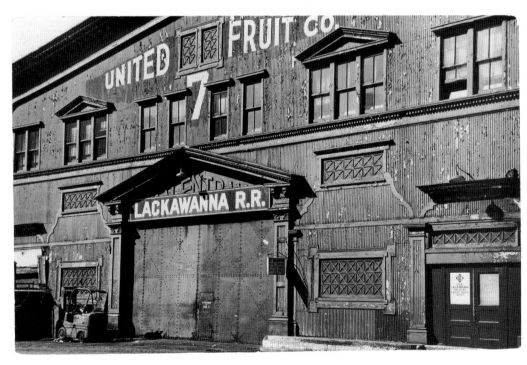

TOP: Crumbling Pier 17 at West Street and Park Place, May 28, 1970. BOTTOM: Lackawanna Railroad terminal, West Street and Morris Street, October 6, 1963. The Lackawanna Ferry connecting Manhattan with New Jersey survived until 1967.

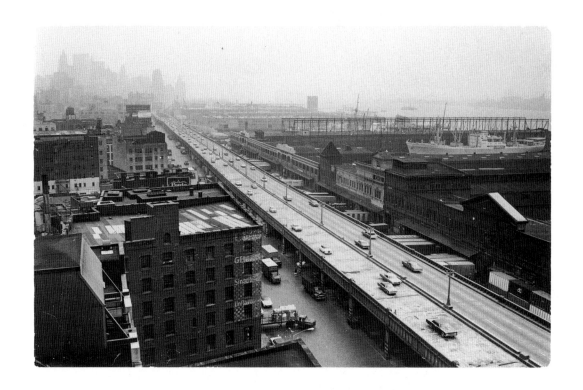

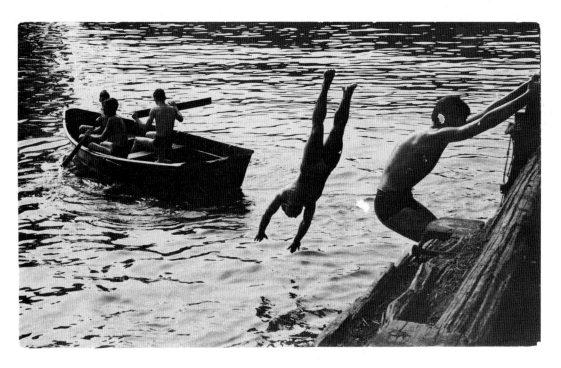

TOP: The waterfront and West Side Highway looking south from Bethune Street, August 14, 1967. When it was built in 1931, it was called the Miller Elevated Highway. In 1973, a dump truck plunged through the roadway and it resulted in its demolition. **BOTTOM:** Boys swimming and rowing in the Hudson River at 59th Street, August 28, 1960, before the water got polluted.

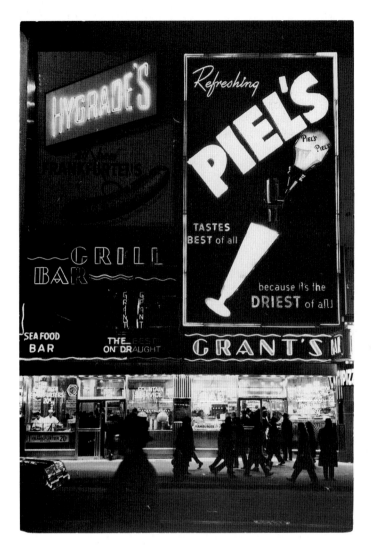

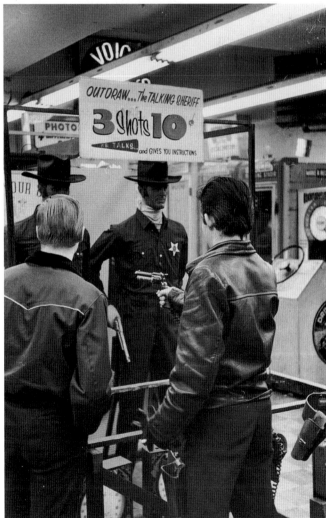

ABOVE: Grant's Hotdog Palace, 42nd Street at Broadway, January 29, 1964. **RIGHT:** Outdraw the Talking Sheriff, Times Square Arcade, January 29, 1964.

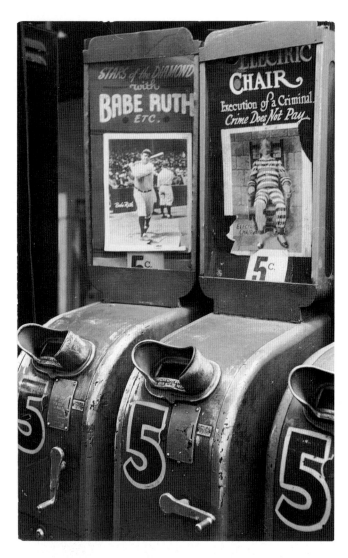

ABOVE: For 5¢ see Babe Ruth or an Execution, popular arcade movie machine, January 29, 1964. **RIGHT:** Photographer's prop, Times Square arcade, February 21, 1964.

Subway arcade, 42nd Street and Broadway, January 29, 1964.

View of the north side of 42nd Street looking west, January 29, 1964.

The Great White Way looking north, February 21, 1964.

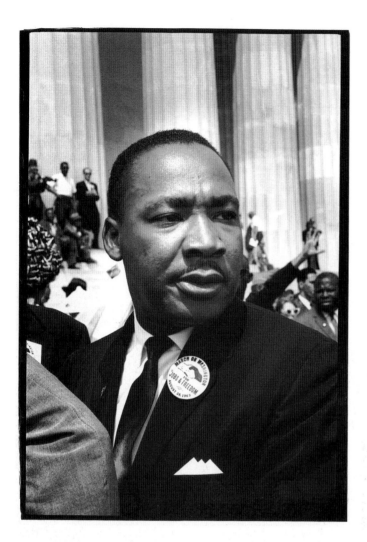

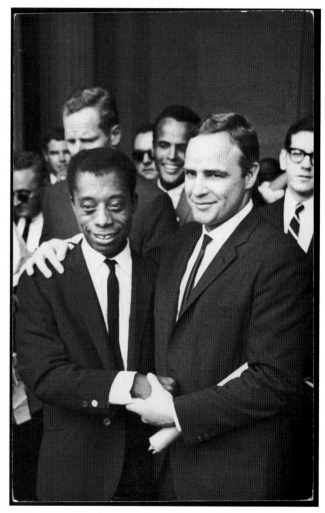

ABOVE: Martin Luther King, August 28, 1963, on the steps of the Lincoln Memorial for March on Washington. **RIGHT:** James Baldwin, Harry Belafonte, Marlon Brando at the Lincoln Memorial for the March on Washington, August 28, 1963.

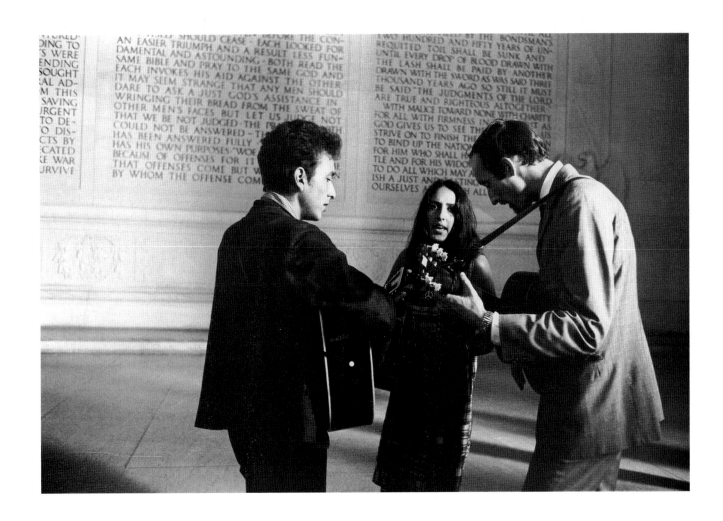

Bob Dylan, Joan Baez, Paul Stookey, August 28, 1963, under the Lincoln Memorial, March on Washington. In March of 1968, Baez married David Harris, a leader in the draft resistance campaign.

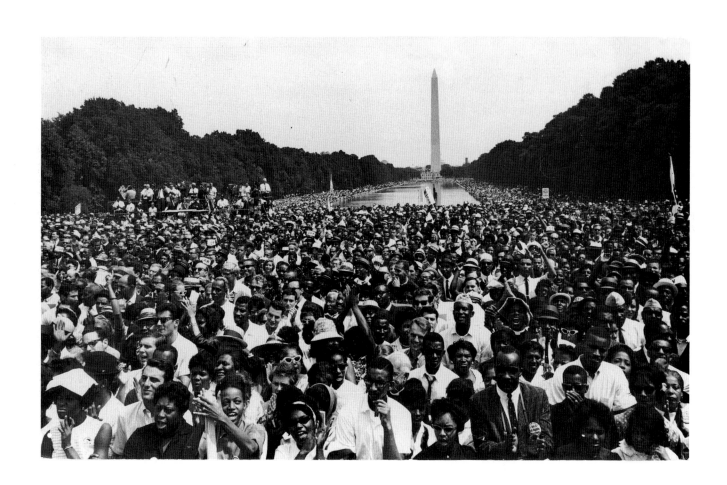

Thousands fill the Mall to hear Martin Luther King give his "I have a dream" speech, August 28, 1963, March on Washington.

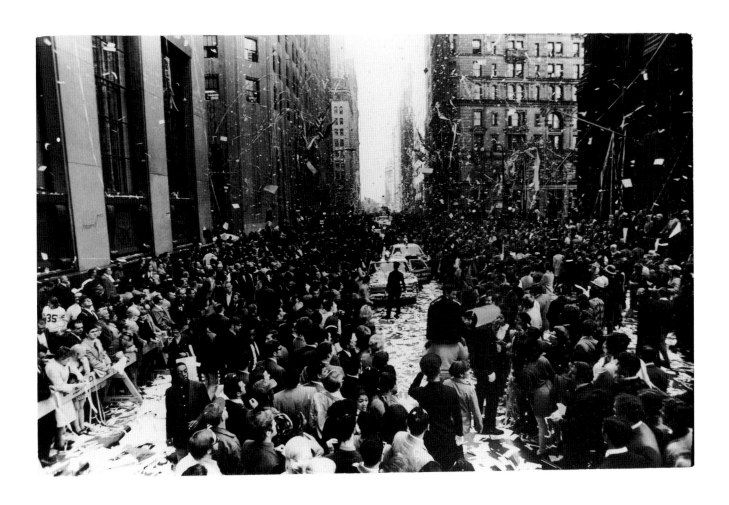

Millions of well-wishers came out to cheer the New York Mets at a tickertape victory parade up the Canyon of Heroes on October 23, 1969. The section of Broadway in lower Manhattan was also the scene of famous welcomes for the Apollo 11 astronauts, Charles Lindbergh, and Nelson Mandela.

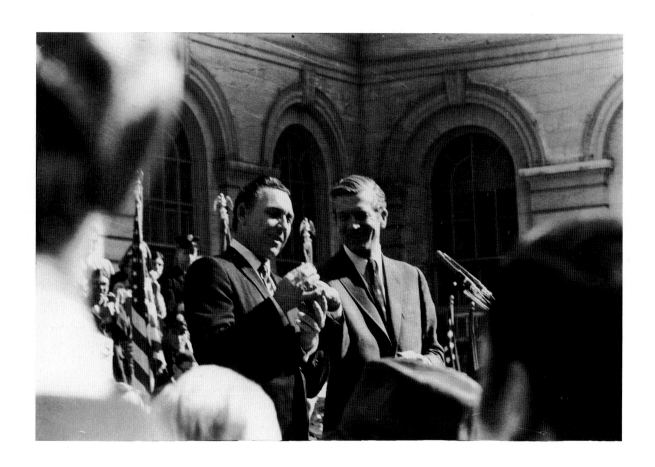

New York City Mayor John Lindsay presents the ceremonial Key to the City to New York Mets manager Gil Hodges on City, October 23, 1969, after a parade celebrating the team winning their first World Series ever.

CLOCKWISE FROM TOP LEFT: Ron Swoboda, Mets outfielder, October 23, 1969. • Ed Charles, Mets third baseman, October 23, 1969. • Tom Seaver, Mets pitcher, October 23, 1969.

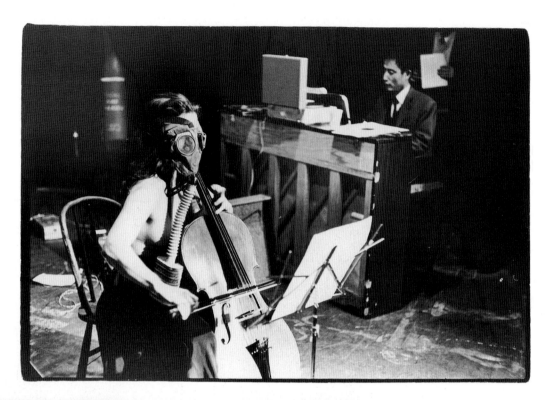

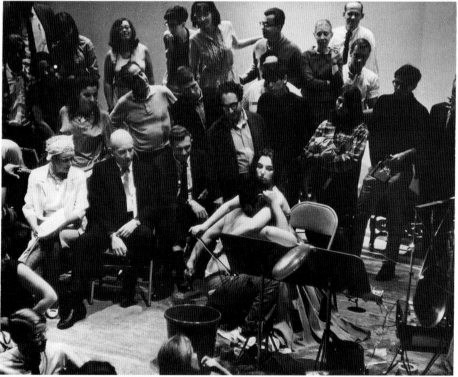

TOP: Charlotte Moorman in gas mask plays the "Opera Sextonique" on the cello accompanied by composer Nam June Paik, February 9, 1967 at Filmmakers Cinematheque, 125 West 41st Street. **BOTTOM:** Nam June Paik holds cord across his back while Charlotte Moorman with cello bow plays "Theatre Piece" by John Cage entitled "26'1. 1499 for a String Player," at Judson Hall, West 57th Street, September 8, 1965. Audience includes Lawrence Alloway and Phyllis Krim.

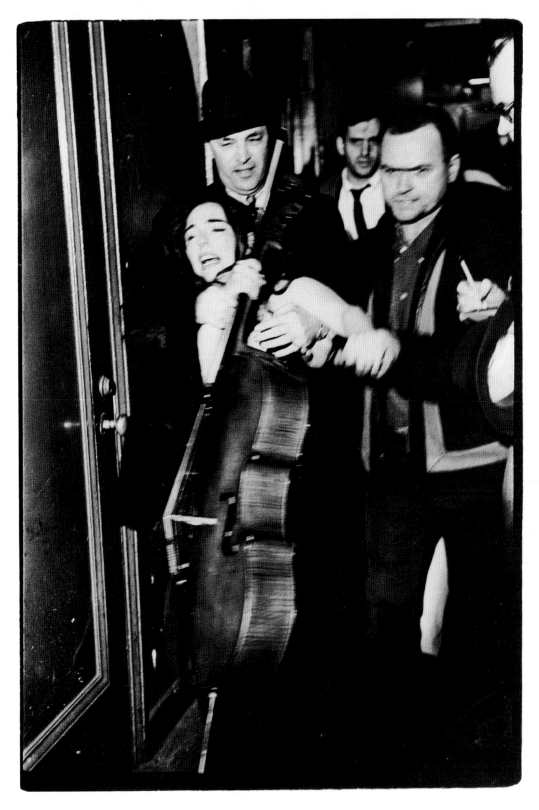

Performance concludes with arrest by New York City police of Charlotte Moorman for exposing her breasts, February 9, 1967.

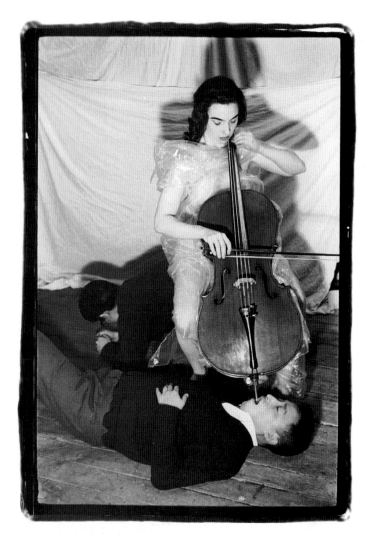

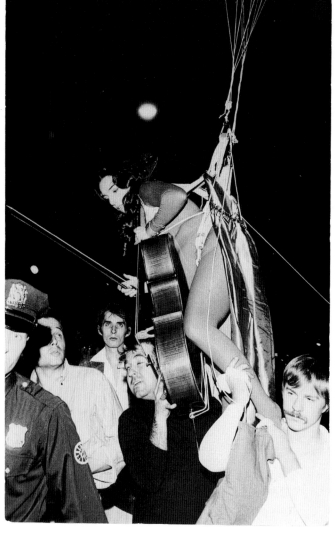

ABOVE: Sitting on the back of an artist, Charlotte Moorman plays the cello while Nam June Paik holds it steady in his mouth (he didn't choke), January 18, 1966. **RIGHT:** Charlotte Moorman dangling from parachute, Central Park West, Sixth Avant Garde Festival, September 14, 1968.

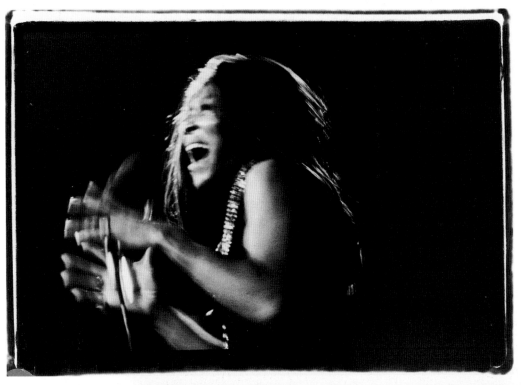

TOP: Tina Turner at Madison Square Garden, November 27, 1969. She was the first performer at the Rolling Stones concert. **BOTTOM:** Charles Mingus at the Village Voice Obie Awards, May 2, 1960.

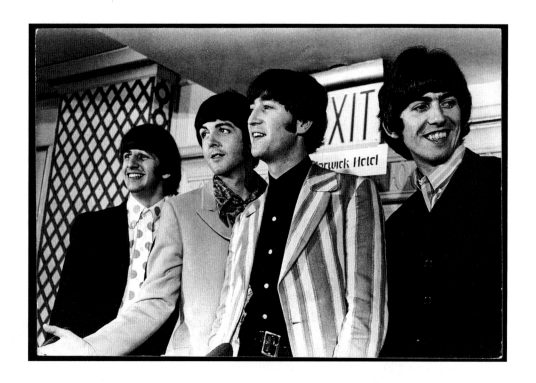

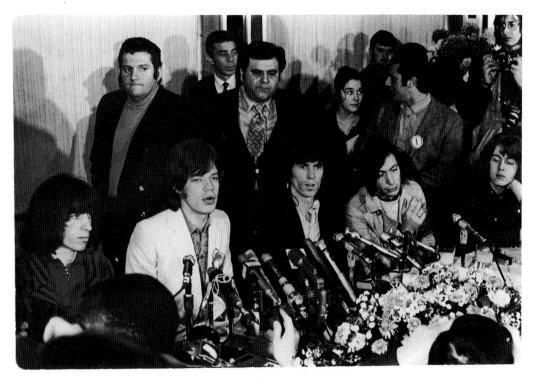

TOP: Beatles meet the press at the Warwick Hotel, August 22, 1966—Ringo Starr (drums), Paul McCartney (piano, guitar, vocal), John Lennon (guitar, harmonica, vocal), George Harrison (lead guitar, sitar). BOTTOM: The Rolling Stones press conference, November 27, 1969. Left to right: Bill Wyman, Mick Jagger, Ron Wood, Charlie Watts, Mick, Taylor. Standing behind on left are Allen Klein, the Beatles Manager, Sid Bernstein promoter who brought the Beatles to the USA.

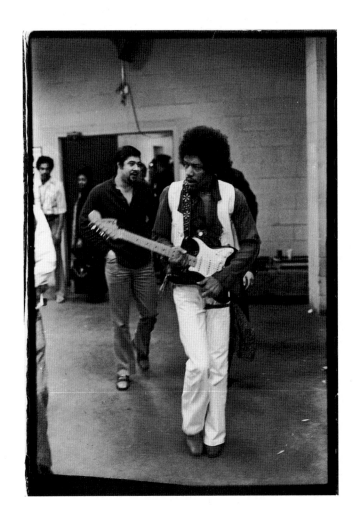

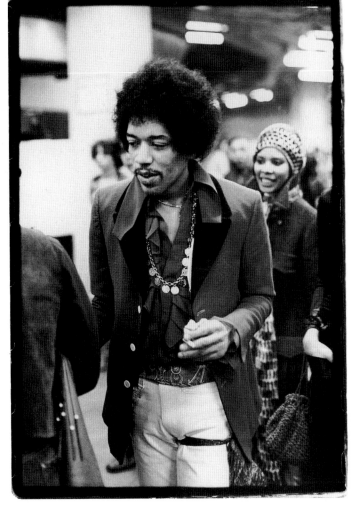

ABOVE: Jimi Hendrix and his Band of Gypsies at Madison Square Garden, January 28, 1970, prior to his appearance on stage at winter carnival for Peace in Vietnam. RIGHT: Jimi Hendrix backstage at Madison Square Garden, January 28, 1970.

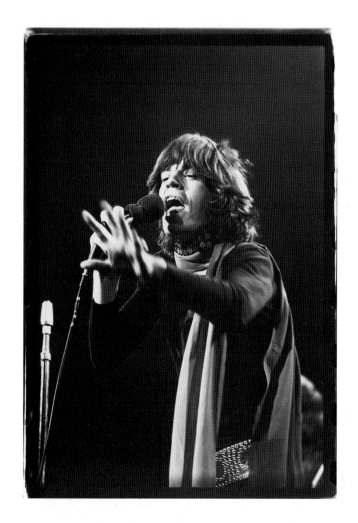

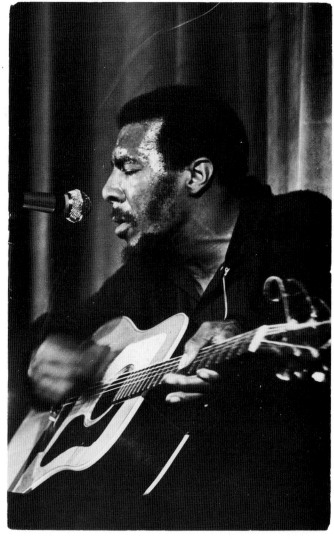

ABOVE: Mick Jagger at Madison Square Garden, November 27, 1969. **RIGHT:** Richie Havens, July 8, 1967, at the Fillmore East.

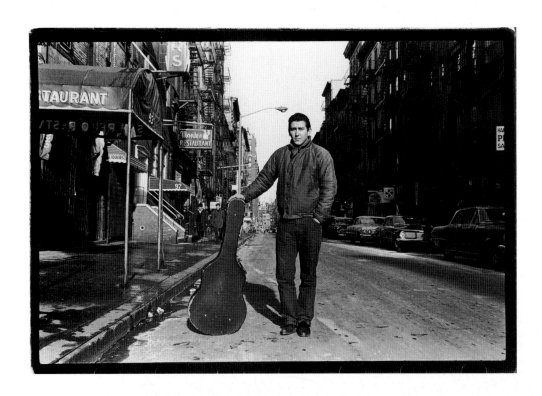

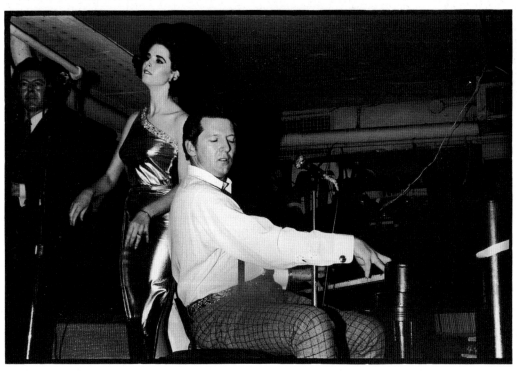

TOP: Phil Ochs on MacDougal Street, January 3, 1965. BOTTOM: Jerry Lee Lewis and Linda Gail Lewis at Steve Paul's "The Scene," 301 West 46th Street, March 17, 1969.

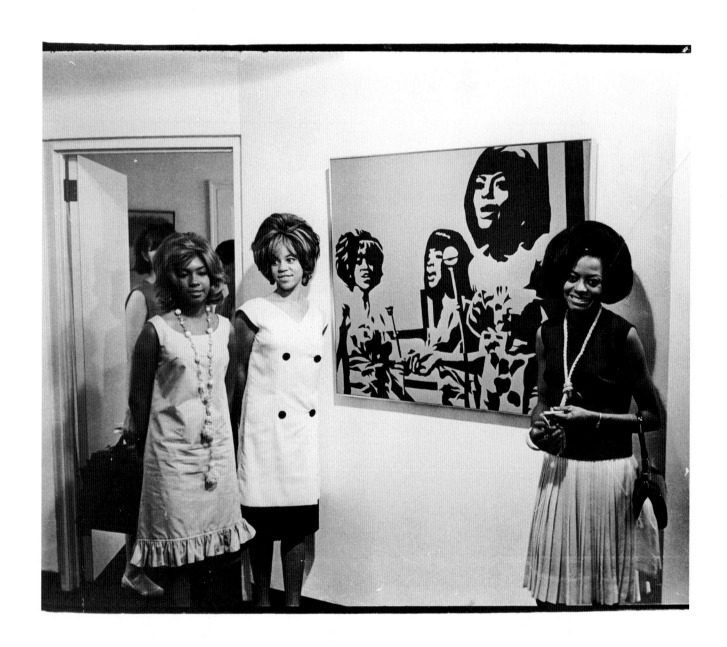

The Supremes with portrait by Bob Stanley at Bianchini Gallery, East 57th Street, May 27, 1965. Diana Ross, Florence Ballard, Mary Wilson.

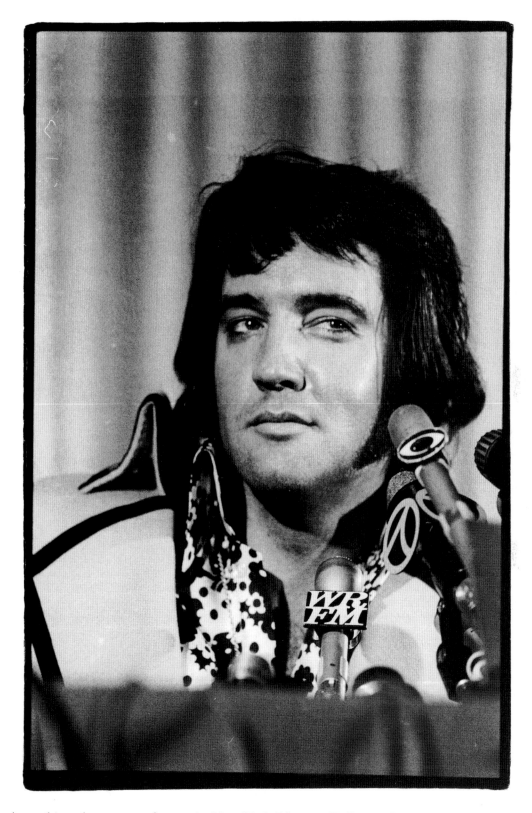

Elvis Presley at his only press conference in New York, Mercury Ballroom, Hotel Hilton, Sixth Avenue and 53rd Street, June 9, 1972.

John Cage playing "Suite for Toy Piano" at the Living Theatre in a concert of new music, March 14, 1960.

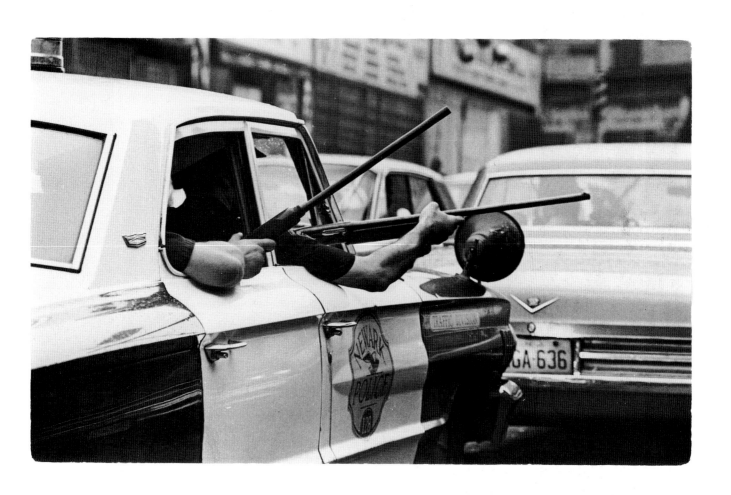

Riding shotgun along Springfield Avenue, Newark, New Jersey, during the height of the riots, July 14, 1967.

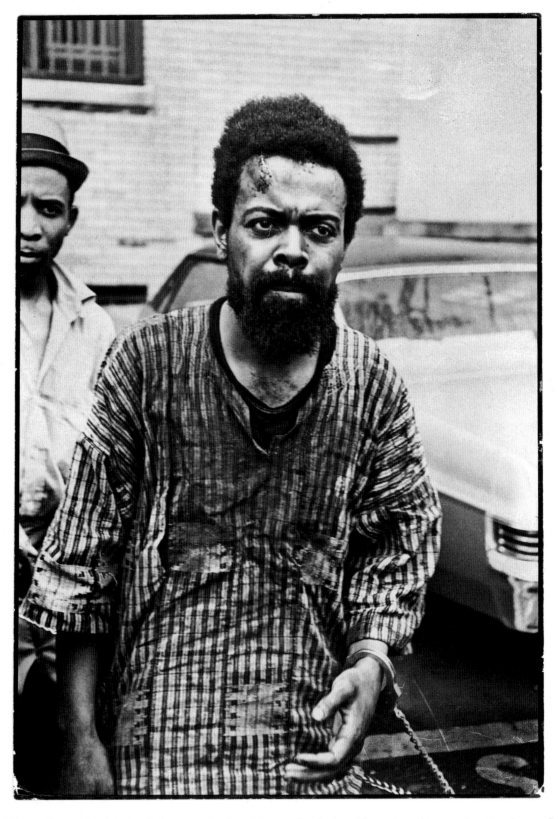

LeRoi Jones (later, Amiri Baraka) accused of inciting a riot leaves Newark police station in chains, July 14, 1967.

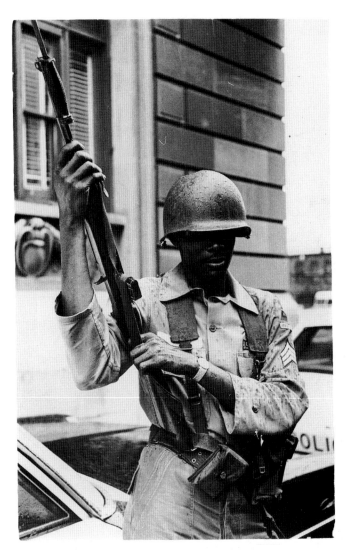

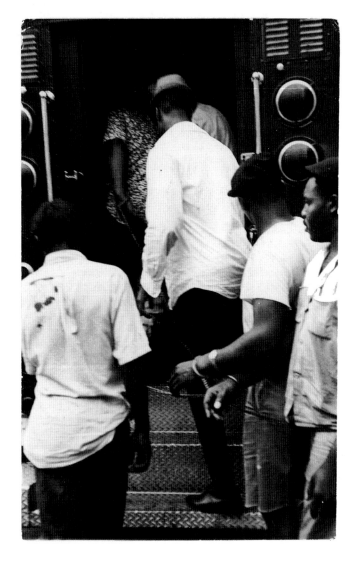

ABOVE: A soldier who was born in Central Ward, Newark, stands guard during the riots, July 14, 1967. RIGHT: Prisoners board police van in Newark riots, July 14, 1967.

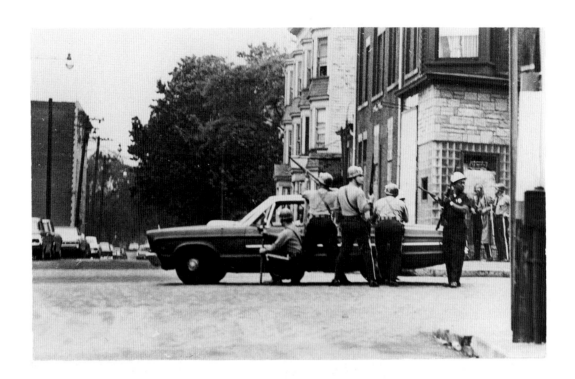

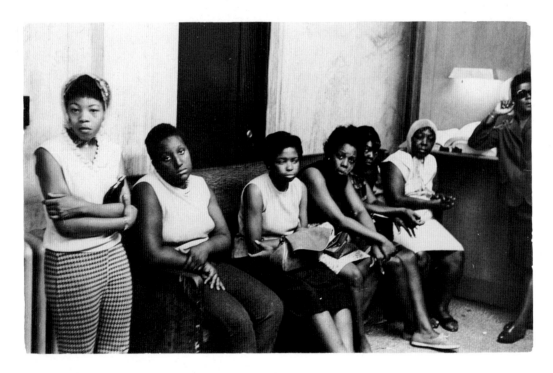

TOP: City police and state troopers fire at snipers in top floors of housing project on Springfield Avenue, Newark riots, July 14, 1967. **BOTTOM:** Women in police headquarters waiting for their relatives who were jailed for looting and rioting, July 14, 1967.

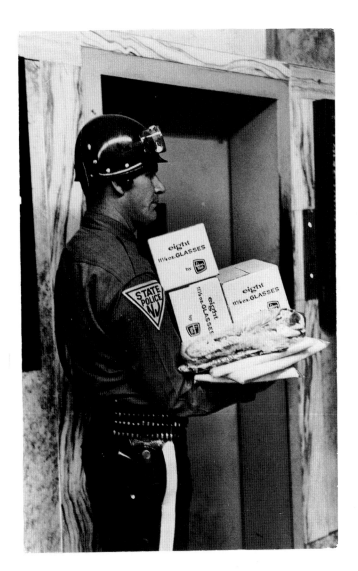

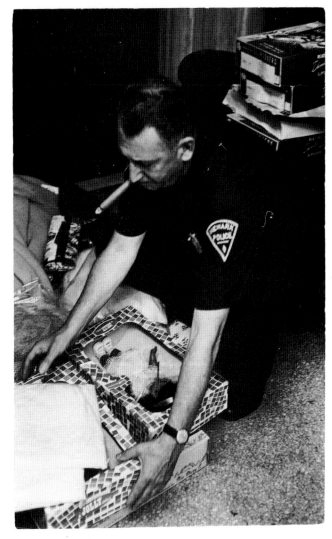

TOP: State police confiscate boxes of stolen water glasses, Newark riots, July 14, 1967. BOTTOM: Black baby dolls among loot in Newark police station, July 14, 1967.

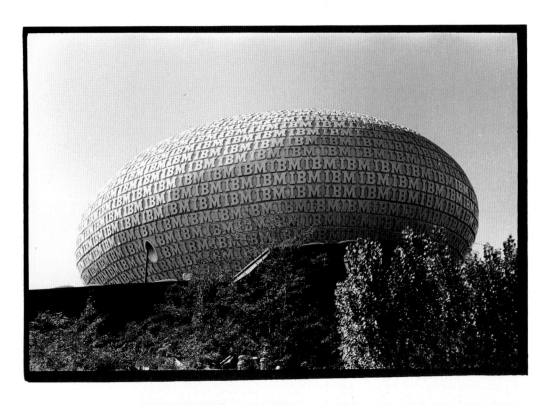

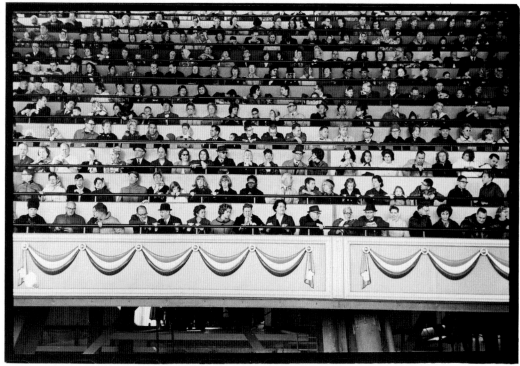

TOP: I.B.M. Pavilion, New York World's Fair 1964-65, Flushing Meadows, Queens, April 21, 1965. BOTTOM: I.B.M. people wall designed by Eero Saarinen, New York World's Fair, April 20, 1965.

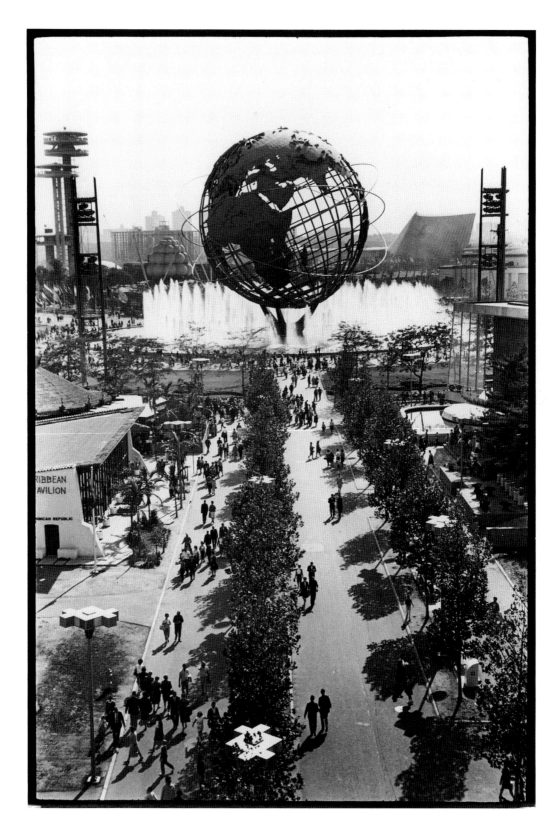

Unisphere sculpture by Gilmore D. Clarke was the centerpiece of the New York World's Fair 1964-65, Flushing Meadows, Queens, April 21, 1965.

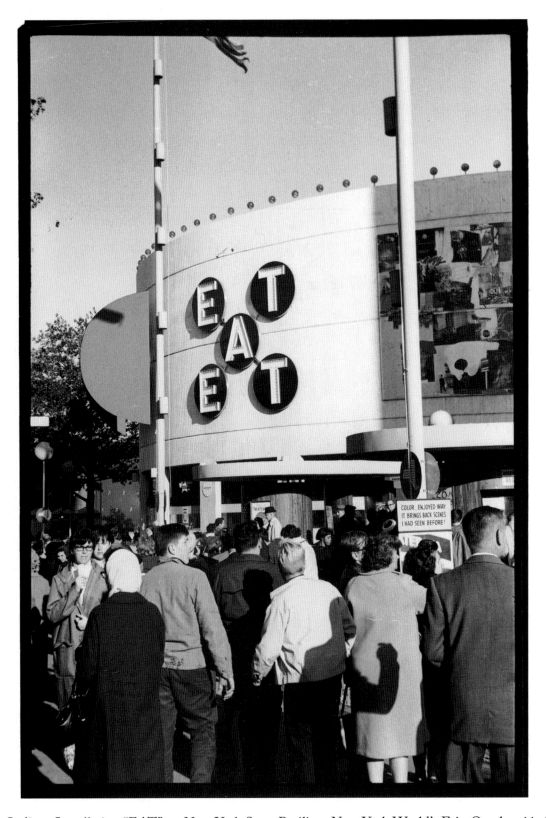

Robert Indiana Installation "EAT" on New York State Pavilion, New York World's Fair, October 11, 1964.

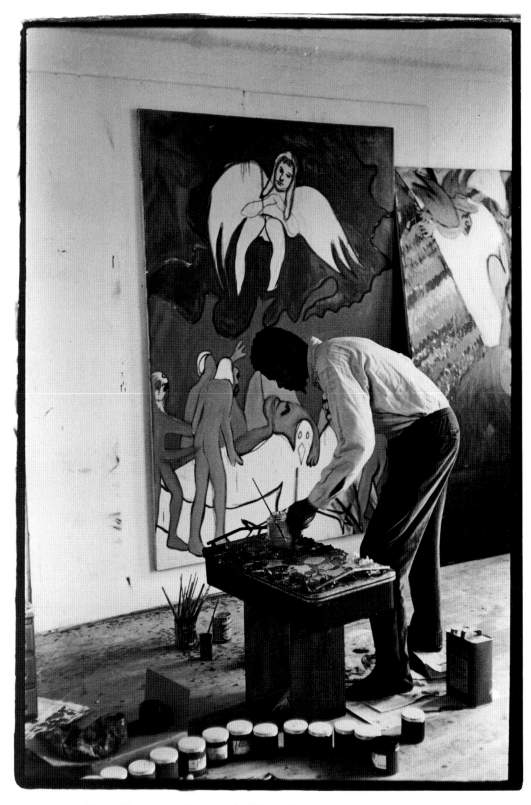

Bob Thompson in his No. 4 Rivington Street loft, November 30, 1963.

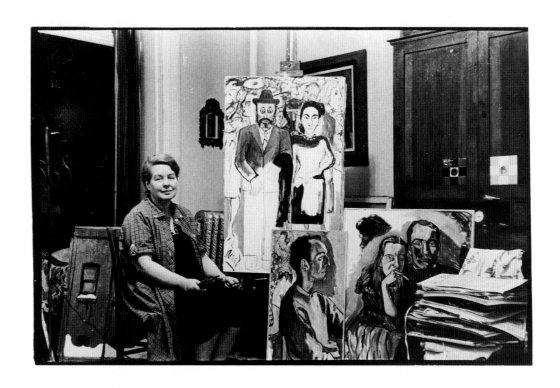

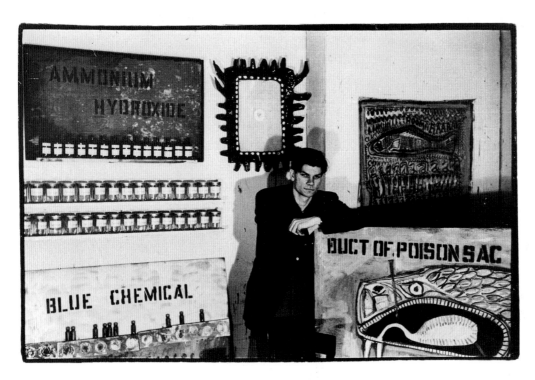

TOP: Alice Neel with paintings of artists in her Spanish Harlem tenement, 21 East 108th Street, February 10, 1961. She married a Cuban artist, had two daughters, and lived in Cuba before moving to New York. **BOTTOM:** Robert Smithson with his chemistry-oriented paintings, October 24, 1962.

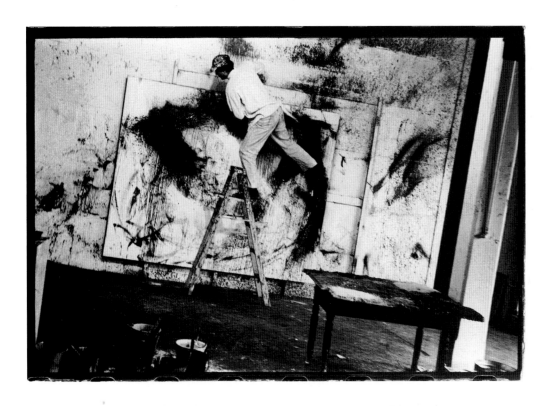

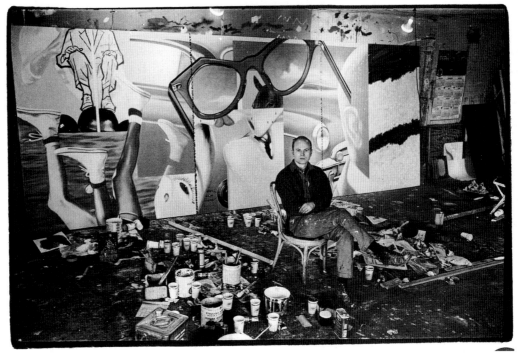

TOP: Action painter, Norman Bluhm, in his Fourth Avenue studio, February 22, 1961. BOTTOM: James Rosenquist in his Coenties Slip loft, June 30, 1963.

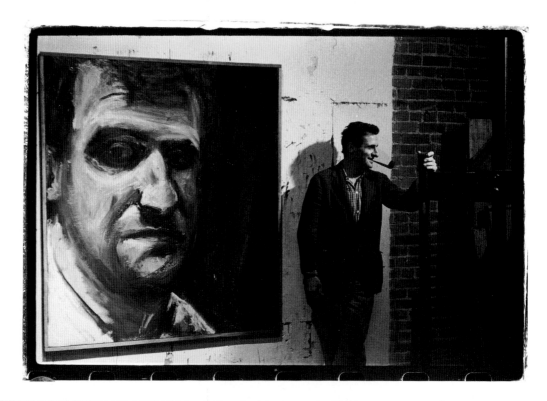

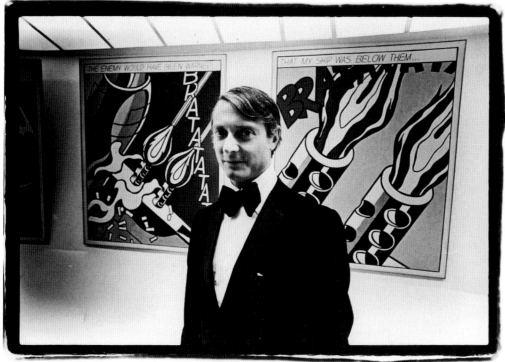

TOP: Paul Georges in his Broadway loft with self-portrait, January 16, 1961. BOTTOM: Roy Lichtenstein at his retrospective exhibit, Guggenheim Museum, 1071 Fifth Avenue, September 18, 1969.

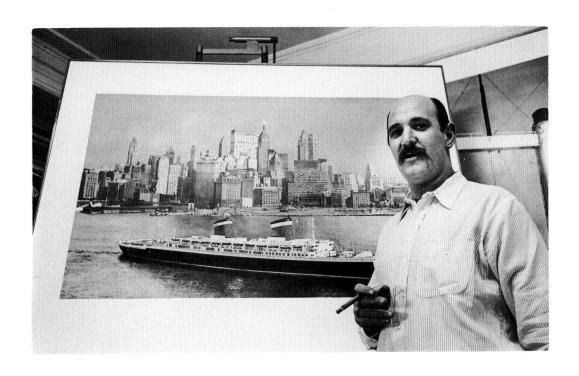

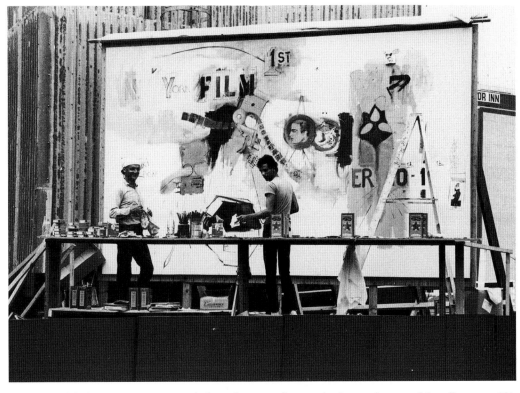

TOP: Malcolm Morley in his Chelsea apartment with his photo realism paintings of steamships, January 27, 1967. His first American exhibit was at the Jill Kornblee Gallery, 58 East 79th Street, in 1964. **BOTTOM:** Larry Rivers and his son Joe painting a mural, August 22, 1963, for the first New York Film Festival at Lincoln Center.

Barnett Newman cutting canvas, April 2, 1961, in his warehouse at 100 Front Street.

Cowboy painter Harry Jackson in his Little Italy loft, September 14, 1962.

ABOVE: Philip Glass at the keyboard in a concert at the New York University Loeb Student Center, LaGuardia Place, November 18, 1972. **RIGHT:** Lucia Dlugoszewski, composer-musician, plays at Circle in the Square, May 18, 1960.

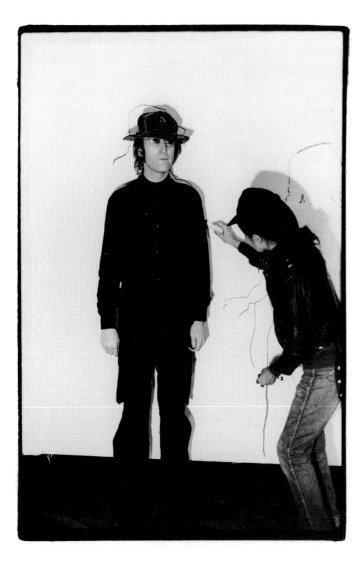

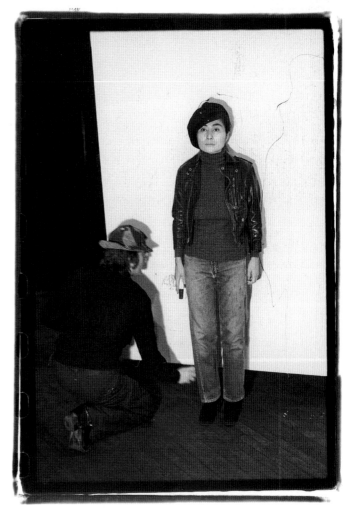

ABOVE: Yoko Ono tracing body of John Lennon at eighth Avant Garde Festival, 69th Armory, Lexington Avenue, November 19, 1971. RIGHT: John Lennon tracing body of Yoko Ono at eighth Avant Garde Festival at the 39th Armory, Lexington Avenue, November 19, 1971.

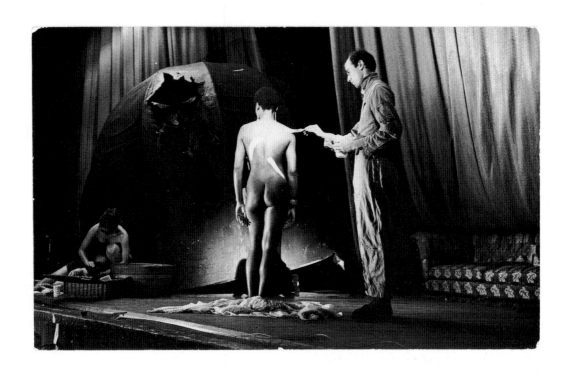

TOP: Ken Dewey performing in his Confederate Memorial Day happening, part 2 time sequence, an Action Theatre event, June 10, 1965. BOTTOM: A Jim Dine happening, "The Dreams," performed by Nancy Fish and Robert Delford Brown, August 30, 1965.

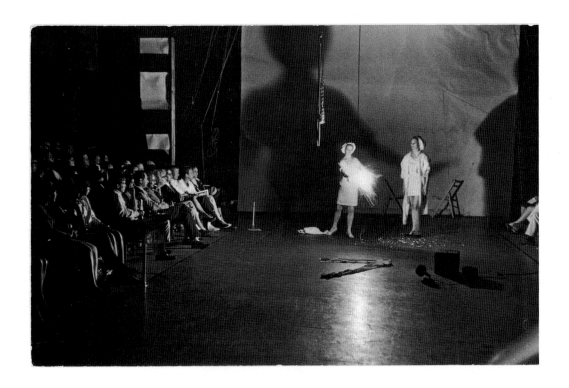

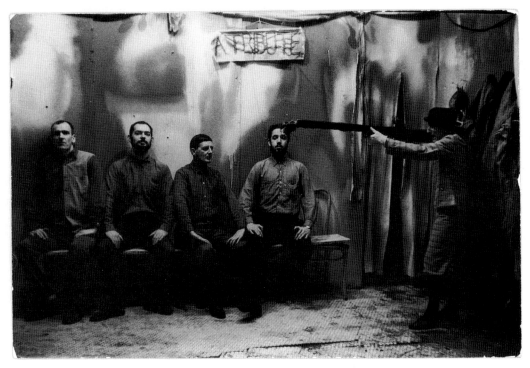

TOP: Robert Whitman's "Prune Flat" performed August 21, 1966, at the Circle in the Square. **BOTTOM:** Ironworks/Fotodeath by Claes Oldenburg with Tom Wessleman (left), Clifford Smith (second from left), Edgar Blakeney (third from left), Carl Lehman-Haupt, Judith Tirsch (right), performed at Reuben Gallery, 44 East Third Street, February 25, 1961.

TOP: Henry Geldzahler of the Metropolitan Museum in Al Roon's health club swimming pool "happening" *Washes* by Claes Oldenburg, May 21, 1965. **BOTTOM:** Les Levine in paper happening, January 16, 1969.

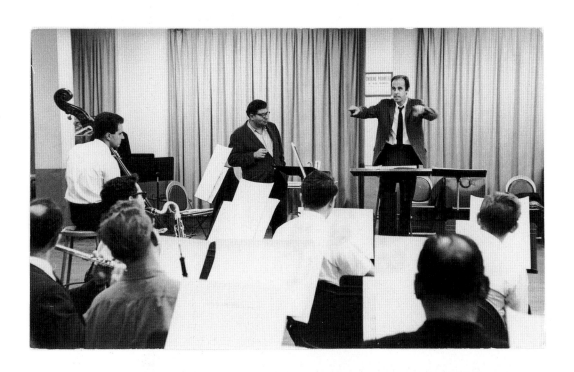

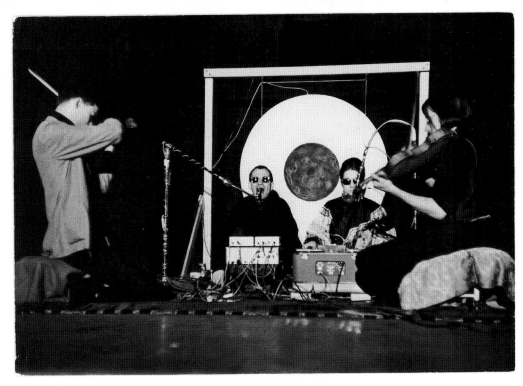

TOP: Earle Brown conducting a composition by Morty Feldman for a class at The New School, September 29, 1963. Together they gave a concert of new music at Town Hall. **BOTTOM:** Private concert in Lower East Side loft, December 12, 1965, with Tony Conrad (left), La Monte Young, Marion Zazeela, and John Cale (right).

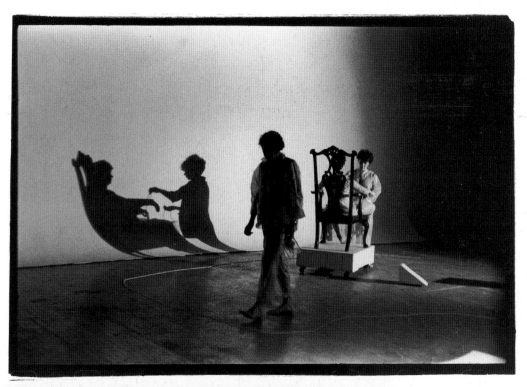

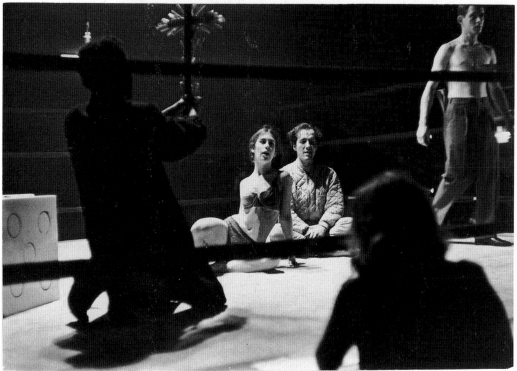

TOP: Linoleum Performance, May 29, 1968, in Burt Stern's studio with Robert Rauschenberg (center), Deborah Hay (right), and Simone Forti seated in a Chippendale chair with a pot of spaghetti on her lep. **BOTTOM:** "The Tart," a happening by Dick Higgins, performed in boxing ring at Sunnyside Gardens, Queens, April 17, 1965.

TOP: A Fluxus clinic event with George Maciunas and Robert Watts (left) conducting an electronic experiment on Jane Barrett, April 29, 1970. "Fluxus refers to the transitory character, the constant change of ideas within Fluxus members." **BOTTOM:** Red Grooms performing in Marcia Marcus' A Garden with Bob Thompson on bongo drums at the Delancey Street Museum, February 6, 1960.

TOP: Jim Dine performing in Car Crash, Reuben Gallery, 75 Fourth Avenue. Robert Indiana (center) and Jill Johnston (right), November 1, 1960. **BOTTOM:** Geoff Hendricks on top of dirt mound at eighth Avant Garde Festival, 69th Armory, in a silent performance with a white mouse, November 19, 1971.

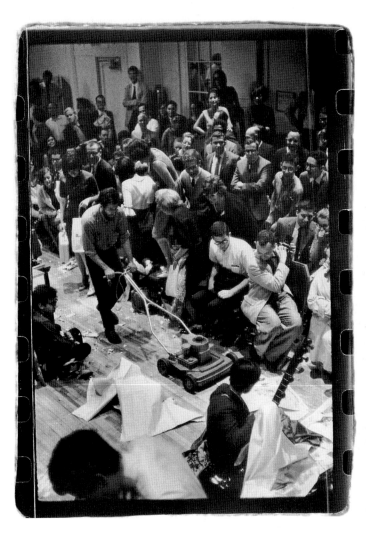

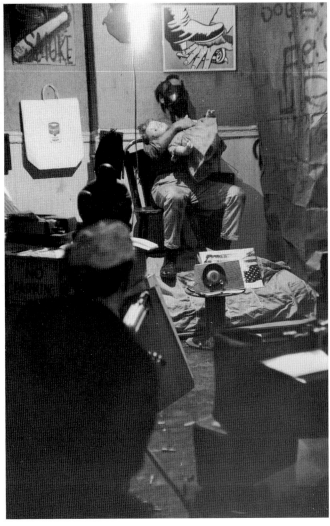

ABOVE: Allan Kaprow mowing the "lawn" at Judson Hall, 165 West 57th Street, Second Avant Garde Festival, September 8, 1964. Kaprow coined the term happening as a collective action combining visual, theatrical, and auditory elements.
RIGHT: Al Hansen being "Machine Gunned" in "Red Dog," his happening, October 31, 1964, at Third Rail Gallery in the East Village. He was a founder of the Fluxus art movement.

N.Y.U. panel discussion, "The Disintegration of a Critic: An Analysis of Jill Johnston," at Loeb Student Center, LaGuardia Place, May 21, 1969—left to right: Charlotte Moorman (performer wrapped in medical gauze), John DeMenil (art patron), Ultra Violet (superstar), David Bourdon (art critic), Gregory Battcock (art critic), Andy Warhol (pop artist), Bridgit Polk (actress), Lil Picard (performer), Walter Gutman (stock broker).

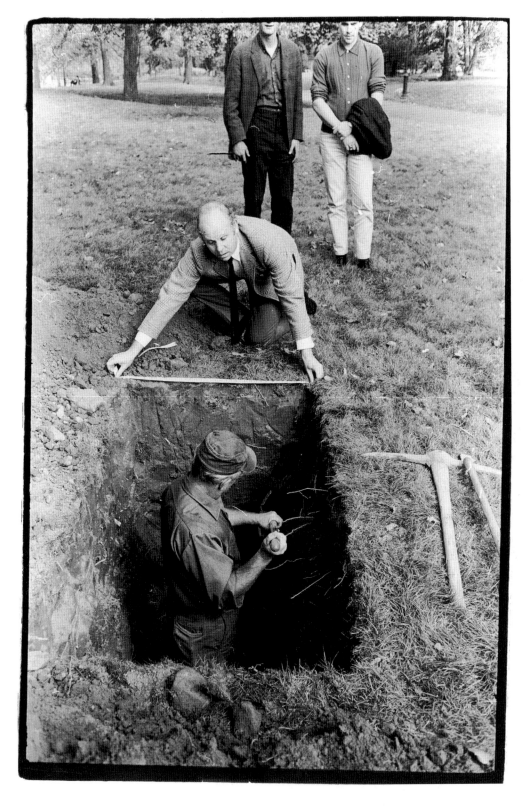

Claes Oldenburg digging coffin-sized "Hole," measured to exact specifications, then closing it up, in Central Park, October 1, 1967, behind the Metropolitan Museum near the Egyptian Obelisk.

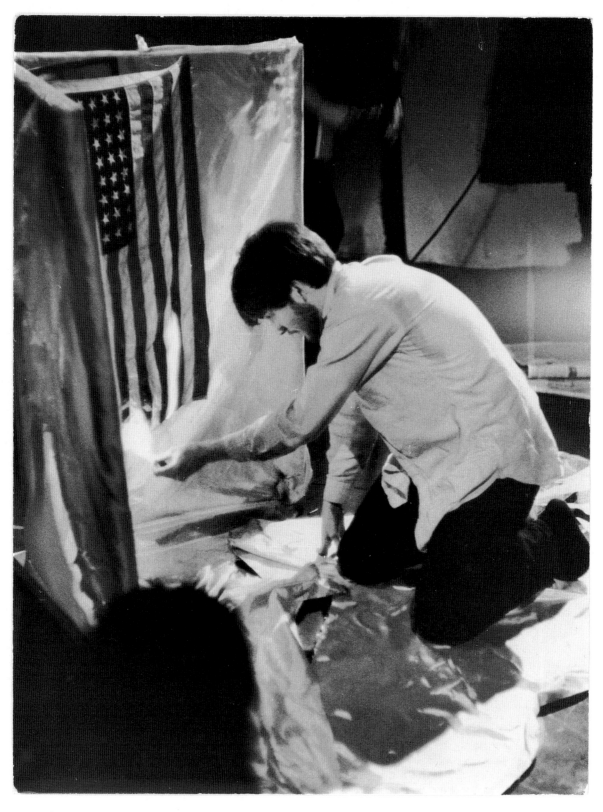

Anti-war theatrical event at the Bridge Theatre, St. Marks Place, April 8, 1965. Jose Rodriguez Soltero lights a match to the American flag.

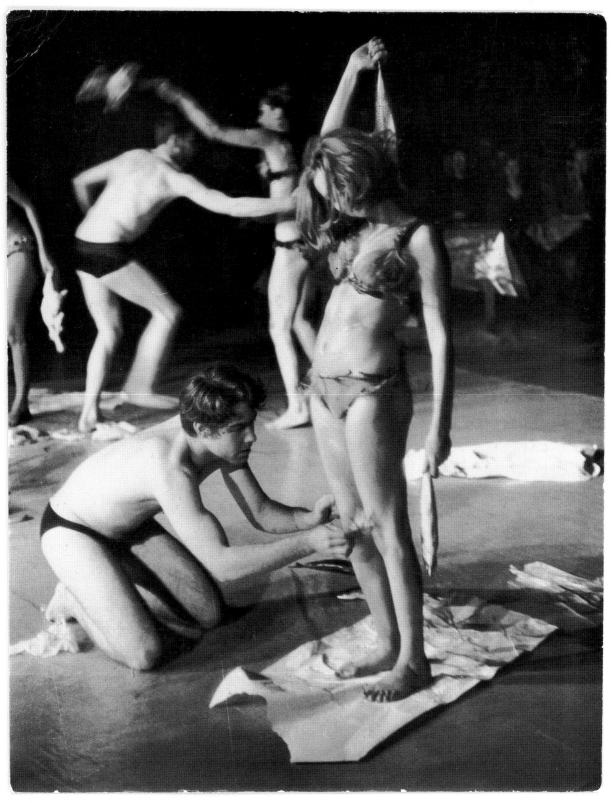

Carolee Schneeman's "Meat Joy," "naked body as environment," a happening at Judson Memorial Church auditorium, November 16, 1964. Players got swatted with raw fish, plucked chickens, and sausages.

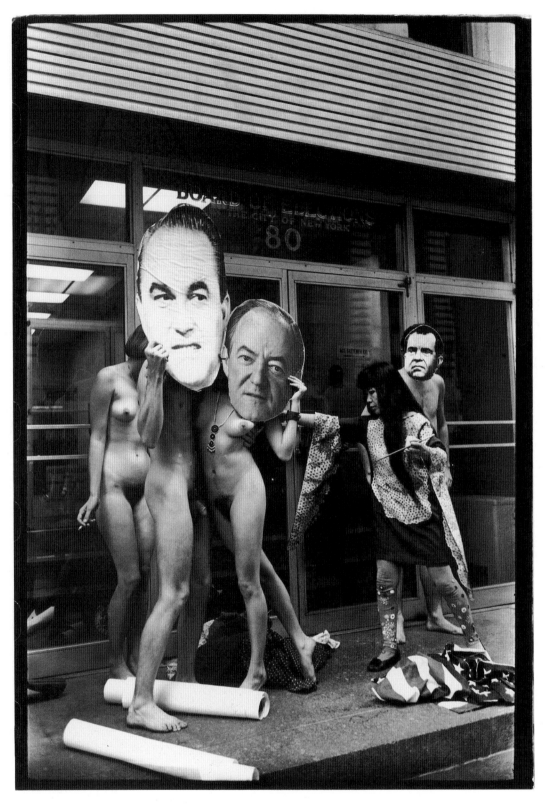

Wallace, Humphrey, Nixon subject of Yayoi Kusama's election day performance, in front of Board of Elections, 80 Varick Street, November 3, 1968.

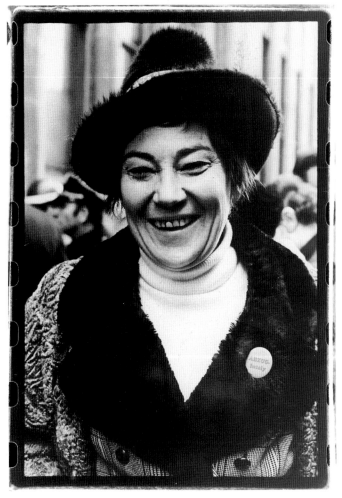

ABOVE: Robert Moses, October 16, 1963, with plans for the New York World's Fair 1965-1966.
RIGHT: Congressman Bella Abzug at an anti-war rally, March 19, 1970.

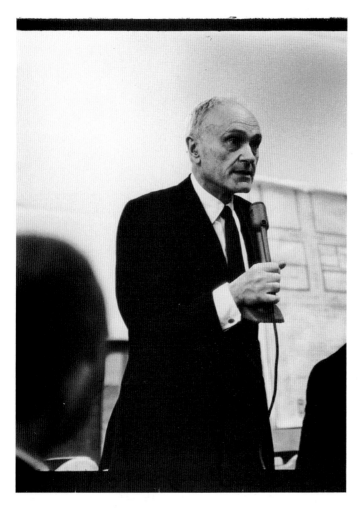

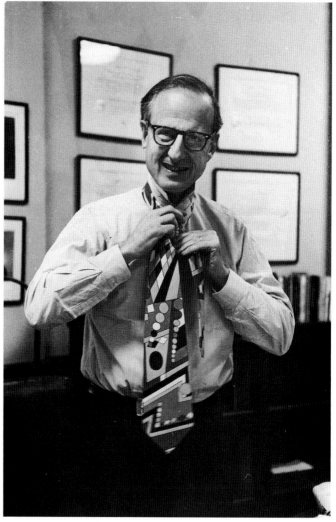

ABOVE: Politician and architect, Philip Johnson, at the Local Planning Board with his plans showing how N.Y.U. can take over Greenwich Village, November 9, 1965. RIGHT: New York District Attorney Robert Morgenthau in his office at One Hogan Place, January 8, 1970.

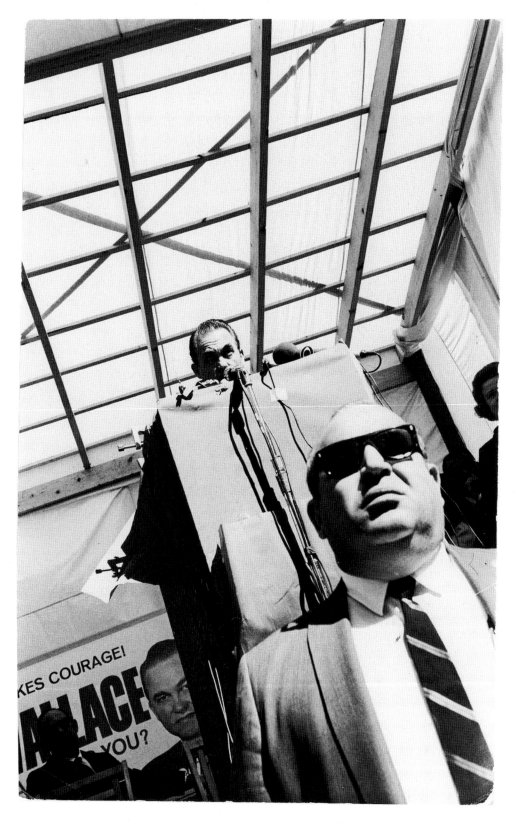

Presidential candidate George Wallace, at a political rally, Newark, October 5, 1968.

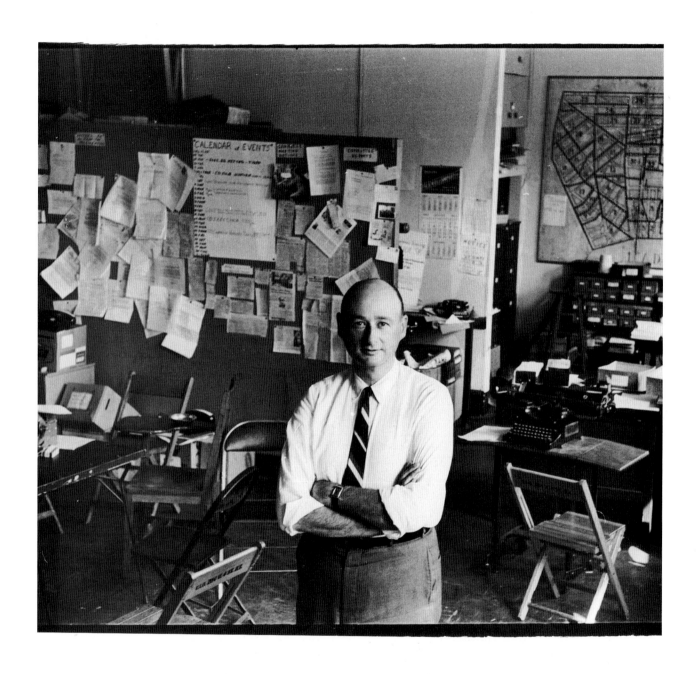

Ed Koch at Village Independent Democrats, Sheridan Square, August 24, 1963. Koch was a combat rifleman in World War II and was an early and outspoken critic of the Vietnam War.

CLOCKWISE FROM TOP LEFT: David Brower of the Sierra Club hiking in Staten Island, January 27, 1968. • Pete Seeger in Central Park at an anti-war rally, April 13, 1967. • Doctor Howard Levy, a draft refuser, September 4, 1969. • Daniel Ellsberg, January 2, 1972, brought the Pentagon Papers to the media.

TOP: Dick Cavett, March 5, 1970. He interviewed Woody Allen and Bob Hope about ten times each during his long-running TV show. Cavett was a writer for Jack Parr and Johnny Carson. **BOTTOM:** Radio monologist Jean Shepherd, November 30, 1966.

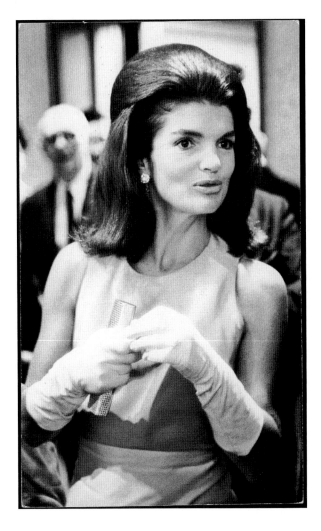

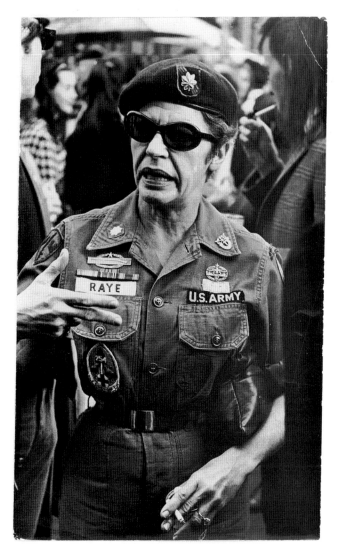

ABOVE: Jackie Onassis at the Whitney Museum opening, October 2, 1966. **RIGHT:** Actress Martha Raye in costume at Norman Mailer's street party for 100th performance of Deer Park, April 30, 1967.

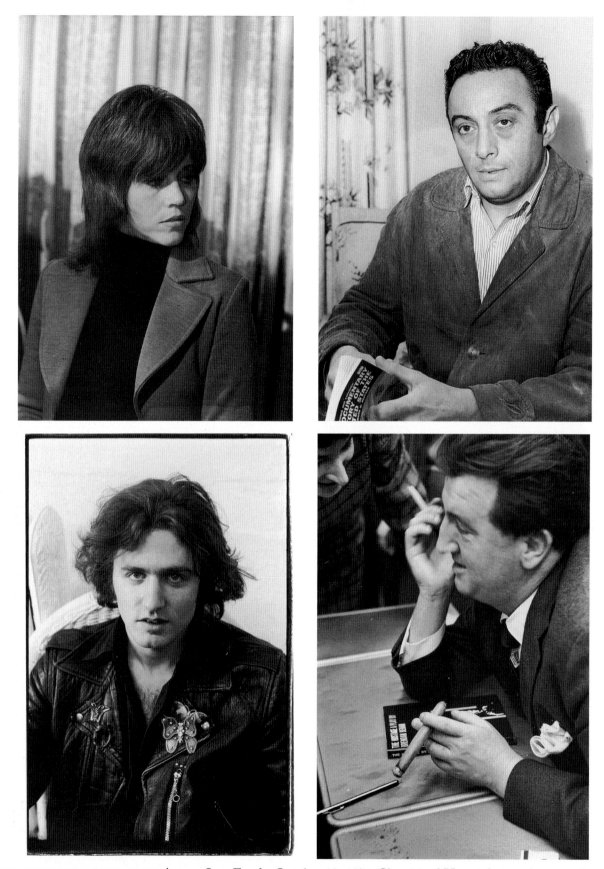

CLOCKWISE FROM TOP LEFT: Actress Jane Fonda, October 12, 1971. She visited Hanoi during the war. • Lenny Bruce in the Marlton Hotel, 5 West Eighth Street, November 5, 1964. • Brendan Behan in Eighth Street Bookshop autographing *The Hostage,* October 13, 1960. • Gerard Malanga, Warhol assistant, at the Factory, 33 Union Square West, April 24, 1969.

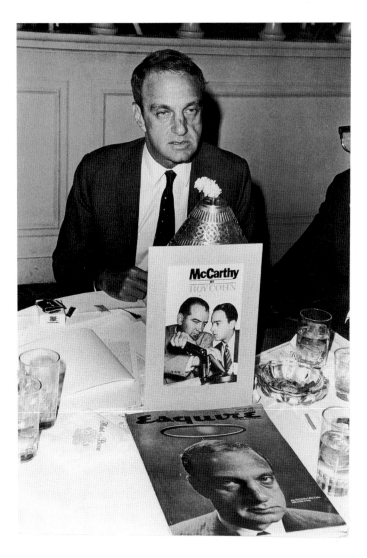

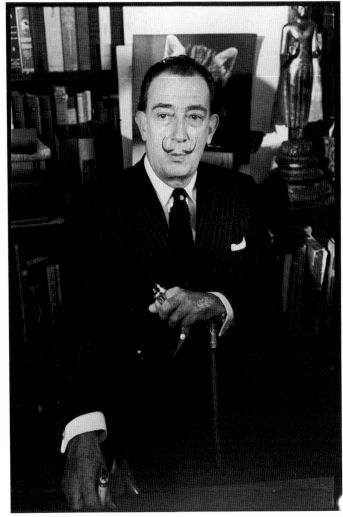

ABOVE: Roy Cohn, Joe McCarthy's partner, at a book signing, March 6, 1968. RIGHT: Salvador Dali at a literary party, Frances Steloff's Gotham Book Mart, 41 West 47th Street, January 4, 1963.

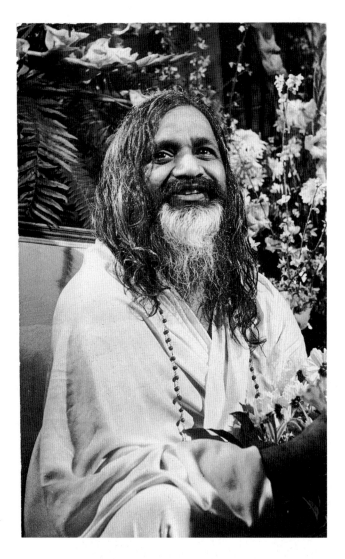

ABOVE: Maharishi Mahesh Yogi at a press conference, January 19, 1968. RIGHT: Pacifist A. J. Muste at draft card protest, October 27, 1965.

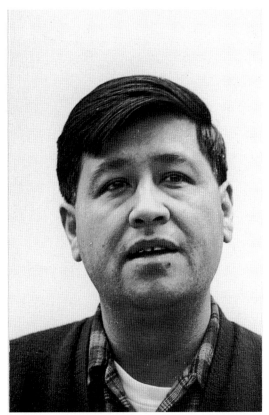

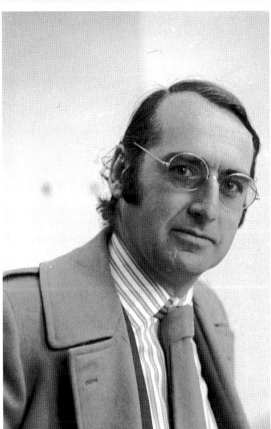

CLOCKWISE FROM THE TOP LEFT: Robert Bly at the National Book Awards, March 6, 1968. • Cesar Chavez leading a grape boycott at a Grand Union supermarket, April 22, 1967. • Avant Garde composer Edgar Varese at the Metropolitan Museum of Art, December 22, 1960, at a concert to celebrate his 75th birthday. • Architect Richard Meier at an art opening, November 1, 1969.

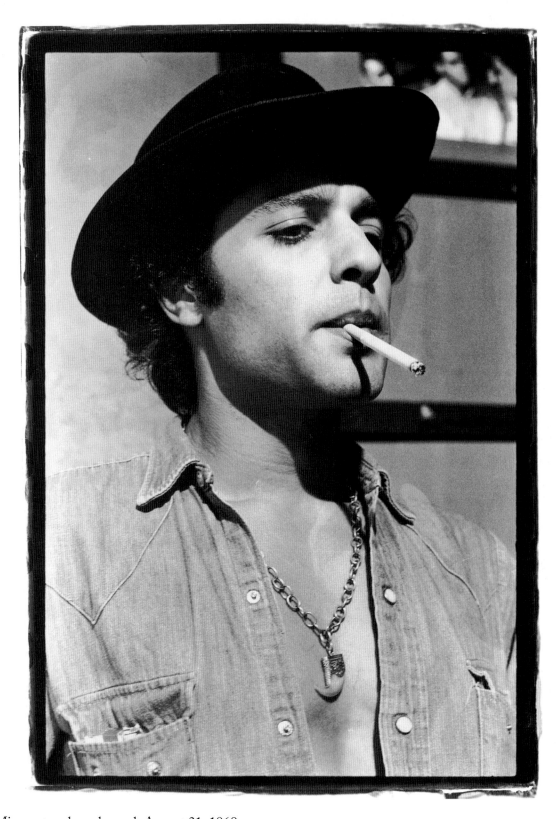

Sal Mineo at a play rehearsal, August 21, 1969.

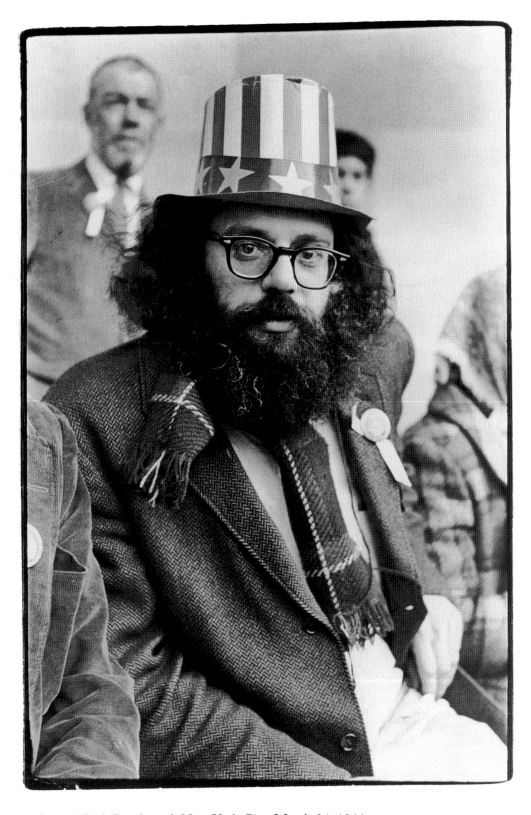

Allen Ginsberg, Central Park Bandstand, New York City, March 26, 1966.

Michael Harrington, author of *The Other America*, on Thompson Street, January 29, 1964. His seminal volume was a report and analysis on contemporary poverty.

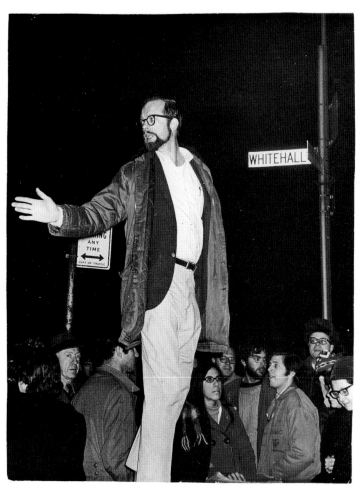

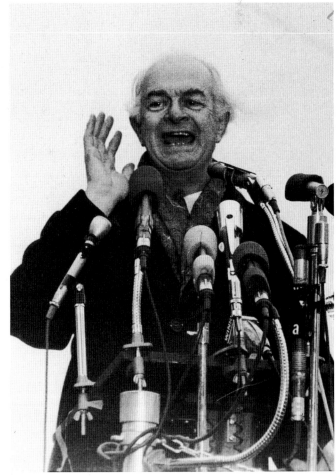

ABOVE: David MacReynolds directs demonstrators at anti-draft rally, Whitehall Street, December 5, 1967. RIGHT: Linus Pauling at United Nations peace rally, April 15, 1967.

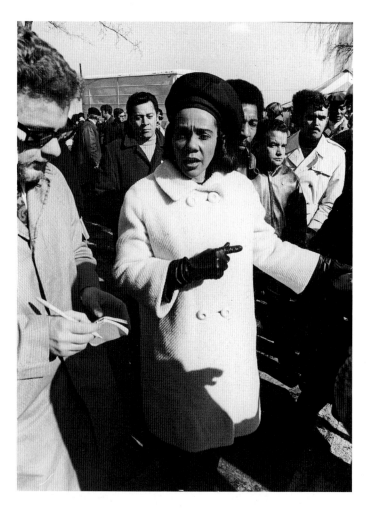

ABOVE: Coretta King in Washington joins massive "March Against Death" demonstration against the war, November 15, 1969. RIGHT: Truth is Dead at the Museum of Modern Art, West 53rd Street, April 24, 1960.

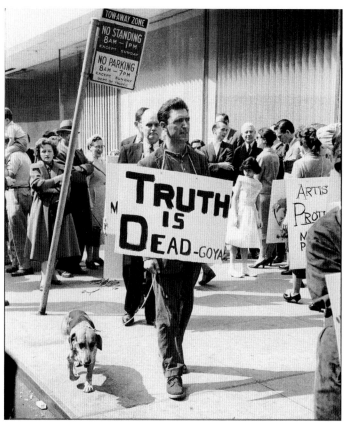

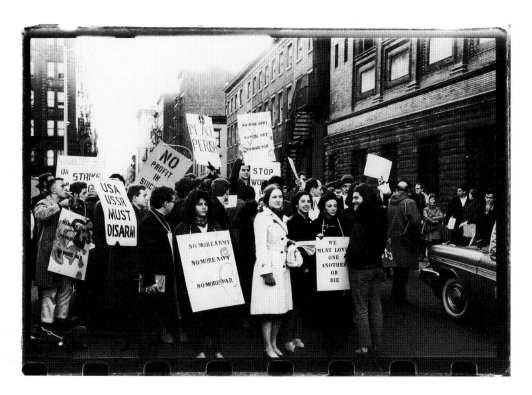

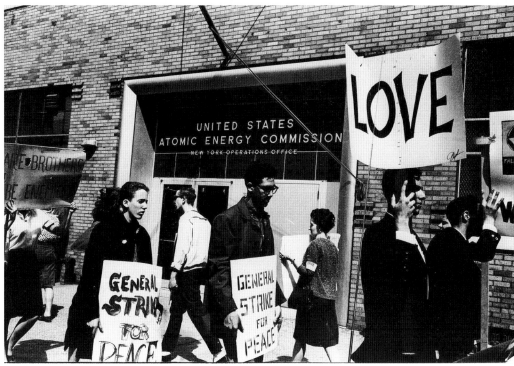

TOP: First protest in New York at the Judson Memorial Church against the war, November 15, 1962. **BOTTOM:** General strike for peace, front of U.S. Atomic Energy Commission, Hudson Street, April 30, 1963.

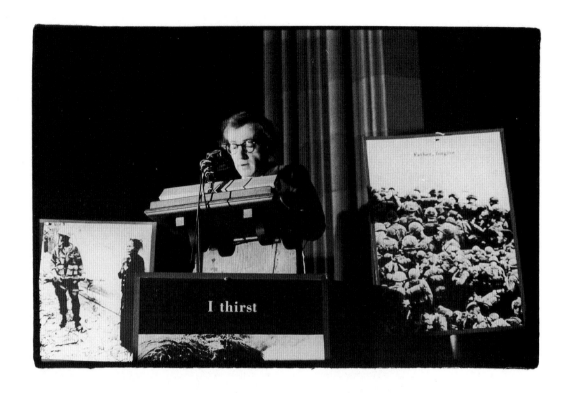

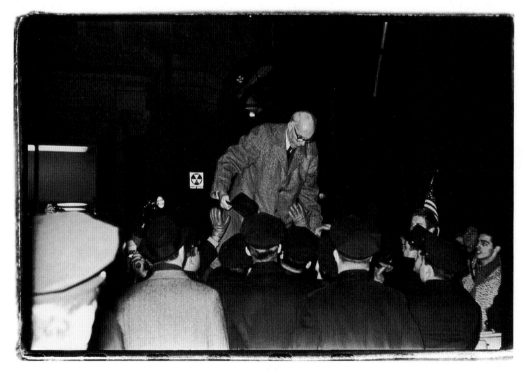

TOP: Woody Allen at Riverside Church during moratorium against the war in Vietnam, October 15, 1969.
BOTTOM: Benjamin Spock blocks door of Army Recruiting Center, Whitehall Street, December 5, 1967.

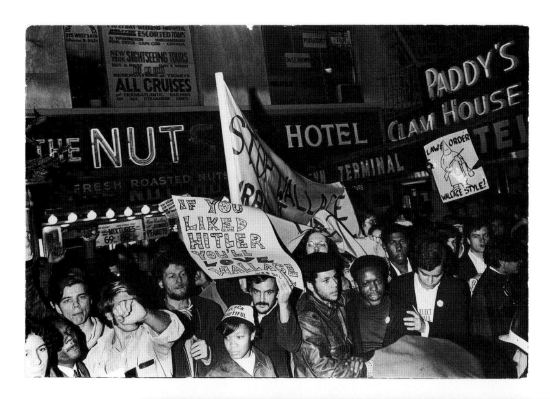

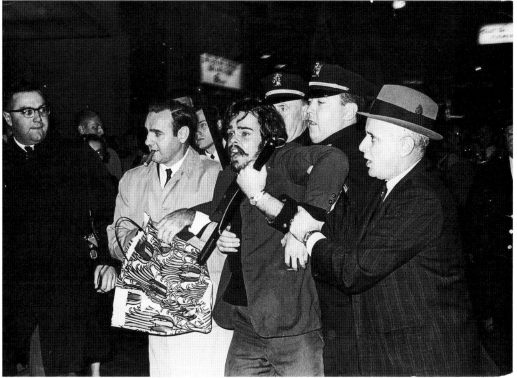

TOP: Anti-Wallace demonstrators from Madison Square Garden during Wallace political rally, October 24, 1968. **BOTTOM:** Grand Central Terminal demonstrator is grabbed with shopping bag used to carry "Doves for Peace," December 19, 1967.

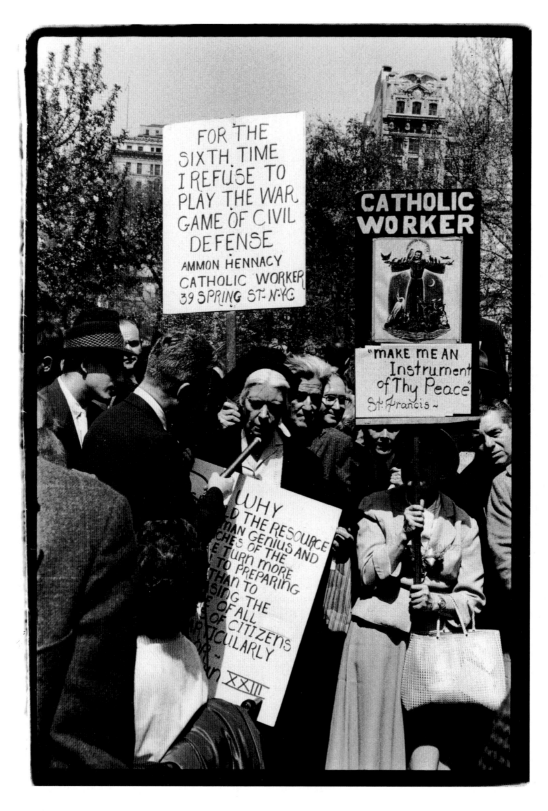

Catholic Worker, Dorothy Day, in City Hall Park, May 3, 1960, protesting against civil defense exercises.

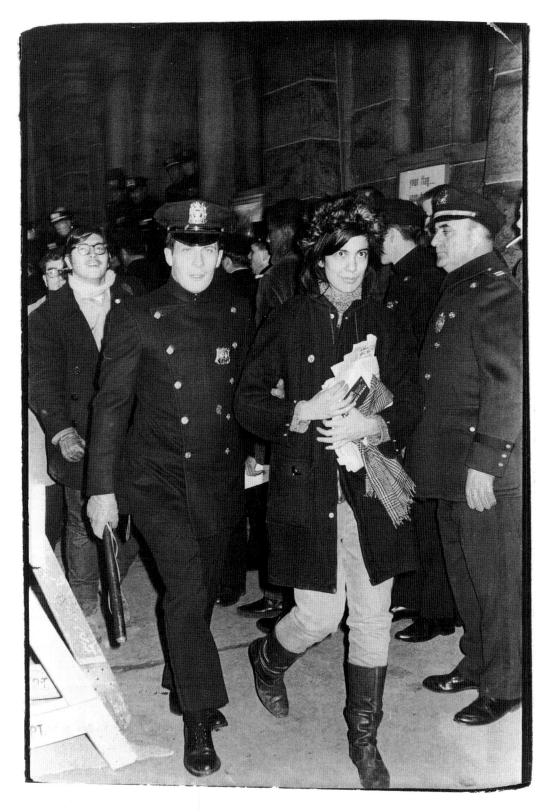

Susan Sontag in a draft protest gets arrested at the Whitehall Street Army Recruiting Center, December 5, 1967.

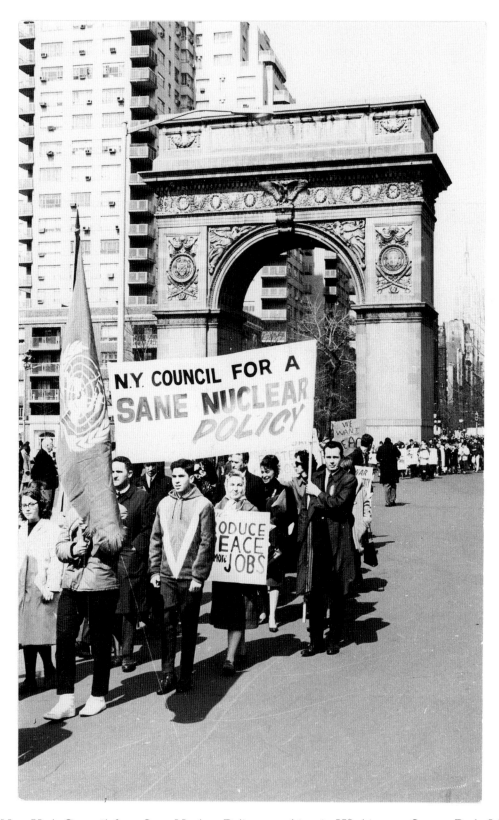

Members of New York Council for a Sane Nuclear Policy marching in Washington Square Park, March 29, 1964.

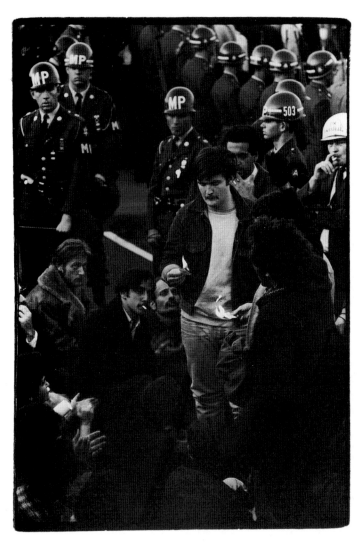

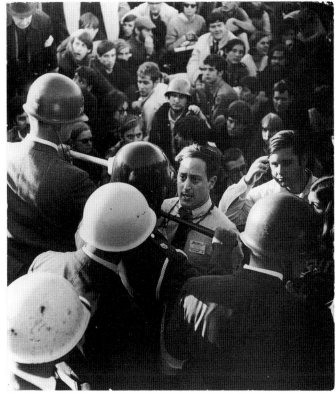

ABOVE: Burning draft cards in front of the Pentagon, October 21, 1967. **BOTTOM:** Protestors stand their ground against Federal officers at the Pentagon, October 21, 1967.

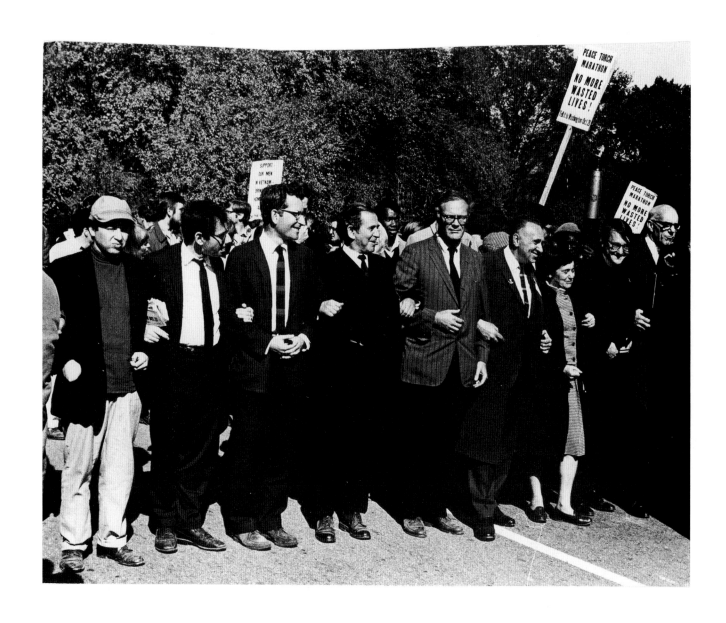

"Raising the Pentagon"—October 21, 1967. Right to left: Dr. Benjamin Spock, Unidentified person, Dagmar Wilson, Sidney Lens, Robert Lowell, Norman Mailer, Naom Chomsky, Marcus Raskin, Unidentified person.

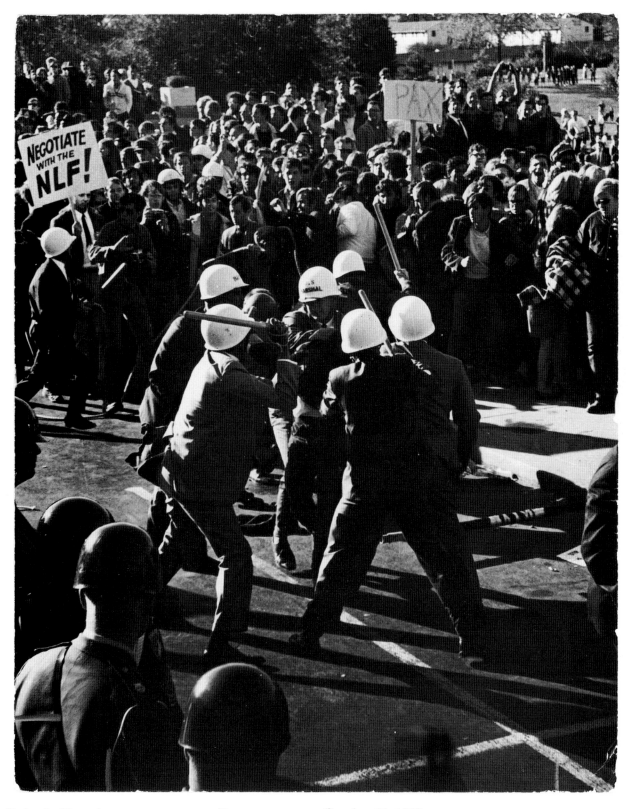

Federal officers beat up protestors at Pentagon protest, October 21, 1967.

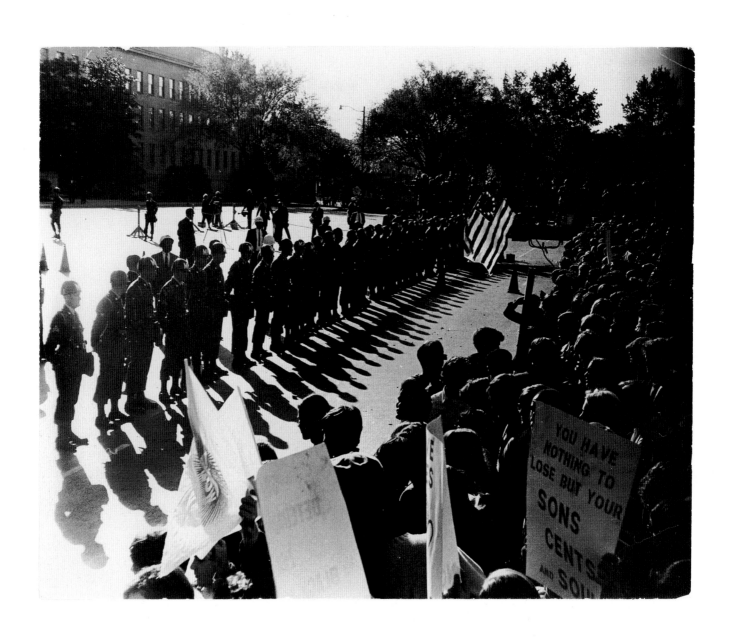

Federal officers and MPs wait for protestors to make a move at the Pentaton, October 21, 1967.

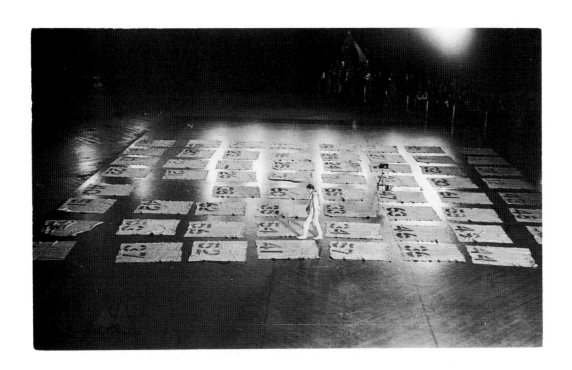

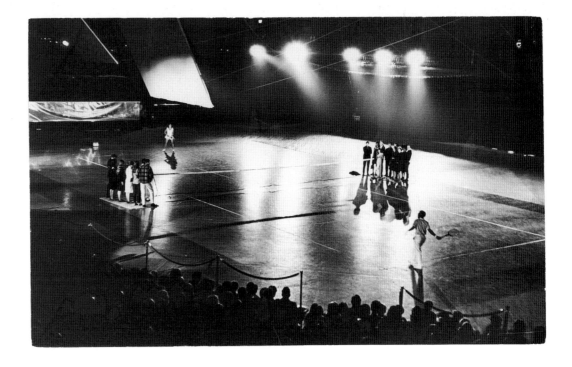

TOP: Alex Hay's "Grass Field," 100 six-foot squares in a checkerboard pattern. A performer wired for sound so that "heartbeat, brain waves, muscle, and eye movements are amplified and transmitted to a central control station." **BOTTOM:** Robert Rauschenberg's "Open Score" begins with an authentic tennis game with rackets wired for sound. "The sound of the game controls the lights. The game's end is the moment the Armory is in total darkness.

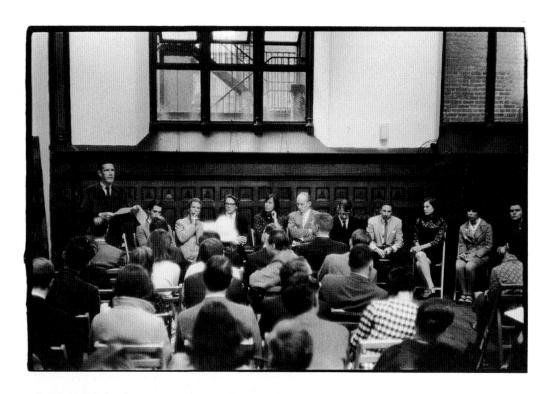

TOP: Press conference for Nine Evenings: Theatre and Engineering held at Rauschenberg's studio, 381 Lafayette Street, September 17, 1966. Left to right: John Cage, Steve Paxton, Alex Hay, Robert Whitman, Yvonne Rainer, Billy Kluver, David Tudor, Robert Rauschenberg, Lucinda Childs, Deborah Hay, Olvind Fahlstrom. **BOTTOM:** The 69th Regiment Armory, Lexington Avenue at 25th Street, on opening night, October 18, 1966. The purpose of Experiments in Art and Technology is to "catalyze the inevitable active involvement of industry, technology, and the arts."

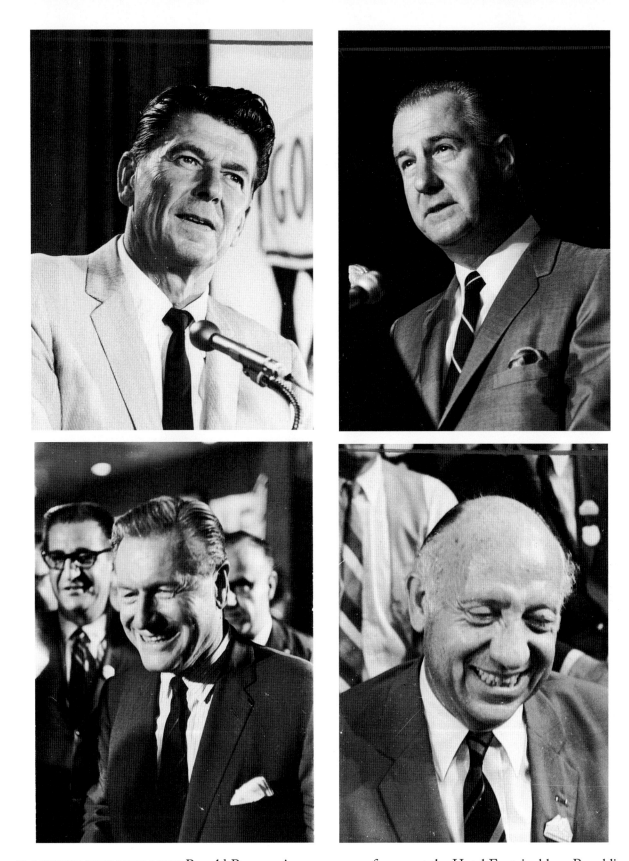

CLOCKWISE FROM TOP LEFT: Ronald Reagan gives a press conference at the Hotel Fontainebleau Republican Convention, in his bid to become the candidate, August 6, 1968. • Spiro Agnew, August 6, 1968, was Nixon's Vice President. Eventually he resigned in disgrace, following allegations of bribery and income tax evasion. • Jacob Javits at Republican Convention, August 6, 1968. • Nelson Rockefeller at Republican Convention, August 6, 1968. As governor of New York, he enacted harsh and cruel laws that sent anyone to prison for a minimum of fifteen years to life for possessing two ounces of marijuana.

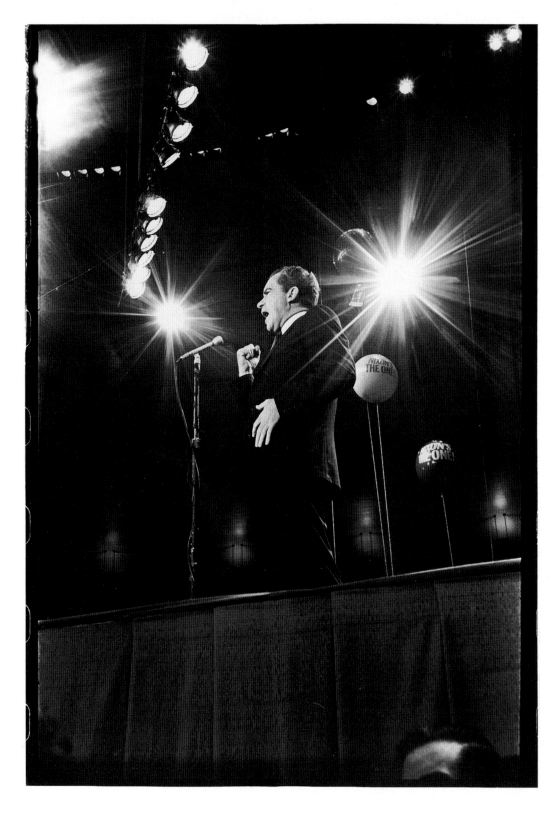

Richard Nixon, Madison Square Garden, in his final campaign appearance in New York, October 31, 1968.

Reporters Norman Mailer and Kermit Lansner of Newsweek, at the Republican Convention, Miami Beach, August 6, 1968.

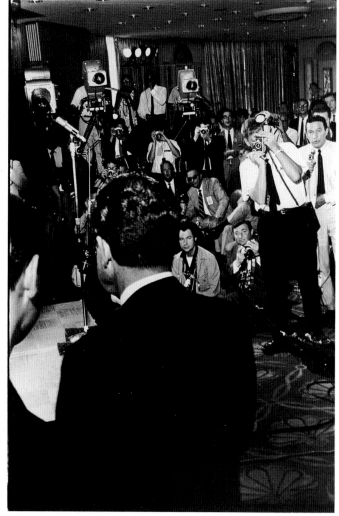

ABOVE: "Nixon's the One," Miami Beach, August 6, 1968. RIGHT: Nixon meets the press, Miami Beach, Florida, Republican Convention, August 6, 1968. Mike Wallace on the far right.

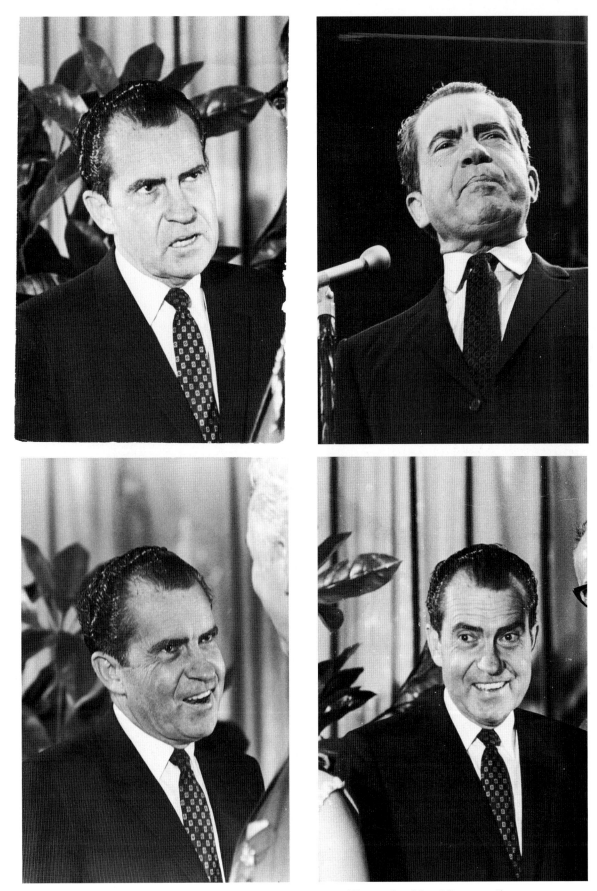

CLOCKWISE FROM TOP LEFT: Nixon frowns. Nixon grimaces. Nixon chuckles. Nixon smiles.

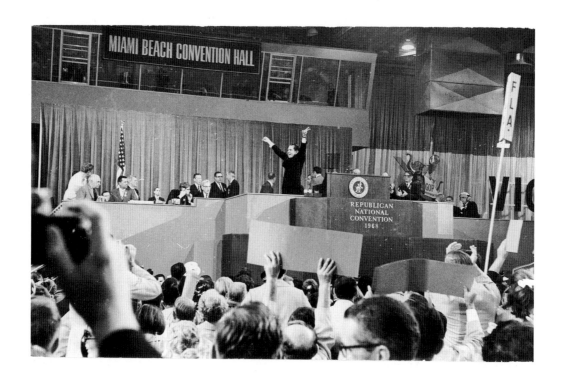

TOP: Nixon wins nomination, August 6th, to represent the Republican Party in the Presidential Election of 1968. **BOTTOM:** Poor People's Campaign led by Ralph Abernathy, Republican Headquarters, Fontainebleau Hotel, 4441 Collins Avenue, Miami Beach, Florida, August 6, 1968.

TOP: Eva Hesse, September 14, 1968. **BOTTOM:** Marisol Escobar, April 14, 1966.

ABOVE: Paul Thek, September 16, 1967. RIGHT:
Jackie Ferrara, April 29, 1966.

ABOVE: Tom Doyle, February 27, 1966. **RIGHT:**
Frosty Meyers, November 14, 1965

Mark diSuvero, October 18, 1960.

278

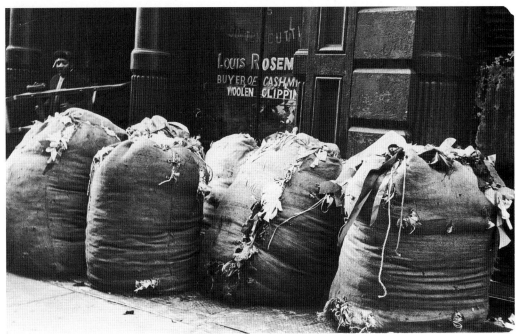

TOP: Moving barrels across Soho streets, October 9, 1969. BOTTOM: Bales full of cashmere and woolen clippings, Mercer Street, January 29, 1966.

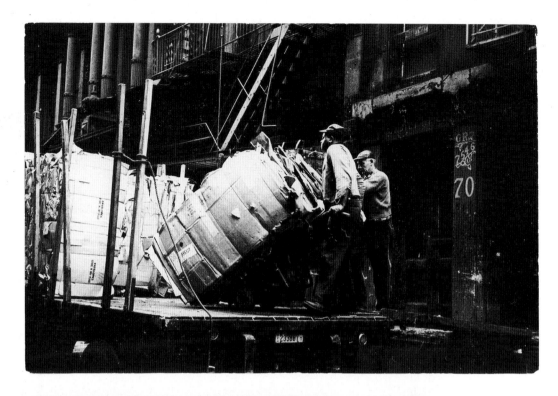

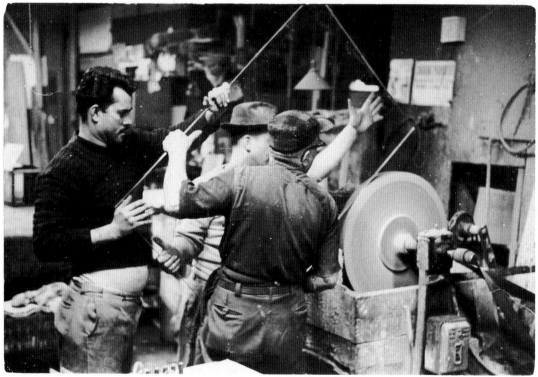

TOP: Perazzo waste paper to Greene Street, December 5, 1962. **BOTTOM:** Grinding and making mirrors, 84 Greene Street, December 5, 1962.

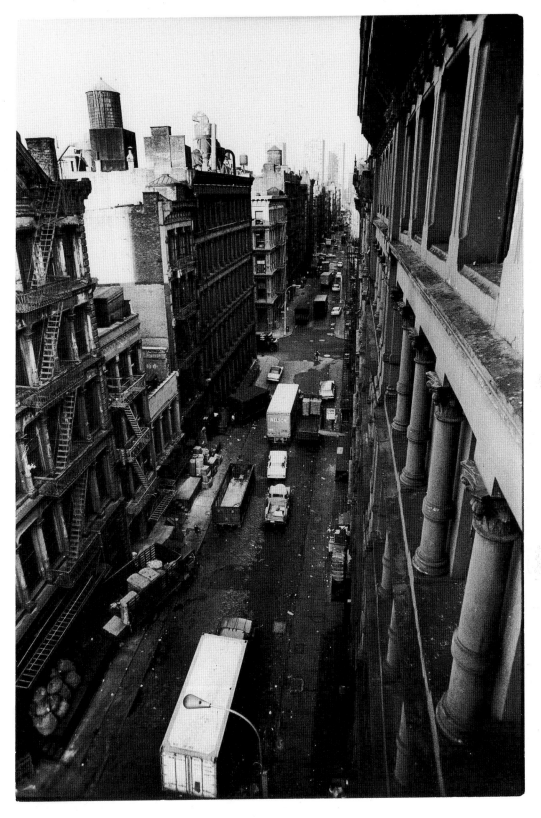

View Looking north into Mercer Street, October 9, 1969.

Opening of 420 West Broadway as an art center, September 25, 1971.

ABOVE: Hot sweet potatoes, Orchard Street, November 13, 1963. RIGHT: Pretzel vendor, Allen Street at Delancey, December 2, 1963.

ABOVE: Colleen Dewhurst on stage of the New York Shakespeare Theatre in Central Park, May 15, 1963. Belvedere Castle is behind her. RIGHT: Theatre producer Joseph Papp of the New York Shakespeare Theatre and the Public Theatre, 425 Lafayette Street, seen here on May 15, 1963, has been the leader in Off-Broadway theatre. In 1963 there were over thirty Off-Broadway productions.

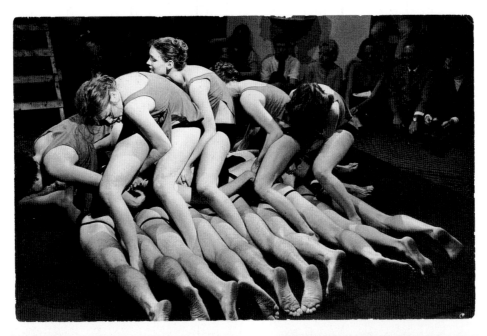

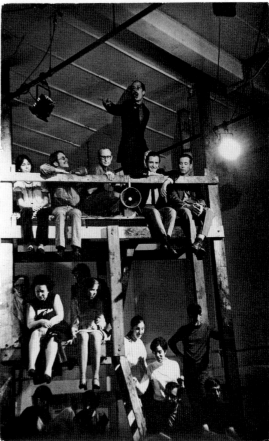

TOP: Birth ritual in Dionysus in '69 done by Richard Schechner's Performance Group in a converted garage at 33 Wooster Street, October 11, 1968. **BOTTOM LEFT:** Richard Schechner, director of the Performance Group, October 18, 1969. **BOTTOM RIGHT:** The Performance Group, founded in November 1967, is exploring techniques of environmental theatre, confrontation, and ritual. Informal seating in the Performance Garage, 33 Wooster Street. Viewers watch Dionysus in '69, October 11, 1968.

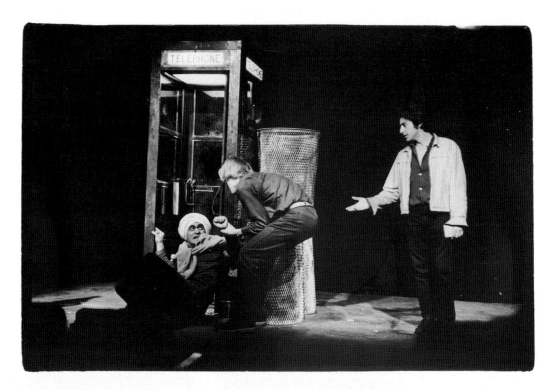

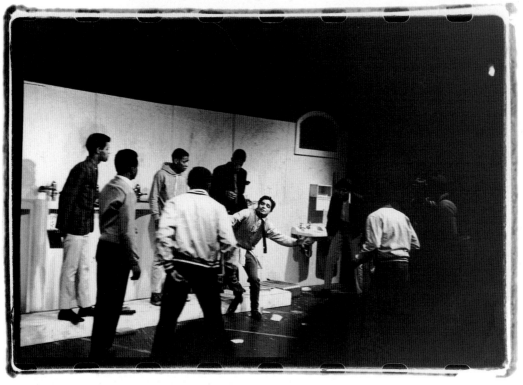

TOP: In his first major role, Al Pacino was featured in Israel Horovitz's *The Indian Wants the Bronx,* at the Astor Place Theatre, 434 Lafayette Street, February 27, 1968. **BOTTOM:** Jamie Sanchez being harassed by classmates in LeRoi Jones' play *The Toilet,* at St. Marks Playhouse, Second Avenue and 8th Street, December 13, 1964. The play was directed by Leo Garin.

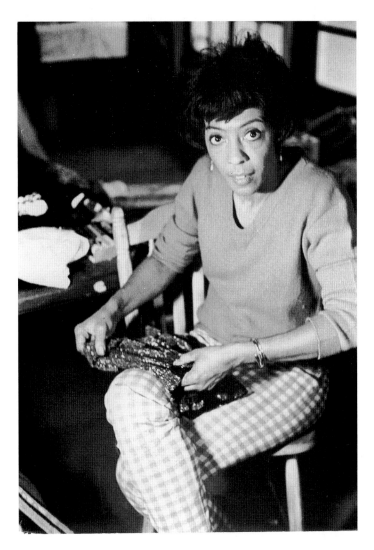

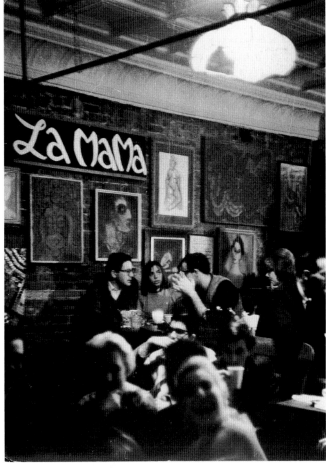

ABOVE: Ellen Stewart repairing costumes in Café La Mama, November 20, 1965. Her theatre opened in the basement at 321 East Ninth Street in 1963. **RIGHT:** The La Mama Experimental Theatre Club (E.T.C.) under the directin of Ellen Stewart at 122 Second Avenue, November 20, 1965.

TOP: Edward Albee presented with an Obie Award by Jerry Tallmer for his play *The Zoo Story*, May 21, 1960.
BOTTOM: Harold Pinter in a rehearsal of his plays *The Dumbwaiter* and *The Collection* at a Ukranian Orthodox church, East 11th Street, November 8, 1962.

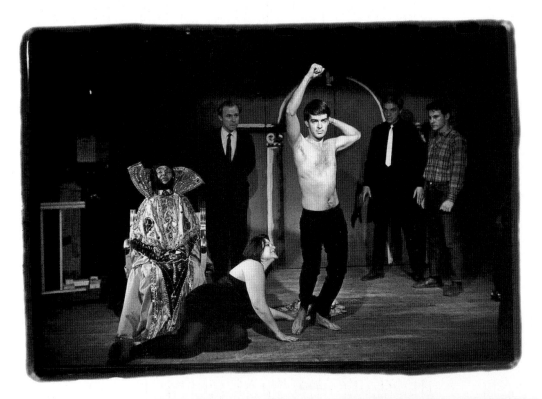

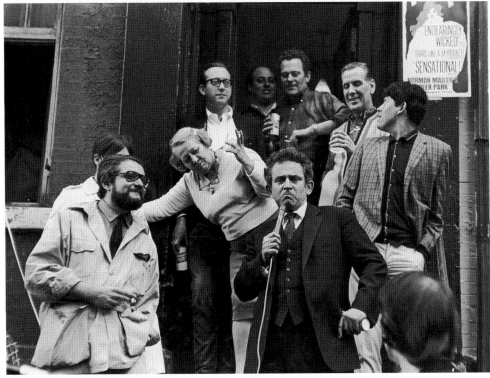

TOP: A scene from Paul Foster's *The Madonna in the Orchard* at Café La Mama, November 20, 1965—left to right: Hortense Alden (in chair), Blanche Dee (on floor), George Bartenieff, Hector Elizondo, Carl Schenzer, Harvey Keitel. BOTTOM: Norman Mailer at street party across from Theatre De Lys, 121 Christopher Street, April 30, 1967, to celebrate 100th performance of his play *The Deer Park*, directed by Leo Garin, left.

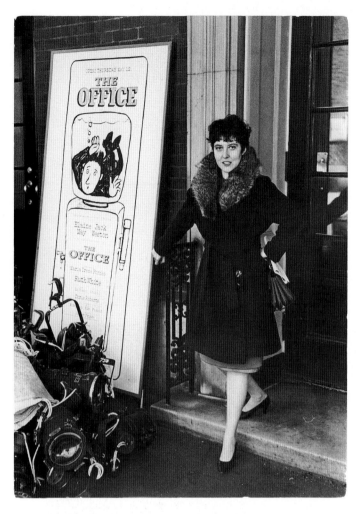

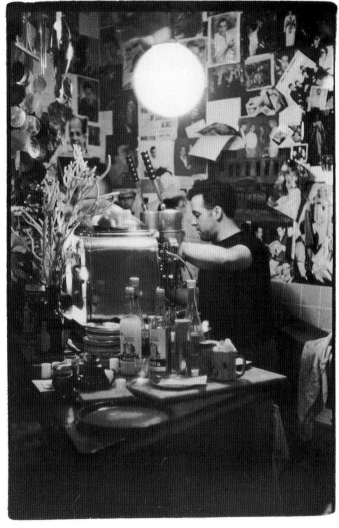

ABOVE: Maria Irene Fornes posing with billboard announcing her play *The Office* at the Henry Miller Theatre, April 16, 1966. **RIGHT:** Joe Cino ran the Off-Broadway Café Cino at 31 Cornelia Street until his place burned to the ground. Cino is at the espresso machine, March 19, 1966.

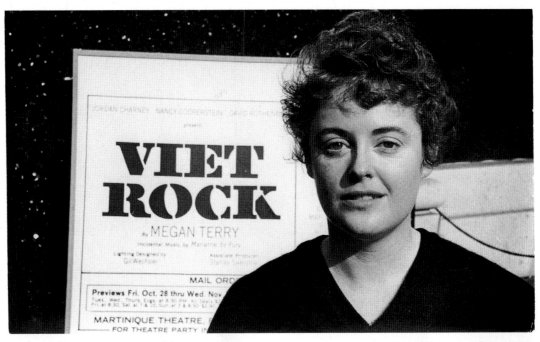

TOP: Playwright Megan Terry, author of anti-war play *Viet Rock*, October 29, 1966. **BOTTOM LEFT:** Playwright Israel Horovitz, February 23, 1968. **BOTTOM RIGHT:** Playwright Jean-Claude Van Itallie, October 29, 1966.

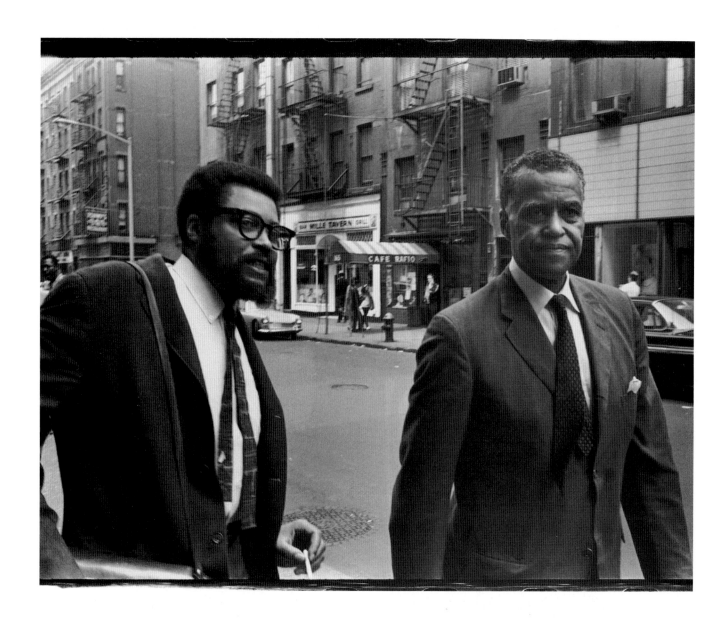

Shakespearean actors James Earl Jones with his father Robert Earl Jones on Bleecker Street on their way to the Village Voice 10th Obie Awards at the Village Gate, May 25, 1965.

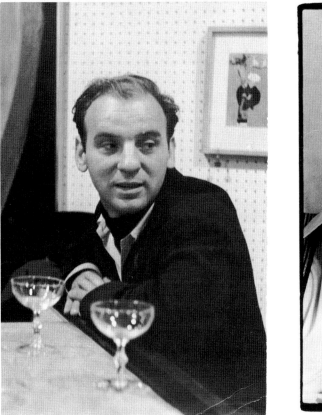

CLOCKWISE FROM TOP LEFT: Joe Chaikin, director of *American Hurrah*, August 30, 1962. • Warren Finnerty, actor, featured in *The Connection* at the Obies, May 21, 1966. • Charles Ludlum, March 23, 1972, founder of the Ridiculous Theatrical Company, 1 Sheridan Square. • Jack Gelber, November 24, 1964. He wrote the award-winning play *The Connection*, a "jazz play" in which a group of heroin addicts are awaiting a "connection" to bring them drugs.

Hugh Romney, Moondog, Tiny Tim perform in a Greenwich Village Review, July 2, 1963, at Fat Black Pussycat Café, 13 Minetta Street.

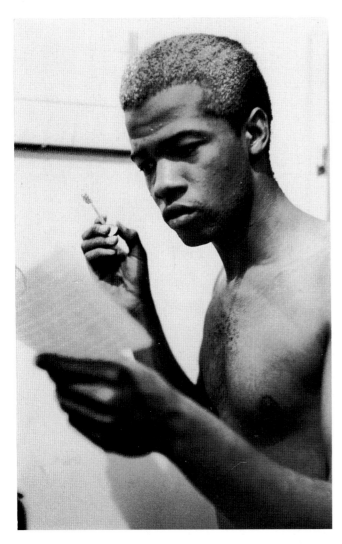

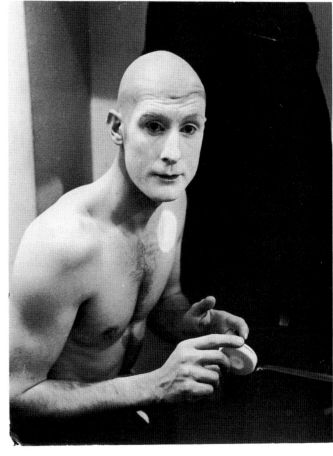

ABOVE: John O'Neal of Free Southern Theatre played Lucky in *Waiting for Godot*, February 10, 1965. This itinerant theatre group played mostly in Mississippi. "We want to provide an atmosphere in which people can speak and think for themselves." **RIGHT:** James Cromwell played Posso in *Waiting for Godot* at Free Southern Theatre, February 10, 1965. They gave a performance at the New School, 66 West Twelfth Street.

 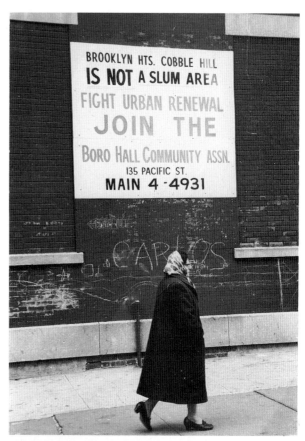

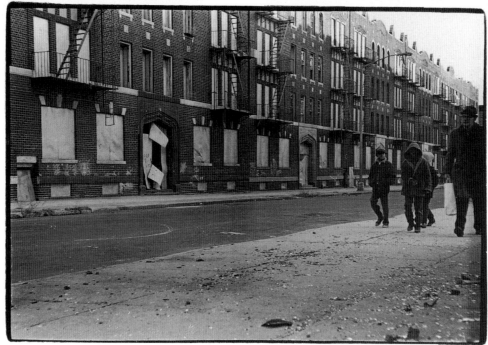

ABOVE LEFT: Abandoned building, Powell Street, January 4, 1969. **ABOVE RIGHT:** Billboard on Atlantic Avenue, November 2, 1962. **BOTTOM:** Abandoned buildings on Powell Street near Riverdale Avenue, Brooklyn, January 4, 1969.

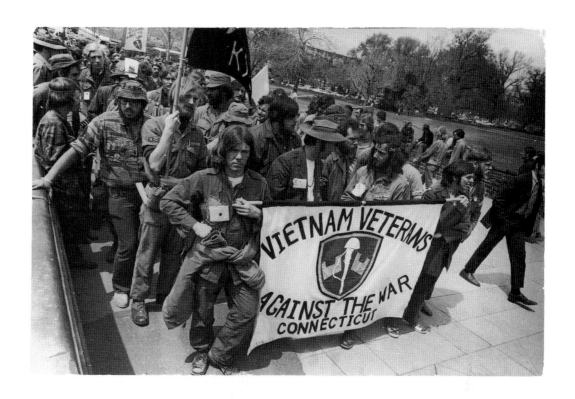

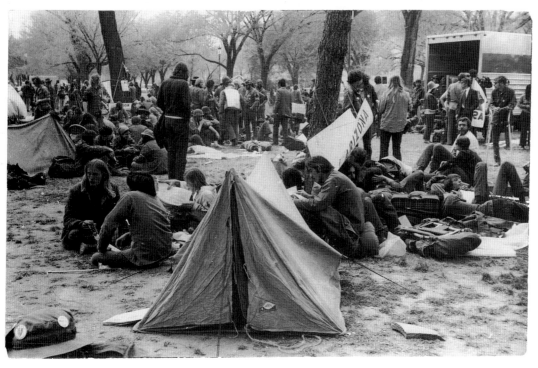

TOP: Veterans across the country converged on Washington, April 23, 1971. **BOTTOM:** Viet Vets sign-up camp in park, April 23, 1971, for "Operation Dewey Canyon."

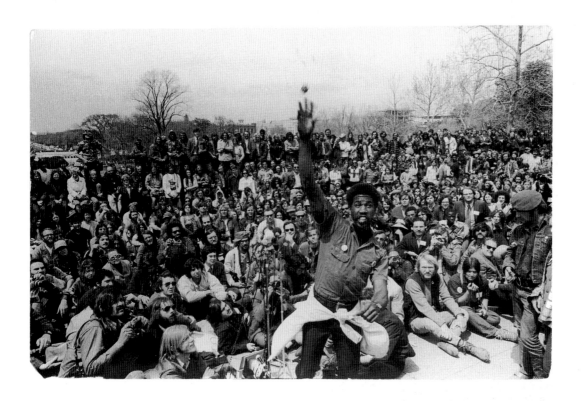

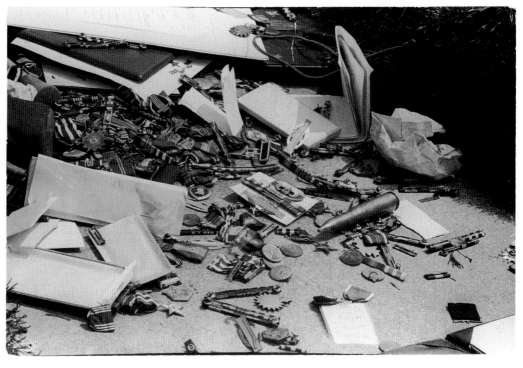

TOP: Veterans sending medals back to Congress, April 23, 1971. **BOTTOM:** Pile of medals thrown back at the Capitol, April 23, 1971.

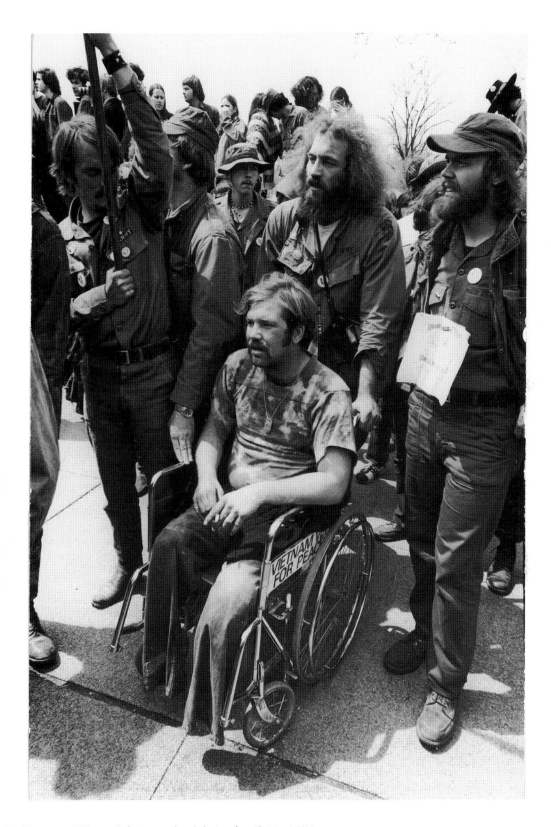

After the Vietnam War, a life in a wheelchair, April 23, 1971.

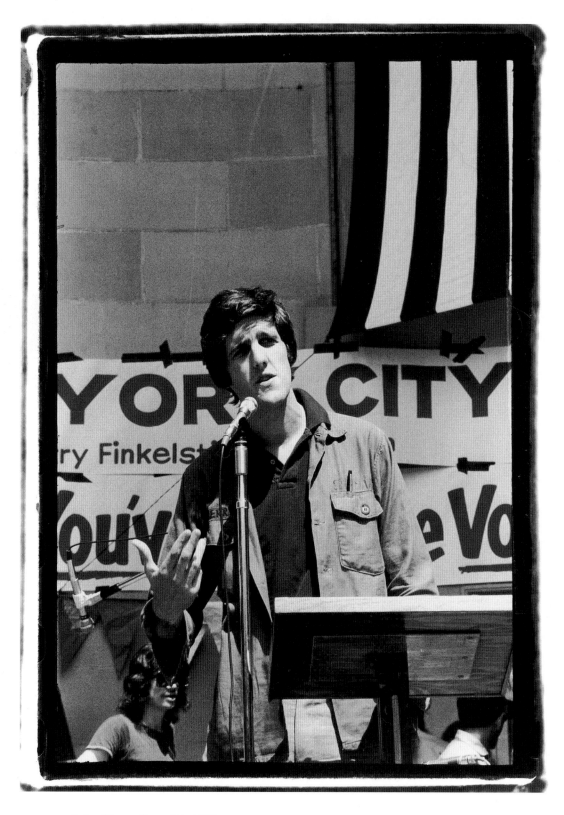

Vietnam veteran John Kerry, June 16, 1971.

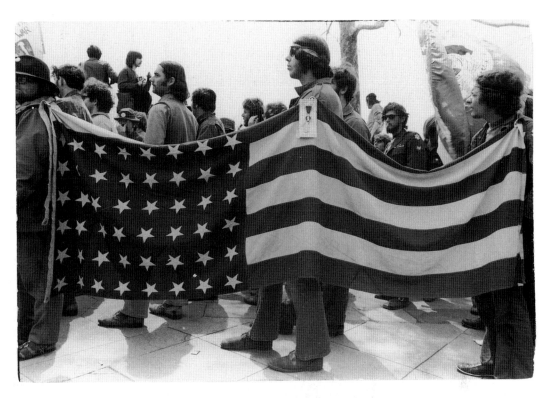

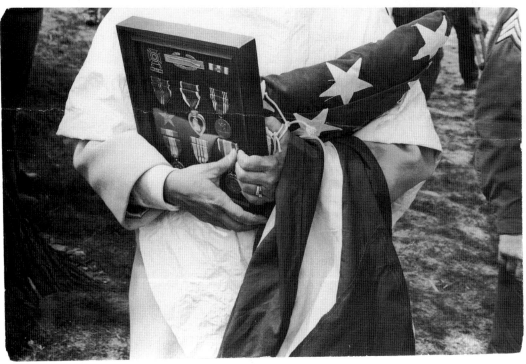

TOP: Old Glory with a Purple Heart, April 23, 1971. **BOTTOM:** Mother with her son's medals, April 23, 1971.

The cost of war, Veterans Administration Hospital, First Avenue, New York City, June 1, 1971—left: John Diakoyani and Bill Wyman lost their legs, Al Caracciolo lost his sight.

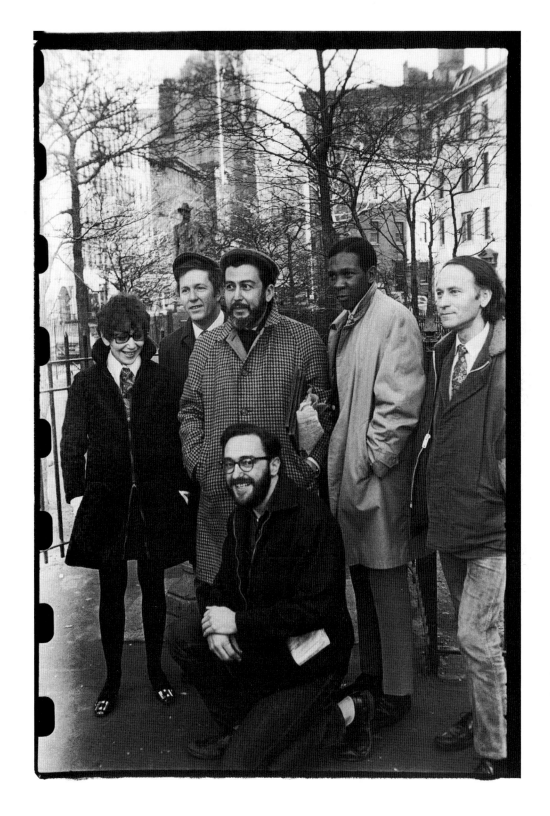

Writers, critics, columnists of the *Village Voice*, December 21, 1967—left to right: Margo Hentoff, Mike Harrington, Nat Hentoff, Carmen Moore, Jonas Mekas, Ross Wetzsteon (kneeling).

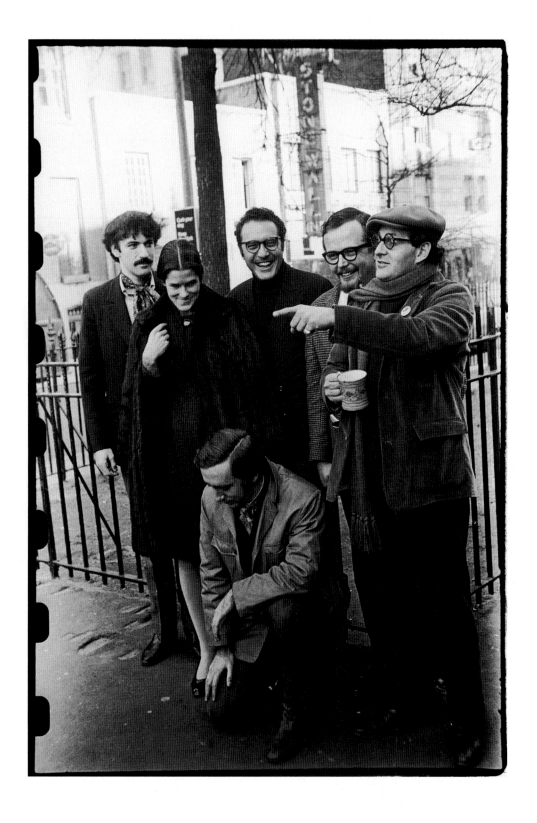

Writers, critics, columnists of the *Village Voice*—left to right: Howard Smith, Deborah Jowitt, Mike Zwerin, Joe Flaherty, Dan List, John Perreault, December 21, 1967.

CLOCKWISE FROM TOP LEFT: Opera critic, Leighton Kerner, October 1, 1971. • Theatre critic, Michael Smith, July 30, 1964. • City Editor, Mary P. Nichols, January 7, 1966. • Reporter Richard Goldstein, June 10, 1966, is probably the most versatile writer on the paper.

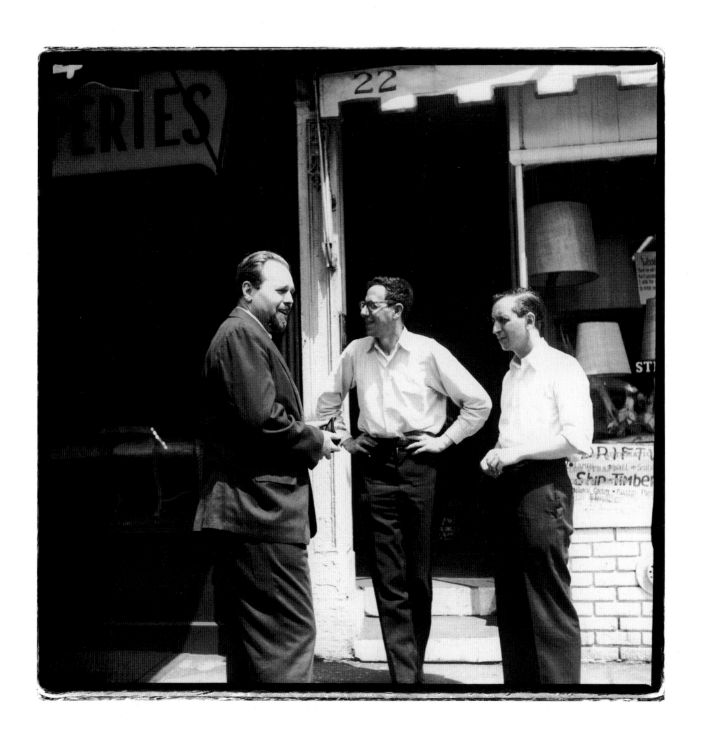

Publisher Edwin Fancher, theatre editor Jerry Tallmer, editor Daniel Wolf in front of 22 Greenwich Avenue, first *Village Voice* office, August 20, 1969.

CLOCKWISE FROM TOP LEFT: Founding member John Wilcock in front of *Village Voice* office, Sheridan Square, October 3, 1962, wrote "The Village Square" column for ten and a half years, then worked briefly at the *East Village Other,* went to work for the LA *Free Press* and eventually became a travel writer. • Bill Manville wrote "Saloon Society" column and at one time was married to the author, Nancy Friday. • Investigative reporter, Jack Newfield, February 3, 1968. • Fashion editors Stephanie Harrington and Blair Sabol (right), January 27, 1968.

Lucian K. Truscott IV, 1969 West Point graduate, novelist, screenwriter, reporter, November 28, 1969.

ABOVE: Cartoonist and writer, Jules Feiffer, October 8, 1963. RIGHT: Film critic, Andrew Sarris, August 22, 1963.

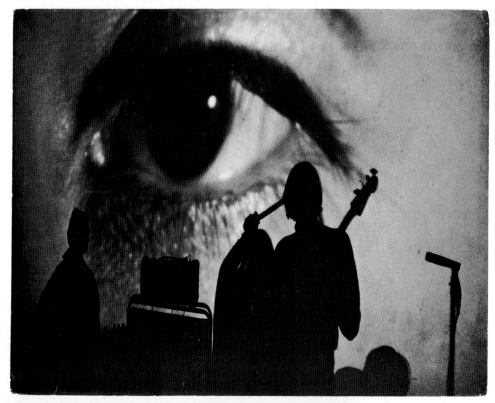

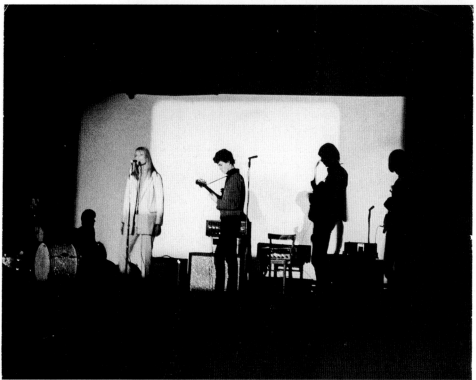

TOP: The Mysterious Eye of the Velvet Underground, April 1, 1966. **BOTTOM:** Maureen Tucker, Nico, Lou Reed, Sterling Morrison, John Cale, The Velvet Underground, performing at the Filmmakers Cinematheque, New York City, February 8, 1966.

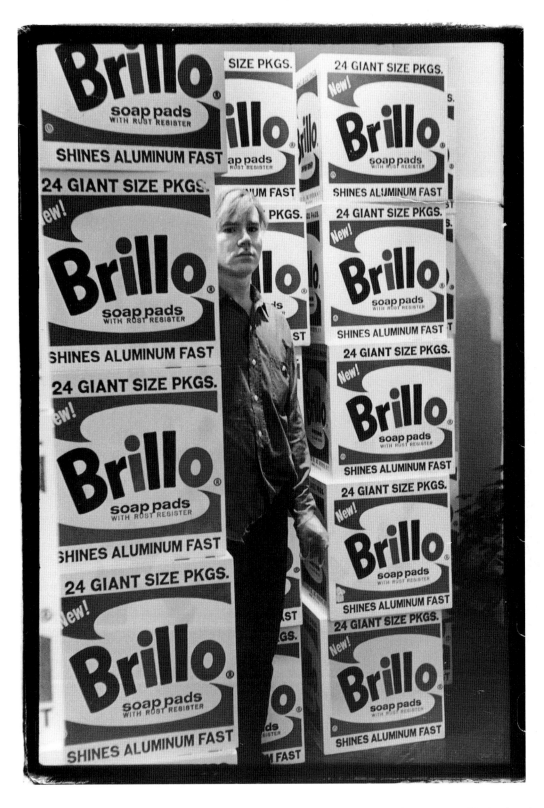

Andy Warhol amid Brillo box sculptures at the Stable Gallery, 33 East 74th Street, New York, April 21, 1964.

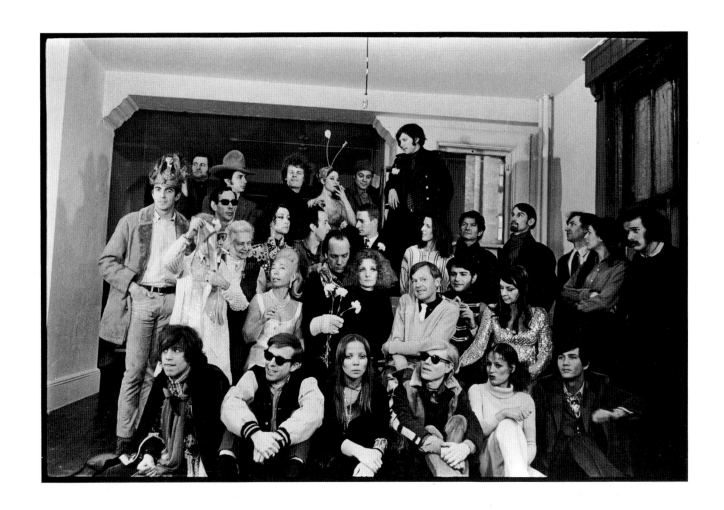

Friends of The Factory, Union Square, March 6, 1968, pose for Charles Henri Ford's book of poetry, *Silver Flower Koo*. **Bottom row, left to right:** Jonathan Lieberson, Andreas Brown, Penelope Tree, Andy Warhol, Catherine Milinaire, Jason Fishbein **Second row:** Lil Picard, Frances Steloff, Lita Hornick, Al Hansen, Viva, Charles Henri Ford, Kenneth King, Ruth Ford **Third row:** Bruce Miller, Buddy Wurthshafter, Ultra Violet, Taylor Mead, Jack Smith, Sally Chamberlain, Wynn Chamberlain, Ron Zimardi, Ken Jacobs, Florence Jacobs, Maurice Hogenbaum **Back row:** Bob Cowan, Fred Hughes, Paul Morrissey, Donna Kerness, John Wilcock, Willoughby Sharp

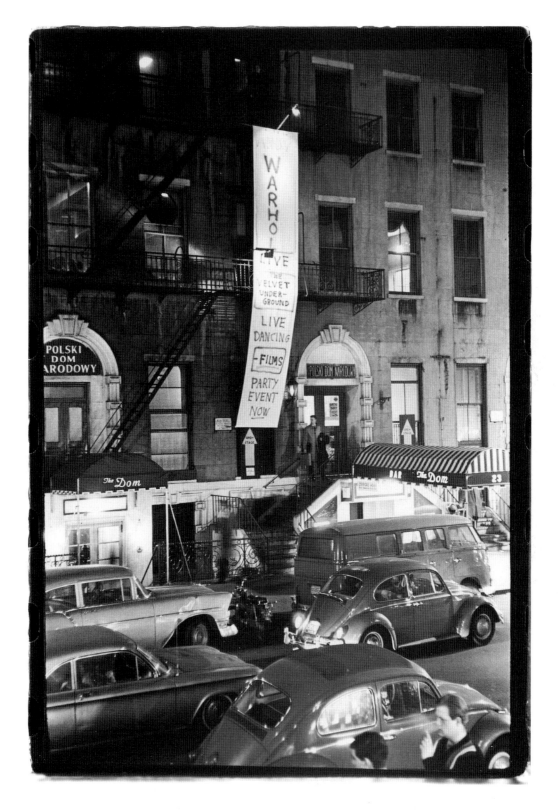

The Dom, 23 St. Marks Place, location of Andy Warhol's "Exploding Plastic Inevitable" with live perform-
ance and dancing by the Velvet Underground.

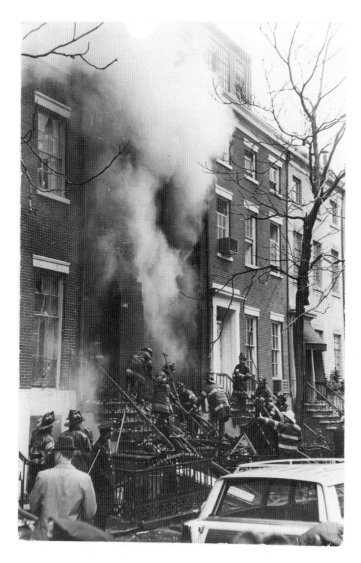

ABOVE: Weathermen accidentally blew up townhouse, 18 West Eleventh Street, March 6, 1970. The revolutionary anti-war group was "determined to overthrow the government believing it had criminally waged war in Vietnam and persecuted the Black Panthers." RIGHT: Dustin Hoffman's house at 16 West Eleventh Street was severely damaged from the "Bomb Factory" next door.

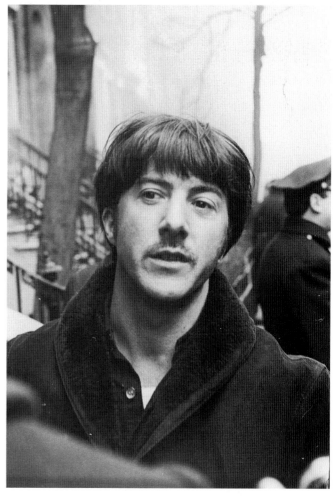

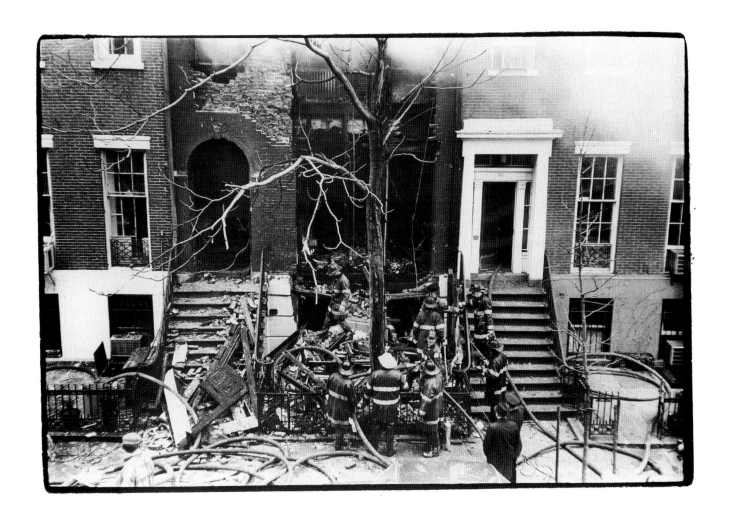

Radical bombers blow up townhouse, 18 West Eleventh Street, March 6, 1970, Ted Gold, Diana Oughton, and Terry Robbins are killed.

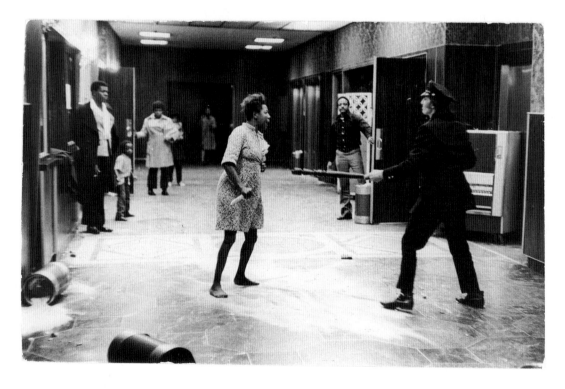

TOP: Broadway Central Hotel, March 4, 1964, 673 Broadway, once a honeymoon hotel later catered to welfare families. BOTTOM: Welfare mother and a security guard have a fierce battle in the lobby of the Broadway Central Hotel, November 18, 1970.

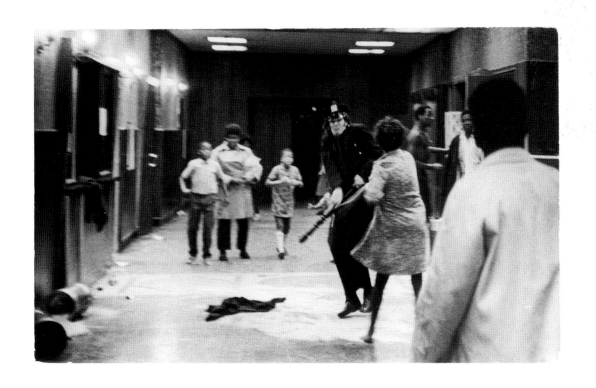

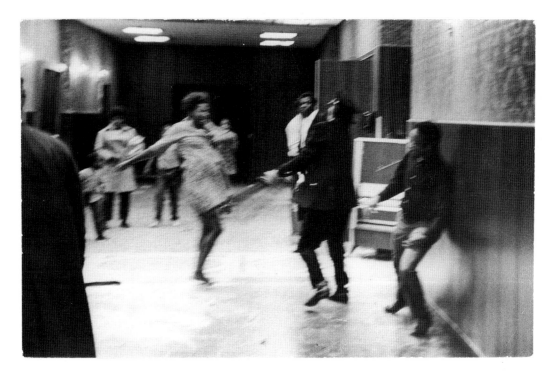

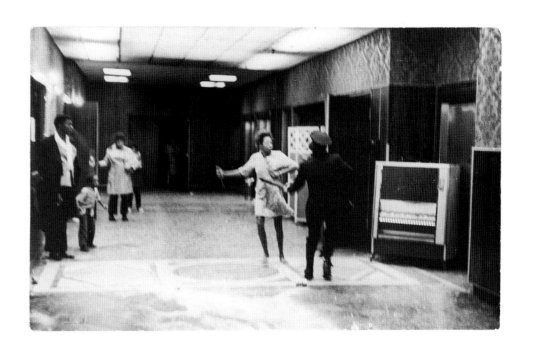

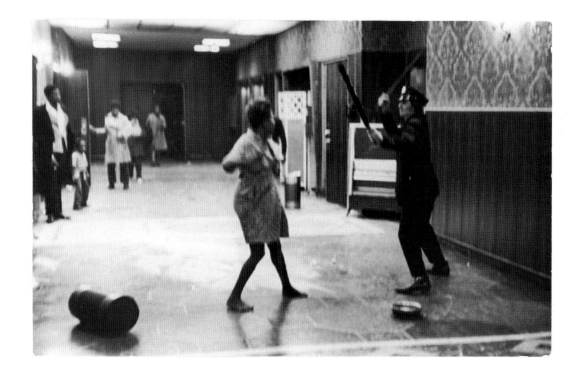

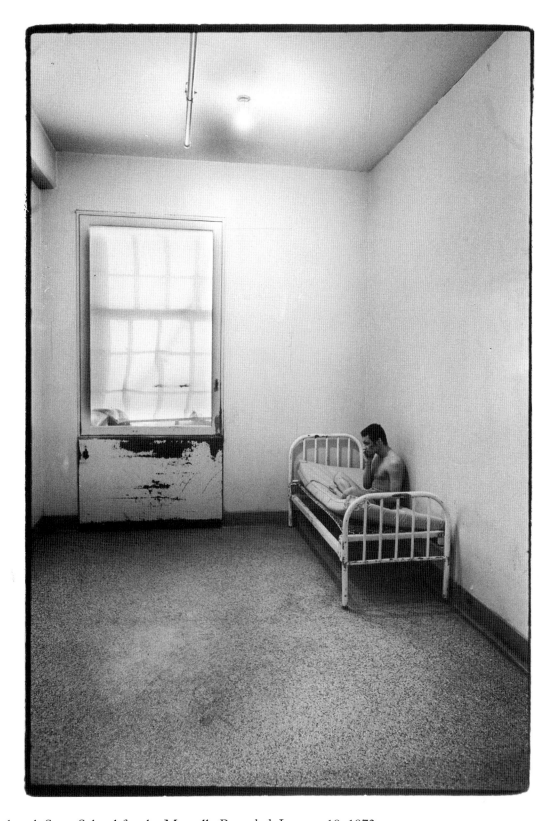

Willowbrook State School for the Mentally Retarded, January 19, 1972.

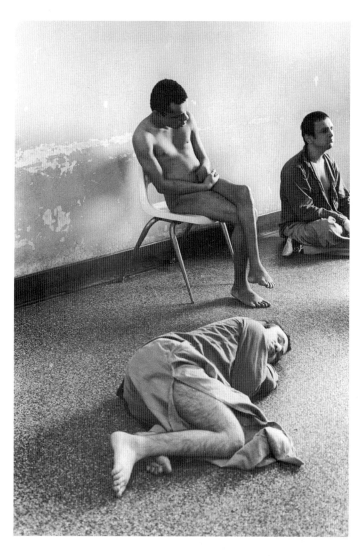

ABOVE: Willowbrook Day Room, January 19, 1972. RIGHT: Willowbrook State School for the Mentally Retarded, January 19, 1972.

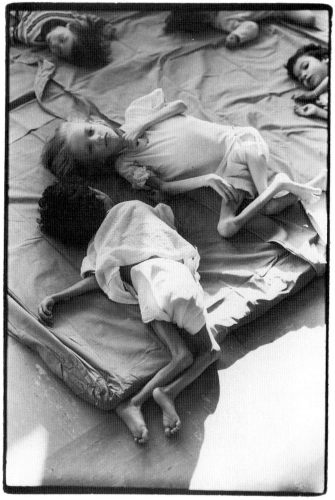

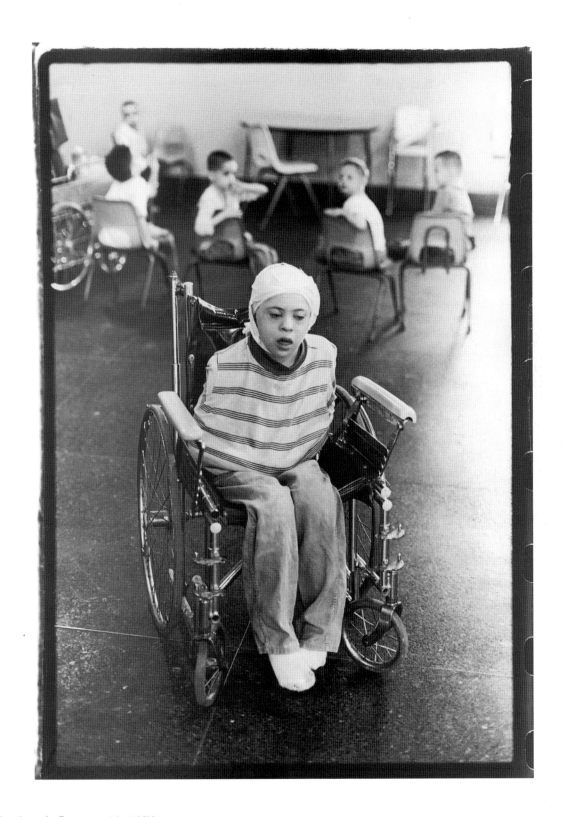

Willowbrook, January 19, 1972.

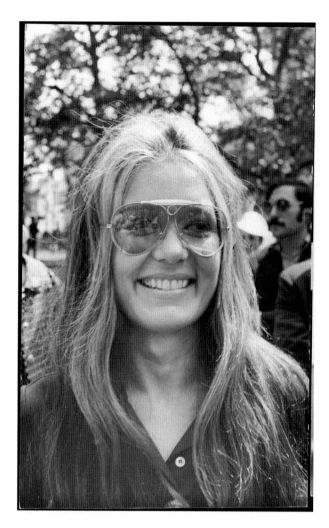

ABOVE: Gloria Steinem in City Hall park for women's rights demonstration, August 22, 1970. She was called the "pin-up girl of the intelligentsia." In 1963 she published "I Was a Playboy Bunny" in *Show* Magazine. RIGHT: Playboy Bunny in training, November 24, 1962.

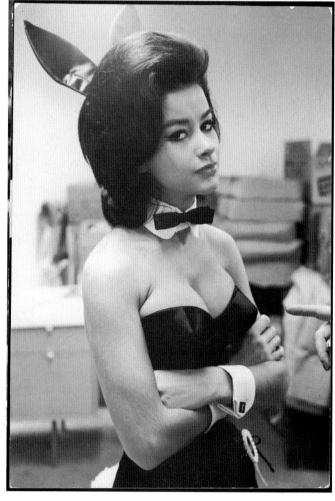

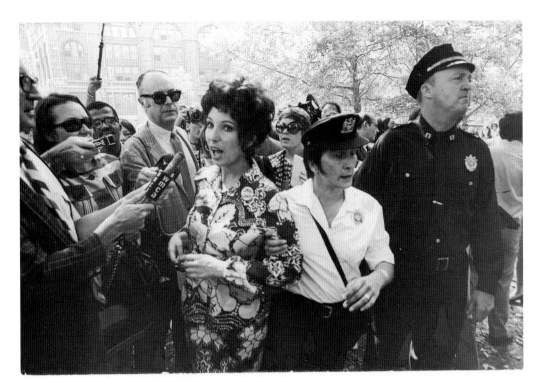

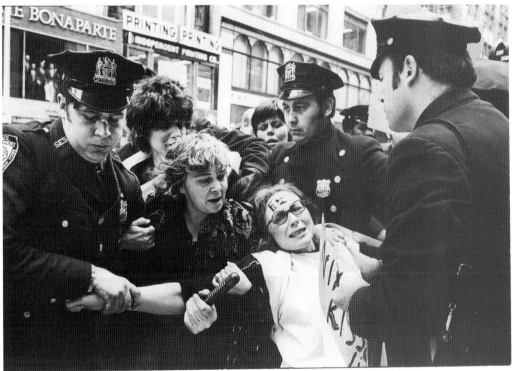

TOP: Lucy Komisar seeking equal rights for women is escorted by police from City Hall park, August 26, 1970.
BOTTOM: Ti-Grace Atkinson being arrested on Madison Avenue at a "Kiss-off-Nixon" demonstration, October 23, 1972. Atkinson was active in the passing of the New York State abortion law in 1970.

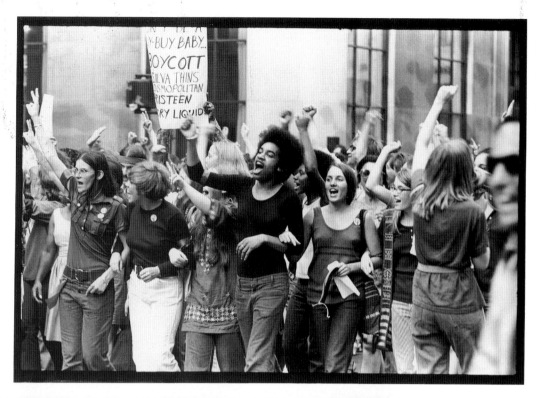

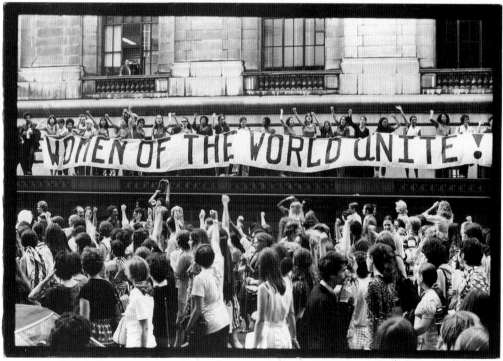

TOP: Women marched on Fifth Avenue, August 26, 1970, to demand equal rights and free abortions on demand. **BOTTOM:** A record umber of women marched up Fifth Avenue, August 26, 1970, to commemorate the 50th Anniversary of women's suffrage.

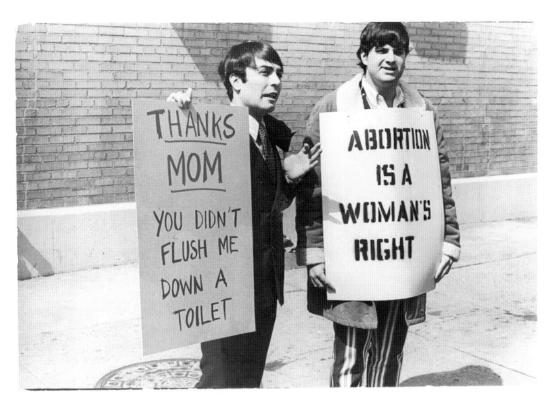

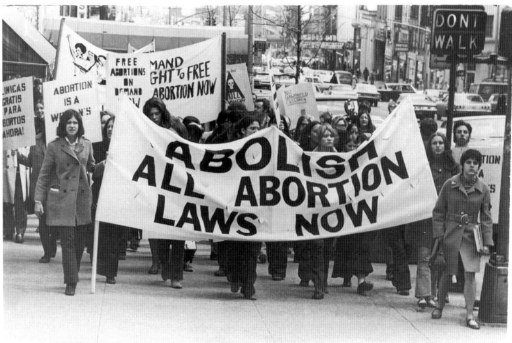

TOP: Two points of view at an abortion rally, March 28, 1970. BOTTOM: New York radical feminists in a march to Union Square, March 28, 1970, declare that abortion is a woman's right.

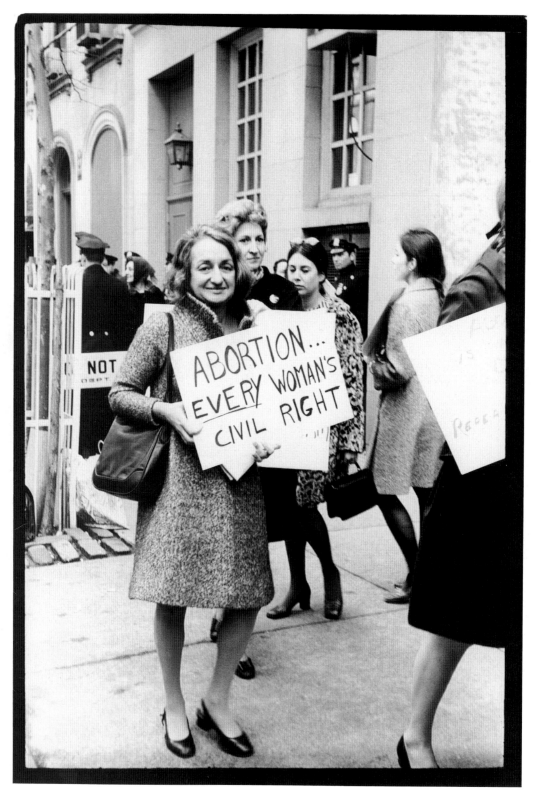

Betty Freidan on West 54th Street in front of Governor Nelson Rockefeller's office on March 21, 1969.

Susan Brownmiller and Sally Kempton on the *Dick Cavett Show*, April 2, 1970, waiting to confront Hugh Hefner and the Playboy Bunny.

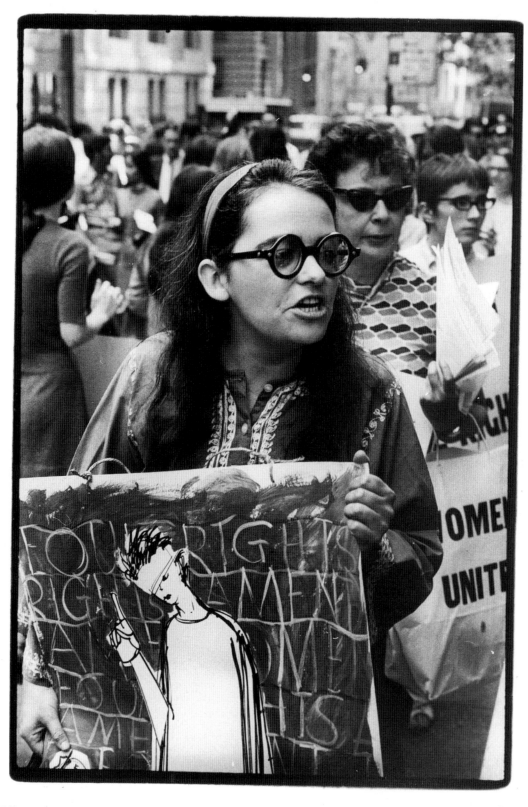

Kate Millett marches in front of New York Stock Exchange in support of "Equal Rights for Women Now," August 22, 1970.

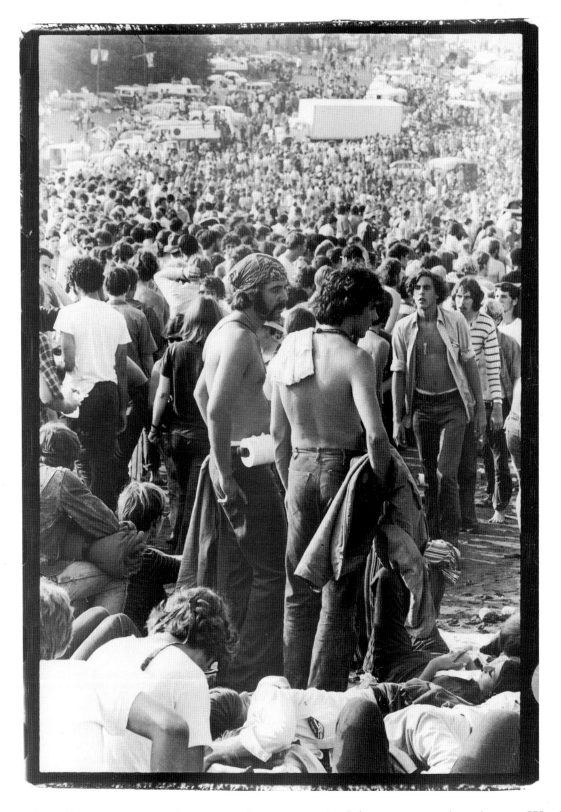

In "three days of peace and music," over thirty bands entertained from sunup until sundown at Woodstock, August 16, 1969.

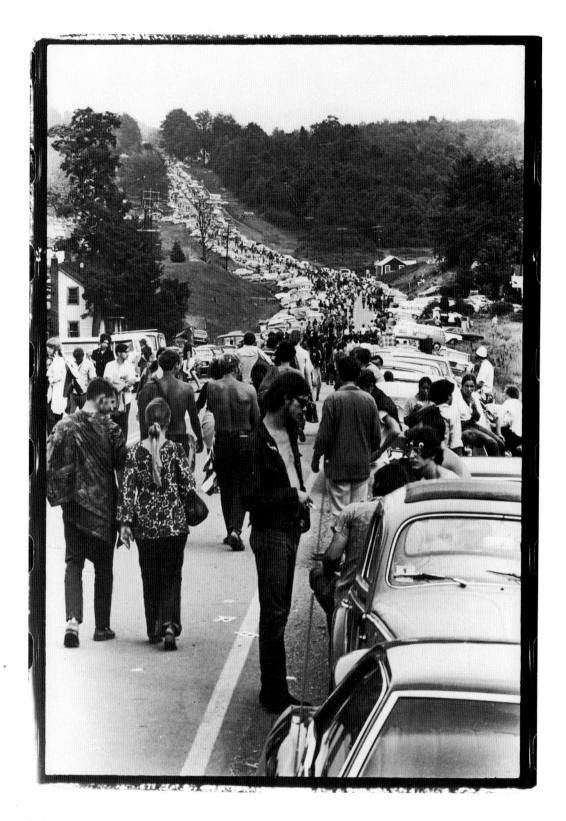

The crowds kept coming for three days to the Woodstock Festival, August 15, 1969. The music and art fair was "an Aquarian Exposition in White Lake, New York—3 Days of Peace and Music."

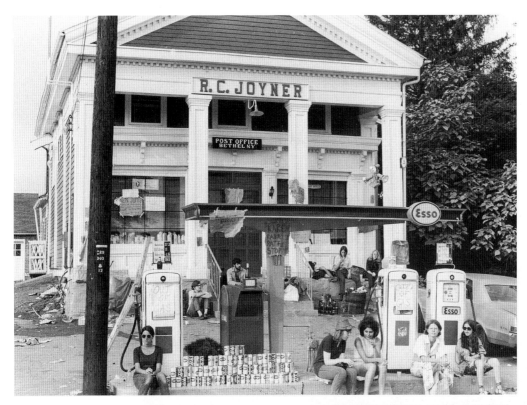

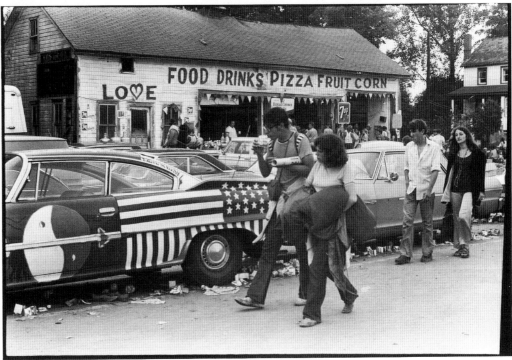

TOP: Woodstock Festival, August 16, 1969, was actually in White Lake town of Bethel, New York, in Sullivan County. BOTTOM: Fans came to the Woodstock Festival, August 15, 1969, for the quality acts—Jimi Hendrix, Joan Baez, Janis Joplin, The Who, Richie Havens, Arlo Guthrie.

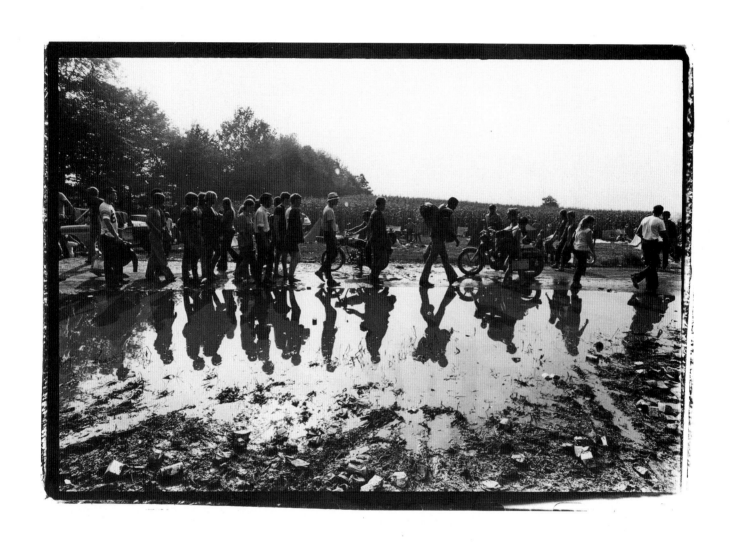

The rain and mud was relentless at the Woodstock Festival, August 15, 1969.

CLOCKWISE FROM TOP LEFT: David Halberstam, Vietnam authority, at a peace rally, April 5, 1969. • Claudia Dreifus in Union Square, March 28, 1970. • *Nation* editor Victor Navasky at a Eugene McCarthy fundraiser, August 15, 1968. • Commentary editor Norman Podhoretz at the 34th International P.E.N. Congress at N.Y.U., June 14, 1966.

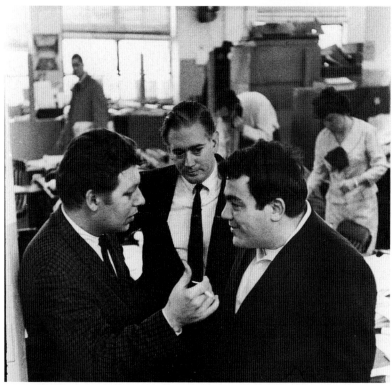

TOP: *New York Post* reporter Al Aronowitz (left) and Steve Paul, disco owner of "The Scene," at a rock concert, January 27, 1970. BOTTOM: Pete Hamill (left), Clay Felker (center), and Jimmy Breslin (right) at the *World Herald Tribune* office the day the newspaper folded, May 5, 1967. Felker later started *New York* magazine, Hamill and Breslin became tabloid columnists.

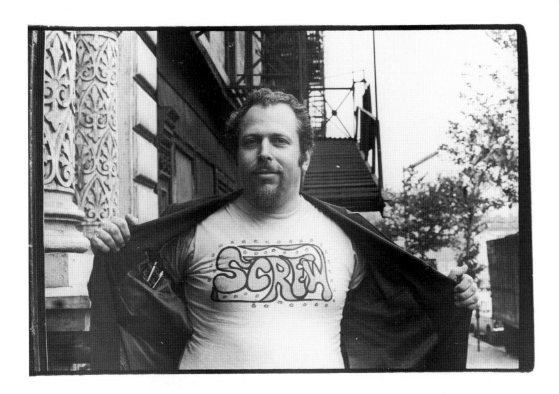

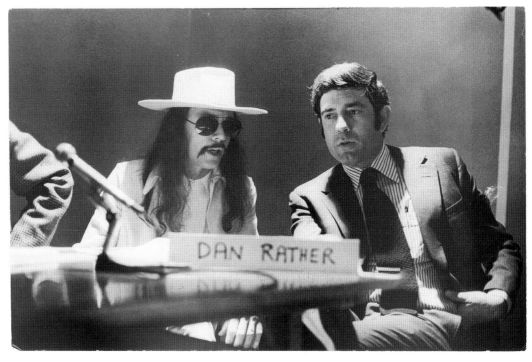

TOP: Al Goldstein, editor of *Screw* flashes his T-shirt as he leaves the Chinatown police station, June 26, 1969.
BOTTOM: Tom Forcade, editor of *High Times,* and TV anchor Dan Rather on a "MORE" Panel, April 23, 1972, to discuss the alternate press.

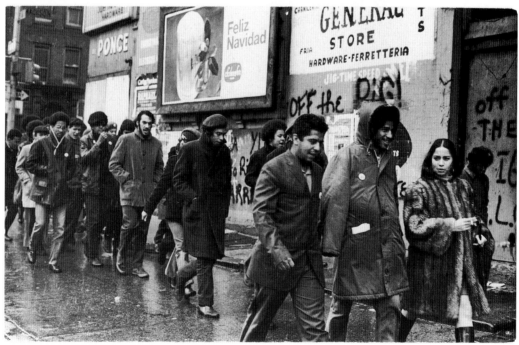

TOP: A Young Lord makes sign soliciting bail fund contributions at a Randall's Island fundraiser, July 17, 1970.
BOTTOM: Young Lords marching through the neighborhood—Carlos Feliciano, Juan Gonzalez.

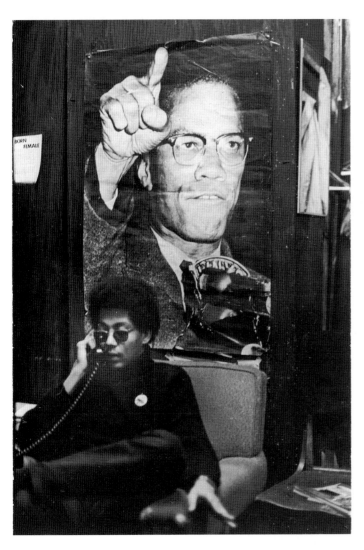

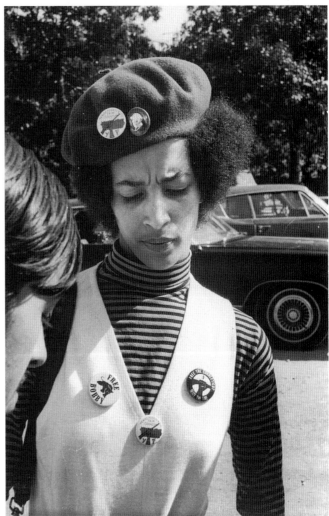

ABOVE: Pablo Yoruba Guzman of the Young Lords discussing strategy on the phone. **RIGHT:** Denise Oliver, information minister of the Young Lords, on Randall's Island, July 7, 1970.

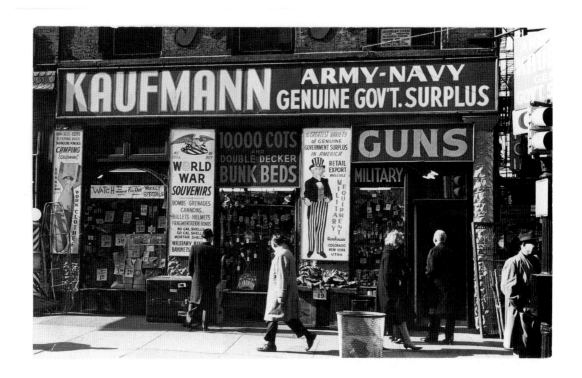

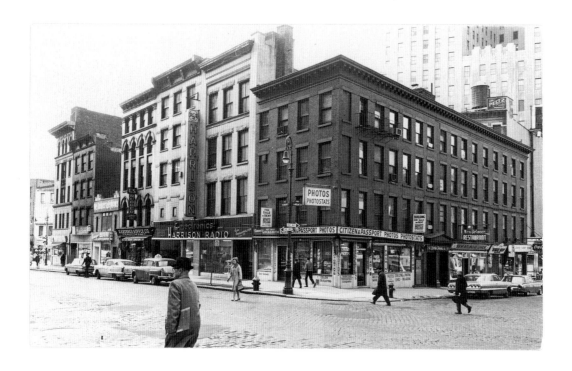

TOP: Popular army and navy goods store, Greenwich at Courtland Streets, November 13, 1963. **BOTTOM:** View southwest corner of Barclay and West Broadway, November 13, 1963, later the site of the World Trade Center.

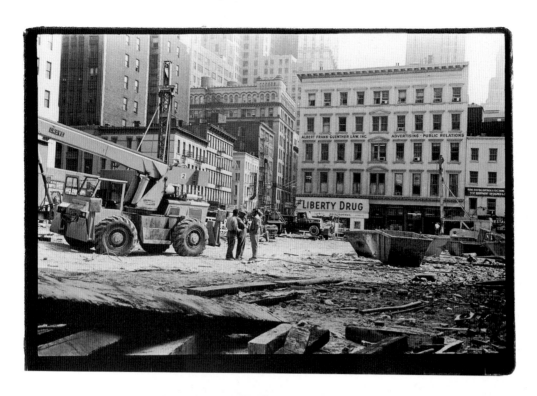

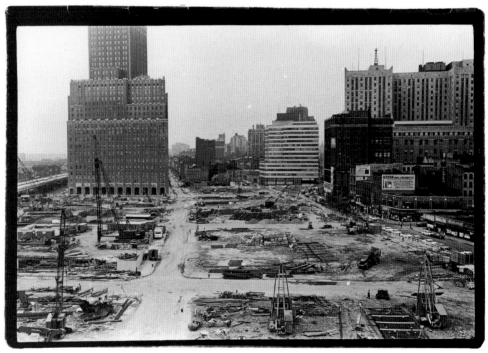

TOP: The advertising agency at 61 Broadway and Liberty Street seen here on June 123, 1967 became part of the World Trade Center site. BOTTOM: Looking north, August 24, 1967, at the site of the World Trade Center showing total demolition of ten block area—New York Telephone, 140 West Street, and elevated West Side Highway on the upper left.

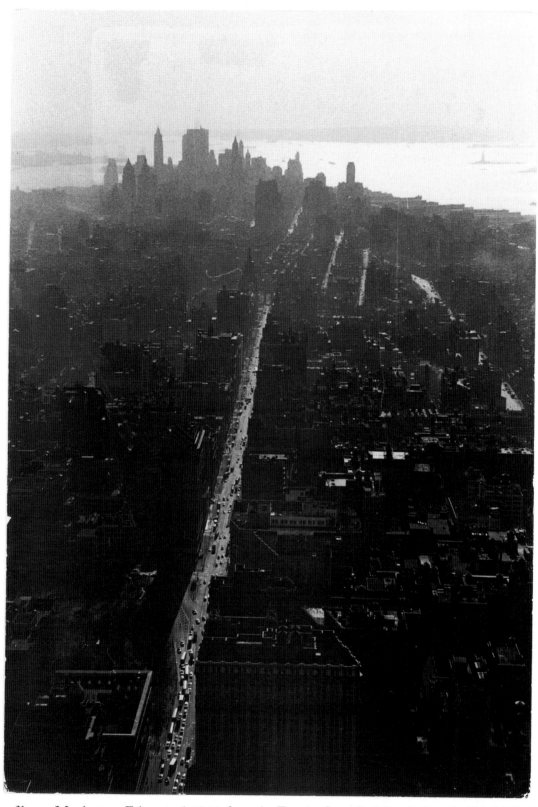

Skyline of lower Manhattan, February 5, 1964, from the Empire State Building before the World Trade Center was built.

Biographies

RALPH D. ABERNATHY, REV. was a civil rights activist, a black clergyman who came to prominence after organizing a bus boycott in Montgomery, Alabama, in response to the 1955 arrest of Rosa Parks for not giving up her seat on a bus to a white passenger. He was a trusted aide to Rev. Martin Luther King, Jr., and after King was killed in 1968, assumed leadership of the Southern Christian Leadership Conference (SCLC), a position he held for ten years.

BELLA ABZUG, as a founding member of the modern feminist movement, spent much of her life in front of a podium or leading a protest march. One of the first women to graduate from Columbia University's law school, she created Women Strike for Peace in 1961, to protest the Vietnam War. In 1970, with the slogan "This woman's place is in the House—the House of Representatives," she became the first Jewish woman member of Congress.

SPIRO AGNEW was President Richard M. Nixon's vice president in 1968 and again in 1972. Agnew resigned from office in 1973 following allegations of bribery and income tax evasion committed while he was governor of Maryland between 1966 and 1968. During his vice presidency he developed a reputation as an aggressive spokesman, lashing out at political opponents, student protesters, the media and left-leaning intellectuals in harsh, often personal attacks.

EDWARD ALBEE was established as a leading young dramatist when his first three-act play, *Who's Afraid of Virginia Woolf?*, was produced on Broadway in 1962. His earlier one-act experimental dramas, including *Zoo Story, The Death of Bessie Smith, The Sandbox,* and *The American Dream,* explored such themes as American racism, and the alienation and disillusionment of modern life. In 1967 his *A Delicate Balance* won the first of his three Pulitzer Prizes.

MUHAMMAD ALI, born Cassius Marcellus Clay, a three-time world heavyweight boxing champion, aroused controversy when he changed his name and refused induction into the U.S. Army. "I ain't got no quarrel with them Viet Cong," he said. Four years later he knocked out Sonny Liston for the world heavyweight title. Asked to explain his second knockout of Liston in a 1965 rematch, Ali replied, "I float like a butterfly, and sting like a bee."

WOODY ALLEN, screenwriter, director and actor, achieved celebrity with his first film comedy, *What's New Pussycat?*. Allen's first play, *Don't Drink the Water* (1966), ran on Broadway for over a year. *Take the Money and Run* (1969) was the first of many films in which Allen would write, direct and star. His comedy is primarily autobiographical, with Allen portraying a wisecracking, skinny, sandy-haired loser, who against all odds manages to win the girl.

LAWRENCE ALLOWAY, an English-born art critic and historian, was a curator at New York's Guggenheim Museum from 1962 to 1966. He is credited with coining the term Pop Art, short for popular art, to characterize works by young artists inspired by consumer products, such as Roy Lichtenstein's comic book images and Andy Warhol's soup cans.

RICHARD ALPERT (later Baba Ram Dass) was the son of a railroad executive and lawyer who was a founder of Brandeis University. As a Harvard professor, Alpert's explorations of human consciousness led him to conduct research with LSD and other psychedelic drugs, in collaboration with Timothy Leary, Aldous Huxley, Allen Ginsberg, and others. Because of the controversial nature of this research, Alpert and Leary were dismissed from Harvard in 1963. Then he famously traveled to India where he adopted his new name and a more spiritual lifestyle.

DAVID AMRAM, a prolific avant garde composer and musician, has had a distinguished career in concerts, television, and film. Since being appointed first composer-in-residence with the New York Philharmonic for its 1966-67 season, he has conducted symphony orchestras around the world and performed as a soloist on the French horn, piano, guitar, numerous flutes and whistles, percussion, and a variety of folkloric instruments from twenty-five countries.

AL ARONOWITZ was the first print journalist to write seriously about the Beat Generation as a literary movement. He is also credited with introducing many pop stars to the public.

JOHN ASHBERY is the author of over twenty works of poetry, including *Self-Portrait in a Convex Mirror* (1975), which received the Pulitzer Prize for Poetry, the National Book Critics Circle Award, and the National Book Award. He was also awarded a MacArthur Foundation genius award. For many years starting in 1965 he was an influential art critic for *New York* and *Newsweek*.

TI-GRACE ATKINSON, a prominent feminist, was president of the New York chapter of NOW (National Organization for Women). However, she resigned in 1968 to protest the group's traditional hierarchical structure. She was a strong supporter and active in the passing of the New York State abortion law in 1970.

W. H. AUDEN, a British born poet and novelist, moved to New York City in 1939. He edited volumes of poetry, taught at a number of colleges, and also wrote libretti for operas. His 1947 novel, *The Age of Anxiety*, won the Pulitzer Prize.

JOAN BAEZ, the first lady of the 1960s folk music scene, has been a liberal and vocal social activist. As a teenager, she was an overnight sensation after her appearance at the 1959 Newport (California) Folk Festival. By the time she headlined opening night at Woodstock ten years later, she had become an icon of the era. Her songs articulated the exhilaration, conflict, yearnings, and turbulence of the Sixties with womanly strength, intelligence, and complexity.

JAMES A. BALDWIN became the preeminent black literary voice of the civil rights movement after the critical and commercial success of his 1963 best seller *The Fire Next Time*, a brilliant essay on the history of black protest. Openly gay, he also was outspoken in condemning discrimination based on sexual orientation.

IMAMU AMIRI BARAKA (born Everett LeRoi Jones), is a Black poet and playwright who founded, with his wife Hettie Cohen, the literary magazine *Yugen*, publishing works by Allen Ginsberg, and other Beat writers. He turned away from the white literary community in 1965 after a visit to Cuba and the assassination of Malcolm X, and became an ardent Black Nationalist.

ALFRED BARR, by the time he retired in 1967 after thirty eight years as director of New York's Museum of Modern Art, had achieved a distinguished reputation for making art accessible to a wide audience, and reshaping a traditional institution by adding departments of photography, film, design, and architecture.

GEORGE BARTENIEFF, actor, appeared off-Broadway in *Krapp's Last Tape, The Zoo Story, The Brig,* and *Home Movies.* His credits at the Judson Church

include *Pantagleize, Devices, Promenade, A Beautiful Day, Patter for a Soft-Shoe Dance, Home Movies,* and *Play I Play II Play III.*

MIKHAIL BARYSHNIKOV at the age of eighteen joined the Kirov Ballet, and this gifted Russian dancer won a gold medal at an international competition. Two years later, he was dancing lead roles crafted especially for him. He caused a global sensation when he defected while on tour in Canada in 1974 and joined the American Ballet Theater. As a dancer and choreographer he displays extraordinary musicality and an uncanny ability to inhabit the characters he portrays.

GREGORY BATTCOCK was an art critic, professor of art history, and painter. His writings on avant garde art appeared in *Arts Magazine* and *Domus* (Milan). He was editor of several books, including *The New Art* (1966) and author of *Why Art* (1972 and 1977).

REATHEL BEAN acted in several plays produced at Judson Church. Among them were *Scene from a Street Play* and Moliere's *The Love Cure* directed by Lawrence Kornfeld with music by Al Carmines.

THE BEATLES were the four lads from Liverpool who burst onto the world stage in February 1964 when the band made their American television debut on the Ed Sullivan show; it was the most watched broadcast ever. They returned to the U.S. in 1965 and sold out New York's 55,000-seat Shea Stadium. By any indicator, the Fab Four—John Lennon, Paul McCartney, George Harrison and Ringo Starr—are the most influential and enduring quartet of rock musicians the world has ever seen.

JULIAN BECK was co-founder with his wife, Judith Malina, of the avant garde off-Broadway Living Theatre company, which, from 1951 to 1969, produced landmark productions such as Jack Gelber's *The Connection,* about narcotics addicts; Kenneth H. Brown's *The Brig,* about a brutal Marine Corps prison; and adaptations of *Antigone* and *Frankenstein* that sharply criticized the United States' involvement in the Vietnam War.

BRENDAN BEHAN, the Irish author and member of the Irish Republican Army, served time in prison for attempting to blow up a Liverpool shipyard and later for the attempted murder of two detectives. His prison experiences led to his autobiographical novel *Borstal Boy* (1958), as well as his plays, including *The Quare Fellow* (1956), and *The Hostage* (1960).

HARRY BELAFONTE, the strikingly handsome singer who popularized calypso music with songs like the "Banana Boat Song" and "Day-O," used his fame as an entertainer to further his work as a civil rights activist. A close friend of Dr. Martin Luther King, Jr., Belafonte stood with King at the 1963 March on Washington and also appeared at numerous anti-war events.

RICHARD BELLAMY ran New York's Green Gallery from 1960 to 1965 where he exhibited the work of many young artists who went on to have notable careers. Among them were Claes Oldenburg, Donald Judd, Tom Wesselman, Larry Poons, Jo Baer, and Mark di Suvero. He was a seminal figure in the art world, and in a highly competitive environment, he was a respected advisor to collectors, museums, and other galleries.

LEONARD BERNSTEIN possessed a prodigious talent as a musician, composer, conductor, and teacher. He wrote numerous hit Broadway musicals, including *On the Town* (1944), *Wonderful Town* (1953), and his most famous work *West Side Story* (1957). In 1958 he became the first American-born director of the New York Philharmonic. He resigned in 1969 to spend more time on composing and other projects, writing poetry, and teaching.

SID BERNSTEIN, rock promoter, brought the Beatles to America for their first tour. On February 9, 1964 they sang on the *Ed Sullivan Show,* which was seen by 73 million people. Bernstein later promoted The Rascals, The Animals, The Kinks, Blood, Sweat and Tears, and Sly & the Family Stone. Bernstein grew up in Harlem and took classes at the New School for Social Research.

CHUCK BERRY, a patriarch of rock and roll, became known for his rollicking guitar style, flowing lyrics, and famous duckwalk on stage. Among his early hit tunes were "Johnnie B. Goode," "Roll Over Beethoven," and "Sweet Little Sixteen."

JOHN BERRYMAN was a poet whose 1964 work *Dream Songs* was awarded the Pulitzer Prize. Much of his work was haunted by the enduring shock of his father's suicide and his own subsequent alcoholism and emotional fragility. He took his own life by jumping off a bridge.

A. C. BHAKTIVEDANTA was born in Calcutta, India, and came to the United States in 1965 where he established the International Society for Krishna Consciousness. His disciples demonstrated their "formula for peace" by burning incense and chanting "Hare Krishna" on street corners. Before his death he saw the Society grow into a worldwide confederation of more than a hundred ashrams, schools, temples, institutes and farm communities.

THE BLACK PANTHER PARTY was a militant civil rights group, founded in Oakland, California in 1966 by Bobby Seale and Huey Newton, that rejected the nonviolent tactics of mainstream black activists. In the late 1960s, as racial tension increased, the Federal Bureau of Investigation blamed the Panthers for inciting violence and began an ultimately successful effort to eradicate the party. By the end of the decade twenty-eight Panthers had been killed and many others were either in jail or had been forced to leave the country to avoid arrest.

NORMAN BLUHM, a member of the "second generation" of Abstract Expressionist artists, developed a distinctive style that combined abstraction with figurative elements. He collaborated with poet Frank O'Hara on a series of twenty six poem-paintings and also designed covers for avant garde literary journals and books of poetry, including collections by Bill Berkson and Paul Auster.

ROBERT BLY, a poet, translator, and publisher, in 1958 founded a literary magazine, *The Fifties,* (later *The Sixties, The Seventies,* and so on), that has had considerable influence on contemporary poetry. One of his own poetry collections, *The Light Around the Body* (1967), won the National Book Award for Poetry in 1968. An anti-Vietnam War activist, Bly co-founded American Writers Against the Vietnam War.

CHARLES BOULTENHOUSE, member of the Creative Film Foundation, did three distinguished films—*Dionysus, Handwritten,* and *Henry James's Memories of Old New York.* He wrote the afterword to the 1995 edition of Parker Tyler's *Underground Film: A Critical History,* as well as a later book of Tyler's, *Screening the Sexes: Homosexuality in the Movies.*

DAVID BOURDON, an art critic and author, was chiefly associated with 1960s Pop and Minimalist art. He wrote what is generally regarded as the definitive work on Andy Warhol, and was an editor at *Life* and wrote art criticism for the *Village Voice* and other periodicals.

WALTER BOWART publisher of *East Village Other (EVO)* taught journalism, worked at the *Aspen Daily News,* and wrote *Operation Mind Control,* a look at the CIA and drug use. In October 1965 he started *EVO* with $500 he had saved tending bar at Stanley's in the East Village. The paper mixed art happenings with drug reports and pictures of LBJ as Hitler.

MARLON BRANDO, the noted actor, won critical acclaim for his performance as a working-class husband in Tennessee Williams's play *A Streetcar Named Desire* in 1947. Brando appeared in a string of hit films, culminating in his Oscar-winning role as a dock worker in *On the Waterfront* (1954). He won a second Oscar for the title role in Francis Ford Coppola's *The Godfather* (1972), but refused the award as a protest against the treatment of Native Americans in films.

ROBERT BREER is an avant garde filmmaker who began his career as an abstract painter. He has experimented with abstract and free-form animation and developed a unique style with motion, rhythm and sound used in unexpected combinations.

JIMMY BRESLIN, a newspaper columnist and author, began his career at the

New York Herald Tribune. He has also worked for the *New York News* and *Newsday.* His first book, *Can't Anybody Here Play This Game?* (1963) was about the New York Mets. Breslin was a candidate for president of the New York City Council in 1969, on a slate headed by Norman Mailer as a candidate for mayor.

DAVID BROTHERS established a branch of the Black Panther Party in Brooklyn in 1968. He became the deputy chairman of the New York State branch of the party, was a community organizer, and with Stokely Carmichael founded the All African People's Revolutionary Party.

DAVID BROWER was an articulate and powerful conservationist, and served as executive director of the Sierra Club throughout the 1960s. He led the fight to prevent the construction of a dam in the Grand Canyon and a Green River Dam in Utah that would have submerged Dinosaur National Monument. When forced out of office for being too radical, he founded Friends of the Earth, but later reconciled with the Sierra Club and served on their board of directors.

ANDREAS BROWN bought The Gotham Book Mart from Frances Steloff in 1967. This funky bookstore on West 47th Street is in the heart of the diamond district. Steloff opened the store in 1920 and it became a literary landmark selling poetry books and avant garde literature.

CAROLYN BROWN, a dancer, choreographer, writer, and filmmaker was principal dancer with the Merce Cunningham Dance Company from 1953 to 1973. She has choreographed numerous works and taught in the U.S. and abroad. Her choreography has been recognized by three National Endowment for the Arts awards and a Guggenheim fellowship.

EARLE BROWN, like other prominent avant garde composers Morty Feldman and John Cage, allowed performers considerable interpretive freedom in how or what to play his work. His graphic scores have been likened to art works. In fact, he collaborated with Alexander Calder in a percussion score called "Calder Piece" (1963–66) that was actually performed by the sculptor's mobile.

H. RAP BROWN joined the militant Black Panther Party in reaction to the violence faced by civil rights demonstrators. He advocated violence, saying it was as American as cherry pie. His legal troubles began after rioting and fires followed a speech he made in Cambridge, Maryland in 1967. His association with the rallying call, "Burn, Baby, Burn" and the radical views expressed in his 1969 book *Die Nigger Die!* further added to his reputation as an extremist.

ROBERT DELFORD BROWN, a conceptual artist, in collaboration with his wife, Rhett, began his art career with a Happening, a raw meat environment in a commercial refrigerator. Brown founded the First National Church of the Exquisite Panic in a former public library branch building in Greenwich Village, and he and Rhett presented exhibits and performances there.

SUSAN BROWNMILLER is a journalist, author, and feminist activist. She was a staff writer for the *Village Voice*, a network newswriter and reporter, and author of nonfiction, including *Shirley Chisholm* (1970) and *Against Our Will: Men, Women and Rape* (1975).

LENNY BRUCE was a controversial monologist whose irreverent humor was peppered with four-letter denunciations of contemporary morals and mores. He was arrested numerous times and finally convicted in a Manhattan court in 1964 because his act was "obscene, indecent, immoral and impure." That case was appealed, but Bruce died of a drug overdose before the conviction was overturned in 1968.

ANTHONY BURGESS, a prolific British novelist, composer, librettist, essayist, semanticist, translator, and critic, is best known for his novel, *A Clockwork Orange* (1962), which offered a bleak vision of a violence-ridden future. The novel's film version (1971), directed by Stanley Kubrick, has become a cult classic.

WILLIAM S. BURROUGHS was a major influence on his fellow Beat Generation writers, notably Allen Ginsberg and Jack Kerouac, who based the character Old Bull Lee in *On the Road* on Burroughs. Burroughs' first book, *Junky* (1953) recounted his early experiences as a drug addict. His best known work, *Naked Lunch* (Paris 1959, New York 1962), is a surrealist depiction of an addict's existence that inspired cultlike admiration.

JOHN CAGE, a prolific and influential composer, used every imaginable kind of sound, from standard orchestral strings to radios and rubber bands to develop his Minimalist compositions. One of his most provocative pieces "4'33" consists of four minutes and 33 seconds of silence, divided into three movements.

JOHN CALE, an innovative composer and musician, was a keyboard player in the trend setting group The Velvet Underground. Winner of a Leonard Bernstein scholarship to study modern composition at the Eastman Conservatory in Massachusetts, he left before completing the program to join LaMonte Young's Dream Syndicate, an avant garde ensemble.

TRUMAN CAPOTE achieved recognition with the novel *Other Voices, Other Rooms* (1948). He turned to nonfiction in the 1960s, publishing *In Cold Blood,* the story of the murder of four members of a Kansas farming family. Capote celebrated the book's publication by hosting the Black and White Ball in the Grand Ballroom of New York's Plaza Hotel, honoring *Washington Post* publisher Katharine Graham. The ball attracted a glittering list of guests, all dressed in black and white, and marked the pinnacle of Capote's literary fame.

LEO CASTELLI was an art gallery owner who championed unknowns who would go on to become major figures in contemporary art. Among the artists he exhibited early in their careers were Andy Warhol, Jasper Johns, and Roy Lichtenstein. He was integral to the emergence, and international acceptance, of the major art movements of the 1960s, including Pop Art, Minimalist Art, and Conceptual Art.

DICK CAVETT, host of a series of television talk shows, began his career with *The Dick Cavett Show* on ABC (1968–74). His talk shows, which continued later on cable and public television, have combined his fascination with show business and his concern for contemporary issues, displayed with a comedian's timing and perspective.

JACQUI CEBALLOS is a feminist activist and administrator. She was president of NOW in New York City, 1971–1972, a cofounder of the Women's Political Caucus, and president of New Yorkers for Women in Public Office.

JOSEPH CHAIKIN, an actor and director, left the Living Theatre to found, in 1963, the Open Theatre, an experimental off-off-Broadway group. The commercial production of Jean Claude van Itallie's *America, Hurrah* (1966) and Megan Terry's *Viet Rock* (1966) evolved out of Open workshops, but generally the group eschewed the commercial theatre, which they felt hindered their expressions of political and aesthetic ideas.

WYNN CHAMBERLAIN, artist and friend of Warhol, Taylor Mead, John Giorno, and Jack Smith, had a summer place in Old Lyme, Connecticut where he occupied an old farmhouse. His friends always packed the place on weekends. The setting was the inspiration for the Warhol film "Sleep" starring John Giorno.

CHAMBERS BROTHERS was a Black gospel group that moved from Mississippi to California where their music took on elements of folk and blues sounds. Their biggest hit was the 1967 psychedelic, grunge, 11-minute epic "Time Has Come Today."

ED CHARLES played third base on the 1969 New York Mets team that won baseball's World Series. His home run off Steve Carlton on September 24, 1969 helped the team clinch their first first-place finish after years of helpless futility. Charles was nicknamed "The Glider" for his smooth play in the field.

CESAR CHAVEZ led the first successful farm workers' union in U.S. history. In 1965, his group joined an AFL-CIO sponsored union in a strike against California grape growers. Against great odds, and with the support of Robert F. Kennedy, Chavez led a successful five-year strike-boycott that rallied millions of supporters to the United Farm Workers.

343

ALFRED CHESTER, a writer of novels, short stories, and essays, was an expatriate for most of his life. In his childhood, Chester had X-ray treatments, which caused him to lose his hair, even his eyelashes and eyebrows. His baldness made him feel like a freak, and his feelings of alienation would stay with him all his life. He died at the age of 42 of a drug overdose.

LUCINDA CHILDS, an avant garde choreographer and dancer, has been a principal with the Judson Dance Theater, the Gramercy Arts Theatre, and the James Waring Dance Company. In one of her works, *Carnation* (1964) she surprised audiences by wearing a colander on her head and stuffing sponges and hair curlers into her "hat." She later collaborated with Philip Glass and Robert Wilson in the opera *Einstein on the Beach* (1976).

SHIRLEY CHISHOLM, an advocate of women's and minority rights, in 1968 became the first black woman ever elected to Congress. An opponent of the Vietnam war, and co-founder of the National Women's Political Caucus, Chisholm ran an historic race for the Democratic presidential nomination in 1972. She served in Congress for seven terms, until 1983.

NOAM CHOMSKY, a linguistics scholar and political activist in the anti Vietnam War movement, published *American Power and the New Mandarins* in 1969, an indictment of American military and economic policy. Chomsky, a faculty member at MIT, has also published studies expounding his theory that all languages share the same basic structure.

CHRISTO [Javacheff], the Bulgarian-born "wrap star" of the art world, began his career wrapping small objects. He said he wanted to give them aesthetic value by destroying their original identity, a technique he called *empaquetge*. In 1966 he exhibited wrapped storefronts at the Leo Castelli Gallery. In 1969 Christo produced his first monumental outdoor piece by wrapping one mile of Australia's coastline with over one million square feet of polypropylene sheeting.

JOE CINO was co-founder, with painter Ed Franzen, of the Caffe Cino, one of the earliest and most influential of the off-off-Broadway theaters in New York's Greenwich Village. At the cafe, Cino hosted nightly performances of avant garde dance concerts, poetry readings, lectures, and theatrical performances. In 1965, a fire destroyed the interior of the building. Although the cafe eventually reopened, it closed for good after Cino's death by his own hand in 1967.

RAMSEY CLARK joined the U.S. Justice Department in 1961 as an Assistant Attorney General. He helped draft the 1964 Civil Rights Act and, as Deputy Attorney General, worked on the Voting Rights Act and led an investigation into the Watts riots. President Johnson appointed him Attorney General in 1967. He served until 1969, earning a reputation as a vigorous defender of civil liberties and human rights.

SHIRLEY CLARKE, an independent filmmaker and cofounder with Jonas Mekas of the Film-Makers Cooperative, is best known for three pictures: *The Connection* (1960), a film version of Jack Gelber's off-Broadway play about drug addiction; *Robert Frost: A Lover's Quarrel with the World* (1962), which won an Academy Award; and *The Cool World* (1963), which followed the life in Harlem of a young man who is leader of a juvenile gang.

ELDRIDGE CLEAVER was Minister of Information for the Black Panther Party and author of the best-selling memoir *Soul on Ice* (1969). He fled the country after a Panther-police gun battle in Oakland, California. He and his wife, the former Panther communications secretary Kathleen Cleaver, returned to the United States in 1975. Cleaver pled guilty to the assault charge and was sentenced to probation and community service.

ROY M. COHN was a controversial New York attorney who served as chief counsel to Sen. Joseph McCarthy's Communist-hunting U.S. Senate permanent investigations subcommittee in 1953 and 1954. Cohn parlayed his reputation into a thriving law practice with clients that ranged from Francis Cardinal Spellman to Donald Trump, and many reputed mob figures. Cohn himself was acquitted on charges of federal bribery, fraud, and income tax evasion.

JUDY COLLINS, a folksinger with a sweet soprano voice, released her first album, *A Maid of Constant Sorrow,* in 1961. Her first gold album, the 1967 *Wildflowers,* included her hit version of "Both Sides Now," by Joni Mitchell, then a little known songwriter. Her best known songs cover a wide range of styles, from the traditional gospel "Amazing Grace" to the Stephen Sondheim ballad "Send in the Clowns."

TONY CONRAD, avant garde video artist, experimental filmmaker, musician, composer, sound artist, teacher, writer, and cofounder with LaMonte Young and Marion Zazeela of the Theatre of Eternal Music, which, he wrote, "utilized non-Western musical forms and sustained sound to produce dream music." Conrad made a thirty-minute film that presents bright blank frames interspersed with solid black frames. The viewer is confronted by an incessant and irritating flicker.

GREGORY CORSO, a poet and writer, was a key figure of the Beat Generation. After his poem "Gasoline" was published in 1958, Allen Ginsberg called him "a great word-swinger . . . a scientific master of mad mouthfuls of language." At poetry readings, Corso would delight fans and inflame critics by muttering disconnected thoughts like "fried shoes," "all life is a Rotary Club," and "I write for the eye of God."

ANDRE COURREGES, the innovative French couturier, is credited with introducing hemlines above the knee and pantsuits for women during the 1960s. His "space-age" designs were further successes, with his trademark white boots, see-through mini-dresses and cut-out clothes unexpectedly exposing more of the wearer.

MERCE CUNNINGHAM, dancer, choreographer, and company director, formed his dance company in 1953. John Cage, Cunningham's collaborator and partner since 1942, and David Tudor were the company's musicians; dancers included Carolyn Brown, Remy Charlip, Paul Taylor, and Viola Farber. Cunningham's dance philosophy was unorthodox, relying on chance and independence of the dancers' movement from the music.

SALVADOR DALI was a Surrealist artist with a famous mustache whose playfully unique vision of everyday objects and virtually everything else paved the way for generations of artists who followed. He also designed and produced surrealist films, illustrated books, handcrafted jewelry, and created theatrical sets and costumes.

CARMEN D'AVINO, a filmmaker, whose *Pianissimo* was nominated for an Academy Award as best short subject, learned cinematography as a photographer-historian during World War II. *Pianissimo* is about a player piano. The keys are all white. It starts to play. As each key hits a note, it acquires a color as well, until the whole keyboard looks like a Mediterranean awning.

ANGELA DAVIS, an advocate of civil rights for women and Blacks, is a scholar and educator who came into conflict with conservative state and federal law enforcement for her leftist views and political activism. She spent sixteen months in jail after an attempted courtroom escape in 1970 resulted in the murder of three people. She was nowhere near that scene, and her arrest generated worldwide protest and countless "Free Angela" rallies. Eventually she was cleared of all charges.

RENNIE DAVIS was one of the Chicago 7 defendants accused of conspiring to incite rioting during the 1968 Democratic Convention. The charges were later dismissed on appeal. Davis was a national coordinator of MOBE—the Mobilization Committee to End the War in Vietnam and a cofounder of Students for a Democratic Society (SDS).

DOROTHY DAY was a radical Catholic social reformer whose life was devoted to the practical application of her political and religious beliefs. As an avowed pacifist, in the 1960s she helped turn her church's attention to peace and justice issues, and was a vocal opponent of the Vietnam War. She was a co-founder of the Catholic Worker movement and the monthly newspaper of the same name that began publication in 1933.

EMILE DE ANTONIO was a filmmaker known for making anti-establishment

documentaries. His subjects included the 1965 New York City mayoral campaign, the assassination of John F. Kennedy (Kennedy was in his Harvard class of 1940), the 1968 Chicago convention, the Vietnam War, Richard Nixon, and the New York art world.

DAVID DELLINGER is a dedicated pacifist who has been active in the War Resisters League, the anti-Vietnam War movement, and nuclear and environmental rallies. He was the oldest defendant at the Chicago 8 conspiracy trial after the 1968 Democratic National Convention. Prosecutors described him as "the chief architect of the conspiracy" because he was the chair of the National Mobilization Committee to End the War in Vietnam. On appeal, the convictions obtained at that trial were all overturned.

JOHN DE MENIL, prominent French-born Texan with homes in Paris, Houston, and New York, collected art on an international and epic scale. His wife Dominique was an heiress to the Schlumberger fortune, a multinational oilfield services company. John was chairman of the board. He was also trustee of The Museum of Modern Art. Through Fred Hughes, also a Texan, the de Menils met Warhol and collected his art. The de Menils commissioned Warhol to "film a sunset," but the project never got off the ground.

MAYA DEREN was a filmmaker who was often referred to as "her own avant garde movement." She came to Greenwich Village after her parents fled the Russian Revolution and she eventually fell in with a bohemian crowd including Anais Nin and Marcel Duchamp. Her experimental films are slowly being recognized for their continuing influence; many were released on DVD in 2002.

KEN DEWEY brought his theatrical training to the creation of Happenings, which included *Sames*, an all-white bridal theatre piece, and *Selma Last Year*, a multi-channel environment installed in the lobby of Lincoln Center's Philharmonic Hall during the 1966 Film Festival. A catalogue of his work, *Action Theatre: The Happenings of Ken Dewey* by Barbara Moore, was published in 1987.

COLLEEN DEWHURST won critical acclaim for her off-Broadway performances in Eugene O'Neill's plays. She won an Obie in 1952 for her portrayal of Abbie Putnam in *Desire Under the Elms* and a Tony in 1973 for *A Moon for the Misbegotten*. She worked for the New York Shakespeare Festival and also appeared in a score of television plays and movies.

JIM DINE, a pioneering Pop artist, was one of the founders of the Judson Art Gallery and created in 1960 the successful Happening called *Car Crash*. Dine moved to England in 1967 where he has continued to produce series of paintings of ordinary objects, such as neckties, tools, and bathrobes.

MARK DI SUVERO, an innovative sculptor, was nearly crushed to death in an elevator accident while preparing for his first solo show in New York in 1960. Confined to a wheelchair and given a prognosis of lifelong paraplegia, Di Suvero, through extraordinary discipline and force of will, regained his ability to walk, and create art. He employs large-scale steel beams and wood in massive works that invite play and public participation with ledges, swings, and other kinetic elements.

LUCIA DLUGOSZEWSKI, an avant garde composer, studied with Edgar Varèse in the early 1950s. Her music is influenced by Oriental poetry and scientific philosophy, and was commissioned for the Erick Hawkins Dance Company. Among her musical innovations are the "timbre piano" and unusual percussion instruments, such as tangent rattles and ladder harps.

ROBERT DOWNEY, SR., a film director with an irreverent, mordant sense of humor, is best known for his 1969 independent film *Putney Swope*, about the hilarious changes made by a token black member of an ad agency after he is accidentally elected Chairman of the Board. Downey added the Sr. to his name after his fame was greatly overshadowed by his actor son.

TOM DOYLE is a sculptor noted for his large wooden architectural structures. His work is highly organic in appearance due to his retention of the natural forms of the wood. The works seem to be carving out volumes of space and

show the influence of Abstract Expressionist and Constructivist design.

CLAUDIA DREIFUS has been a journalist since the 1960s, when she wrote for the *East Village Other*. She has been politically active, doing public relations for SANE and a founding-member of Media Women. Her work has appeared in periodicals ranging from *Playboy* to *Ms.* and she is author of *Scientific Conversations*, a book of interviews on science from the *New York Times*.

BOB DYLAN became the foremost folk singer and songwriter of the 1960s with such songs as "Blowing in the Wind," "Mr. Tambourine Man," and "The Times They Are A-Changin'." Only months after his January 1961 arrival on the Greenwich Village folk circuit from his native Minnesota, the singer, with the distinctive gravelly voice and rough charisma, earned a glowing review in the *New York Times*, and a subsequent record contract. He has never gone out of style.

JACK ELLIOTT has been playing folk music since the 1940s. Strongly influenced by Woody Guthrie, he derives his tunes from folk, blues, and country sources.

RALPH ELLISON is best known for his book *The Invisible Man*, a stark account of racial alienation that is credited with helping to spark the civil rights movement. It was hugely successful both commercially and critically, but he was never able to follow it with another major work, although he did publish several collections of short stories, reviews and criticism.

DANIEL ELLSBERG leaked the Defense Department report on U.S. involvement in Vietnam, known as "The Pentagon Papers," to the *New York Times* and other newspapers. Published in 1971 they helped to mobilize opposition to the war. President Nixon's Justice Department indicted Ellsberg for illegal possession of government documents, conspiracy, theft, and espionage, but the charges were dismissed by a federal judge who cited "gross government misconduct"—including a break-in that President Nixon had authorized at Ellsberg's former psychiatrist's office in an attempt to discredit him.

ED EMSHWILLER, an avant garde filmmaker, began his career as a painter and illustrator of science fiction. After experimenting with filmmaking, he collaborated from 1963 to 1973 on a series of dance films with Alwin Nikolais. In the 1970s he turned to video work, and his 1974 program *Pilobolus and Joan* on public television was named the year's best drama.

BRIAN EPSTEIN was the manager of The Beatles and is credited with shrewdly guiding them to their unique position as the foremost rock and roll group of the sixties. The band first came to his attention when flocks of teenagers came to Epstein's family's Liverpool record store looking for their releases. Epstein remained their manager until his death at age 32 of an apparent drug overdose.

OYVIND FAHLSTROM, an innovative artist who began his career in Sweden, used comic strip imagery that made him seem like an early Pop artist. He moved to the United States in 1966 where Robert Rauschenberg was an influential supporter. Although Fahlstrom died before achieving widespread recognition, he has become an important influence on younger artists.

EDWIN FANCHER, a practicing psychologist, was a co-founder with Daniel Wolf and Norman Mailer of the *Village Voice* and its publisher for the first nineteen years. The *Voice* was an irreverent alternative newspaper, publishing stories about avant garde art and culture and taking on the city's political establishment with surprising success.

JAMES FARMER, a Black leader of the civil rights movement, was an early advocate of non-violent protest. As a founder of CORE (Congress of Racial Equality), Farmer led the first Freedom Ride, challenging segregated interstate bus travel in the South. He was beaten and arrested, and jailed for forty days. He also directed lunch counter sit-ins, voter registration drives, and school desegregation protests.

JULES FEIFFER established himself as a satirical cartoonist with his weekly panels in the *Village Voice* newspaper. His cartoons depicted a caustic version of

modern life, attacking the self-centeredness of personal relationships, the cheapness in consumer society and the hypocrisy of posturing politicians. Richard Nixon was a constant target as was Lyndon Johnson and his Vietnam War policies.

MORTON FELDMAN was an avant garde composer who only after his death started to emerge from the shadow of his mentor, John Cage. For some listeners, Feldman's distinctive brand of musical stasis has been called the equivalent of aural water torture; but fans find a hypnotic concentration and enigmatic mystery to his music, which becomes even more compelling with repeated listening.

CLAY FELKER was the editor of the *New York Herald Tribune*'s Sunday magazine supplement *New York*. When the newspaper folded, Felker led the effort to publish *New York* as an independent entity. The magazine's success led to the founding of similar city magazines nationwide. The first and prototype issue of *Ms.* magazine, edited by *New York* staffer Gloria Steinem, was backed by Felker's *New York*.

JACKIE FERRARA, a Detroit-born sculptor, is known for her architectonic forms that range from ghostly effigies in coffin-like boxes to benches and entire rooms. She has been the recipient of National Endowment for the Arts and Guggenheim awards.

WARREN FINNERTY was born in Brooklyn and educated at the University of California in Berkeley. He studied and acted at the Actors' Workshop and Theatre Arts Colony at the Laguna Playhouse. After joining The Living Theatre, he appeared in a number of T.V. shows and was featured in the movie *Murder Inc.* Finnerty won the 1960 OBIE award for best actor for his historic performance in *The Connection*.

NANCY FISH, an artist, achieved her fifteen minutes of fame when she posed for Andy Warhol in his three-minute film portraits, *Thirteen Most Beautiful Girls*. She was in good company—Sally Kirkland, Ethel Scull, Marisol, Barbara Rose, Lucinda Childs, and the ubiquitous Baby Jane Holzer, a young Park Avenue housewife. The number of women photographed usually exceeded the figure specified in the title.

JOE FLAHERTY was working as a longshoreman when he sent a handwritten article to the *Village Voice* in 1966. He was hired on as a staff writer, later managed Norman Mailer's 1969 campaign for New York mayor, and published several books.

DAN FLAVIN was a Minimalist sculptor whose primary medium was prefabricated tubes of colored fluorescent light. He would run his lamps along walls or place them in quiet corners where they created a meditative atmosphere. The light articulated the space and asserted the continuity between the real world of everyday things and art.

JANE FONDA, an actress who starred in such movie hits as *Cat Ballou* (1965) and *Barbarella* (1968), also has been a political activist. She supported the anti-Vietnam War movement, and made a highly publicized visit to North Vietnam. Fonda has worked on behalf of environmental and women's rights campaigns, Native Americans, Black Panthers, lettuce workers, and other groups.

MARGOT FONTEYN, the English ballerina, is considered one of the finest dancers of the twentieth century. She made her debut in 1934, in *The Nutcracker,* and continued to dance with the Royal Ballet for the rest of her career. She and Rudolf Nureyev danced together in 1962, and their continuing partnership was an artistic triumph that aroused enthusiastic audience responses worldwide.

TOM FORCADE was the founder in 1974, and publisher and editor of *High Times* magazine. He co-authored a widely distributed pamphlet on how to start an underground paper and helped to establish the Underground Press Syndicate. He also is believed to have worked with Abbie Hoffman on his book, *Steal This Book.* Forcade died by his own hand in 1978 under mysterious circumstances.

CHARLES HENRI FORD was a prolific Surrealist poet, editor, novelist, and artist. He published the influential art magazine called *View* and was a noted photographer in his later years. He said his role model was Jean Cocteau, "who considers himself a poet in everything he does."

RUTH FORD came to New York from Hazelhurst, Mississippi to become an actress. She played on stage in *Dinner at 8* in 1966 and in the film *The Keys of the Kingdom.* Charles Henri Ford is her brother.

MARIA IRENE FORNES, is an Obie-winning dramatist whose work, though rarely seen outside New York City, is highly regarded as cutting edge in off-Broadway theatre. She came to the United States from Cuba at the age of fifteen. Her first production was *Tango Palace,* in 1963, and later works were produced at La Mama ETC, Judson Poets Theatre, the Open Theater as well as the Actors' Workshop in San Francisco.

SIMONE FORTI is a choreographer and dancer who developed her own material based on three movement themes—crawling, animal movements, and circling. She also participated in Robert Whitman's Happenings at the Lower East Side storefront he shared with Claes Oldenberg.

ROBERT FRANK, the Swiss born photographer and filmmaker, achieved cult status with his first book, *The Americans* (1959). When judged by conventional standards, Frank's photographs look harsh, informal, blurred, and grainy. His first film, *Pull My Daisy* (1959), has become a classic. It is the story of a Beat character and his conflicts with his family directed by Frank and the painter Alfred Leslie and narrated by Jack Kerouac.

FREE SOUTHERN THEATRE was inspired by the goals of the civil rights movement. It was formed in 1963 with John O'Neal, Gilbert Moses, James Cromwell, and Murray Levy as the principal players, and was the South's first integrated theatre. Although their aim was to promote Black theatre, productions like *Waiting for Godot* appealed more to white than Black audiences.

BETTY FRIEDAN became a leading figure in the feminist movement after publication of her *The Feminine Mystique* in 1963. She argued that women need opportunities for fulfillment beyond those provided by marriage and motherhood. She was a co-founder in 1966 of the National Organization for Women (NOW) and has campaigned vigorously for reforms that would end discrimination against women.

JOHN FROINES, was a scientist and one of the Chicago 7 defendants accused of conspiring to incite a riot at the Chicago 1968 Democratic Convention. Froines had met two other defendants, Tom Hayden and Rennie Davis, while a student at Yale in 1964. Froines was acquitted of the 1968 charges and later went on to become a professor of public health at the University of California.

THE FUGS, who called themselves the "freakiest singing group in the history of Western Civilization," were an alternative rock band composed of a group of poets that performed at political and community benefits and anti-war rallies. Founded in 1964 by Ed Sanders and Tuli Kupferberg, The Fugs also included Vin Leary, Steve Weber, Ken Weaver, and Peter Stampfel. Among the printable titles of their singles were "Kill for Peace," "CIA Man," "Coca Cola Douche," and "Nothing."

WILLIAM GADDIS published his first novel, *The Recognitions*, in 1955. It is an immense work filled with literary, historical, mythological, and religious allusions and follows more than fifty characters over a thirty-year period. While it had little immediate impact, it was rediscovered during the 1960s and hailed by critics and readers as a unique landmark of contemporary literature.

JOHN KENNETH GALBRAITH, scholar, public servant, and author, taught economics at Harvard University for over forty years. He has written more than two dozen books, the most famous was *The Affluent Society* (1958), in which he argued that a wealthy society like the United States should use its resources to benefit the public and not simply continue to increase production. Galbraith was appointed ambassador to India by President John F. Kennedy.

LEO GARIN was a theatre director, stage manager, designer and actor. He directed Jean Genet's *Deathwatch* and LeRoi Jones's *The Slave* and *The Toilet*. Garin studied with Lee Strasberg and Harold Clurman and was involved in over fifty theatrical productions.

BARBARA GARSON wrote *MacBird!*, an off-Broadway Shakespearean parody that opened at the Village Gate theater in February 1967. The main character, MacBird, played by Stacy Keach, instigated the murder of his chief John Ken O'Dunc (played by Paul Hecht). The murder was then avenged by John's brother, Robert Ken O'Dunc (William Devane). The irreverent sensationalism of the concept shocked audiences who flocked to the small theater.

JACK GELBER was the author of *The Connection*, winner of an Obie as the best full length new American play off Broadway. Called a jazz play because a quartet remains on stage throughout the production, *The Connection* graphically conveyed the misery and state of permanent crisis in a roomful of heroin addicts waiting for their pusher, or connection.

HENRY GELDZAHLER was an art critic and curator of American Art at the Metropolitan Museum of Art in the 1960s. He assembled the Museum's groundbreaking and controversial centennial exhibition—"New York Painting and Sculpture: 1940–1970," which is considered a turning point in the history of contemporary American art—for the first time putting the stamp of approval of a conservative museum on the work of abstract artists.

JEAN GENET was one of the most prominent and controversial figures in contemporary French literature. A novelist, poet, and playwright, Genet supported the Paris student uprising in 1968 and, on assignment from *Esquire* magazine, covered the 1968 Democratic National Convention in Chicago.

PAUL GEORGES was a realist painter whose massive self and family portraits were an anomaly in the New York art community of the fifties and early sixties when Abstract Expressionism was the reigning art movement. He remained steadfast in his chosen sphere and his striking images now belong to such prestigious collections as the Museum of Modern Art and the Smithsonian Institution.

RUDI GERNREICH, an innovative fashion designer, created the topless bathing suit in 1964. Publicity surrounding the design was immediate and intense. Like all his designs, the bathing suits aimed to liberate women from the restraints of haute couture by allowing the natural form of the female body to predominate.

ALLEN GINSBERG was the foremost poet of the Beat movement. His controversial poem "Howl!" became the literary manifesto of his generation. After "Howl!" his most celebrated work is 1961's *Kaddish and Other Poems*, a stream of consciousness confessional dealing with his mother's life and death in a mental hospital. Ginberg was a revered figure, a veritable guru of the counterculture, and an ubiquitous presence at many of the political protest and cultural events that marked the 1960s.

PHILIP GLASS is an avant garde composer who has won a wide audience for his minimalist music, often featuring repetitive, harmonically static and highly rhythmic sound. His 1960s works, considered radical because they did not offer melodies, were performed in art galleries and museums before they were heard in concert halls. He moved into compositions of greater complexity and collaborated with Robert Wilson on the opera *Einstein on the Beach* (1976).

AL GOLDSTEIN became the "king of pornography" with *Screw* magazine and *Midnight Blue*, a cable TV show, which features, "the best smut and escort services anywhere." He had edited *Hush Hush* and *Confidential*, was married three times, and in November 1968, Goldstein and Jim Buckley unleashed *Screw* "for the raincoat crowd." Progressives and even radicals denounced its obsessional, sordid approach to both its editorial content and startling sex ads. Goldstein survived numerous arrests over insinuations about J. Edgar Hoover's sexuality and visual puns about Tricky Dick Nixon. *Screw's* circulation peaked at 150,000.

RICHARD GOLDSTEIN is a writer and editor who has been associated with the *Village Voice* since his graduation from Columbia in 1966. He was one of the first rock journalists but later branched into other areas as well. His books include *Student Rationale for Drug Usage, The Poetry of Rock* (1968) and *Goldstein's Greatest Hits* (1970).

JUAN GONZALEZ was one of the founders of The Young Lords Party and a member of the Students for a Democratic Society. He was a leader of the student strikes at Columbia in 1968. Gonzalez became a columnist at the *New York Daily News* and is a winner of a George Polk Award for his columns on the poor and disenfranchised.

BILL GRAHAM came to the United States as a ten-year-old orphan, a refugee from Nazi Germany. In the 1960s, he became the creative promoter of rock concerts in his concert halls, the Fillmore West in San Francisco and the Fillmore East in New York City. Graham organized, produced, and marketed such sixties performers as Jimi Hendrix, The Who, The Doors, Janis Joplin, and The Grateful Dead.

CLEMENT GREENBERG was an art critic who helped to establish Abstract Expressionism as a serious artistic movement. His advocacy of Jackson Pollock, especially, established his own credentials as an influential art voice.

GERMAINE GREER, Australian born writer and feminist, wrote the controversial and highly successful book *The Female Eunuch* (1970). She portrayed marriage as legalized slavery for women and attacked the traditional female characteristics valued by males (delicacy, timidity, passivity). She became a regular contributor to newspapers and magazines and was a familiar figure on television talk shows.

DICK GREGORY began his career as a comedian in 1961 when he was hired as a replacement at the Chicago Playboy Club. Within a year he was a nationally known headliner, performing in night clubs and on television, and recording comedy albums. He was a committed civil rights activist, appearing at marches to oppose the Vietnam War, world hunger, and drug abuse. He fasted in protest more than sixty times.

RED GROOMS, sculptor and performance artist from Nashville, Tennessee, studied with Hans Hofmann in Provincetown and achieved first notice with the theatre event *The Burning Building* in 1959. His multi-media, three-dimensional panorama composed of cutout comic strip figures assembled in a tableau reveal a complete story. His "Grooms Zany Manhattan" puts the city in focus.

ARLO GUTHRIE, the son of legendary folksinger Woody Guthrie, became an icon for anti-Vietnam War protestors with his 1967 anti-establishment hit song, "Alice's Restaurant," a comic lament that related how the singer's arrest for littering saved him from the draft. The composition became the cornerstone of Guthrie's debut album, and inspired a feature film.

WALTER GUTMAN, stockbroker and art patron, was the author of *The Gutman Letter*, a weekly service for investors. In addition to being a former art critic, he exhibited his paintings and collected art. He also bankrolled films.

PABLO GUZMAN was a founder of the Young Lords Party, a radical Puerto Rican activist group committed to Puerto Rican independence and community self-help programs. They opposed racism, "machismo," and capitalism. Guzman left the group in the mid-1970s and became an Emmy Award winning journalist.

DAVID HALBERSTAM, a journalist and author, covered the Vietnam War for the *New York Times*. He won a Pulitzer Prize in 1964 for his reporting and in his 1965 book, *The Making of a Quagmire: America and Vietnam During the Kennedy Era* he predicted that the war was unwinnable. Halberstam left the *Times* in 1967. His book *The Best and the Brightest* (1972), an examination of the Kennedy and Johnson administrations, won a National Book Award.

ANN HALPRIN, a dancer and choreographer based on the west coast, had a seminal influence on the New York dance scene with her use of improvisation and other nonacademic dance forms. Her New York debut in 1967 was

interrupted by police because her *Parades and Changes* (1965) featured nude performers.

PETE HAMILL, a newspaper columnist, reporter, editor, and novelist, has worked for the *New York Daily News*, the *New York Post*, and the *Village Voice*. His writing has appeared in *Esquire, Vanity Fair, Playboy* and other magazines. He achieved an unusual level of celebrity for a print journalist with his outspoken opinions and novels based on his early years in Brooklyn.

AL HANSEN was one of the first Happenings artists and a founder of the Fluxus art movement. He founded the Third Rail Gallery in 1962 where he produced events that included music, light projections and films. His Fluxus art included collages and assemblages of found objects that might include Hershey bar wrappers and burnt matches. His book, *A Primer of Happenings and Time/Space Art,* was published in 1965.

MICHAEL HARRINGTON was a crusading writer and teacher, and author of the influential 1962 book *The Other America.* It contrasted the appalling contradictions of American mid-century prosperity with the fact that one out of four Americans was living in poverty. Except for Norman Thomas, Harrington was the most visible American spokesman for Socialist ideals in the twentieth century.

STEPHANIE HARRINGTON wrote "Outside Fashion" with Blair Sabol. They broke the rules and often wrote features that had little to do with fashion. Before fashion, Stephanie Harrington was an aggressive reporter covering Lenny Bruce, John Henry Falk's libel suit, school boycotts, and a World's Fair sit-in, a demonstration she covered when her husband, Michael Harrington, was arrested.

RICHIE HAVENS is an internationally renowned Black folk singer. He was a popular figure on the Greenwich Village folk circuit with regular appearances at the Cafe Wha? and Gerdes Folk City. His album *Mixed Bag* (1967), with tracks like the scathing anti-war anthem "Handsome Johnny" and a striking version of Bob Dylan's "Just Like A Woman," was a major turning point in his career.

ERICK HAWKINS was a leading figure in modern American dance who formed his own company in 1957. He introduced a generic free-flowing style reflecting his Zen philosophy that was a radical departure from the techniques of most modern dance. His dances, with their expression of contemporary angst and unresolved conflict and physical demands, were serene, plotless celebrations of the human body.

ALEX HAY, a Pop and performance artist, was involved in avant garde dance, notably with Merce Cunningham and Robert Rauschenberg. He appeared in the 1966 series "9 Evenings: Theatre and Engineering" at the 69th Regiment Armory. His performances included roller skating with parachutes and wiring his body for sound. He also produced paintings of commonplace objects like paper products and sculpture.

DEBORAH HAY is a dancer and choreographer who studied with Merce Cunningham and performed with Cunningham's troupe before she became associated with the Judson Church's avant garde dance collective. She choreographed a performance for "Nine Evenings of Theater and Engineering" and originated the Spring Gallery series.

TOM HAYDEN entered the national stage as one of the Chicago 7 defendants, accused of conspiracy to incite a riot during the 1968 Democratic National Convention. He was already well known to leftist groups as the author of the 1962 Port Huron Statement, which called for an alliance of students, teachers, labor, and other liberal forces dedicated to building a better world. The first president of Students for a Democratic Society, Hayden became a dedicated civil rights activist and helped to mobilize anti-Vietnam War protests.

JOSEPH HELLER, American novelist who wrote the perennial best-selling novel *Catch 22* which took him eight years to complete. He formerly taught writing at Yale and wrote the play *We Bombed in New Haven* as well as TV and movie screenplays. He was an airforce bombardier in World War II and started as an advertising writer for *Look* and *Time* magazines in the 1950s.

LILLIAN HELLMAN, was the author of many successful plays, including the anti-fascist *Watch on the Rhine*, which won the Critics Circle award in 1941. Called before the Communist witch-hunting Un-American Activities Committee headed by Sen. Joseph McCarthy in 1952, she refused to name any friends who were left-leaning. She famously said, "I can't cut my conscience to fit this year's fashions." Her memoirs were published in four best-selling volumes.

GEOFFREY HENDRICKS, performance artist, member of Fluxus Group, did alternate military service teaching art at the St. Barnabas Hospital for Chronic Diseases in the Bronx. His influences from mostly fellow Rutgers artists came from Kaprow, Segal, Watts, Whitman, Brecht, Samaras. Hendricks created *Painting to See the Skies and Eternal Time,* followed by *Sky Banner, Sky Billboard, Sky Set, Sky Lunch, Sky Games, Sky Cakes,* and *The Sky is the Limit.*

JIMI HENDRIX, an inventive rock and roll virtuoso, was noted for his inspired stage performances, including a classic rendition of "The Star Spangled Banner" at Woodstock and his literally setting fire to his guitar at Monterey. He played a right-handed Fender Stratocaster—his "Electric Lady"—guitar upside-down and left-handed as an electronic sound source capable of feedback, distortion, and a host of other effects that crafted a fluid emotional vocabulary.

NAT HENTOFF, a staff writer for the *Village Voice* for over forty-five years, writes about jazz, civil liberties, and education. He is also a syndicated columnist for the *Washington Post.* Among his published works are *Free Speech for Me and Not for Thee* and *Listen to the Stories: Nat Hentoff on Jazz and Country Music.*

TOM HESS was the influential editor of *Art News* magazine, who wrote the first serious assessment of Abstract Expressionism. He championed the careers of artists like Willem de Kooning and Barnett Newman, among others. He also served as consultative chairman of the Department of Twentieth Century Art at the Metropolitan Museum of Art.

EVA HESSE, a German-born Jew, survived a harrowing childhood to become a successful Minimalist sculptor. Her career was cut short when she succumbed to a brain tumor at 34. Originally a painter, she made her first three dimensional work in 1962, a costume of chicken wire and soft jerseys for one of Allan Kaprow's Happenings. She stopped painting, and using discarded industrial materials, turned to making dreamlike objects that stretched from floor to ceiling.

DICK HIGGINS was a poet, artist, composer, and a seminal figure in the Happenings and Fluxus movements. He founded, funded, and operated the Something Else Press, which published works by Claes Oldenburg, John Cage, Gertrude Stein and Merce Cunningham.

DAVID HILLIARD was chief of staff of the radical Black Panther Party in the late 1960s. Despite its violent reputation, the Party served the black community with health clinics and services for the elderly. Hilliard, who spent several years in prison in the 1970s on charges stemming from a shootout between Panthers and the police, wrote an autobiography, *This Side of Glory,* to explain the youthful idealism and anger that led to the party's formation.

GIL HODGES, nicknamed "The Quiet One," was the manager of the Miracle Mets that won baseball's World Series in 1969. He was a longtime star player for the Brooklyn Dodgers, helping them gain their only World Series title in 1955. In 1950, he tied a major league record by hitting four home runs in one game.

ABBIE HOFFMAN, the charismatic counterculture radical, embodied the spirit of rebellion, celebrating youth, antiwar protest, and drug use. He staged stunts that were actually organized guerilla theater performances. He scattered dollar bills from the balcony of the New York Stock Exchange; led a ceremony at the Pentagon that had a chain of people holding hands as they surrounded the building and tried to levitate it; organized protests at the 1968 Democratic

National Convention in Chicago; and founded the Youth International Party, or YIPPIES.

DUSTIN HOFFMAN began his acting career in the off-Broadway theater. His first movie role was in *The Graduate* (1967), which won him an Oscar nomination. His second role, in *Midnight Cowboy,* in 1969, also won a nomination. He starred in a string of hit movies, and finally won an Oscar for *Kramer vs. Kramer* in 1980. His most popular movie was *Tootsie* (1982), in which he played a man disguised as a woman actor in a T.V. soap opera.

DENNIS HOPPER, actor, photographer, artist, author, epitomized the sixties outsider in *Easy Rider,* a biker film that he co-wrote with Peter Fonda and Terry Southern. Hopper also acted in the film, a raw, realistic picture of America rarely seen in mainstream Hollywood films. The movie was nominated for two Academy Awards, one for screenplay and one for Jack Nicholson as best supporting actor.

LITA HORNICK took over *Kulchur* magazine from Marc Schleifer in February 1961, after the third issue. The magazine continued publication until 1965, specializing in the work of new American writers like Robert Duncan, Allen Ginsberg, and Frank O'Hara. After the magazine ceased publication, Hornick published books under the Kulchur Press imprint. Her own books included *Kulchur Queen* and *Night Flight* and a memoir, *The Green Fuse.*

ISRAEL HOROVITZ, a playwright as well as a producer, and actor, first won public attention for his 1968 off-Broadway play, *The Indian Wants the Bronx.* The play, a study in psychological terrorism, introduced Al Pacino to theater audiences in the role of a sadistic punk who along with a second thug torments a man from India they encounter at a bus stop.

THOMAS P. F. HOVING left a position as director of medieval purchase at the Metropolitan Museum of Art when he was appointed New York City's Parks Commissioner by Mayor Lindsay in 1965. Hoving staged Happenings in Central Park, closed parks to traffic, and installed safety surfaces in playgrounds, gaining a reputation as a maverick. He returned to the Metropolitan in 1967, where during his ten year reign he presided over such groundbreaking exhibitions as the landmark "Harlem on My Mind."

FREDERICK W. HUGHES was Andy Warhol's business manager for more than twenty-five years, and his deft guidance is credited with helping Warhol achieve his iconic status as an international art star. Hughes began sweeping floors inside the Factory studio in the mid 1960s and made himself indispensable in Warhol's business affairs. After Warhol died, Hughes was the executor of his estate.

HUBERT H. HUMPHREY, vice president of the United States from 1965 to 1969, and a U.S. senator from Minnesota for the prior 32 years, was an articulate champion of liberalism. He ran for the presidency in 1968, after President Lyndon B. Johnson chose not to seek a second term, but Humphrey's public support of Johnson's Vietnam War policy was unpopular, and he was narrowly defeated by Richard Nixon.

HERBERT HUNCKE was the legendary Beat Generation writer who named the movement and whose lifestyle epitomized its canon. He was a heroin addict, a charismatic street hustler and petty thief who enthralled a galaxy of Beat writers including Jack Kerouac, William S. Burroughs, and Allen Ginsberg. His first book, *Huncke's Journal,* was published in 1965. The character of Elmer Hassel in Kerouac's *On the Road* was based on Huncke.

ROBERT INDIANA, a leading Pop artist, achieved recognition for his single most famous image, the word *Love* (1966), which has been reproduced in every size imaginable, from a postage stamp to towering sculpture, 18-karat-gold rings to editions of prints. His next most popular image, *Money,* is also rendered in the clean-edge tradition of American sign painting.

HARRY JACKSON was originally considered an Abstract Expressionist artist, but he abandoned nonobjective art for traditional representationalism in painting and sculpture. Strongly identified with the American West, he painted two gigantic murals of cowboy life in the Mare Chiaro bar in New York's Little Italy. The murals were pictured in Life magazine in 1958 and garnered nationwide attention.

JANE JACOBS published *The Death and Life of Great American Cities,* in 1961. She argued that the sterile high-rise buildings and elevated highways being advocated by city planners and developers were destroying, not improving city neighborhoods. Her book was an immediate success and helped her own Greenwich Village community defeat construction of a roadway through Washington Square Park.

KEN JACOBS is an independent filmmaker noted for his innovative use of color. His features include such titles as *Saturday Afternoon Block Sacrifice: TV Plug: Little Cobra Dance* starring Jack Smith and *Baudelarian Capers,* a musical.

RONA JAFFE achieved recognition with her first novel, *The Best of Everything* (1958), about a group of young women making their way in New York City. She went on to write a dozen more novels and a children's book and her books have sold over twenty million copies worldwide

MICK JAGGER, lead singer and frontman of The Rolling Stones, and Stones guitarist Keith Richards wrote one of the top rock songs ever, "Satisfaction (I Can't Get No)" in 1961. The band, ironically known as the anti-Beatles, has continued to tour and record for over forty years.

SIDNEY JANIS was a contemporary art dealer in New York City. A 1962 show he curated, New Realists, became a touchstone for the emerging Pop Art movement. In 1967, he famously donated 103 works from his private collection to the Museum of Modern Art. The gift included art that ranged from an early Picasso to a James Rosenquist painting.

JACOB JAVITS began his political career as New York State attorney general. He went on to become a congressman, and U.S. senator (1957-1981). A prominent spokesman for liberal Republicans, Javits represented New York in the Senate longer than anyone before him. The Javits Convention Center was named for him.

JEFFERSON AIRPLANE was a psychedelic rock band that emerged from San Francisco's Haight Ashbury. Formed by folk guitarists Marty Balin and Paul Kantner they were joined by Jorma Kaukonen, Skip Spence, Jack Casady and vocalist Signe Anderson. They became rock icons after Grace Slick replaced Anderson and they released the *Surrealistic Pillow* album in 1967.

TED JOANS was a Beat poet whose work blended avant garde jazz rhythm with his own experiences as a Black man in white America. He was also a talented Surrealist painter and lecturer. Joans lived in Paris for many years and traveled to Africa, where he lived in Timbuktu. He was a friendly, ubiquitous presence in Greenwich Village in the Beat era, when he hosted or attended numerous parties and poetry readings.

JASPER JOHNS was a leading figure in both the Pop Art and Minimalist movements in the late 1950s and early 1960s. Using such symbolic imagery as beer cans, American flags, numbers, maps, and targets as his subject matter, Johns honed his minimalist technique and unique style, moving away from the prevailing Abstract Expressionism toward a new emphasis on the concrete.

LYNDON B. JOHNSON, elected vice president in 1960, entered the presidency upon Kennedy's assassination in 1963. Johnson's Great Society programs, which included anti-poverty initiatives and Head Start schooling, were passed by congress after he had shepherded Kennedy's voting rights act into law. Johnson was reelected in 1964, but public opposition to his escalation of U.S. involvement in the Vietnam War led to Johnson's decision not to seek reelection in 1968.

PHILIP JOHNSON is a noted architect whose projects range from New York City's Seagram building, in collaboration with Mies van der Rohe, to the National Center for the Performing Arts in Bombay, India. He coined the term International School of Architecture for an exhibition at the Museum of Modern Art. Among his most famous works is The Glass House in New Canaan, Connecticut.

RAY JOHNSON started the New York Correspondence (a.k.a. Correspondance) School in 1968. Using coin-operated library copying machines and the U.S. Postal Service, he circulated personalized art-and-wordplay to friends around the world, requesting each "correspondent" to add something and pass the work to someone else in the "school." Much of the work featured a bunny and a snake.

JILL JOHNSTON, critic, activist and autobiographer, was born in London to an American nurse. Her grandmother raised her while her mother worked. She studied dance at Columbia and wrote Dance Journal for *The Village Voice*. Her column was maddening to some readers as she refused to use punctuation. Her own mother wrote the paper offering to pay them not to run it anymore. Her books include *Marmalade Me, Paper Daughter, Lesbian Nation,* and a biography of Jasper Johns.

JAMES EARL JONES, an actor of great presence with a rich, powerful voice, achieved stardom in October 1968 in the Broadway production of *The Great White Hope,* a stirring blank-verse drama by Howard Sackler. It was based on the life of Jack Jefferson, the first Black heavyweight boxing champion of the world who is destroyed by racial prejudice. He is hounded out of the country for having accompanied his white mistress across a state line and winds up in poverty and despair.

JANIS JOPLIN was the premier white female blues vocalist of the 1960s and one of the biggest stars of the era. She belted out songs in her raspy, shrieking voice with a passion that won her millions of fans but left her emotionally and physically exhausted. Known for drinking a bottle of Southern Comfort on stage, she died of a heroin overdose when she was twenty-seven.

DEBORAH JOWITT, *Voice* dance writer, choreographer, and teacher, studied with Martha Graham, Jose Limon, and the American Ballet Center. She was one of the original members of New York's Dance Theatre Workshop where she presented her own choreography. She edited *Meredith Monk* published by Johns Hopkins University Press.

ALLAN KAPROW originated the performance art phenomenon called Happenings, which combined elements of surrealism and Dada with drama, music, and the visual arts. In October 1959 he staged *18 Happenings in 6 Parts,* and the term was taken up by the media to describe performance events. His seminal book, *Assemblage, Environments & Happenings* (1966) was an anthology of events by many artists, including Rauschenberg, Dine, and Oldenburg.

IVAN KARP, as the director of the Leo Castelli Gallery, acquired a reputation as the King of Pop because he exhibited controversial shows featuring works by Andy Warhol and other young artists. Karp opened his own gallery, the OK Harris, in 1969. It was one of the pioneering Soho galleries in what would become a trendy area of galleries and designer boutiques.

ALLEN KATZMAN, a poet who lived in New York's Lower East Side, along with Walter Bowart in October 1965 started the *East Village Other,* an alternative newspaper covering the counterculture in downtown New York in somewhat raunchier style than the *Village Voice,* which had been established some eight years earlier. Katzman was also one of the founders of the Underground Press Syndicate and became the Minister of Information for the Yippies when they first began.

DON KATZMAN, playwright, actor, editor of the *Seventh Street Anthology,* and the Judson Review. He played the part of Baby in Judson's production of *Breasts of Tiresias* and appeared in the Hardware Poet's theatre production of Bob Nichol's *Family Difficulties* and his play *The Wax Engine.*

STACY KEACH, JR., actor on stage, in movies, and television, made his Broadway debut in 1969 as Buffalo Bill in Arthur Kopit's *Indians* a performance that earned him a Tony nomination for Best Actor. He played the title role in Barbara Garson's off Broadway satire *Macbird,* earning an Obie Award, a Vernon Rice Award, and the Drama Desk Award. He has continued to win numerous awards for his performances on and off Broadway.

HARVEY KEITEL launched his acting career in Martin Scorsese's *Mean Streets* (1973), and he has become one of the screen's most intense and talented performers. He has played in a variety of roles, many of them on the wrong side of the law, and won several awards including the Palme d'Or at the Cannes film festival for *Pulp Fiction* (1994) and *The Piano* (1993).

MURRAY KEMPTON was a liberal model of conscience for five decades of New York newspaper readers, and newspaper writers. The Pulitzer Prize-winner was known for traveling to assignments on an old bicycle. An editor once said Kempton was "unmatched in his moral insight into the hypocrisies of politics and their consequences for the poor and powerless."

SALLY KEMPTON, one of the best *Voice* reporters, was the daughter of the respected *New York Post* columnist, Murray Kempton. She wrote about Carmine DeSapio, Irving Howe, I. F. Stone, Jerry Rubin, Frank Zappa. In an anti-draft demonstration at the Whitehall Induction Center, Sally Kempton changed from reporter to participant and got herself arrested. This may have been a turning point in her life. She joined a West Coast cult group and never again wrote for the *Voice.*

JOHN F. KENNEDY, United States 35th president, offered the promise of youthful vigor and social change when he assumed office. In the thousand days until his assassination in Dallas, Texas on November 22, 1963 he was able to carry out several initiatives of his New Frontier—the Food for Peace program, the Peace Corps, and the Alliance for Progress, which provided aid to Latin American countries. He supported the fight against discrimination and segregation in the South and appointed the first black Supreme Court justice, Thurgood Marshall.

ROBERT F. KENNEDY in 1961 was named U.S. attorney general by his brother, President John F. Kennedy. After the president's assassination, he resigned from office in 1964 and moved to New York City, and was elected to the U.S. Senate that November. He actively promoted social welfare programs and was instrumental in founding the Bedford Stuyvesant Restoration Corporation. He opposed President Johnson's escalation of the Vietnam War and in 1968 entered the race for the Democratic presidential nomination. He was assassinated the night he won the California primary.

LEIGHTON KERNER, *Village Voice* classical music critic, has sustained a long and distinguished career for over forty years. He studied science at Tufts and journalism at Boston University. His lifelong interest in music began when he listened to classical music programs on the radio. Kerner also is a critic for *Opera News.*

JACK KEROUAC, legendary icon of the Beat Generation, came to widespread media attention with publication of his second book, *On the Road* (1957), a free-wheeling novel based on his own cross country trips. He became a symbol of youthful rebellion and continued to turn out novels inspired by his interest in jazz and Buddhism: *The Dharma Bums* (1958), *The Subterraneans* (1958), *Big Sur* (1962), and *Desolation Angels* (1965). Kerouac's growing conservatism alienated him from his Beat followers. Alcoholism led to his early death.

JOHN F. KERRY, a Vietnam War hero and U.S. Senator from Massachusetts, became an antiwar activist after he became disillusioned about the goals and mission of the conflict. He took part in the 1969 Moratorium to End the War protests and later served as national coordinator for Vietnam Veterans Against the War. He also helped organize Dewey Canyon III, in which veterans of the war threw medals earned in the conflict onto the Capitol steps.

CORETTA SCOTT KING was a student at the New England Conservatory of Music, in Boston, when she met, and in 1953 married Martin Luther King, Jr, who was a doctoral student in theology at Boston University. The couple moved to Montgomery, Alabama, where he was pastor at the Dexter Avenue Baptist Church. In 1962 they moved to Atlanta. She reared four children and worked alongside her husband at the forefront of the civil rights movement. After his assassination in 1968 she continued to promote Dr. King's principles, and in 1969 she founded the Atlanta-based Martin Luther King Jr. Center for Nonviolent Change to train students in nonviolent protest.

MARTIN LUTHER KING, JR., the most influential figure of the civil rights era, was a Baptist clergyman and a founder of the Southern Christian Leadership Conference. His strength of purpose, calm under pressure and transcendent rhetoric won him the admiration and trust of Blacks who were tired of injustice and racial discrimination. His first campaign for integration in Montgomery, Alabama in 1955 began a social revolution. He continued his work in Albany in 1962, in Birmingham in 1963, in St. Augustine in 1964, and in Selma in 1965. His doctrine of nonviolence became the civil rights movement's strategy, and his deeply moving "I Have a Dream" speech was the movement's emotional peak. He was awarded a Nobel Peace Prize in 1964. King was assassinated on April 4, 1968 in Memphis, where he had gone to help a sanitation workers' strike proceed in a more peaceful manner. His death caused outbreaks of rioting in many U.S. cities.

ALLEN KLEIN, a music entrepreneur whose client list in the early sixties included Bobby Darin and Sam Cooke, sought to manage the Beatles after the death of Brian Epstein in 1967. Although Klein was accepted by John Lennon, George Harrison, and Ringo Starr, Paul McCartney preferred to have his business affairs handled by his father-in-law, Lee Eastman. Despite Klein's efforts to reunite the Beatles, a High Court ordered the partnership dissolved in 1971.

BILLY KLUVER, an electrical engineer, in the early 1960s collaborated with artists like Jean Tinguely, Jasper Johns, and John Cage on works of art incorporating new technology. In 1966 Kluver, Robert Rauschenberg, and Robert Whitman founded Experiments in Art and Technology, an organization to provide artists with technical information on such topics as electronics. E.A.T.'s first and best known project was "9 Evenings: Theatre and Engineering" in 1966.

WHITMAN KNAPP was a New York judge who headed the Knapp Commission (1969–1972) to Investigate Allegations of Police Corruption in the city, based on the testimony of former police officer Frank Serpico. Serpico's story was told in a book, later made into the movie *Prince of the City*, released in 1981.

EDWARD I. KOCH was a Greenwich Village lawyer who began his rise in politics in 1963, when he defeated longtime Tammany boss Carmine DeSapio for the post of District Leader and became the de facto head of the city's reform movement. He won election to the City Council in 1966 and two years later was elected to Congress. In 1977, Koch was elected mayor and began a three-term run as one of New York's most outspoken chief executives.

LUCY KOMISAR, a writer and a feminist, in 1970-71 was a national vice-president of the National Organization for Women. She has written on social issues for the *Village Voice* and about the women's movement in *The Saturday Review, Newsweek, The Nation* and elsewhere. She also lectured on feminism nationally.

JILL KORNBLEE, an art dealer, ran an avant garde gallery but became known for an unusual off-beat puppet play presented in the gallery called *The Ice Queen* by Rosalyn Drexler which starred the voices of Ruth Ford, Warren Finnerty, and Zachary Scott.

ALEXEI KOSYGIN was the Soviet politician who in 1964 succeeded Nikita Khrushchev as prime minister (chairman of the Council of Ministers). He attempted modest, decentralizing reforms, but was blocked by the party machine and rival Leonid Brezhnev. Kosygin resigned in 1980 because of ill health and died soon thereafter.

JANE KRAMER was a staff reporter for the *Village Voice* and later became European correspondent for *The New Yorker*. Her numerous books include *Off Washington Square, Whose Art Is It? The Last Cowboy,* and *Allen Ginsberg in America*. She is married to the anthropologist Vincent Crapanzano and lives mostly in Italy.

SAM KRAMER owned a longtime Greenwich Village shop, at 29 West 8th Street, where he sold his modernist jewelry, much of it biomorphic or anthropomorphic. A flamboyant figure, he was known for his lavish parties featuring flamenco dancers and mimes. At one event, on October 12, 1959, he held a ceremony to cut the plaster casts from nightclub owner Eddie Condon's broken arm and writer Anatole Broyard's broken leg.

PAUL KRASSNER published *The Realist,* a 1960s humor magazine that mocked sacred cows, and often exceeded the bounds of good taste. The magazine's slogan changed from issue to issue, from "The Magazine of Basic Insecurity" to "The Magazine of Mob Violence" or "Summer Reruns," "Criminal Negligence," and "Applied Paranoia."

PHYLLIS KRIM is best known for her paintings of classic automobiles, predominantly from the 1930s through the 1950s. Her work has been exhibited at numerous automotive exhibitions, including the Pebble Beach Concours d'Elegance and the Limerock Racetrack and art museums nationwide. She was the first woman invited to be a member of the Automotive Fine Arts Society.

SEYMOUR KRIM was a writer, an editor, and a mentor to many Beat Generation writers. He published essays and criticism in the *Partisan Review, Commentary,* the *Village Voice,* the *New York Times Book Review* and the *Washington Post Book World*. His own books included an anthology called The Beats and an essay collection, *Notes of a Nearsighted Cannoneer.*

STANLEY KUNITZ published his first book of verse in 1930, *Intellectual Things*. His career gathered force in the 1950s, when he won a Pulitzer Prize for his *Selected Poems 1928-1958*. Since then he has achieved iconic status with advancing age.

WILLIAM M. KUNSTLER rocketed to fame as the flamboyant and quick-witted defense lawyer in the Chicago Eight conspiracy trial. He went on to play a key role in many of the nation's most publicized legal controversies, defending clients or movements that were rarely popular. Kunstler was with the Rev. Martin Luther King Jr. in Memphis when King was killed.

TULI KUPFERBERG is a pamphleteer, poet, publisher of *Birth,* and author of over twenty books, notably *1001 Ways to Beat the Draft, 1001 Ways to Live Without Working,* and *1001 Ways to Make Love*. He was a founder of the 1960s rad-rock group The Fugs.

YAYOI KUSAMA, a Japanese performance artist known for her *Naked Happenings,* said in 1968 that she wanted to feature nudes because, "I ask you to become one with eternity by obliterating your personality and returning to the primordial state of union with the eternal forces of nature." She also produced sculptures filled with autobiographical, psychological, and sexual content. She said she used her art to overcome her childhood fears and phobias.

JOHN LAHR, a theatre critic and author of fiction and nonfiction works, has reviewed plays for the *Village Voice, Evergreen Review,* and *New Yorker* magazine. His first book was *Notes on a Cowardly Lion* (1969), a biography of his father, comic Bert Lahr. Other biographies include *Prick Up Your Ears:The Biography of Joe Orton* (1978) and *Sinatra: The Artist and the Man* (1998).

MARK LANE was a New York City attorney who was not satisfied with the Warren Commission enquiry into the murders of President John F. Kennedy, Officer J.D. Tippett, and Lee Harvey Oswald in Dallas in 1963. After two years of investigating the unexplained aspects of the President's assassination, he wrote *Rush to Judgment,* a critique of the Commission, the FBI, and the Dallas police.

KERMIT LANSNER joined *Newsweek* in 1954 as book editor and advanced to become editor in the 1960s. He was also a vice president of the Louis Harris polling firm. His wife, Fay Lansner, is a prominent artist.

JEREMY LARNER, a novelist and screenwriter, published *Drive, He Said,* in 1964. A movie version, directed by Jack Nicholson, was not a success, though it captured the zeitgeist of doomed radical causes with its story of basketball and revolution. Larner also has written extensively on politics and sociology and been a board member of *Dissent* magazine.

JAMES LAUGHLIN, American publisher, editor and poet, was an heir of the

Jones-Laughlin steel fortune. His interest in literature started at the Choate School. When he went to France, he stayed with Gertrude Stein and Alice B. Toklas, then went to Rapallo and stayed with Ezra Pound. He later founded New Directions and published works by Dylan Thomas, Djuna Barnes, John Hawkes, Frederico Garcia Lorca, James Purdy, Nathaniel West, and Yukio Mishima.

DR. TIMOTHY F. LEARY more than any one individual embodied the drug culture with his famous mantra "turn on, tune in, and drop out." Supporters saw him as the prophet of a new age of enlightenment; critics called him a menace who destroyed lives by encouraging the use of lysergic acid diethylamide, or LSD. A member of the faculty at Harvard, he was fired in 1964, and after LSD was declared illegal, his long troubles with the law began.

GERALD LEFCOURT, a criminal defense lawyer, represented Abbie Hoffman at the Chicago Eight conspiracy trial in 1969. His most famous legal victory was the Panther 21 case, wherein all thirteen defendants (eight others were severed from the original case and not charged after the initial arrest) were acquitted. The Panthers, accused of conspiracy to blow up the New York Botanical Gardens and other public targets, had spent years in jail. The government spent millions to try the case, Lefcourt worked without payment, and won.

JOHN LENNON, in addition to his celebrity as the leader of the Beatles, had a solo career as an artist, writer, and peace advocate. He published two collections of his writings, *In His Own Write* in 1964 and *A Spaniard in the Works* in 1965. In 1968 he collaborated with Yoko Ono to create *Unfinished Music, No. 1: Two Virgins,* an experimental noise collage. Lennon's first concert after the Beatles stopped touring came in Toronto in 1969, where he introduced his solo hit "Give Peace a Chance."

SIDNEY LENS, an independent radical and trade union leader, was from the lower East Side. His involvement with the labor movement began after he was beaten by police when he attempted to unionize workers in an Adirondacks resort. He wrote several books, *The Counterfeit Revolution, Crisis of American Labor,* and *Unrepentant Radical.* Lens was a founder of Dissent magazine with Irving Howe.

RICHARD LESTER directed a number of films depicting the swinging sixties. Lester directed, shot, and edited *A Hard Day's Night,* a strikingly original film filmed in black and white, documentary style and purportedly followed the rock stars during a day in their lives in London. Lester's other sixties films included The Beatles' *Help!* (1965), *The Knack and How to Get It* (1965), *How I Won the War* (1967), and *Petulia* (1968).

LES LEVINE is a conceptual artist who uses mass media and information processing devices to create his works of art. In one notable instance, he is pictured strewing paper on an empty lot in Greenwich Village. The picture appeared on the menus of Levine's, an Irish-Jewish-Canadian restaurant named for the artist in 1969.

HOWARD LEVY, a U.S. Army doctor, was court-martialed in 1967 for refusing to provide medical training for soldiers headed for Vietnam. Levy was convicted of "disobedience and seeking to promote disloyalty." He served 26 months in Leavenworth Penitentiary where he co-authored a book with David Miller who was prosecuted for burning his draft card.

JERRY LEE LEWIS, one of rock and roll's alltime greats, distilled his piano and singing style from a variety of sources, including country swing, rock, jump band rhythm & blues, and jazz. Hits like "Great Balls of Fire" and "High School Confidential" brought him stardom. His career suffered a setback when news of his marriage to a thirteen-year-old cousin broke, but he successfully made a comeback in 1968.

SOL LEWITT, a painter, sculptor, and conceptual artist, has worked in a variety of media. His first works were three-dimensional floor and wall geometric forms. In 1964 he produced modular structures, in wood or metal, in the shape of pyramids, cubes and angles. In the late sixties he translated his three-dimensional constructions into networks of lines. LeWitt later moved those networks

into colorful large-scale works. In 1976 he founded the bookshop called Printed Matter that sells artists' books.

ROY LICHTENSTEIN is best known for his Pop canvases of the early 1960s, in which he made blowups from comic strip frames, bubblegum wrappers, and advertising art figures. In imitation of newspaper printing, he used exaggerated dot screens and even had his characters' thoughts in bubbles above their heads. His ironic vision led him later to parody works by Picasso, Mondrian, and other twentieth century masters.

A.J. LIEBLING, an outstanding American journalist, had a varied career with the *New Yorker,* which he joined in 1935. His early articles covered politics, sports, and gastronomy. During World War II he was in France, England and North Africa sending back dispatches that were later published in *The Road Back to Paris* (1944). In 1946 he took over "The Wayward Press" column in the magazine and became a harsh critic of establishment journalism.

JOHN V. LINDSAY was a maverick Republican Congressman from New York City's Silk Stocking District from 1958 to 1965 and the city's mayor from 1965 to 1973. In a time of national unrest after the assassination of Martin Luther King, Jr., Lindsay walked the streets of Harlem in shirtsleeves, expressing his solidarity with the stricken community and preventing the urban riots that took place in other U.S. cities. Lindsay changed his party affiliation to Democrat before making failed runs for president in 1972 and U.S. Senator in 1980.

DAN LIST handled circulation for the *Village Voice* and also wrote a column about cars. He was a sports car collector and repairman and was in charge of the *Voice*'s annual downtown car rally. He later managed distribution of the *Soho Weekly News* and the *New York Observer.*

BARBARA LLOYD danced with the Princeton Ballet Society from 1951 to 1953. From 1961 to 1965 she danced in New York with Aileen Passloff, William Davis, and members of the Judson Dance Theatre. She has been a member of the Merce Cunningham Dance Company since 1962.

ROBERT LOWELL was a Pulitzer Prize winning poet of post-World War II Amerca, and a committed peace advocate long before the United States become mired in the Vietnam War. Throughout his life he was preoccupied with political and social issues and in 1965 refused an invitation to attend a White House Arts Festival because of U.S. policies abroad. Lowell marched in the front line of the Washington "Raising the Pentagon" protest in 1967.

FELIPE LUCIANO, chairman of the Young Lords, grew up in Brownsville, Brooklyn. In 1963 he was convicted of manslaughter and served two years at Coxsackie. Out of jail, he enrolled at Queens College as a political science major. Many years later in an ironic twist, when police brutality was at its peak, Luciano was appointed to a mayor's task force to facilitate discussions between civilians and police. The Young Lords collectively were the best educated of all the revolutionary groups. Many turned to the media for a career. Luciano became a TV journalist and radio talk show host.

CHARLES LUDLAM, an avant garde playwright, director, and star, founded and led the Ridiculous Theatrical Company, a Greenwich Village repertory that staged Ludlam's unique farces that were a satiric blend of Elizabethan drama, camp, burlesque, vaudeville, silent movies, and opera. Ludlam won four Obies for off-off-Broadway achievement.

DWIGHT MACDONALD was an author, essayist, editor, and pop culture critic, who, with a group of like-minded Marxist sympathizers in 1937 revived *Partisan Review,* a radical journal founded in 1934. It became the leading forum for the intellectual elite. Macdonald was active in the anti-Vietnam War movement, speaking out against American involvement and urging young men to defy the draft even if it meant going to jail.

NANCY MACDONALD grew up in a conservative milieu—her grandfather had been president of the New York Stock Exchange, she was educated at Vassar. But she became an anarchist and supporter of the Loyalist exiles who fought against Franco in the Spanish Civil War. She also helped

radicalize her husband, Dwight Macdonald, the founding editor of *Partisan Review*.

GEORGE MACIUNAS, along with Nam June Paik and Wolf Vostell, was a founder of Fluxus, an irreverent art movement, in Wiesbaden, West Germany in 1962. Fluxus was formed as a reaction against the expressionistic and symbolic aspects of happenings and incorporated Dada as well as Surrealist aspects. The Lithuanian born Maciunas's own art consisted of small boxes accumulating debris in some way and unusual graphic designs.

MAHARISHI MAHESH YOGI was a Hindu monk who taught Transcendental Meditation to hippies, chic society folk, the Beatles, the Rolling Stones, and other rock groups, and thousands of ordinary citizens. The Yogi created the International Meditation Society to further the process by which one could reach a state of pure consciousness in which the mind would be unaware of anything in particular.

NORMAN MAILER has stood among the first rank of American writers since the publication and success of his first novel, *The Naked and the Dead* (1948). In addition to fiction he has published poetry and nonfiction. His *Armies of the Night* (1967), which won a National Book Award and Pulitzer Prize, documented an anti Vietnam War protest in Washington in the personalized style of the new journalism. Mailer ran for mayor of New York City in 1969. Although he lost, some of his ideas, like closing city parks to traffic, which seemed fantastic at the time, have been realized.

GERARD MALANGA, a multimedia artist and poet, was one of the brighter stars in Andy Warhol's galaxy of assistants, associates, actors and actresses, artists and assorted hangers-on. He was central to the operation of The Factory from 1963 until 1968, was a major influence on many Warhol paintings and films, choreographed and danced on stage with a bullwhip during performances of the Velvet Underground, and was a cofounder of *Interview* magazine in 1969.

MALCOLM X (Malcolm Little) was a black nationalist who articulated the rage felt by African Americans who lived in a nation that prided itself on liberty, but treated its black citizens with violence and hatred. Malcolm had served time in prison, but transformed himself into an Islamic family man whose ascetic life forbid drugs and alcohol. He broke from the Black Muslims' Nation of Islam in 1964 because they advocated separation from mainstream America. Malcolm was shot to death in the Audubon Ballroom in New York City on February 21, 1965; his death has been attributed to violent Black Muslim followers.

JUDITH MALINA, a director, actress, producer and writer, co-founded the Living Theatre with her husband, Julian Beck. The first production was Gertrude Stein's *Doctor Faustus Lights the Lights* in 1952 at the Cherry Lane Theatre. The off-Broadway company expressed the anarchist, pacifist philosophy of its founders and their space at 14th Street and 6th Avenue, which opened in 1959, became a cultural center, hosting poetry readings, dance performances, and avant garde plays.

BILL MANVILLE was an advertising copywriter before he started writing his "Saloon Society" column for the *Village Voice*. He also contributed articles to the *Saturday Evening Post* and *Cosmopolitan*. He has written several books, among them *Breaking Up*, *Goodbye* and *The Palace of Money*.

MARISOL (Escobar) was born in Paris to Venezuelan parents and studied at the Ecole Beaux Arts Students League and with Hans Hoffman. She became famous for her brilliantly satirical carvings and assemblages, often incorporating her own striking image. Her deadpan approach and sophisticated wit sets her apart from her contemporaries. She has had exhibits at most of the elite galleries: Stable Gallery, Sidney Janis, and Leo Castelli.

THE MAYSLES brothers, Albert and David, were independent filmmakers, little known until their first feature-length film in 1969. *Salesmen* was a penetrating, ironic documentary hailed by critics as the cinematic equivalent of the nonfiction novel. It recorded eight weeks that the brothers spent on the road with four salesmen from the Mid-American Bible Company. The brothers' best known work is *Gimme Shelter* (1970), a film on the Rolling Stones and their controversial 1969 concert at Altamont Speedway in California.

EUGENE MCCARTHY was a U.S. senator who ran for the Democratic nomination for president in 1968, in opposition to President Johnson's escalation of the Vietnam War. McCarthy was a hero to youthful voters, who vowed to "stay clean for Gene." When Robert F. Kennedy entered the race, liberal Democrats were divided in their support, and Hubert H. Humphrey won the nomination. McCarthy retired from the Senate in 1971 and devoted himself to teaching and writing.

MARY MCCARTHY, who had a long career as a novelist, memoirist, journalist, and critic, achieved mainstream celebrity with the 1963 publication of *The Group*, a novel that followed the postgraduate lives of eight women who had roomed together at Vassar, McCarthy's alma mater, in 1933.

GEORGE S. MCGOVERN was elected to the U.S. Senate from South Dakota in 1962 and reelected in 1968. He was a leading voice against the Vietnam War, calling for a political rather than a military solution to the conflict. He was defeated by Hubert Humphrey for the Democratic presidential nomination in 1968, but did secure the nomination in 1972. He lost to Richard Nixon, who painted the liberal McGovern as a radical because he supported amnesty for draft resistors, the decriminalization of abortion, and drastic cuts in defense spending.

FLOYD MCKISSICK was a lawyer and civil rights leader who became head of the Congress of Racial Equality (CORE) in 1966 when James Farmer left. McKissick rejected the Rev. Martin Luther King's philosophy of nonviolence and advocated a more aggressive stance. He left CORE in 1968 to focus on ways to empower the economic and political strength of the black community.

MARSHALL MCLUHAN was a Canadian scholar of the media who coined the phrase "The medium is the message," in his influential book *Understanding Media: The Extensions of Man* (1964). In 1963 he founded the Centre for Culture and Technology at the University of Toronto. In his 1962 book, *The Gutenberg Galaxy: The Making of Typographic Man*, McLuhan claimed that electronic media had turned the world into a "global village," thus contributing another catchy phrase to media studies.

ROBERT S. MCNAMARA. as U.S. Secretary of Defense during much of the Vietnam War, was chief architect of President Lyndon Johnson's expansion of the conflict. After visiting South Vietnam and seeing firsthand the political corruption of the government, he urged Johnson to end the war. Johnson considered McNamara's change of mind a betrayal and asked for his resignation. McNamara joined the World Bank in 1968, where he was president until retiring in 1983.

DAVID MCREYNOLDS worked for the War Resisters League, a pacifist group founded in 1923. The WRL organized anti Vietnam War events, assisted in the burning of draft cards, promoted civil disobedience at army induction centers, and aided men who resisted the draft. In 1969, McReynolds published a collection of political writings, *We Have Been Invaded by the 21st Century*, which included an essay about his homosexuality.

TAYLOR MEAD is an underground film and stage actor as well as a poet. The star of Andy Warhol's 1968 *Lonesome Cowboy*, Mead also played in Ron Rice's *Flower Thief*, and Jonas Mekas's *Hallelujah the Hills*. He won an Obie for his performance in Frank O'Hara's play *The General Returns from One Place to Another*. Mead's poetry notebooks have been published as *Excerpts from the Anonymous Diary of a New York Youth*.

RICHARD MEIER is an architect whose modernist designs are simple, often sculptural forms in which space is extended vertically. Among his large scale projects are the High Museum in Atlanta and the Getty Center in California.

JONAS MEKAS, *Village Voice* film critic, filmmaker, and co-founder of the Filmmakers Cooperative and the Filmmakers Cinematheque, has become the leader and chief spokesman of underground filmmaking. Born in Lithuania, he came to the United States in 1949. His writing appeared in the *Voice* from 1959 to 1975. His first film, made with his brother, Adolphus, was the surrealistic *Guns of the Trees* (1962), with poetry by Allen Ginsberg and music by Lucia Dlugoszewski.

JAMES MEREDITH was twice at the forefront of major events in the civil rights movement. In 1961 he applied to the University of Mississippi, an all-white institution. After eighteen months of resistance by university and state officials, including Gov. Ross Barnett, an executive order from President John F. Kennedy enabled Meredith to gain entrance to the university. In 1965, Meredith was shot and wounded while completing a 220 mile "walk against fear" in Mississippi to encourage blacks to register and vote.

ARTHUR MILLER is a leading dramatist who deals with issues of moral and political consequence played out in the context of family and society. His masterpiece, *Death of a Salesman,* (1949), won a Pulitzer Prize. His 1960s plays included *After the Fall,* an autobiographical account of Miller's failed marriage to actress Marilyn Monroe, that was the first production of the Lincoln Center Repertory Theatre, and two one-act plays, *Incident at Vichy* (1965) and *The Price* (1968).

KATE MILLETT became one of the most respected and effective voices in the national feminist movement after publication in 1970 of *Sexual Politics.* The book originated from a speech that Millett made while she was working on a doctorate at Columbia University. In her book, she urged women to gain control of their own destiny, and free themselves from male domination and the inferior roles forced on them by the culture.

SAL MINEO was a screen actor who had great success playing juvenile characters. He won Best Supporting Oscar nominations for his portrayal of Plato, James Dean's friend, in the classic *Rebel Without a Cause* (1955) and again for his role as Dov Landau in *Exodus* (1960). With rumors regarding his sexuality swirling about Hollywood, Mineo found it increasingly difficult to find work. At the age of 37 he was stabbed to death outside his Hollywood apartment.

CHARLES MINGUS was a highly regarded jazz musician, a bass player and a composer, using improvisation to achieve a seminal new sound. His *The Black Saint And The Sinner Lady* (1963) encompassed styles from New Orleans and gospel to bebop and free jazz. His most famous work was the 1956 album *Pithecanthropus Erectus.*

MEREDITH MONK, an influential performance artist, has created an innovative series of pieces incorporating dance, music, language and film. She was briefly associated with the Judson Dance Theatre before she developed her own company, The House, in 1968. Her vocal music has been performed by numerous soloists and groups. She has also been a pioneer in site-specific performances, such as *Juice: A Theater Cantata in 3 Installments* (1969).

JOSEPH MONSERRAT, a key figure on the Knapp Commission and president of the New York City Board of Education, was well grounded in Puerto Rican politics, police work, immigration and all around legal issues involving corruption in government. He was an official of the Migration Division of Puerto Rico.

ROBERT MOOG developed the Moog Synthesizer, an electronic music synthesizer that resembles an organ, when he was a Cornell University graduate student in 1964. The Moog quickly became a staple in the recording industry, featured on albums by The Beatles and on film soundtracks like Stanley Kubrick's *A Clockwork Orange,* where the electronic Beethoven rendition helped lend the movie its malevolent sheen.

MOONDOG, a blind musician whose real name was Louis Thomas Hardin, stood mysteriously at the corner of Sixth Avenue and 52nd Street in New York City for eight hours a day, winter and summer, all during the 1960s, a tall silent figure cloaked Viking-like in a homespun brown garment. He held an eight-foot-long spear as he stood at attention, evoking curious glances. A poet and avant garde composer, he sold his poems and compositions to passersby. His name is said to have been taken in memory of a pet that bayed at the moon.

CARMEN MOORE, *Voice* music critic, conductor, teacher, and writer on music, studied at the Juilliard School of Music. He helped launch the Society of Black Composers in 1968, and taught at Manhattanville College, as well as Yale and Queens College. "He makes imaginative use of various genres, ranging from jazz to the avant-garde."

CHARLOTTE MOORMAN, a performance artist noted for playing the cello while topless, conceived the idea of a Festival of the Avant Garde. After the first festival in 1963, it became an annual celebration of nontraditional art with numerous participants-musicians, actors, poets, visual artists-each doing their own thing. Moorman's festivals continued for ten years, always in September, but at various New York City locations, including a baseball stadium, the Staten Island ferry, and a National Guard air base. Participants included John Lennon, Yoko Ono, John Cage, Nam June Paik, Allen Ginsberg, and Allan Kaprow.

ROBERT MORGANTHAU became district attorney of New York County in 1975 and has been in that office ever since. His father was Secretary of the Treasury under President Franklin Roosevelt, and Morganthau has continued the family tradition of public service since 1961 when he was U.S. attorney for the Southern District of New York 1961 to 1970.

MALCOLM MORLEY, British born realist, was educated at the prestigious Royal College of Art in London. He moved to New York in 1958. After painting a series of warships and ocean liners, he became identified with Super Realism. Many of his scenes were culled from travel brochures. He eventually abandoned the photo realism style and became more of a Neo-Expressionist.

PAUL MORRISSEY collaborated with Andy Warhol on some of the seminal underground films of the 1960s, including *Poor Little Rich Girl, The Chelsea Girls, My Hustler, Vinyl, Bike Boy,* and *Lonesome Cowboys.* After Warhol was shot in 1968, Morrissey played an even more important role in the creation of Warhol's films, notably *Flesh, Heat,* and *Trash,* which was the first underground film to "crossover" to commercial cinemas.

JIM MORRISON, lead singer of the 1960s rock band The Doors, achieved mythic stature with the group's first album, *Light My Fire,* in 1967. Morrison's charismatic stage presence invited a cultlike following, but the band's self-destructive lifestyle resulted in increasingly unpredictable behavior. Morrison was found dead in a hotel bathtub in Paris in 1971, and his grave in Pere Lachaise cemetery has become a major tourist attraction.

ROBERT MOSES, as New York City parks commissioner (1934–1960) and head of the Triborough Bridge and Tunnel Authority (1946–1968), initiated vast and often controversial programs of parks and beachfront development and highway construction that, according to Robert Caro's Pulitzer Prize winning 1974 biography, *The Power Broker,* included 12 major bridges, 658 playgrounds, 627 miles of highway, and more than 2.5 million acres of parks, along with Jones Beach, Shea Stadium, Lincoln Center, the United Nations and the 1939 and 1964 World's Fairs. Critics denounced Moses for not promoting mass transit and for destroying city neighborhoods.

ALBERT MURRAY is an African American writer whose books focus on the influence of African culture on American life. His first published nonfiction was *The Omni-Americans* (1970), a collection of essays refuting the theory that African Americans are subservient to white social infrastructures. Other writings include a fiction trilogy and an autobiography of Count Basie as narrated to Murray, *Good Morning Blues* (1985).

A.J. MUSTE was a tireless worker on behalf of world peace. In the 1960s he devoted himself to groups opposing United States participation in the Vietnam War. Among them were such organizations as the Vietnam Day Committee, the Fort Hood Three Defense Committee, the Fifth Avenue Vietnam Peace Parade Committee, and the Spring Mobilization Committee to End the War in Vietnam.

FORREST MYERS, environmental sculptor, came from Long Beach, California, and was one of the core artists in John Gibson's Park Place Gallery on LaGuardia Place. One of his unusual "sculptures" was "Searchin 1966," a series of huge laser searchlights crisscrossing in the sky above Tompkins Square Park.

VICTOR NAVASKY has been with the *Nation* magazine since 1978, first as editor then editorial director and publisher. He has also been a professor of journalism at Columbia University and author of several books, including

Kennedy Justice (1971), a National Book award nominee, and *Naming Names* (1980), an American Book Award winner.

ALICE NEEL was a representational painter noted for her portraits of art world personalities. In 1974 she was one of the first women to have a major retrospective at the Whitney Museum.

PABLO NERUDA, Chile's most prominent poet, is a hero whose scope transcends national boundaries. He is an "orthodox Marxist who breaks free from the narrow prisons of class interest, political institutions, and party lines." Neruda has received the International Peace Prize as well as many others. He is a member of the International P.E.N. Congress.

JACK NEWFIELD from Bed-Stuy, Brooklyn, controversial muckraking reporter for the *Voice,* went after corrupt judges, thieving landlords, nursing home scoundrels, dishonest politicians, and crooked fight promoters. He is the author of *Robert Kennedy: A Memoir, Prophetic Majority, City for Sale* (with Wayne Barrett), *Only in America,* and *The Life and Crimes of Don King.* Newfield eventually went to the *New York Post.*

BARNETT NEWMAN was a painter, printmaker, and sculptor known for his huge, luminous colored canvases divided by a vertical line. He was a contemporary and friend to New York School painters like Jackson Pollock, Robert Motherwell, and Mark Rothko. His most important work was the *14 Stations of the Cross* (1958-66), in which he used the power of abstract painting to convey a spiritual message.

HUEY P. NEWTON and Bobby Seale founded the Black Panther Party to fight the racist oppression of blacks. The Panthers monitored police actions, and Newton became a magnet for police hostility. In 1967 he was charged with the murder of a police officer, and supporters began an intensive "Free Huey" campaign. A 1968 conviction was overturned in 1970. His life began a downward spiral after the Panthers disbanded in 1982 and he was killed in a drug-related incident.

MARY PEROT NICHOLS had two prominent careers. First, she was a crusading and influential editor at the *Village Voice.* In her column, "City Politics," she exposed corruption in municipal politics. After her lifelong friend and ally Ed Koch was elected mayor of New York City, she was appointed head of the city's public radio and T.V. station, WNYC.

MIKE NICHOLS is an actor, director, writer, and producer who established his reputation in New York in the 1960s with a string of six Broadway hits—Neil Simon's *Barefoot in the Park* (1963), *The Knack* (1964), *Luv* (1964), *The Odd Couple* (1965), *The Apple Tree* (1966), and *Plaza Suite* (1968). His film work of that decade includes *Who's Afraid of Virigina Woolf?* (1966) and *The Graduate* (1967), for which he won an Academy Award for best director.

NICO (Paffgen) is best known as the vocalist that Andy Warhol chose to include on the first Velvet Underground record album. She also appeared in Warhol's movie *Chelsea Girls.* After she left the Velvets in 1967, Nico continued recording as a solo artist with her haunting, often sparse sound and signature deep-voiced intonation.

RICHARD M. NIXON was a Congressman, senator, vice president to Dwight D. Eisenhower, and 37th president of the United States (1969 -74). He led the United States withdrawal from Vietnam and informally recognized the People's Republic of China. The Watergate scandal at the beginning of his second term led to his resignation. Nixon was the Republican candidate for president in 1960, but lost to John F. Kennedy.

RUDOLF NUREYEV, the celebrated Russian-born dancer, was a soloist with the Kirov Ballet when he defected to the West while visiting Paris with the company in 1961. He later danced in the United States, Britain, and Europe. For many years he was primarily associated with the British Royal Ballet where he danced with ballerina Margot Fonteyn. He staged his own productions of ballet classics but also extended his range to include contemporary works.

PHIL OCHS was a singer-songwriter who became a favorite on the blossoming folk-protest circuit in Greenwich Village. His first two albums, 1964's *All the News* and 1965's *I Ain't Marching Anymore* were moderate successes. *Pleasures of the Harbor* (1967) and the sardonically titled *Phil Ochs Greatest Hits* (1970) documented a deeply troubled personality. He took his own life when he was 36.

ODETTA (Odetta Holmes Gordon Shead Minter) was a star of the early 1960s folk movement, and has been a dynamic influence in the American folk music scene. Her eclectic repertoire contains gospel, blues, jazz, spirituals, and folk songs, such as "Old Cotton Fields at Home," "Sometimes I Feel Like a Motherless Child," and "Blowin' In The Wind." She participated in the Selma marches and performed at the 1963 March on Washington.

FRANK O'HARA, the New York School poet, art curator, and critic, died in a freak accident, after being struck by a beach taxi on Fire Island, a tragedy described as "incalculable and all but unspeakable" by his friends in the art community. His poetry followed ordinary speech patterns, marked by humor and first person anecdotes. He published six volumes of poems, notably *Lunch Poems* (1964) and *Love Poems (Tentative Title)* (1965).

CLAES OLDENBURG is a Pop Art icon, known for his soft sculptures of "real" objects in materials incongruous to the subjects. His 1962 exhibit at the Green Gallery first displayed his *Giant Blue Men's Pants, Soft Pay Telephone, Soft Wall Switches, Soft Typewriter, Soft Toilet, Soft Bathtub,* and *Giant Ice Cream Cone.* He went on to make massive pieces like a 24 foot lipstick tube now in New Haven, a huge cherry on a spoon in the sculpture garden at the Walker Art Center in Minneapolis and a forty foot tall clothespin in downtown Philadelphia.

DENISE OLIVER joined the Young Lords Party in 1969 and was soon given the rank of minister. In 1971 she left the party to join the militant Eldridge Cleaver faction of the Black Panther Party, which had split with Huey P. Newton, who was considered too moderate.

JACQUELINE BOUVIER KENNEDY ONASSIS was riding beside her husband, President John F. Kennedy, when he was assassinated in Dallas, Texas on November 22, 1963. As first lady she was known as a patron of the arts who supervised the restoration of the White House. After the president's death, she and her children moved to New York City, where she embarked on a career as a book editor. In 1968 she married Greek shipping millionaire Aristotle Onassis.

YOKO ONO was an accomplished conceptual artist who became internationally famous after she married John Lennon in 1969. They met in 1966 at London's Indica Gallery, where Ono was exhibiting a work called *Ceiling Painting,* which invited viewers to climb a ladder to get to a magnifying glass to read words on the ceiling. Their first musical collaboration was 1968's *Two Virgins,* which was controversial both for its sound—experimental noises and Ono's distinctive wail—and the cover art, a picture of the two of them naked.

PETER ORLOVSKY, long time companion to Beat poet Allen Ginsberg posed nude with Ginsberg for a full length portrait by Richard Avedon in 1963. Circulated as a poster, the image helped raise public awareness of gay unions. Orlovsky began to write poetry in the sixties; his collection *Straight Hearts Delight: Love Poems and Selected Letters* was published in 1980.

AL PACINO had a breakthrough performance in 1968 when he won an Obie for his role in Israel Horovitz's *The Indian Wants the Bronx.* His role as Michael Corleone in *The Godfather* (1972) brought him an Oscar nomination for best supporting actor. Equally at home on stage and screen, he has played an extraordinary variety of roles with great distinction.

NAM JUNE PAIK was recognized as the preeminent artist in the fledgling field of video art almost immediately after he moved to New York in 1964. Paik was a member of the Fluxus movement in Germany, a loosely knit, nonconformist group noted for its Happenings. He began to create video art with such works as *Participation TV* (1963–71), in which images on a TV monitor are altered in response to ambient sound. With Charlotte Moorman he was a cofounder of the avant garde festivals.

GRACE PALEY is a short story writer, poet and teacher, and an active feminist

and pacifist who helped found the Greenwich Village Peace Center in 1961. Her first collection, *Little Disturbances of Man: Stories of Women and Men in Love* (1959) was hailed by critics impressed by her ear for dialogue and ability to express deep feelings in short stories.

JOSEPH PAPP was the energetic director of the New York Shakespeare Festival and one of the most influential producers in the history of modern American theater. He presented free Shakespeare in the park in the 1950s, and in the 1960s, he took over the old Astor Library in downtown Manhattan and turned it into the nonprofit Public Theater, a six-theatre complex where he presented the work of young playwrights, including *Hair,* the archetypal sixties musical, in 1967.

DR. LINUS PAULING, a scientist and social activist, won the first of his two Nobel awards in 1954 for chemical research into the molecular formations making up all complex substances. In 1962 he received the Nobel Peace Prize for his antiwar activism, including his campaign against nuclear testing. He founded the Linus Pauling Institute of Science and Medicine in California to study how to use vitamins and other dietary supplements in the treatment of various diseases.

STEVE PAXTON is a dancer and choreographer. He was one of the founder-members of the Judson Dance Theater in 1962 and a founding member of the improvisational Grand Union in 1970. Paxton's choreography incorporated everyday movements into his repertoire. One work, the 1967 *Satisfyin' Lover,* had performers simply walking across the floor. Paxton developed Contact Improvisation, a system of improvised movement between two performers.

TOM PAXTON was born in Chicago and moved to Oklahoma when he was ten. After his BFA from the University of Oklahoma, he joined the Army. He was a regular performer at The Gaslight Café on MacDougal Street. Paxton has recorded children's music and written books for children as well.

JOHN PERREAULT, *Voice* art reporter, curator, artist, does "real time performances involving artists as a presence sculpting time and space." He ran the museum at Sailor's Snug Harbor on Staten Island, and was a recipient of a National Endowment grant for art criticism. He became art editor of *The Soho Weekly News.*

PETER, PAUL & MARY was a folk singing group consisting of Peter Yarrow, Noel Paul Stookey, and Mary Travers. They first appeared in Greenwich Village and went on to become fixtures at national protests. In 1962, their first, self-titled album sold two million copies and spawned the single "If I Had a Hammer," a Weavers song that became a civil rights anthem. Their second album, *Moving* (1963) featured "Puff, The Magic Dragon," now a children's standard.

LIL PICARD, performance artist and sculptor, studied art in Vienna and Berlin and at the Art Students League in New York. Her main interest, "self performances in personal realism style," involved at times wrapping her nude models in yards of hospital gauze. She was a participant in numerous art panels.

HAROLD PINTER established an international reputation in 1958 with the London production of *The Birthday Party,* and has continued to intrigue audiences with plays invested with suspenseful plots and sinister threats. Akin to the theater of the absurd, Pinter's plays are filled with tension, oftentimes in silences that seem longer than the curt speeches of his characters. His 1964 play, *The Homecoming,* is generally regarded as his best work.

GEORGE PLIMPTON was one of the founders of the literary periodical the *Paris Review.* His curiosity as a journalist has led him to take on the roles of wrestler, baseball player, and prizefighter and to write about his adventures and misadventures. His best-selling book, *Paper Lion,* told about his experiences with the Detroit Lions pro football team.

NORMAN PODHORETZ, was the longtime editor-in-chief of *Commentary,* a position he assumed in 1960. Podhoretz wrote extensively about the Beat movement in *Partisan Review* and *Esquire.* His books include *The Fifties and After in American Writing* (1964) and *Making It* (1968).

BRIGID POLK (born Brigid Berlin), rebelling against her wealthy family, turned to drugs and began frequenting Andy Warhol's Factory studio and clubhouse. Her bold performances in Warhol movies *Chelsea Girls* and **** led one critic to dub the overweight actress "the hippopotamus of sin." Despite her obesity, she often appeared nude in Warhol's movies, displaying not a trace of self-consciousness.

ADAM CLAYTON POWELL represented New York City's Harlem in Congress for twenty-five years and never lost the support of his constituents, despite allegations of impropriety that led to his being temporarily stripped of his seat in 1967. He maintained the accusations were made because he was Black, and in 1969, he was cleared by the Supreme Court.

ELVIS PRESLEY was the King of Rock and Roll who rose from humble beginnings in the Deep South, to become one of the world's most famous entertainers. He maintained a strong presence on the charts and in films in the 1960s, but his sculpted hair, mutton-chop sideburns and once-stylish attire gave him a dated, un-hip look in comparison with the long-haired, casual style of the late 1960s. His 1968 television special, *Elvis,* showed Presley as a still-vibrant stage artist.

RICHARD PRESTON is a filmmaker who has done silent and sound 16mm films. He is a member of the Creative Film Foundation and to his credit are the short films *Conversations in Limbo, Paper Dolls, Son of Dada, Ecstacy, Manifesto,* and many others.

MARY QUANT, an innovative British fashion designer, manufactured trend-setting miniskirts and dresses that were taken up by young women. Although there was widespread negative reaction to the new "mod" fashion, it was short-lived and the style has survived. Quant's boutique on King's Road in London's Chelsea was the epicenter for her miniskirts, vinyl boots, and dresses with wild geometric patterns.

YVONNE RAINER is an alternative filmmaker who was originally a dancer. She was a founder of the Judson Dance Theater and was instrumental in gathering Judson choreographers to found Grand Union, a radical dance company featuring improvisation and ordinary movement. Rainer began making short films to screen during her performances. Her first feature length film, *Lives of Performers* (1972), emphasized issues of women's identity.

MARCUS RASKIN, a writer on politics and economics, has published books on such topics as U.S. policy in Vietnam, the federal budget and national security. He has also served on the Presidential Commission on Education, the editorial board of the *Nation,* and contributed numerous articles on public policy to major journals.

DAN RATHER, the quintessential journalist with fifty years of experience, has a degree from Sam Houston State Teachers College. He worked for UPI, the *Houston Chronicle,* was a White House correspondent, a reporter in Vietnam, and an Emmy Award winner. He is co-editor of *60 Minutes,* and author of *The Camera Never Blinks Twice.*

DAN RATTINER was a co-founder in 1965 with the Katzman brothers, of the *East Village Other,* an alternative downtown weekly in New York City. Rattiner had gained newspaper experience after he founded *Dan's Papers* in the Hamptons seven years earlier. Rattiner eventually moved from Manhattan to eastern Long Island where he continues as editor and publisher of *Dan's Papers.*

ROBERT RAUSCHENBERG has been a leading figure in avant garde American art since the 1950s. Rauschenberg first exhibited as a painter, and later became known for his mixed media works using photographs, sculpture, found objects, and furniture. Rauschenberg has also been deeply involved in collaborative performance and dance works, working closely with such performers as Trisha Brown and Merce Cunningham.

MARTHA RAYE, flamboyant Hollywood actress, was born in the charity ward in Butte, Montana, where her touring vaudeville parents were stranded. She is best known for entertaining the troops in World War II, the Korean War, and in Vietnam. She was married and divorced six times. She apparently

felt comfortable wearing Army fatigues, complete with combat badge and ribbons.

RONALD REAGAN was, in 1960, a registered Democrat, host of the CBS television series *General Electric Theater,* and president of the Screen Actors Guild. His fears that communist infiltration could destroy the nation led him to a more conservative philosophy. Handsome, charismatic, and displaying a masterful sense of timing, he spoke out on political issues. He switched his party affiliation in 1962 and by the end of the decade, as the Republican governor of California, he was the nation's preeminent conservative politician and poised for a two term run in the 1980s as President of the United States.

LOU REED and his fellow musicians John Cale, Sterling Morrison and Maureen Tucker formed The Velvet Underground, a group that was considered the epitome of urban hipness and downtown New York cool. Andy Warhol became their manager after seeing them at a Greenwich Village club. Reed's biggest commercial hit, "Walk on The Wild Side," (1972) is an homage to the sexually ambiguous members of Warhol's entourage.

STEVE REICH is a composer whose interest in non-Western music led him to study drumming in Ghana. In the 1960s, he composed a number of works that showed the influence of John Cage. Like Philip Glass, Reich has been an exponent of minimalism, and his characteristic music, notably *It's Gonna Rain* (1965), features repetitive phrases in slightly different forms.

ELMER RICE won the Pulitzer Prize for *Street Scene* (1929), a realistic drama that focused on the New York City slums. In 1947, it was made into an opera by Langston Hughes and Kurt Weill. The work became a major influence on the next generation of playwrights. Categorized by many as a crusader and reformer, Rice used his work to express his social and political views.

LARRY RIVERS was a figurative painter associated with the Abstract Expressionist movement, as well as an accomplished musician, filmmaker, writer, and occasional actor. His self-mocking bad boy persona encapsulated the spirit of a restless era. He drank and argued about art with Willem de Kooning at the Cedar Tavern, and collaborated on projects with everyone from Frank O'Hara to Jack Kerouac.

NELSON ALDRICH ROCKEFELLER, the grandson of Standard Oil founder John D. Rockefeller, was governor of New York State from 1959 to 1973. His administrations were noted for their expansion of social welfare programs, harsh drug laws, and the violent Attica prison uprising in 1971. A moderate Republican, he failed in three attempts during the 1960s to become the party's presidential nominee. He was appointed to the vice presidency by Gerald Ford, and served between 1974 and 1977.

JOSE RODRIGUEZ-SOLTERO is an artist and mixed media filmmaker whose work has been described as "daring and controversial." He was featured in the New Visions Festival in 1966 with *Jerovi,* "a narcissism myth described in sexual-Freudian terms, placed in the luxuriance of nature." He also showed his film *LBJ.*

THE ROLLING STONES proclaimed themselves The World's Greatest Rock and Roll Band. Few can argue the point. They have survived a tumultuous history written in tabloid headlines, but have remained extremely popular and prodigiously productive. The original group began with Mick Jagger and Keith Richards who shared an affinity for American blues music. Brian Jones played guitar, Bill Wyman bass, and Charlie Watts drums. Their name was derived from a Muddy Waters song.

HUGH ROMNEY, before he assumed the personae of Wavy Gravy, guru of the Hog Farm, a traveling commune, was a dapper figure among the younger Beat poets in Greenwich Village in the late 1950s. He formed a trio with Moondog and Tiny Tim that performed at the Fat Black Pussy Cat on Minetta Street. Romney was an organizer of the Pigasus for President campaign in Chicago in 1968, and emceed at the Woodstock Festival the following year.

HAROLD ROSENBERG was the art critic for the *New Yorker* magazine from the late sixties until his death as well as a contributor to the *Partisan*

Review. He was an influential supporter of Abstract Expressionism and coined the term "Action Painting."

JAMES ROSENQUIST is one of the major Pop artists. Using the techniques he learned as a billboard painter, he produced close-up, fragmented compositions with garishly colored images of American culture. His best known painting is *F-111,* which is ten feet high and 86 feet long and can be organized into a complete room surrounding the viewer. The painting includes fragmented images of destruction along with ordinary details like a light bulb and a plate of spaghetti as well as the 86-foot-long image of the F-111 fighter-bomber.

BARNEY ROSSET founded Grove Press in 1951, he was also the publisher and editor, along with Fred Jordan, Richard Seaver, and Donald Allen of *Evergreen Review,* the most influential of Beat era periodicals. Over 95 issues were published between 1957 and 1967, featuring the work of avant-garde writers, poets, playwrights, composers, painters, and photographers.

PHILIP ROTH is a major American writer, the prolific author of witty, sharply satirical, and sometimes fantastic novels that portray the moral and sexual anxieties of contemporary American life. His first book, *Goodbye Columbus* (1959), won the National Book Award.

JERRY RUBIN was a longhaired counterculture Yippie who coined the catchphrase "Never trust anyone over 30." Rubin and his comrade in chaos, Abbie Hoffman made fun of nearly everything and everybody (themselves included). Rubin appeared at Congressional hearings dressed variously as Paul Revere, Uncle Sam, Santa Claus, and a bare-chested Viet Cong soldier, draped with bullets and waving a toy machine gun. During the 1968 Democratic National Convention in Chicago, he ran a mock campaign for vice president under the Youth International Party (Yippie!) banner. The presidential candidate was a 40-pound swine, Pigasus The Immortal. Rubin was among the eight Chicago protest leaders convicted of conspiracy to riot. A 1972 appeals court reversed the decision.

MARK RUDD, leader of the Columbia student rebellion and takeover of President Grayson Kirk's office in 1968, was a hero to radical students. The strike protested the Vietnam War, the construction of a new Columbia gym that would impinge on Harlem, and the presence on campus of a government think tank. In 1969, Rudd became leader of the Weatherman faction of the Students for a Democratic Society. After the group held a "Four Days of Rage" rampage in Chicago in October of that year, Rudd and several other Weathermen were indicted on conspiracy charges that were later dropped.

DEAN RUSK was U.S. Secretary of State 1961 - 1969 and an important foreign policy advisor to both presidents John F. Kennedy and Lyndon B. Johnson. During the years of the Vietnam War, Rusk was a hardliner who fully supported the American military presence in Vietnam. When he left office, he was considered the primary architect of the U.S. escalation of the war.

MICKEY RUSKIN owned and managed the legendary hangout Max's Kansas City, which is often regarded as the cultural Ground Zero of the 1960s New York underground. He hosted personalities ranging from Andy Warhol (whose Factory was a block away) to Jane Fonda to various transvestites, often bartered art for food with struggling artists and booked unknown music acts like the Velvet Underground, Bruce Springsteen and Billy Joel for his upstairs stage.

ARTHUR RUSSELL was a composer whose work had almost medieval quality. His tone combinations of two or three notes "tuned to modal/raga scales" are played by various instrumental groups. His career was cut short when he died in 1992 at age 41.

BAYARD RUSTIN was a civil rights activist who helped start the Southern Christian Leadership Conference with Dr. Martin Luther King Jr. In 1960, he was forced from his position in the SCLC because he was homosexual. However, King continued his friendship with Rustin and the two men were the prime organizers of the 1963 March on Washington. In 1965, when the AFL-CIO started a civil rights organization designed to strengthen relations

between the black community and the labor movement, Rustin accepted an offer to head the A. Philip Randolph Institute.

BLAIR SABOL, fashion writer along with Stephanie Harrington, wrote columns that were hip and irreverent, based on the premise that an industry like fashion claiming to create art ought to be judged critically. They went far afield writing a tongue-in-cheek commentary on the riot gear worn to demonstrations by *Voice* photographer Fred McDarrah.

ALBERT SAIJO lived in San Francisco's North Beach in the mid-fifties, where he became friendly with Beat Generation writers. In 1959 Lew Welch introduced Saijo to Jack Kerouac, and the three set off on a cross country trip, composing haiku to pass the time. The haiku was published in *Trip Trap*, and also inspired the poem written by the three friends in McDarrah's anthology *The Beat Scene*.

YVES SAINT-LAURENT started his career in fashion design as an assistant to Chrisian Dior. He became head of that house on the death of Dior in 1957, and in 1962 St-Laurent opened his own house of haute couture in Paris. In 1969 St-Laurent launched his Rive Gauche line, one of the first high fashion designers to offer factory-made clothing of high quality at ready-to-wear prices.

ED SANDERS reached a wide countercultural audience with raunchy songs protesting the Vietnam War, performed by his band, The Fugs. Typical song titles were "Kill for Peace" and "Slum Goddess of the Lower East Side." Sanders was initially a poet, then a novelist. He also published a periodical, *Fuck You: A Magazine of the Arts,* and opened the Peace Eye bookstore on New York's Lower East Side. He moved to upstate New York where he is publisher of the *Woodstock Times.*

WILLIAM SAROYAN was the noted author of stories, novels, and plays, including the Pulitzer Prize winning *The Time of Your Life.* His writings, especially those about small towns, were a major influence on Jack Kerouac, notably in Kerouac's first full-length work, *Atop an Underwood.*

ANDREW SARRIS, the *Village Voice* film critic, married to Molly Haskell also a film critic. Sarris is Editor-in-Chief of *Cahiers du Cinema,* is professor at Columbia, and author of several books: *The American Cinema, Confession of a Cultist, Politics and Cinema.* He is a Guggenheim Fellow and became film critic for the *New York Observer* in 1989.

RICHARD SCHECHNER, a theatrical director and writer, founded the Performance Group in 1967. He was strongly influenced by Jerzy Grotowski's Polish Laboratory Theatre, and wanted to explore styles and techniques beyond traditional texts and proscenium stages. The company was housed in a former trucking garage and took the name of Performance Garage. Their first and most successful production, which opened on March 28, 1968, was an adaptation of Euripides' *The Bacchae* and consisted of a series of rituals relating to sexual freedom and spiritual expression.

CAROLEE SCHNEEMANN, performance, video and multi-media installation artist, gained literary status from her seminal and provocative *Meat Joy* performance at Judson Church in 1964 in which she explores issues of the erotic, the sacred, and the taboo. Schneemann was the first to use the body to express the relationship between "the world lived experience and the imagination." In *Imaging Her Erotics,* Duke Professor Kristine Stiles writes, "Schneemann has created a method for translating feelings, inhibitions, and sensations into communicable information."

PETER SCHUMANN founded the Bread & Puppet Theatre, which presented mime and mask plays, using both actors and grotesque larger-than-life stick puppets, in children's shows, street theater, parades, political demonstrations, and at their home base on New York City's Lower East Side. At some peace demonstrations the puppets, dressed in burlap bags, represented Christ and his followers, symbolizing the doom of Christ's last day on earth. A monstrous effigy of Lyndon Johnson led the group.

MARTIN SCORSESE worked as a film editor until his first feature, *Who's That Knocking At My Door?* (1968) caught the attention of Roger Corman who

asked him to direct *Boxcar Bertha*. Scorsese had also worked as an assistant director on the groundbreaking musical documentary *Woodstock* (1970). After doing Corman's low-budget action movie, Scorsese wanted to direct a more meaningful film. He returned to New York to film *Mean Streets* in 1973 and went on to a distinguished career as a filmmaker.

ETHEL SCULL was a rich socialite art collector with her husband Robert, a taxi baron who intimidated artists and bought their work cheap. When the Sculls auctioned off 13 paintings from their collection, an outraged Robert Rauschenberg verbally attacked them in the gallery. At a fundraising party in the Scull's palatial East Hampton estate, Jill Johnston, in an act of defiance, dived half-naked into their swimming pool to short-circuit the party.

BOBBY SEALE co-founded the radical Black Panther party with fellow activist Huey Newton in 1966 after the assassination of Malcolm X. The Black Panthers were a militant group that called on Blacks to arm themselves for the liberation struggle. Seale was one of the Chicago 8 defendants, but the judge severed Seale's case from that of the other defendants. He was sentenced to four years in jail for contempt, but the sentence was later reversed.

RICHARD SEAVER edited the literary magazine *Merlin* in 1950s Paris. In the 1960s he moved to New York and was managing editor of *Evergreen Review* and editorial director of Grove Press. With his wife, Jeannette, he founded Seaver Books, then an imprint of Viking Press.

TOM SEAVER was alternately known as "Tom Terrific" and "The Franchise" after he pitched the New York Mets to an unlikely baseball World Series title in 1969, winning 25 games and the league's prestigious Cy Young award for best pitcher. He went on to win 311 major league games and three Cy Young awards before entering the Hall of Fame in 1992.

PETE SEEGER is a musician, singer, songwriter, folklorist, labor activist, environmentalist, and peace advocate, who has devoted his musical talent to further his beliefs. Throughout the 1960s he appeared at scores of anti-Vietnam war protests and his version of "We Shall Overcome" became the anthem of the civil rights movement. On the Smothers Brothers' television show in 1966, he sang "Waist Deep In The Big Muddy," an antiwar song that CBS censors cut from the broadcast. He was invited back to sing it again, which he did. CBS retaliated by canceling the show.

HUBERT SELBY, JR., a Brooklyn native, published his first and most famous book, *Last Exit to Brooklyn* in 1964. The book, a controversial collection of related stories, depicts life among the prostitutes, transvestites, vicious thugs, and striking union workers on Brooklyn's waterfront. In 1966 the book was branded obscene in Britain and all copies were ordered destroyed. That decision was successfully appealed in 1968.

FRANK SERPICO, police detective, was the central figure in the Knapp Commission hearings. In 1967 he helped gather evidence of payoffs from drug dealers, bookies, organized crime, and shakedowns of small merchants. Serpico gave the evidence to the *New York Times* only after failing to hear from the police brass or City Hall. Peter Maas wrote the book *Serpico,* and Al Pacino played the detective on screen.

WILLOUGHBY SHARP, performance and video artist, consultant, and art dealer, studied at Brown, Columbia, and the University of Paris, and runs his own gallery. He once isolated himself at the 112 Greene Street Gallery in a solo performance for 300 hours in a huge crate with tiny port holes.

JEAN SHEPHERD was an engaging raconteur who transformed the small events of everyday life into tall tales of fantastic adventure that he broadcast on New York's WOR radio station for over 20 years, starting in 1956. He worked without a script, conjuring up tales based on his Indiana upbringing, or an incident he observed on the street that day, or whatever came to mind. He was one of the first radio personalities to welcome callers on air, and he inspired great affection from his devoted fans.

BARTON SILVERMAN emigrated from Brooklyn to become a news photographer for the *New York Times.* But he eventually switched to sports, a

subject in which he has distinguished himself, turning his photos into a true art form.

SHEL SILVERSTEIN, a poet who melded silliness and sophistication, sold over ten million copies of his books for children, including his 1964 classic *The Giving Tree*, a story about a tree that surrenders its shade, fruit, branches and finally its trunk to a boy in order to make him happy . Silverstein was also adept as a cartoonist, playwright, singer, and songwriter. His talent as a songwriter gave Johnny Cash his 1969 hit, "A Boy Named Sue."

GRACE SLICK, American rock vocalist, was born in Chicago and joined the Jefferson Airplane in 1966. She recorded the classic album, *Surrealistic Pillow*, which included the songs "White Rabbit" and "Somebody to Love," her signature songs.

HOWARD SMITH wrote the "Scenes" column, which began running in the Village Voice in 1966. He has had a wide-ranging career as a photojournalist, radio talk show host, and filmmaker. He produced and directed *Gizmo* and the Academy Award-winning documentary *Marjoe*.

JACK SMITH was a filmmaker whose output of innovative and idiosyncratic movies began with his first feature length work, *Flaming Creatures* (1962), which was deemed legally obscene. It was a celebration of homosexual love and its screening occasioned a trial with celebrity defense witnesses like Susan Sontag and Allen Ginsberg. Smith's influence is evident in the work of Andy Warhol, John Waters, and George Kuchar.

MICHAEL SMITH, theatre critic who took over the position at the *Voice* when Tallmer left for the *New York Post*. Smith stayed eleven years. Off-Broadway added off-off-Broadway and the Village cafes, Cino, Reggia, Borgia, La Mama, got recognition for their theatre presentations. Michael Smith also wrote and directed plays.

ROBERT SMITHSON was a pioneer in creating Earthworks, an art form developed in the late 1960s in which the artist employs the elements of nature *in situ*, or rearranges the landscape with earthmoving equipment. Smithson reshaped the landscape in a way that recalled both the forces of nature and ancient archaeological sites. His most famous creation, *Spiral Jetty* (1970), was a 15-foot wide dirt road, edged with stones, spiraling out into Utah's Great Salt Lake. It eventually became submerged as the lake rose.

HOLLY SOLOMON was an art gallery owner who opened one of the first performance art spaces in New York and gave early exposure to Laurie Anderson, Robert Mapplethorpe and Nam June Paik. Solomon was the subject of a glamorous portrait by Andy Warhol which cemented her legacy.

SUSAN SONTAG is a cultural critic, author of fiction, and film director. She achieved recognition with her essay on popular culture, "Camp," written in 1964 for the *Partisan Review* and republished in her 1966 collection *Against Interpretation*. The essay argued that serious cultural works were no more worthy of respect than such expressions of mass culture as rock concerts or movies. Sontag's use of the word "camp," as an exaggerated reproduction of the style and emotions of pop culture, brought the term into popular usage.

TERRY SOUTHERN wrote the screenplays for *Dr. Strangelove* and *Easy Rider*, two films that captured the rebellious spirit of the counterculture in the 1960s. His controversial 1958 novel *Candy*, written in collaboration with Mason Hoffenberg, launched his career as a writer. The book, an exaggeratedly obscene version of Voltaire's *Candide*, was the subject of widespread criticism and a 1967 Pennsylvania Supreme Court case, which described it as "revolting and disgusting."

A.B. SPELLMAN, poet, music critic, historian and arts administrator, became interested in writing at Howard University where his classmate, Amiri Baraka, encouraged him to seek his fortune in New York. His book of poems, *The Beautiful Day*, had introductory notes by Frank O'Hara. His later book, *Black Music: Four Lives*, covers Cecil Taylor, Ornette Coleman, Jackie McLean, and Herbie Nichols.

DR. BENJAMIN SPOCK was a pediatrician whose *Baby and Child Care*, first published in 1946, was regarded as the bible of child care. Spock moved into the political limelight in 1962, warning of the hazards of nuclear testing. He was an active opponent of the Vietnam War, leading a march on the Pentagon in 1967. In the Spock Trial; in June 1968, he was sentenced to two years in prison for conspiracy in aiding young men to avoid the draft. The verdict was reversed on appeal.

JOHN E. SPRIZZO, federal judge, a key member of the Knapp Commission, was an assistant U.S. attorney in the Department of Justice and associate professor at Fordham University Law School. He was appointed to the bench by the Reagan administration. In one of his cases, Judge Sprizzo refused to punish two protestors who blocked access to an abortion clinic, which is a federal crime, because Sprizzo "felt they were true believers."

GLORIA STEINEM has written, organized, and campaigned for women's rights. Her first published article, in *Esquire* magazine in 1962, discussed the changing role of women and men's failure to change their attitudes toward women. Steinem's *New York* magazine column, "City Politics", espoused such causes as legal abortions, the legal defense fund for Black activist Angela Davis, and the poor people's march in California led by Cesar Chavez. She was the founding editor of *Ms.* magazine in 1972.

FRANCES STELOFF, extraordinary book dealer, opened the Gotham Book Mart in 1920 and over the years turned it into an international literary haven. Her customers were legendary authors, poets, actors, and playwrights such as Theodore Dreiser, John Dos Passos, H. L. Mencken, Eugene O'Neill, Saul Bellow, even Woody Allen. She sold banned books like *The Tropic of Cancer* and *Lady Chatterley's Lover*. She lived in an apartment above the 47th Street store and apparently had a good life as she lived to be 101 years old.

ELLEN STEWART founded the LaMama Experimental Theatre Company in New York City's East Village in 1961; it was a boutique by day and a basement theatre at night. LaMama ETC welcomed the work of new playwrights and young actors. Harvey Fierstein, Bette Midler, Richard Dreyfuss and Robert DeNiro are among the personalities who appeared at LaMama before achieving mainstream recognition.

WILLIAM STYRON won the Pulitzer Prize for literature in 1968 for his third novel, *The Confessions of Nat Turner*, a fictionalized account of the bloody slave uprising of 1811 as told by its leader, Nat Turner. Styron was an outspoken opponent of the Vietnam War and attended the 1968 Democratic National Convention in Chicago.

THE SUPREMES were a popular singing group composed of three childhood girlfriends from Detroit: Diana Ross, Mary Wilson, and Flo Ballard. The Supremes achieved nationwide popularity after they signed with Motown records and producer Berry Gordy. Their first hit was "Where Did Our Love Go?" in 1964. Among their hit songs are "Stop! In The Name of Love" (1965), "Back In My Arms Again" (1966), and "You Can't Hurry Love" (1966).

RON SWOBODA is noted for his game saving catch of a Brooks Robinson line drive in the ninth inning of Game Four of the 1969 World Series. The Mets won the game in extra innings and won the World Series the next day. In 1971, he played briefly for the New York Yankees, becoming one of a handful of players to play for both modern day New York teams.

JERRY TALLMER, a founding member of the *Village Voice* staff, was associate editor and drama critic. Under his direction the *Voice* covered off-Broadway theater and began the Obie awards. From 1962 to 1991 Tallmer was a reporter and cultural critic for the *New York Post*.

MEGAN TERRY, American dramatist, was born in Seattle and brought up in community theatre. She taught at the Cornish School where she directed her own first plays. Her association with Joseph Chaikin of the Open Theatre resulted in the production of *Viet Rock*, a seminal anti-war play. This was one of forty plays to her credit.

PAUL THEK, sculptor and artist, is best known for the installation of objects depicting surrealistic scenes of death and renewal. He was a native of Brooklyn. His best known work shown at the Stable Gallery was a gruesome wax figure, an effigy of himself reposed in a coffin.

FRANKLIN THOMAS, lawyer, was the first African American president of the Ford Foundation. He grew up in Brooklyn, worked with the Federal Housing Agency, the District Attorney's office, and with the New York City Police Department. In 1967 he was president of the Bedford Stuyvesant Restoration Corporation, working where he grew up.

BOB THOMPSON produced a large body of Renaissance-inspired expressionistic paintings that fused art-historical quotations with raw personal fantasy. He achieved an unprecedented level of critical and commercial success for a young Black painter of his age, and in his age. He attacked taboos head on, such as depicting white female nudes in his work, and was at once brash, inspired, fallible, gifted, and driven.

HUNTER S. THOMPSON, the "gonzo" journalist became famous for his rollicking 1967 book *Hell's Angels,* an account of life with the motorcycle gang, and his articles in *Rolling Stone* magazine that often celebrated 1960s drug culture. His 1971 tome, *Fear and Loathing in Las Vegas,* sealed his reputation as a counterculture icon.

TINY TIM (Herbert Butros Khaury) was a six-foot, one-inch entertainer with exaggerated effeminate gestures, odd topics of conversation, and shoulder length hair. When he married a 17-year-old fan called Miss Vicki on The Tonight Show with Johnny Carson in 1969, the event drew more than 40 million viewers. His leitmotif was a 1929 ditty, "Tiptoe Thru The Tulips," which he sang in his falsetto voice.

HAPPY TRAUM was a part of the folk music community in New York City in the late 1950s. He was a member of the New World Singers and with his brother Artie formed a folk-rock band called the Children of Paradise. He moved to Woodstock in 1967 where he recorded several tracks with Bob Dylan that appear on volume two of Dylan's *Greatest Hits.*

PENELOPE TREE, model, was the daughter of a rich and serious-minded family who did not want her to be a model. When she was thirteen, Diane Arbus photographed her. Her father vowed he would sue if the photos were published. In 1967 she moved into David Bailey's flat which became a hippie hangout. In the 1970s, Tree moved to Sydney, Australia.

DIANA TRILLING was a cultural and social critic for over 50 years and a widely-published champion of intellectual culture. Writing for the *Nation,* she reviewed some of the leading books of her generation, from George Orwell's 1984 to Jean Paul Sartre's *Age of Reason.* After her husband, literary critic and scholar Lionel Trilling, died in 1975 she worked to assure his legacy while continuing to maintain her lofty place in the literary establishment.

LUCIAN K. TRUSCOTT IV is a third-generation West Pointer, class of 1969. He was the product of an illustrious military family. But he did a complete about-face, and joined the *Voice* as a reporter. He once went to a *Voice* party in full dress uniform and shocked everybody. Truscott eventually became a best-selling novelist.

DAVID TUDOR was a performer and composer of avant garde electronic music and was closely associated with John Cage. He also served as musical director of the Merce Cunningham Dance Company.

TINA TURNER (born Anna Mae Bullock), with her sensual and dynamic voice, fronted the Ike and Tina Turner Revue, one of the most durable acts of the era. They recorded "A Fool in Love" in late 1959, and by the autumn of 1960 the record was number two on the charts. They recorded a string of classics, including '60s anthems "River Deep, Mountain High" and "I Can't Believe What You Say."

ULTRA VIOLET, underground film star, was the daughter of a conservative glove manufacturer in Grenoble. She was too eccentric for that staid city where she smoked cigars in the cafés and lit them with Franc bills. In New York she was the mistress of John Graham, then Salvador Dali. She never passed up a photo opportunity or a TV talk show.

JEAN-CLAUDE VAN ITALLIE is a Belgian born playwright, director, producer, and actor whose avant garde plays are a blend of European tradition and the American experience interpreted in a poetic experimental form. His first professional production was *War,* in the 1965-66 season as part of a program called *6 From La Mama.* His second, *America Hurrah* (1966), placed him in the forefront of experimental theater. His 1969 play *The Serpent* won a *Village Voice* Obie.

CYRUS VANCE, diplomat, was born in Clarksburg, West Virginia. He went to Yale where his classmates were Sargent Shriver, William Scranton, William Bundy, and Stanley Resor. He served in government with all of them. he was on the Knapp Commission and later named to the New York Commission of Government Integrity to investigate corruption in government.

STAN VANDERBEEK, filmmaker, has been producing what some describe as "home movies." But his skill as an artist cannot be challenged as proven by his awards from the Ford Foundation, Creative Film Foundation, and the West German and Bergamo International Film Festivals. His highly stylized, staccato film techniques utilize modern images and idols, space vehicles, TV sets, pin-ups, popular heroes, all drawn from slick magazines.

EDGAR VARÈSE was born in Paris and moved to New York in 1915, where he formed the International Composers Guild in 1921. A gifted composer, he didn't gain critical recognition for his work until the 1950s, with his electronic compositions *Deserts* for chamber orchestra and tape and *Poeme electronique* for tape alone.

THE VELVET UNDERGROUND, founded in 1965 with Lou Reed, John Cale, Sterling Morrison, and Maureen Tucker, gained public attention through their collaboration with Andy Warhol. On his suggestion, they brought in Nico who sang songs written by Lou Reed.

VIVA (born Janet Sue Hoffman) appeared in five of Andy Warhol's movies beginning in 1967, when she was in *Lonesome Cowboy, The Loves of Ondine, Nude Restaurant,* and *Bike Boy.* In 1968 she was in Warhol's *Blue Movie.*

ANDREI VOZNESENSKY, Soviet poet, was a protégé of Boris Pasternak. He was very popular here and abroad. In 1963 his government curtailed his writing and placed him under close surveillance. He wrote *Parabola* and *Mosaic* in 1960, and *Antiworlds* in 1964.

GEORGE C. WALLACE, the fiery four-time governor of Alabama, was an ardent segregationist. In his inaugural address on January 14, 1963, he declared, "I draw the line in the dust and toss the gauntlet before the feet of tyranny, and I say, segregation now! Segregation tomorrow! Segregation forever!" Wallace kept a campaign pledge to stand "in the schoolhouse door" to block school integration. His action caused President John F. Kennedy to federalize the Alabama National Guard and order soldiers to the campus.

MIKE WALLACE, television interviewer and reporter, has been associated with CBS's *60 Minutes* news magazine since 1968. He started his career in radio as a news reader in 1939 and then moved into television in the 1950s as an interviewer on *Night Beat* on Channel Five in New York City. He later was the host for *The Mike Wallace Interview* on ABC before he going to CBS.

ANDY WARHOL (born Andrew Warhola) was the leading figure of the Pop Art movement. He exhibited his *Campbell Soup Can* paintings for the first time at the Ferus Gallery in Los Angeles in 1962. It made him a star. His oft-quoted remark that "In the future everyone will be famous for 15 minutes" added to his celebrity. At his New York City studio, The Factory, he painted commonplace objects such as dollar bills and Brillo boxes and celebrity portraits assisted by a crew of admirers. This coterie also worked on his movies, and contributed to the magazine he created, Inter/View, and the underground rock band, The Velvet Underground, that he managed.

ROBERT WATTS with a degree in mechanical engineering was versatile in

all media, paintings, sculpture, performance, costume design, and filmmaking. A member of Fluxus Group, he was associated with Douglas College Gallery artists at Rutgers University. As a stamp collector in his youth he created "Stamp Art," a protest against the U.S. government.

LEE WEINER was one of the Chicago 8 defendants accused of conspiracy to incite riots during the 1968 Democratic Convention. Along with John Froines, Weiner was also accused of making incendiary devices. Weiner was acquitted of both charges and went on to work on behalf of political and social reform.

LEW WELCH was a Beat Generation writer who collaborated with Kerouac and Albert Saijo on the 1959 collection *Trip Trap: Haiku Along the Road from San Francisco to New York.* Welch's collected works appeared in 1977, five years after his mysterious disappearance in the foothills of the Sierra Nevada, described in Aram Saroyan's *Genesis* (1977).

TOM WESSELMANN was one of the first Pop artists; he had his first one-man show at the Sidney Janis Gallery in 1966. His work has evolved from small-scale collages made from discarded paper and other found material to large format poster-like designs, with bright colors and real objects integrated into the picture.

ROSS WETZSTEON, theater critic for the *Village Voice,* was a prominent figure in the off-Broadway world. He was the longtime chairman of the Obie Awards, which he helped create shortly after he joined the Voice in 1966. He later served briefly as the paper's editor-in-chief before returning to his primary interest, writing about and championing the theater as a senior editor at the *Voice.*

ROBERT WHITMAN was one of the early performance artists, along with Allen Kaprow and Jim Dine. His work involved interaction between live performers and filmed images. His best known piece was *Prune Flat,* first presented on the stage of the Film-Makers' Cinematheque in 1965. In it two women dressed in white performed a sequence of movements that were repeated in filmed images on a screen behind them.

DAVID WHITNEY, curator of the Jasper Johns retrospective at the Whitney Museum in 1977, is also the editor if *Andy Warhol: Portraits of the 70's,* an exhibition catalogue and picture book of commissioned portraits. He installed the exhibit at the Whitney Museum.

THE WHO, one of the rock and roll bands called the British Invasion, came to America in 1967. Founded in the early 60s by lead guitarist Pete Townshend, the original group was known for its rowdy onstage antics, and included Roger Daltrey, singer and also on guitar, John Entwistle on bass, and Doug Sanden

(later replaced by Keith Moon) on drums. Their recording of the rock opera *Tommy,* created by Townshend, brought them international fame.

JOHN WILCOCK, an English-born writer, was a founding contributor to the *Village Voice* and wrote a column, "Village Square," that ran for over ten years. He also wrote for a competing alternative newspaper, *East Village Other.* He moved to the West Coast where he edits and writes travel books.

TENNESSEE WILLIAMS was born in Mississippi. When he turned eleven, his mother gave him a typewriter. Williams went to the University of Iowa to get into their playwriting program. His plays depicted American life: *The Glass Menagerie, A Streetcar Named Desire,* and *Cat on a Hot Tin Roof.* He won four Drama Critics Circle Awards.

DAGMAR WILSON, founder of the Women Strike for Peace, was once charged with contempt of Congress in a closed hearing by the House Un-American Activities Committee for refusing to answer questions about the alleged Communist ties of her group. No proof of such ties was ever found. She organized 50,000 middle-class housewives in sixty cities in a national peace strike in 1961, urging an end to the arms race.

BUDDY WIRTSCHAFTER, environmental artist and filmmaker, studied fine arts with Hans Hofmann at the New School for Social Research. He taught film and multimedia at Southampton College, New York University, and Cooper Union. Wirtschafter directed the documentary film *I'm Here Now,* shown at the San Francisco and New York Film Festivals. He has worked with Andy Warhol on the films *Vinyl* and *Kitchen* and with Alfred Leslie in *The Last Clean Shirt.*

DAN WOLF was a founder, along with Norman Mailer and Edwin Fancher, of the *Village Voice* newspaper in 1955. None of the three had experience in journalism, and Wolf's idiosyncratic editing granted unusual freedom to the young writers who found the *Voice* a congenial outlet for their work. After the original owners sold the *Voice,* Wolf became an adviser to Mayor Edward Koch.

LAMONTE YOUNG is an avant garde composer who has produced a pioneering body of work exploring the possibilities of musical innovation. In one "composition" he released butterflies into a performance space as a piece of music. Among his major works is "The Well-Tuned Piano" (1964), a five-hour work in which Young plays a piano retuned to just intonation.

MARIAN ZAZEELA is an artist who has presented light installations and conducted light performances throughout the United States and Europe and won both NEA and CAPS grants. She has collaborated with the avant garde composer LaMonte Young and held a commission from the Dia Art Foundation to create locations for her performances.

Selected Reading List of the '60s

Abernathy, Ralph. *And the Walls Came Tumbling Down.* New York: Harper & Row, 1989.

Adams, Sidney P. *The Avant-Garde Film: A Reader in Theory and Criticism.* New York: New York University Press, 1978.

Adelson, Alan. *SDS.* New York: Scribner's, 1972.

Albert, Jane. *Growing Up Underground.* New York: William Morrow and Co., 1981.

Albert, Judith Clavir, and Stewart Edward Albert, eds. *The Sixties Papers: Documents of a Rebellious Decade.* New York: Praeger, 1984.

Alpert, Richard, and Sidney Cohen. *LSD.* New York: New American Library, 1966.

Amburn, Ellis. *Pearl: The Obsessions and Passions of Janis Joplin.* New York: Warner Books, 1992.

Amram, David. *Offbeat Collaboration with Kerouac.* New York: Thunder's Mouth Press, 2002.

Anderson, Terry H. *The Movement and the Sixties: Protest in America from Greensboro to Wounded Knee.* New York: Oxford University Press, 1995.

Anson, Robert Sam. *McGovern: A Biography.* New York: Holt, Rinehart & Winston, 1972.

Anthony, Gene. *The Summer of Love.* Berkeley: Celestial Arts, 1980.

Ashton, Dore. *The New York School: A Cultural Reckoning.* New York: The Viking Press, 1973.

Baldwin, James. *Nobody Knows My Name.* New York: The Dial Press, 1961.

Ball, Gordon. *'66 Frames.* Minneapolis: Coffee House Press, 1998.

Banes, Sally. *Greenwich Village 1963: Avant-Garde Performance and the Effervescent Body.* Durham: Duke University Press, 1993.

Barranger, Milly S. Theatre: *A Way of Seeing.* Fifth Edition. Belmont: Wadsworth, 2002.

Bates, Tom. *RADS: The 1970 Bombing of the Army Math Research Center at the University of Wisconsin and Its Aftermath.* New York: HarperCollins Publishers, 1992.

Belfrage, Sally. *Freedom Summer.* New York: Viking, 1965.

Berrigan, Daniel. *Absurd Convictions, Modest Hopes: Conversations after Prison.* New York: Vintage, 1973.

_____. *The Trial of the Cantonsville Nine.* Boston: Beacon, 1970.

_____. *Prison Journals of a Priest Revolutionary.* Compiled and edited by Vincent McGhee. New York: Holt, 1970.

Black, Jonathan. *Radical Lawyers: Their Role in the Movement and in the Courts.* New York: Avon Books, 1971.

Bloom, Lynn Z. Doctor Spock: *Biography of a Conservative Radical.* Indianapolis: Bobbs-Merrill, 1972.

Blum, John M. Years of Discord: *American Politics and Society 1961-1974.* New York: W. W. Norton, 1991.

Bockris, Victor. *The Life and Death of Andy Warhol.* New York: Bantam Books, 1989.

_____. *Transformer: The Lou Reed Story.* New York: Simon & Schuster, 1994.

Bourdon, David. *Warhol.* New York: Harry N. Abrams, 1989.

Branch, Taylor. *Parting the Waters: America in the King Years, 1954-1963.* New York: Simon & Schuster, 1988.

Brindle, Reginald Smith. *The New Music: The Avant-Garde Since 1945.* 2d ed. New York: Oxford University Press, 1987.

Brower, David. *For Earth's Sake: The Life and Times of David Brower.* Salt Lake City: Peregrine Smith Books, 1990.

Brown, H. Rap. *Die Nigger Die!* New York: The Dial Press, 1969.

Brownmiller, Susan. *Shirley Chisholm.* Garden City, NY: Doubleday & Co., 1970.

_____. *Against Our Will: Men, Women and Rape.* New York: Bantam Books, 1975.

_____. *In Our Time: Memoir of a Revolution.* New York: The Dial Press, 1999.

Bruce, Lenny. *The Essential Lenny Bruce.* John Cohen, ed. New York: Ballantine, 1967.

Bruce, Lenny. *How To Talk Dirty and Influence People.* Naples, FL: Trident Press Int., 1967.

Bryan, John. *Whatever Happened to Timothy Leary?* San Francisco: Renaissance Press, 1980.

Buchlow, Benjamin H. D., and Judith F. Rodenbeck. *Experiments in the Everyday: Allan Kaprow and Robert Watts—Events, Objects, Documents.* New York: Columbia University Press, 1999.

Buckley, Gail. *American Patriots: The Story of Blacks in the Military from the Revolution to Desert Storm.* New York: Random House, 2001.

Buhle, Mari Jo, Paul Buhle, Dan Georgakas. *Encyclopedia of the American Left.* 2d ed. New York: Oxford University Press, 1998.

Burner, David. *Making Peace with the 60s.* Princeton: Princeton University Press, 1996.

Burroughs, William S. *Junkie*: Confessions of an Unredeemed Drug Addict. New York: Ace, 1953.

Calderwood, James L., and Harold E. Toliver, Eds. *Perspectives on Drama.* New York: Oxford University Press, 1968.

Campbell, James. *Talking at the Gates: A Life of James Baldwin.* New York: Viking, 1991.

Carmichael, Stokeley, and Charles V. Hamilton. *Black Power: The Politics of Liberation in America.* New York: Random House, 1967.

Caro, Robert A. *The Years of Lyndon Johnson: Means of Ascent.* New York: Alfred A. Knopf, 1990.

Carson, Clayborne. *In Struggle: SNCC and the Black Awakening of the 1960s.* Cambridge: Harvard University Press, 1981.

Castellucci, John. *The Big Dance: The Untold Story of Kathy Boudin and the Terrorist Family that Committed the Brink's Robbery Murders.* New York: Dodd, Mead, 1986.

Caute, David. *The Year of the Barricades: A Journey through 1968.* New York: Harper & Row, 1988.

Charters, Ann. *Kerouac: A Biography.* New York: Straight Arrow Books, 1973.

Chisholm, Shirley. *The Good Fight.* New York: Harper & Row, 1973.

Chomsky, Noam. *Language and the Problem of Knowledge: The Managua Lectures.* Cambridge: MIT Press, 1988.

Clavir, Judy, and John Spitzer, eds. *The Conspiracy Trial.* Indianapolis and New York: The Bobbs-Merrill Company, 1970.

Cleaver, Eldridge. *Soul on Ice.* New York: Delta Books, 1968.

Cohen, John. *The Essential Lenny Bruce.* New York: Ballantine Books, 1967.

Cohen, Robert, and Reginald E. Zelnik, eds. *The Free Speech Movement: Reflections on Berkeley in the 1960s.* Berkeley: University of California Press, 1973.

Colacello, Bob. *Holy Terror: Andy Warhol Close Up.* New York: HarperCollins Publishers, 1990.

Colaico, James A. *Martin Luther King, Jr.: Apostle of Militant Nonviolence.* New York: St. Martin's Press, 1988.

Cook, Bruce. *The Beat Generation.* New York: Charles Scribner's Sons, 1971.

Cott, Jonathan. *Dylan.* Garden City: Doubleday, 1984.

Curtis, Richard. *The Berrigan Brothers: The Story of Daniel and Philip Berrigan.* New York: Hawthorn Books, 1974.

Dallek, Robert. *An Unfinished Life: John F. Kennedy, 1917-1963.* Boston: Little, Brown & Co., 2003.

Davis, Angela. *Angela Davis: An Autobiography.* New York: Random House, 1974.

Davis, Flora. *Moving the Mountain: The Women's Movement in America Since 1960.* New York: Simon & Schuster, 1991.

Dearborn, Mary V. *Mailer: A Biography.* Boston: Houghton Mifflin Company, 1999.

Dellinger, David. *From Yale to Jail: The Life Story of a Moral Dissenter.* New York: Pantheon Books, 1993.

Devlin, Bernadette. *The Price of My Soul.* New York: Alfred A. Knopf, 1969.

Dickstein, Morris. *Gates of Eden: American Culture in the Sixties*, 2nd ed. Cambridge: Harvard University Press, 1997.

Diner, Pierre. *The Living Theatre.* New York: Horizon Press, 1972.

Doctorow, E. L. *Welcome to Hard Times.* New York: Simon & Schuster, 1960.

Dougherty, Richard. *Goodbye, Mr. Christian: A Personal Account of McGovern's Rise and Fall.* Garden City, NY: Doubleday & Co., 1973.

Dreifus, Claudia, ed. *Seizing Our Bodies: The Politics of Women's Health.* New York: Vintage Books, 1977.

Duberman, Martin. *Stonewall.* New York: E. P. Dutton & Co., 1993.

Echols, Alice. *Daring To Be Bad: Radical Feminism in America 1967-1974.* Minneapolis: University of Minnesota Press, 1989.

_____. *Scars of Sweet Paradise: The Life and Times of Janis Joplin.* New York: Henry Holt and Co., 1999.

Ellsberg, Daniel. *Papers on the War.* New York: Simon and Schuster, 1972.

Epstein, Edward Jay. *Inquest: The Warren Commission and the Establishment of Truth.* New York: Viking, 1966.

Epstein, Jason. *The Great Conspiracy Trial: An Essay on Law, Liberty and the Constitution.* New York: Random House, 1970.

Evans, Rowland, and Robert Novak. *Nixon in the White House.* New York: Random House, 1971.

Farber, David. *Chicago '68.* Chicago: The University of Chicago Press, 1988.

_____. *The Age of Great Dreams: America in the 1960s.* New York: Hill & Wang, 1994.

_____. *The 1960s: From Memory to History.* Chapel Hill: University of North Carolina Press, 1994.

Fariña, Richard. *Been Down So Long It Looks Like Up To Me.* New York: Random House, 1966.

Feiffer, Jules. *Pictures at a Prosecution: Drawings and Text from the Chicago Conspiracy Trial.* New York: Grove Press, 1971.

Feigelson, Naomi. *The Underground Revolution: Hippies, Yippies, and Others.* New York: Funk & Wagnalls, 1970.

Firestone, Shulamith. *The Dialectic of Sex: The Case for Feminist Revolution.* New York: Morrow, 1970.

Ford, Charles Henri, ed. *View, Parade of the Avant-Garde: An Anthology of View Magazine (1940-1947).* New York: Thunder's Mouth Press, 1991.

Foster, Edward Halsey. *Understanding the Beats.* Columbia: University of South Carolina Press, 1992.

Frankfort, Ellen. *The Voice: Life at The Village Voice.* New York: William Morrow and Company, 1976.

_____. *Kathy Boudin and the Dance of Death.* New York: Stein and Day, 1983.

Friedan, Betty. *The Feminine Mystique.* New York: W. W. Norton & Co., 1963.

Friedman, Myra. *Buried Alive: The Biography of Janis Joplin.* New York: William Morrow & Company, 1973.

Frith, Simon. *Sound Effects: Youth, Leisure, and the Politics of Roc 'n' Roll.* New York: Pantheon Books, 1981.

_____. *"Rock and the Politics of Memory,"* in The 60s without Apology, ed. S. Aronovitz, F. Jameson, S. Sayres, A. Stephanson. Minneapolis: University of Minnesota Press, 1984.

Gaddis, William. *The Recognitions.* New York: Harcourt Brace, 1955.

Galbraith, John K. *A Life in Our Times.* Boston: Houghton Mifflin, 1981.

Gifford, Barry, and Lawrence Lee. *Jack's Book: An Oral Biography of Jack Kerouac.* New York: St. Martin's, 1978.

Gitlin, Todd. *The Whole World Is Watching: Mass Media in the Making and Unmaking of the New Left.* Berkeley: University of California Press, 1980.

_____. *The Sixties: Years of Hope, Days of Rage.* New York: Bantam Books, 1987.

Glatt, John. *Rage & Roll: Bill Graham and the Selling of Rock.* New York: Carol Publishing Group, 1993.

Glessing, Robert J. *The Underground Press in America.* Bloomington: Indiana University Press, 1970.

Goldberg, Roselee. *Performance: Live Art Since 1960.* New York: Harry N. Abrams, 1998.

Goldman, Albert. *Ladies and Gentlemen: It's Lenny Bruce!! From the Journalism of Lawrence Schiller.* New York: Random House, 1971.

_____. *Elvis.* New York: McGraw-Hill Book Company, 1981.

Goldstein, Malcolm. *Landscape with Figures, a History of Art Dealing in the United States.* New York: Oxford University Press, 2000.

Gooch, Brad. *City Poet: The Life and Times of Frank O'Hara.* New York: Alfred A. Knopf, 1993.

Goodman, Mitchell. *The Movement Toward a New America.* Philadelphia: Pilgrim Press, 1970.

Goodman, Paul. *Growing Up Absurd.* New York: Random House, 1960.

Goodwin, Doris Kearns. *Lyndon Johnson and the American Dream.* New York: Harper & Row, 1976.

Goodwin, Richard N. *Remembering America: A Voice from the Sixties.* Boston: Little, Brown and Company, 1988.

Graham, Bill, and Robert Greenfield. *Bill Graham Presents: My Life Inside Rock and Out.* New York: Doubleday & Co., 1992.

Greenberg, Clement. *Art and Culture.* Boston: Beacon Press, 1961.

Greer, Germaine. *The Female Eunuch.* New York: McGraw-Hill Book Company, 1971.

Grogan, Emmett. *Ringolevio: A Life Played for Keeps.* Boston: Little, Brown, 1972.

Hajdu, David. *Positively 4th Street: The Lives and Times of Joan Baez, Bob Dylan, Mimi Baez Fariña, and Richard Fariña.* New York: Farrar, Straus and Giroux, 2001.

Halberstam, David. *The Making of a Quagmire.* New York: Random House, 1965.

_____. *The Best and the Brightest.* New York: Random House, 1972.

_____. *The Powers That Be.* New York: Alfred A. Knopf, 1979.

Haley, Alex. *Malcolm X: The Autobiography.* New York: Grove Press, 1965.

Hamilton, Neil A. *The 1960s Counterculture in America.* Santa Barbara: ABC-Clio, Inc., 1978.

Hamilton, Nigel. *J.F.K.: Reckless Youth.* New York: Random House, 1992.

Hampton, Henry, Steve Fayer, and Sarah Flynn. *Voices of Freedom: An Oral History of the Civil Rights Movement from the 1950s through the 1960s.* New York: Bantam Books, 1990.

Hansen, Al. *A Primer of Happenings & Time/Space Art.* New York: Something Else Press, Inc., 1965.

Harrington, Michael. *The Other America: Poverty in the United States.* New York: The Macmillan Company, 1962.

_____. *Toward a Democratic Left.* New York: The Macmillan Company, 1968.

Harris, David. *Dreams Die Hard: Three Men's Journey through the Sixties.* San Francisco: Mercury House, 1993.

Hayden, Tom. *The American Future: New Visions beyond Old Frontiers.* Boston: South End, 1980.

_____. *Reunion:* A Memoir. New York: Random House, 1988.

Heath, Jim F. *Decade of Disillusionment: The Kennedy-Johnson Years.* Bloomington: Indiana University Press, 1975.

Heller, Joseph. *Catch-22.* New York: Simon & Schuster, 1961.

Henry, Sondra, and Emily Taitz. *One Woman's Power: A Biography of Gloria Steinem.* Minneapolis: Dillon Press, 1987.

Heylin, Clinton. *Bob Dylan: A Life in Stolen Moments Day by Day 1941-1995.* New York: Schirmer Books, 1996.

Hilliard, David, and Lewis Cole. *This Side of Glory: The Autobiography of David Hilliard and the Story of the Black Panther Party.* Boston: Little, Brown, 1993.

Hoberman, J., and Jonathan Rosenbaum. *Midnight Movies.* New York: Harper & Row, 1983.

Hoff, Mark. *Gloria Steinem: The Women's Movement.* Brookfield: Millbrook Press, 1991.

Hoffman, Abbie. *Revolution for the Hell of It.* New York: The Dial Press, 1968.

Hoffman, Jack, and Daniel Simon. *Run, Run, Run: The Lives of Abbie Hoffman.* New York: G. P. Putnam's Sons, 1994.

Hope, Marjorie. *Youth Against the World.* Boston: Little, Brown and Company, 1970.

Hopkins, Jerry, ed. The *Hippie Papers: Notes from the Underground Press.* New York: Signet Books, 1968.

_____. Yoko Ono. New York: Macmillan, 1986.

Horak, Jan-Christopher. *Making Images Move: Photographers and Avant-Garde Cinema.* Washington: Smithsonian Institution Press, 1977.

Hotchner, A. E. *Blown Away: The Rolling Stones and the Death of the Sixties.* New York: Simon & Schuster, 1990.

Howard, Gerald, ed. *The Sixties: Art, Politics and Media of Our Most Explosive Decade.* New York: Washington Square Press, 1982.

Jacobs, Harold, ed. *Weatherman.* Berkeley: Ramparts, 1970.

Jacobs, Paul, and Saul Landau. *The New Radicals: A Report with*

Documents. New York: Random House, 1966.

Jamison, Andrew. *Seeds of the Sixties.* Berkeley: University of California Press, 1994.

Jeffers, H. Paul. *Sal Mineo: His Life, Murder and Mystery.* New York: Carroll & Graf, 2000.

Jezer, Marty. *Abbie Hoffman: American Rebel.* New Brunswick: Rutgers University Press, 1992.

Johnston, Jill. *Paper Daughter: Autobiography in Search of a Father, Volume II.* New York: Alfred A. Knopf, 1985.

_____. *Jasper Johns: Privileged Information.* New York: Thames & Hudson, 1996.

Joplin, Laura. *Love, Janis.* New York: Willard Books, 1992.

Kaiser, Charles. *1968 in America: Music, Politics, Chaos, Counterculture, and the Shaping of a Generation.* New York: Weidenfeld & Nicolson, 1988.

Kaprow, Allan. *Assemblage, Environments & Happenings.* New York: Harry N. Abrams, 1966.

Kasher, Steven. *The Civil Rights Movement: A Photographic History, 1954-68.* New York: Abbeville Press, 1996.

Katzman, Allen. *Our Time: An Anthology of Interviews from the "East Village Other."* New York: Dial Press, 1972.

Kearns, Doris. *Lyndon Johnson and the American Dream.* New York: Harper and Row, 1976.

Kennedy, John F. *The Strategy of Peace.* New York: Harper and Row, 1960.

Kennedy, Robert F. *Thirteen Days: A Memoir of the Cuban Missile Crisis.* New York: W. W. Norton, 1969.

Kerner Commission. *Report of the National Advisory Commission on Civil Disorders.* New York: E. P. Dutton, 1968.

Kesey, Ken. *One Flew Over the Cuckoo's Nest.* New York: Viking Press, 1962.

Kirby, Michael. *Happenings: An Illustrated Anthology.* New York: E. P. Dutton, 1965.

_____. *Futurist Performance.* New York: E. P. Dutton, 1971.

Kirkpatrick, Sale. *SDS.* New York: Random House, 1973.

Kissinger, Henry. *White House Years.* Boston: Little, Brown, 1979.

Knight, Brenda. *Women of the Beat Generation: The Writers, Artists and Muses at the Heart of a Revolution.* Berkeley: Conari Press, 1966.

Knight, Douglas. *Streets of Dreams: The Nature and Legacy of the 1960s.* Durham: Duke University Press, 1989.

Kostelanetz, Richard. *The Fillmore East.* New York: Schirmer Books, 1995.

_____. *Dictionary of the Avant-Gardes*. 2nd ed. New York: Schirmer Books, 2000.

_____. *Conversing with Cage*. 2nd ed. New York: Routledge, 2003.

Kramer, Jane. *Allen Ginsberg in America*. New York: Random House, 1969.

Krassner, Paul. *How a Satirical Editor Became a Yippie Conspirator in Ten Easy Years*. New York: G. P. Putnam's Sons, 1971.

_____. *Confessions of a Raving Unconfined Nut: Misadventures in the Counter-culture*. New York: Simon & Schuster, 1993.

Krim, Seymour. *Views of a Nearsighted Cannoneer*. New York: E. P. Dutton & Co., Inc., 1968.

_____. *You & Me*, New York: Holt, Rinehart and Winston, 1974.

Kunen, James Simon. *The Strawberry Statement: Notes of a College Revolutionary*. New York: Random House, 1969.

Kunstler, William. *My Life as a Radical Lawyer*. New York: Birch Lane, 1994.

Laing, R. D. *The Divided Self: An Existential Study in Sanity and Madness*. London: Tavistock, 1960.

_____. *The Politics of Experience*. New York: Pantheon Books, 1967.

Lane, Mark. *Rush to Judgment: A Critique of the Warren Commission's Inquiry into the Murders of President, John F. Kennedy, Officer J. D. Tippit, and Lee Harvey Oswald*. New York: Holt, Rinehart & Winston, 1966.

Larner, Jeremy. *Nobody Knows: Reflections on the McCarthy Campaign*. New York: Macmillan, 1969.

Lasar, Matthew. *Pacifica Radio: The Rise of an Alternative Network*. Philadelphia: Temple University, 1999.

Lask, Thomas. *Voices in Dissent*. New York: Random House, 1968.

Leary, Timothy. *High Priest*. Cleveland: World Publishing Company, 1968.

_____, Ralph Metzner, and Richard Alpert. *The Psychedelic Experience*. Secaucus: Citadel, 1970.

_____. *Flashbacks*. New York: G. P. Putnam's Sons, 1990.

Lee, Martin A., and Bruce Shlain. *Acid Dreams: The CIA, LSD, and the Sixties Rebellion*. New York: Grove, 1985.

Lens, Sidney. *Unrepentant Radical: An American Activist's Account of Five Turbulent Decades*. Boston: Beacon Press, 1980.

Levy, Peter B., ed. *America in the Sixties Right, Left and Center*. Westport: Praeger, 1998.

Lewis, Randolph. *Emile de Antonio: Radical Filmmaker in Cold War America*. Madison: University of Wisconsin Press.

Lippard, Lucy R. *Pop Art*. New York: Frederick A. Praeger Publishers, 1966.

Lipton, Lawrence. *The Holy Barbarians*. New York: Julian Messner, Inc., 1959.

Lukas, J. Anthony. *Don't Shoot—We Are Your Children!* New York: Random House, 1967.

_____. *The Barnyard Epithet and Other Obscenities: Notes on the Chicago Conspiracy Trial*. New York: Harper & Row, 1970.

Macedo Stephen, ed. *Reassessing the Sixties: Debating the Political and Cultural Legacy*. New York: W. W. Norton, 1997.

MacIntyre, Alasdair. *Herbert Marcuse*. New York: Viking Press, 1970.

Maharishi Mahesh Yogi. *Meditations of Maharishi Mahesh Yogi*. New York: Bantam, 1968.

Maier, Thomas. *Dr. Spock: An American Life*. New York: Basic Books, 2003.

Mailer, Norman. *Advertisements for Myself*. New York: G. P. Putnam's Sons, 1959.

_____. *The Armies of the Night: History as a Novel, The Novel as History*. New York: New American Library, 1968.

_____. *Miami and the Siege of Chicago*. New York: New American Library, 1968.

Makower, Joel. *Woodstock: The Oral History*. New York: Doubleday, 1989.

Malcolm X. *The Autobiography of Malcolm X*. With Alex Haley. New York: Grove Press, 1965.

_____. *Malcolm X Speaks*. New York: Path Press, 1976.

Malina, Judith, and Julian Beck. *Paradise Now: Collective Creation of the Living Theatre*. New York: Random House, 1971.

Manchester, William. *Death of a President*. New York: Harper and Row, 1967.

Manso, Peter. *Mailer: His Life and Times*. New York: Simon and Schuster, 1985.

Marcuse, Herbert. *Eros and Civilization*. Boston: Beacon Press, 1955.

_____. *Critique of Pure Tolerance*. Boston: Beacon Press, 1965.

_____. *Counter-revolution and Revolt*. Boston: Beacon Press, 1972.

Marine, Gene. *Black Panthers*. New York: New American Library, 1969.

Marter, Joan, ed. *Off Limits: Rutgers University and the Avant-Garde, 1957-1963*. New Brunswick: Rutgers University Press, 1999.

Martin, Bernard. *The Existentialist Theology of Paul Tillich.* New York: Harper & Row, 1976.

Martin, Justin. *Nader: Crusader, Spoiler, Icon.* Cambridge: Perseus Publishing, 2002.

Marwick, Arthur. *The Sixties: Cultural Revolution in Britain, France, Italy, and the United States, 1958—1974.* New York: Oxford University Press, 1998.

Matusow, Allen J. *The Unraveling of America: A History of Liberalism in the 1960s.* New York: Harper & Row, 1984.

McAdam, Doug. *Freedom Summer.* New York: Oxford University Press, 1988.

McAuliffe, Kevin Michael. *The Great American Newspaper: The Rise and Fall of the Village Voice.* New York: Charles Scribner's Sons, 1978.

McCord, William. *Mississippi: The Long, Hot Summer.* New York: W. W. Norton, 1965.

McDarrah, Fred W., and Gloria Schoffel McDarrah (introduction by Thomas B. Hess, Editor of Art News). *The Artist's World in Pictures.* New York: E. P. Dutton & Co., 1961.

McDarrah, Fred W., and Timothy S. McDarrah. *Kerouac and Friends: A Beat Generation Album.* New York: Thunder's Mouth Press, 2002.

McGinniss, Joe. *The Selling of the President 1968.* New York: Trident Press, 1969.

McKissick, Floyd. *Three-fifths of a Man.* New York: Macmillan, 1969.

McLuhan, Marshall. *Understanding Media: The Extensions of Man.* New York: McGraw-Hill, 1964.

McLuhan, Marshall, and Quentin Fiore. *The Medium Is the Massage: An Inventory of Effects.* New York: Bantam Books, 1967.

McNally, Dennis. *Desolate Angel: Jack Kerouac, the Beat Generation, and America.* New York: Random House, 1979.

McNeill, Don. *Moving through Here.* New York: Alfred A. Knopf, 1970.

McReynolds, David. *We Have Been Invaded by the 21st Century.* New York: Praeger Publishers, 1970.

Meier, August, and Elliott Rudwick. *CORE: A Study in the Civil Rights Movement, 1942-1968.* New York: Oxford University Press, 1973.

Meier, August, Elliot Rudwick, and John Bracey, Jr., eds. *Black Protest in the Sixties.* New York: Markus Wiener, 1991.

Mekas, Jonas. *Movie Journal: The Rise of a New American Cinema, 1959-1971.* New York: Macmillan, 1972.

Michener, James A. *Kent State: What Happened and Why.* New York: Random House, 1971.

Miles, Barry. *Ginsberg: A Biography.* New York: Simon and Schuster, 1989.

_____. *William Burroughs: El Hombre Invisible, a Portrait.* New York: Hyperion, 1993.

Miller, James. *"Democracy Is in the Streets": From Port Huron to the Siege of Chicago.* New York: Simon and Schuster, 1987.

Millett, Kate. *Sexual Politics.* Garden City, NY: Doubleday & Company, 1970.

_____. *Flying.* New York: Alfred A. Knopf, 1974.

Mills, Hilary. *Mailer: A Biography.* New York: Empire Books, 1982.

Mitford, Jessica. *The Trial of Dr. Spock.* New York: Alfred A. Knopf, 1969.

Moldea, Dan E. *The Killing of Robert F. Kennedy: An Investigation of Motive, Means, and Opportunity.* New York: Norton, 1995.

Morgan, Robin. *Sisterhood Is Powerful: An Anthology of Writings from the Women's Liberation Movement.* New York: Random House, 1970.

Morgan, Ted. *The Life and Times of William S. Burroughs.* New York: Holt, 1988.

Morrison, Joan, and Robert K. Morrison. *From Camelot to Kent State: The Sixties Experience in the Words of Those Who Lived It.* New York: Times Books, 1987.

Mungo, Raymond. *Famous Long Ago: My Life and Hard Times with Liberation News Service.* Boston: Beacon Press, 1970.

_____. *Beyond the Revolution: My Life and Times Since Famous Long Ago.* Chicago: Contemporary Books, 1990.

Munroe, Alexandra, with Jon Hendricks. *Yes Yoko Ono.* New York: Harry N. Abrams, 2000.

Muste, Abraham John. *The Essays of A. J. Muste. Edited by Nat Hentoff.* Indianapolis: Bobbs-Merrill, 1967.

Nader, Ralph. *Unsafe at Any Speed: The Designed-in Dangers of the American Automobile.* New York: Grossman, 1965.

Newfield, Jack. *A Prophetic Minority.* New York: New American Library, 1966.

_____. *Robert Kennedy: A Memoir.* New York: Nation Books, 2003.

Newton, Huey P. *Revolutionary Suicide.* New York: Harcourt Brace Jovanovich, Inc., 1973.

Nicosia, Gerald. *Memory Babe: A Critical Biography of Jack Kerouac.* New York: Grove Press, Inc., 1983.

_____. *Home To War: A History of the Vietnam Veterans' Movement.* New York: Crown Publishers, 2001.

Nitopi, Bill. *Jimi Hendrix: Cherokee Mist, the Lost Writings.* New York: HarperCollins Publishers, 1993.

Nixon, Richard R. N. *The Memories of Richard Nixon.* New York; Grosset & Dunlap, 1978.

O'Brien, James. *A History of the New Left, 1960-1968.* Boston: New England Free Press, 1969.

O'Neill, William L. *Coming Apart: An Informal History of America in the 1960's.* Chicago: Quadrangle Books, 1971.

Obst, Lynda Rosen. *The Sixties: The Decade Remembered by the People Who Lived It Then.* New York: Rolling Stone Press, 1977.

Oblesby, Carl, ed. *New Left Leader.* New York: Grove Press, 1969.

Orenstein, Gloria. *The Theater of the Marvelous: Surrealism and the Contemporary Stage.* New York: New York University Press, 1975.

Paley, Grace. *Just As I Thought.* New York: Farrar Straus and Giroux, 1999.

Palmer, Robert. *Rock & Roll: An Unruly History.* New York: Harmony Books, 1995.

Pauck, Wilhelm, and Marion Pauck. *Paul Tillich: His Life and Thought.* New York: Harper & Row, 1976.

Pearson, Hugh. *Huey Newton and the Price of Black Power in America.* Reading: Addison-Wesley, 1994.

Peck, Abe. *Uncovering the Sixties: The Life and Times of the Underground Press.* New York: Pantheon Books, 1985.

Perron, Wendy. *Judson Dance Theater: 1962-1966.* Bennington: Bennington College Judson Project, 1981.

Perry, Paul. *On the Bus: The Complete Guide to the Legendary Trip of Ken Kesey and the Merry Pranksters and the Birth of the Counterculture.* New York: Thunder's Mouth Press, 1990.

_____. *Fear and Loathing: The Strange Saga of Hunter S. Thompson.* New York: Thunder's Mouth Press, 1992.
Podhoretz, Norman. *Doings and Undoings.* New York: Farrar, Straus and Giroux, 1964.

Quinn, Edward, and Paul J. Dolan, eds. *The Sense of the Sixties.* New York: The Free Press, 1968. New York: Harper Collins, 1992.

Raines, Howell. *My Soul is Rested: Movement Days in the Deep South Remembered.* New York: G. P. Putnam's Sons, 1977.

Ralph, James R. Jr. *Northern Protest: Martin Luther King, Jr., Chicago, and the Civil Rights Movement.* Cambridge, MA: Harvard University Press, 1993.

_____. *Liberty and Sexuality: The Right to Privacy and the Making of Roe v. Wade.* New York: Macmillan, 1994.

Raskin, Jonah. *For the Hell of It: The Life and Times of Abbie Hoffman.* Berkeley: University of California Press, 1996.

Reich, Charles. *The Greening of America: How the Youth Revolution Is Trying to Make America Livable.* New York: Random House, 1970.

Rivers, Larry, with Arnold Weinstein: *What Did I Do? The Unauthorized Autobiography.* New York: HarperCollins, 1992.

Rodriguez, Consuelo. *Cesar Chaves.* New York: Chelsea House, 1991.

Rollyson, Carl. *The Lives of Norman Mailer: A Biography.* New York: Paragon House, 1991.

Rosenthal, Raymond, ed. *McLuhan Pro and Con.* New York: Funk and Wagnalls, 1968.

Rostagno, Aldo. *We, the Living Theatre.* New York: Ballantine Books, 1970.

Roszak, Theodore. *The Making of a Counter Culture: Reflections on the Technocratic Society and Its Youthful Opposition.* New York: Doubleday, 1969.

Roth, Philip. *Goodbye Columbus.* New York: Houghton Mifflin, 1959.

Rout, Kathleen. *Eldridge Cleaver.* Boston: Twayne, 1991.

Royko, Mike. *Boss: Richard J. Daley of Chicago.* New York: New American Library, 1971.

Rubin, Jerry. *DO IT: Scenarios of the Revolution.* New York: Simon and Schuster, 1970.

_____. *We Are Everywhere.* New York: Harper & Row, 1971.

_____. *Growing (Up) at Thirty-Seven.* New York: M. Evans & Co., 1976.

Sale, Kirkpatrick. *SDS.* New York: Random House, 1973.

Sanders, Edward. *Shards of God.* New York: Grove Press, Inc., 1970.

_____. *1968: A History in Verse.* Santa Rosa: Black Sparrow Press, 1997.

Sandler, Irving. *American Art of the 1960s.* New York: Harper & Row, 1988.

Sarris, Andrew. *The American Cinema: Directors and Directions, 1949-1968.* New York: E. P. Dutton, 1968.

Sayre, Nora. *Sixties Going on Seventies.* New York: Arbor House, 1973.

Sayres, Sohnya. *The 60s Without Apology.* Minneapolis: University of Minnesota Press, 1984.

Schlesinger, Arthur Jr. *A Thousand Days.* New York: Houghton Mifflin, 1965.

_____. *Violence: America in the Sixties.* New York: Signet Broadside, 1968.

_____. *Robert F. Kennedy and His Times.* New York: Houghton Mifflin, 1978.

Schneemann, Carolee. *Imaging Her Erotics: Essays, Intervals, Projects.* Cambridge: The MIT Press, 2002.

Schumacher, Michael. *There but for Fortune: The Life of Phil Ochs.* New York: Hyperion, 1996.

Seale, Bobby. *Seize the Time: The Story of the Black Panther Party and Huey P. Newton.* New York: Random House, 1970.

_____. *A Lonely Rage.* New York: Times Books, 1978.

Seaver, Richard, Terry Southern, and Alexander Trocchi, eds. *Writers in Revolt: An Anthology.* New York: Frederick Fell, 1963.

Selby, Hubert Jr. *Last Exit to Brooklyn.* New York: Grove Press, 1964.

Sellers, Cleveland, and Robert Terrell. *The River of No Return: The Autobiography of a Black Militant and the Life and Death of SNCC.* New York: William Morrow, 1973.

Shapiro, Harry, and Caesar Glebbeek. *Jimi Hendrix: Electric Gypsy.* New York: St. Martin's, 1990.

Sitney, P. Adams. *Visionary Film: The American Avant-Garde.* New York: Oxford University Press, 1974.

Solomon, David, ed. *LSD: The Consciousness-expanding Drug.* Boston: G. P. Putnam's Sons, 1966

Sontag, Susan. *Against Interpretation.* New York: Delta Books, 1966.

Sorenson, Theodore. *Kennedy.* New York: Harper and Row, 1965.

Stearns, Gerald, ed. *McLuhan Hot and Cold.* New York: Dial Press, 1967.

Steigerwald, David. *The Sixties and the End of Modern America.* New York: St. Martin's Press, 1995.

Stein, David Lewis. *Living the Revolution: The Yippies in Chicago.* Indianapolis: Bobbs-Merrill, 1969.

Stein, Jean, and George Plimpton. *Edie: An American Biography.* New York: Alfred A. Knopf, 1982.

Steinem, Gloria. *Revolution from Within: A Book of Self-Esteem.* Boston: Little, Brown, 1992.

Stern, Robert A. M., Thomas Mellins, and David Fishman. *New York 1960: Architecture and Urbanism between the Second World War and the Bicentennial.* New York: The Monacelli Press, 1995.

Stiles, Kristine, and Peter Selz. *Theories and Documents of Contemporary Art: A Sourcebook of Artist's Writings.* Berkeley: University of California Press, 1996.

Stone, I. F. *Polemics and Prophecies 1967-1970.* New York: Random House, 1971.

Sukenick, Ronald. *Down and In: Life in the Underground.* New York: Beech Tree, 1988.

Swerdlow, Amy. *Women Strike for Peace: Traditional Motherhood and Radical Politics in the 1960s.* Chicago: University of Chicago Press, 1993.

Szulc, Tad. *Then and Now How the World Has Changed Since World War II.* New York: William Morrow & Co., 1990.

Thompson, Hunter. *Hell's Angels: A Strange and Terrible Saga.* New York: Random House, 1966.

Trilling, Diana. *We Must March, My Darlings.* New York: Harcourt Brace Jovanovich, 1977.

Truscott, Lucian K IV. *Dress Gray.* Garden City: Doubleday & Company, 1979.

Tyler, Parker. *Underground Film: A Critical History.* New York: Grove Press, 1969.

Tytell, John. *Naked Angels: The Lives & Literature of the Beat Generation.* New York: McGraw-Hill, 1976.

_____. *The Living Theatre: Art, Exile, and Outrage.* New York: Grove Press, 1995.

Unger, Irwin. *The Movement: A History of the American New Left, 1959-1972.* New York: Dodd, Mead, 1974.

Van DeBurg, William L. *New Day in Babylon: The Black Power Movement and American Culture, 1965-1975.* Chicago: University of Chicago Press, 1992.

Vaughan, David (chronicle and commentary), and Melissa Harris, editor. *Merce Cunningham: Fifty Years.* New York: Aperture, 1997.

Viorst, Milton. *Fire in the Streets: America in the 1960s.* New York: Simon and Schuster, 1979.

Wakefield, Dan. *New York in the Fifties.* Boston: Houghton Mifflin, 1992.

Walker, Daniel. *Rights in Conflict: The Violent Confrontation of Demonstrators and Police in the Parks and Streets of Chicago During the Week of the Democratic National Convention of 1968.* Philadelphia: Braceland Brothers, 1968.

Weiner, Rex, and Deanne Stillman. *Woodstock Census: The Nationwide Survey of the Sixties Generation.* New York: Viking, 1979.

Weisbrot, Robert. *Freedom Bound: A History of America's Civil Rights Movement.* New York: W. W. Norton, 1990.

Wells, Tom. *Wild Man: The Life and Times of Daniel Ellsberg.* New York: St. Martins, 2001.

White, Theodore H. *The Making of the President, 1960.* New York: Atheneum, 1961.

_____. *The Making of the President, 1964.* New York: Atheneum, 1965.

_____. *The Making of the President, 1968.* New York: Atheneum, 1969.

_____. *The Making of the President, 1972.* New York: Atheneum, 1973.

White, Thomas. *Rock Lives: Profiles & Interviews.* New York: Henry Holt & Co., 1990.

Wills, Gary. *Nixon Agonistes.* New York: New American Library, 1970.

Witcover, Jules. *White Knight: The Rise of Spiro Agnew.* New York: Random House, 1972.

Wofford, Harris. *Of Kennedy and Kings: Making Sense of the Sixties.* Pittsburgh: University of Pittsburgh Press, 1980.

Wolf, Daniel, and Edwin Fancher, eds. *The Village Voice Reader: A Mixed Bag from the Greenwich Village Newspaper.* Garden City, NY: Doubleday & Company, 1962.

Wolf, Leonard, and Deborah Wolf. *Voices from the Love Generation.* Boston: Little, Brown, 1968.

Wolfe, Tom. *Radical Chic and Mau-mauing the Flack Catchers.* New York: Farrar, Straus and Giroux, 1970.

_____. *The New Journalism.* New York: Harper and Row, 1973.

Zelevansky, Lynn, Laura Hoptman, Akira Tatehata, Alexandra Munroe. *Love Forever: Yayoi Kusama, 1958-1968.* Los Angeles: Los Angeles County Museum of Art, 1998.

Index